SPECTACULAR HOMES

of New England

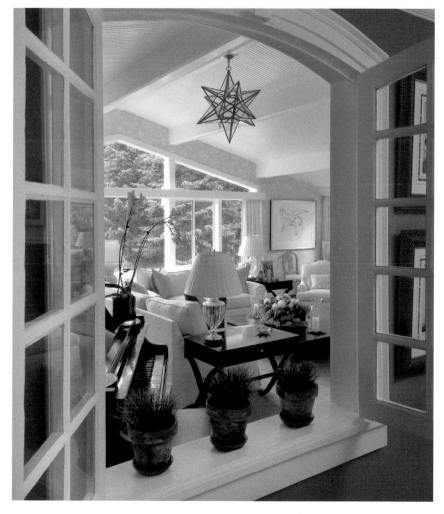

AN EXCLUSIVE SHOWCASE OF THE FINEST DESIGNERS IN NEW ENGLAND

Published by

PANACHE
PANACHE PARTNERS, LLC

13747 Montfort Drive, Suite 100
Dallas, Texas 75240
972.661.9884
Fax 972.661.2743
www.panache.com

Publishers: Brian G. Carabet and John A. Shand
Executive Publisher: Phil Reavis
Associate Publisher: Mary Whelan
Editors: Lauren Castelli and Rosalie Wilson
Contributing Editor: Stacy Kunstel
Designer: Mary Elizabeth Acree

Printed in Malaysia

Distributed by Gibbs Smith, Publisher
800.748.5439

PUBLISHER'S DATA

Spectacular Homes of New England

Library of Congress Control Number: 2007920150

ISBN 13: 978-1-933415-19-2
ISBN 10: 1-933415-19-3

First Printing 2007

10 9 8 7 6 5 4 3 2 1

Previous Page: Inside/Out, LTD.
See page 125 Photograph by Eric Levin Photography

This Page: Cebula Design, Inc. *Fine Interiors*
See page 91 Photograph by Michael Rixon

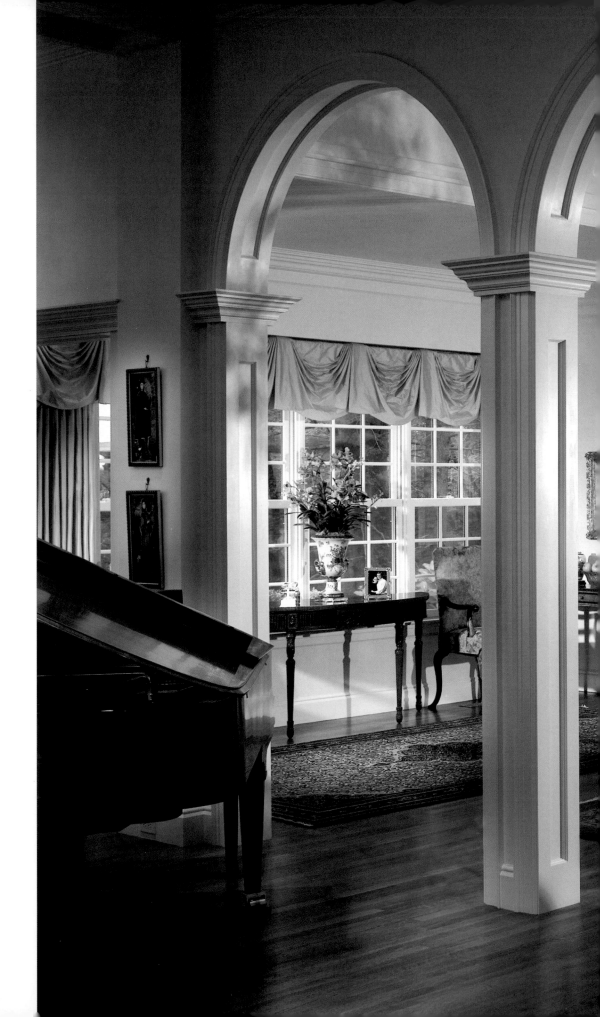

SPECTACULAR HOMES
of New England

AN EXCLUSIVE SHOWCASE OF THE FINEST DESIGNERS IN NEW ENGLAND

FOREWORD

N ew England interiors are as varied as the New England landscape, as unlike as the four distinct New England seasons, and as unpredictable as New England weather.

New England decorating has sometimes been labeled stiff, stodgy, stuffy, somewhat tattered, dusty, and full of brown furniture. To dispel that myth, the interiors showcased in this beautiful book were created by some of New England's finest designers whose work reflects a wide range of taste and styles that will please and surprise the eye.

New Englanders are, by and large, consistent folk. We set our standards high and we demand quality in the things that surround us. We have a deep respect for the value of a dollar, hence we are not easily caught up in, or impressed by, current trends and passing fancies. Longevity in design is key. Shock for shock's sake is not on our agenda. We like our homes to reflect our New England spirit, incorporating not only a respect for the past but also an eye toward the future. Our interiors are designed to be lived in rather than simply to impress—which in and of itself is impressive.

The lovely country homes and city apartments presented herein are fine examples of gracious 21st-century New England interior design. There is a sense of continuity, of quality and livability in these rooms—from the use of soft, subtle color with a dash of the bold and the playful; the eclectic mix of classic and modern furnishings, and the refined blend of pattern and texture—all the elements that exemplify great interior design.

As you turn the pages of this book, perusing these timeless interiors, you'll begin to wonder just where all that brown furniture has gone.

Enjoy!

Charles Spada

Photograph by Raymond Forbes

The diversity of architecture in New England goes far beyond the popular Currier and Ives portraits imbedded in the minds of most Americans. Admittedly, our city streets and country lanes boast many traditional styles—Colonial, Federal, Capes, and Saltboxes. But beyond the quaint villages and historic centers there are also modern leanings (one look at MIT's Frank Gehry–designed Stata Center quickly establishes that modernism is alive and well in the region).

There are so many visual cues you become aware of when living in New England. The reddened, frost-filled face of a Maine lobsterman working in the cold of winter, the hardscape of rock walls tracing centuries-old farms, the cotton puffs of sheep punctuating a green Vermont hillside, the sandy dunes that stretch inland from a windswept Cape Cod beach.

Skilled interior designers in these six states embrace myriad styles—be it an 18th-century Colonial on the gray shores of Nantucket, a new urban loft in Boston, or converting an old mill building in Providence into a gracious residence. They work with homeowners to make personal statements that reflect their art, their collections, their approach to living. The variety of decorating here is immense and the talents of designers may be unmatched.

Living in New England means many things—independence, work ethic, understatement, honesty and humor, fairness, and of course the ability to endlessly complain about the weather, always. But it most often means love of the region, love of home and of history.

To say New Englanders are house-proud is an understatement. Home tours in our region are ubiquitous, from the grand brick houses of Boston's Beacon Hill to the charming homes in historic villages such Jaffrey Center, New Hampshire, where I live in a timeless 1905 Cape. Preservation is a way of life. We hand our houses down to our children as our most important heirlooms.

It gives me great pleasure to introduce you to some of the finest and most talented designers in America, all of whom are gathered together in our pages to show their skills and share with you their beautiful work.

Homes, like people, are diverse, fun, and sometimes difficult. America started here, and in home design and decorating, New England continues to be a leader in preserving the past while celebrating the bright future of the region.

Enjoy!

Stacy Kunstel

Contributing Editor

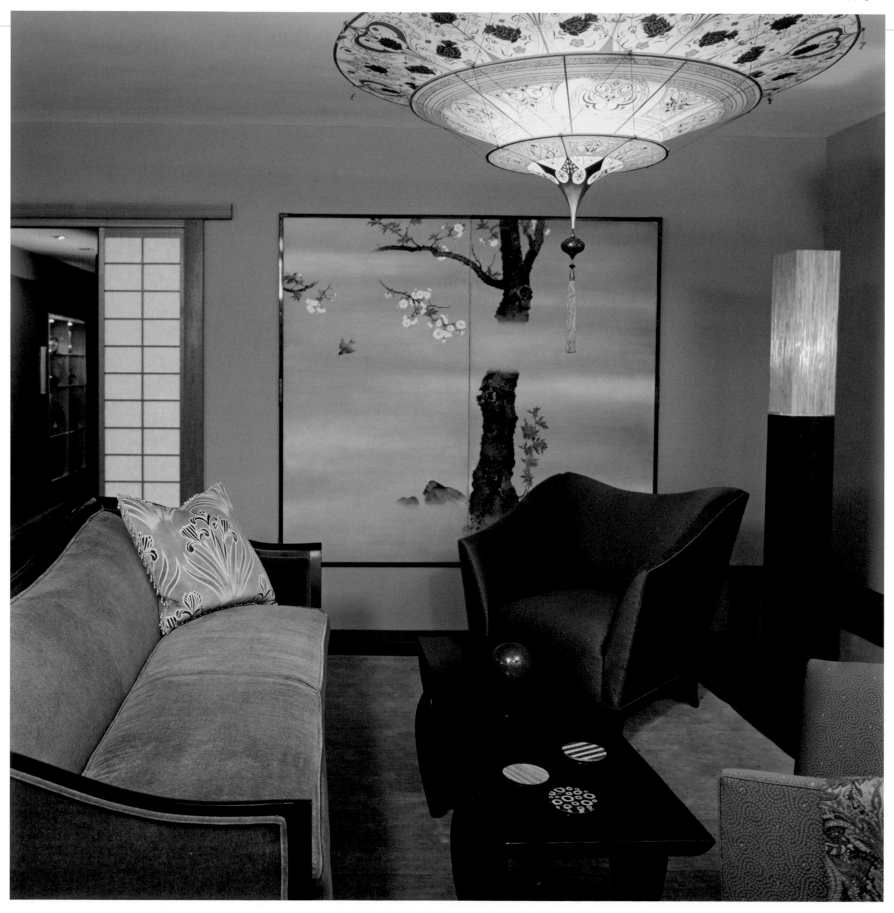

TABLE OF CONTENTS

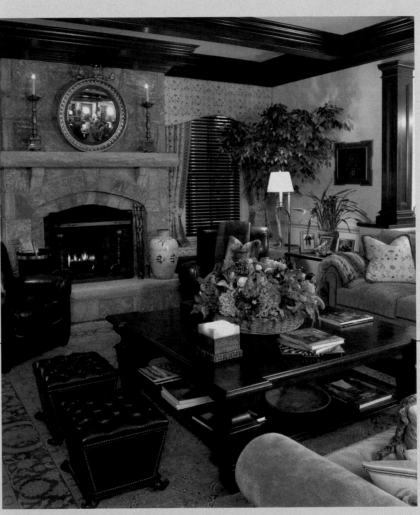

DESIGNER LINDA RUDERMAN INTERIORS, page 45

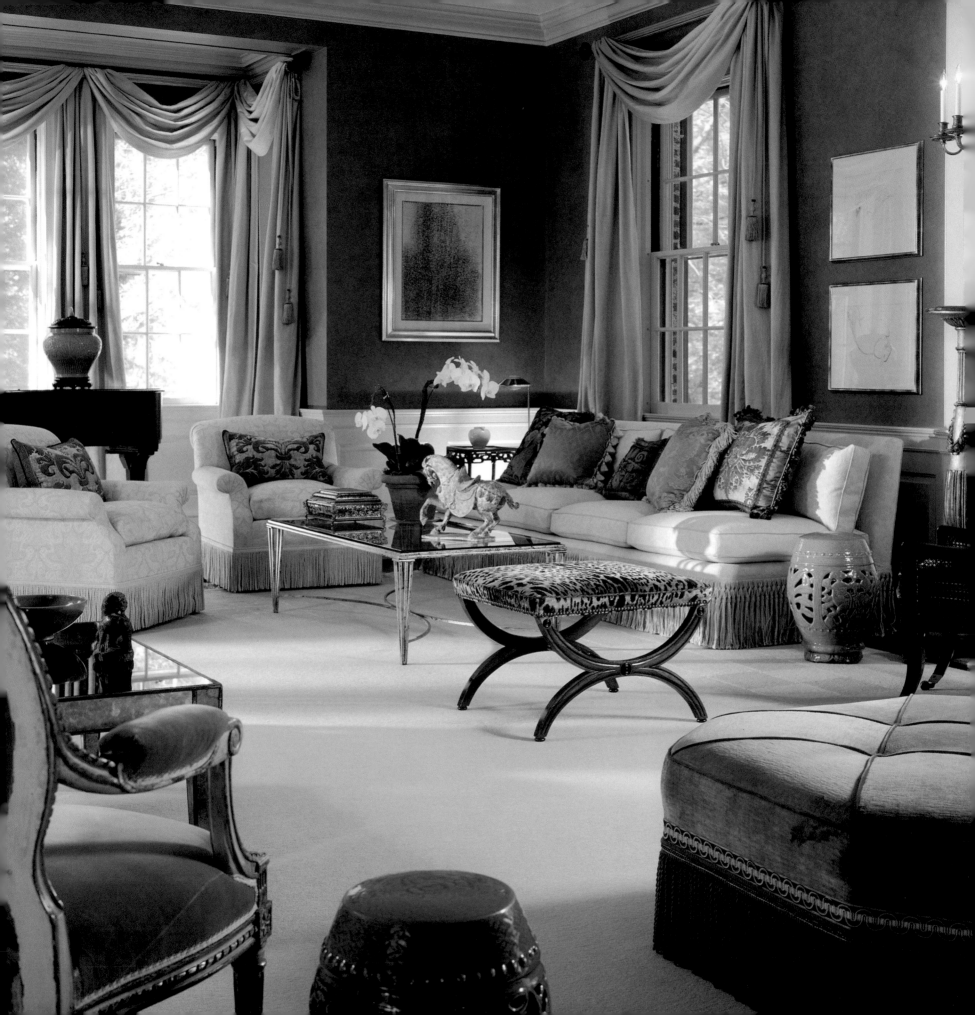

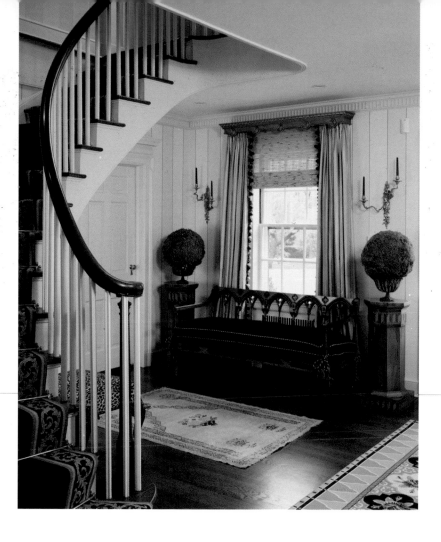

CONNIE BEALE

CONNIE BEALE, INC.

Interior design is a learning process in a variety of ways. Homeowners seek out design professionals to help them interpret their particular styles in a way that is functional as well as aesthetically pleasing. Connie Beale believes that information flows both ways: She learns about the people she works with and also from them. With over 30 years of design experience, she and her firm can interpret a variety of styles in a way that best represents the clients and allows them to be comfortable in their own homes.

Founded in 1979, Connie Beale, Inc. offers a variety of architectural and interior design services to clients nationwide. Projects range from Western ranches and ski chalets to homes in Florida and Bermuda. Each locale presents an array of technical and design problems that Connie, senior designer Brian Del Toro and architect George Sirinakis work out with their staff of assistants. Whether working independently on a renovation

project or with another architectural firm on new construction, Connie's goal is to preserve the aesthetic vision while making the house functional and unique for the client.

From working with celebrities, entrepreneurs, bankers and their wives and husbands, Connie has learned to identify the needs of high-end clients and successfully execute their special requests. She avoids an off-the-shelf look and shops both domestically

ABOVE
An oak Gothic-style settee with aubergine velvet and Charles X pedestals from Nancy Lancaster estate, found by Brian Del Toro, welcome guests to this elegant home. Custom-printed wallpaper, Louis XV sconces and a gilded valance add panache.
Photograph by Mick Hales

FACING PAGE
This classically-styled living room features a custom-designed sofa, ottoman and rug. Tobacco-colored glazed walls highlight Chinese antiquities and contemporary art, including a painting by Tobey.
Photograph by Durston Saylor

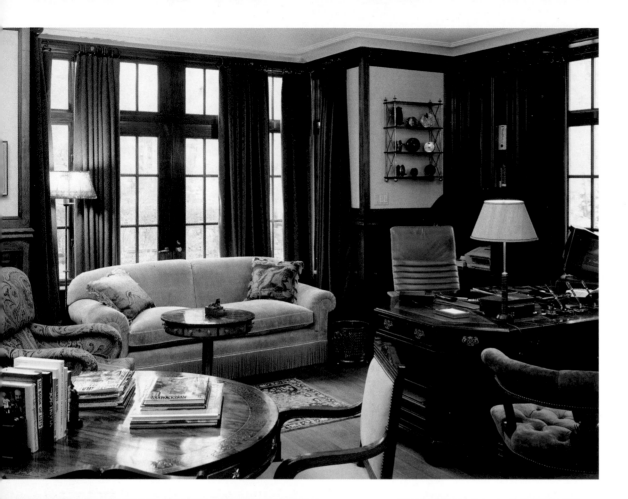

and abroad to find the one-of-a-kind pieces that suit her clients' personalities. Custom-designed pieces further display the firm's talents. One can find interiors by Connie Beale, Inc. in *House and Garden, The Robb Report, Veranda, Country Living, Connecticut Cottages & Gardens* and *House Beautiful*, the last of which has named her one of its top 100 designers.

Connie maintains that her work is not the end but the beginning of a home's design. Her role as a designer is to provide a suitable background for clients to express themselves and begin to accumulate art and accessories. Her main goal is to make a house the client's own. She tells of the Texas living room she revisited some time after the project's completion. There were newspapers all over the couch, cigarette butts in the ashtray and slippers on the Oriental rug. She knew then that her clients really were comfortable living in the space she had designed.

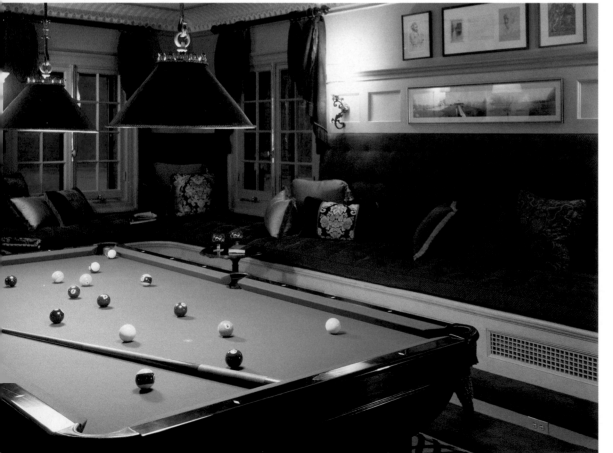

TOP LEFT
Oak paneling designed by CBI, a Regency table and a collection of old fishing reels behind the desk lend a traditional tone, while a comfortable, contemporary desk chair completes this televison producer's study.
Photograph by Mick Hales

BOTTOM LEFT
A built-in banquette, reupholstered in red cut velvet, surrounds an antique pool table and light fixture in the restored billiard room of this 1919 Carrere and Hastings mansion.
Photograph by Mick Hales

FACING PAGE LEFT
CBI's Brian Del Toro designed this stylish dining room, replete with custom ceiling detail, Directorie-style table, mid-20th-century chairs and tri-color banded curtains.
Photograph by Mick Hales

FACING PAGE RIGHT
Traditional style abounds in this living room with raisin-colored walls, ivory-colored moiré curtains with coral-motif passementerie tiebacks, a damask-patterned ivory wool rug and a Lee Jofa chintz sofa.
Photograph by Mick Hales

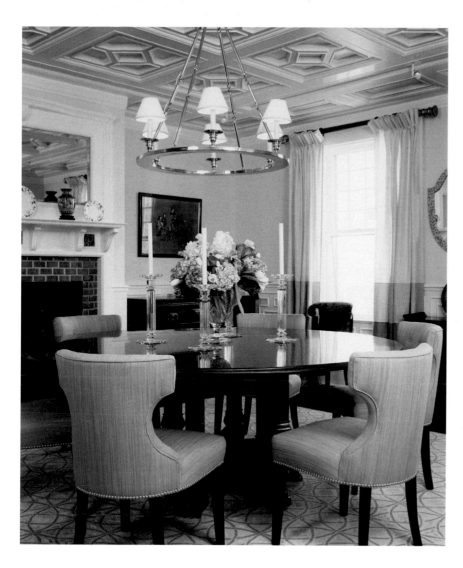

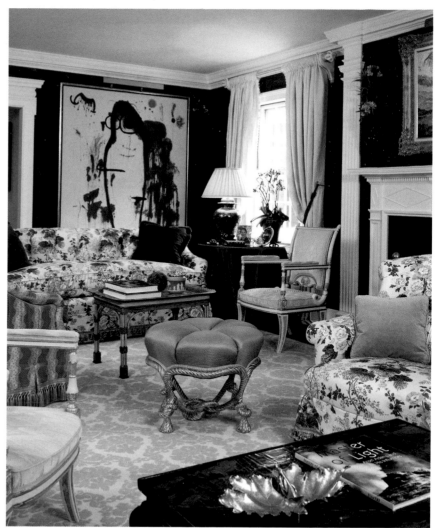

Q&A

MORE ABOUT CONNIE ...

WHAT IS THE HIGHEST COMPLIMENT YOU'VE RECEIVED PROFESSIONALLY?

I've heard from clients that pieces I chose for their homes looked like they had always been there.

WHAT DESIGN PROJECT GAVE YOU THE MOST DIFFICULTY AND WHY?

My own home, largely due to overexposure. I am around such a variety of styles and design elements that it's difficult to tie myself to one.

WHAT IS A SINGLE THING YOU WOULD DO TO BRING A DULL HOUSE TO LIFE?

Introduce unique light fixtures.

NAME ONE THING MOST PEOPLE DON'T KNOW ABOUT YOU.

I listen to country music ... It makes me laugh!

CONNIE BEALE, INC.
Connie Beale, ASID
125 East Putnam Avenue
Greenwich, CT 06830
203.661.6003
Fax 203.661.6292

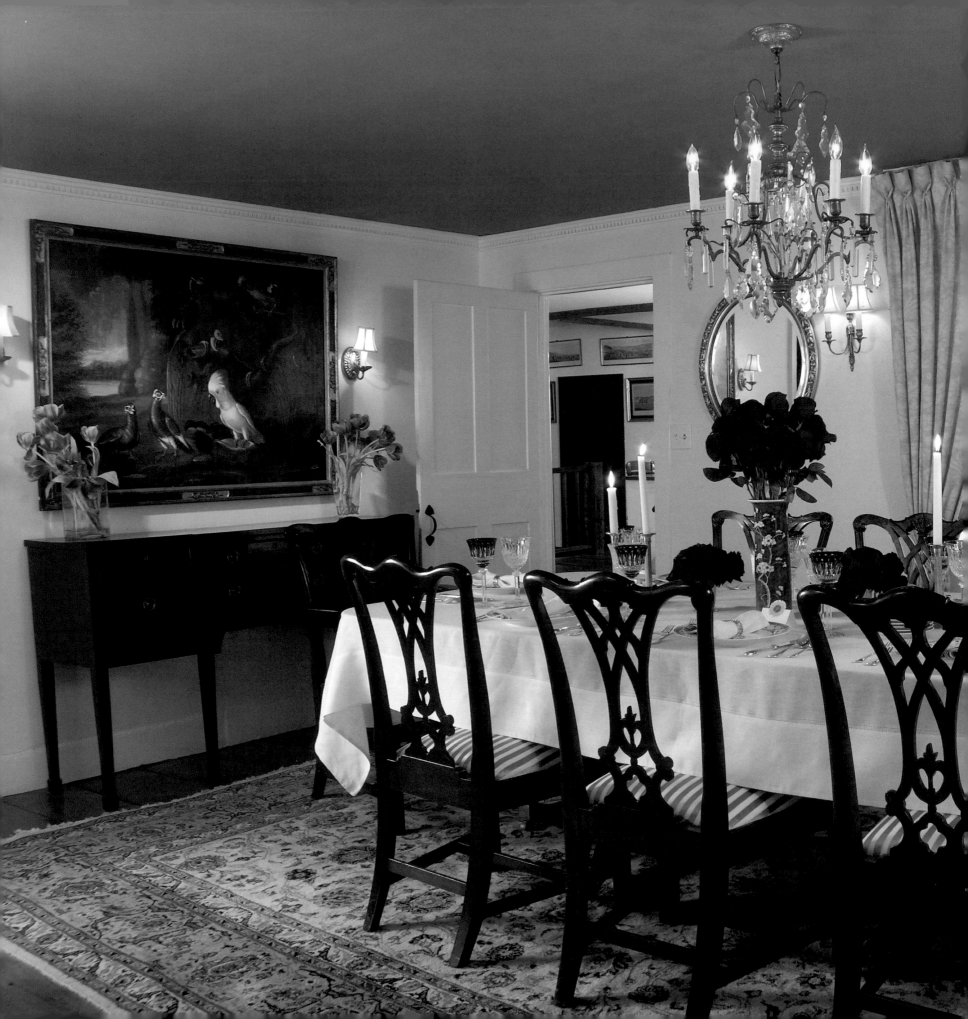

KAT BURKI

KAT BURKI INTERIORS

Recently, a little girl was playing with her brother in a Southport business. Having thoroughly explored the first-floor establishment, she came upon a flight of stairs. Curious, the little girl began to climb. Upon reaching the top, she froze, eyes wide, and called to her brother, "Robert! Come quick!" Overcoming her initial shock at finding people at work inside, the girl took in the supposed wonderland she had found: "It's beautiful!" She had come upon the enchanting loft that houses Kat Burki Interiors.

Kat Burki arrived at her business in a similar fashion. Ten years ago, she would not have expected to find herself in a design firm at all, much less owning the vibrant, seven-person company she runs today—Kat earned a double major in business and law. But she was always a designer at heart, drafting a layout of her bedroom as early as eighth grade and designing interiors for relatives and friends as a young adult. Those who saw her designs were captivated by them and by Kat's tremendous talent.

When one such couple asked to hire her to design the lake house they were building, Kat jumped at the opportunity. In law school and raising two boys at the time, Kat also worked in a legal clinic. She soon discovered that she could not hold four full-time jobs and maintain her sanity. After much soul

LEFT
Sophisticated antique Colonial with painted ceiling, English antiques, Persian rug and French antique chandelier.
Photograph by Robert Grant

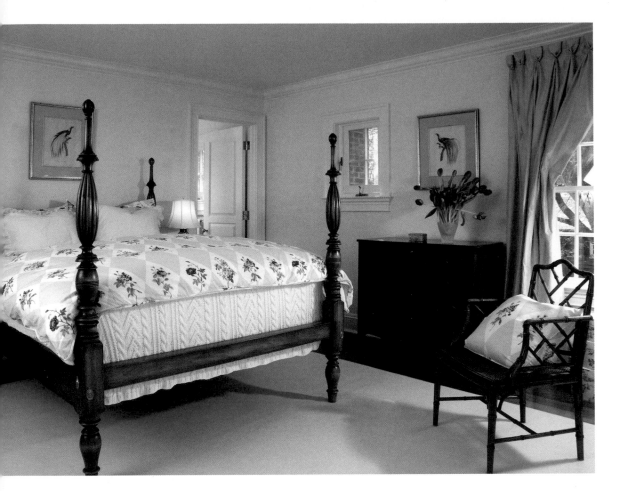

searching, Kat decided to pursue her passion and open what would become a very successful design business. In 2002, she signed the lease on her loft space, which she then refurbished and filled with the antiques and beautiful upholstery that would years later enthrall a little girl.

Kat has since designed residences and businesses across the country and has launched her own line of wildly popular home accessories. Indeed, when she placed a national ad for her initial product run, she sold her entire stock in less than two months. Kat's impressive popularity stems from her use of bold colors and patterns, an uncommon practice in regions infused with contemporary design. Her work is particularly desired by California residents, who are hard pressed to find designers who use florals, stripes and other more traditional motifs as Kat does. She prides herself on her ability to mix and match patterned fabrics in a sophisticated—not "cutesy"—way that her clients embrace.

Kat's designs, which range from crisp cottage couture to richer, more sumptuous styles, have been featured in publications such as *Veranda* and *The New York Times*. Homes she has designed, including her own, have been featured in a number of designer home tours. Clearly, Kat's self-exploration revealed her own dream world, and she has shaped it into a rewarding reality.

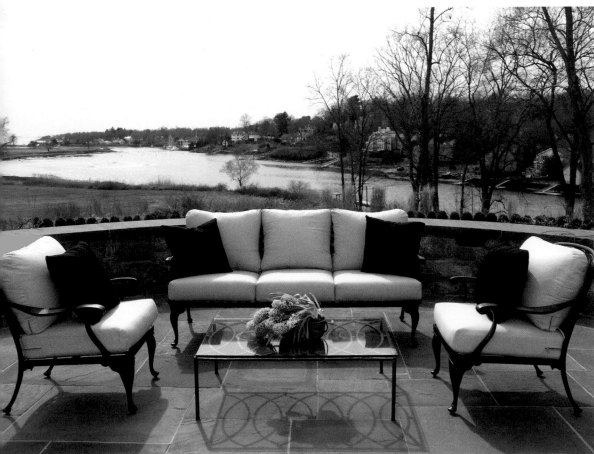

TOP LEFT
Newly built home with bed and breakfast flair opens to gorgeous views of the ocean.
Photograph by Robert Grant

BOTTOM LEFT
Sleek stone terrace with custom overstuffed seating incorporates all the comfort of indoors on the Gold Coast of Connecticut.
Photograph by Robert Grant

FACING PAGE
Chic, brick red library—a mix of new and old—with original artwork by Patricia Nix.
Photograph by Robert Grant

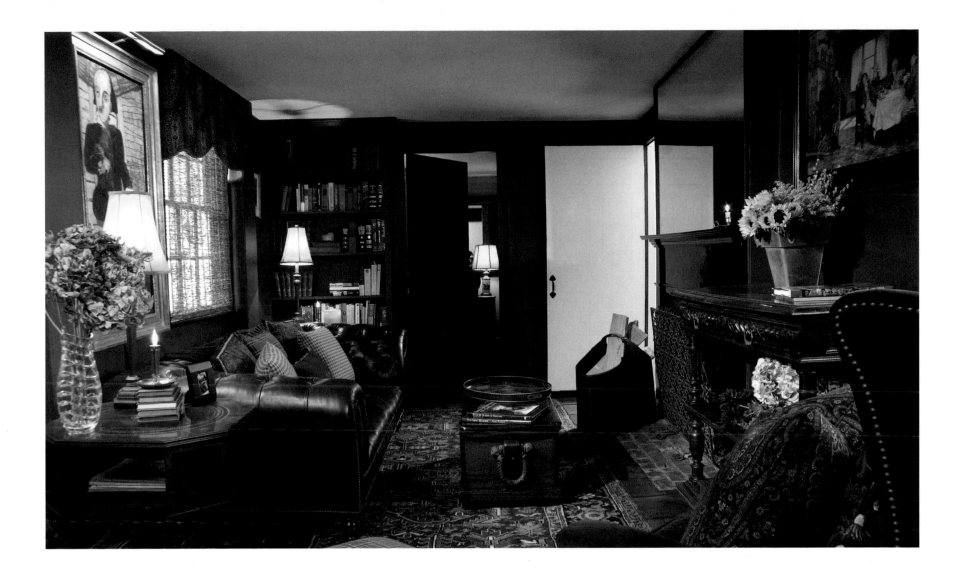

Q & A

MORE ABOUT KAT ...

WHAT IS THE BEST PART OF BEING AN INTERIOR DESIGNER?

There is nothing like making people feel happy with my designs.

WHAT IS THE BEST COMPLIMENT YOU'VE RECEIVED PROFESSIONALLY?

Guests visiting the first home I designed were moved to touch me when they found out I was the designer. They were affected in a palpable way by my work in the home, which is my goal as a designer.

WHAT COLOR BEST DESCRIBES YOU AND WHY?

Blue, because it is peaceful and happy.

IF YOU COULD ELIMINATE ONE DESIGN OR ARCHITECTURAL STYLE FROM THE WORLD, WHAT WOULD IT BE?

I don't understand why one wouldn't finish a room with crown moulding. It's inexpensive to do, it raises the ceiling, and it makes the room more polished and elegant, but so many homes don't have it.

WHAT IS A SINGLE THING YOU WOULD DO TO BRING A DULL HOUSE TO LIFE?

Often I'll go into a really pretty house, and the color of the paint is off. The wrong paint can make an otherwise bright room look dark and dull. Repainting can revive a home.

KAT BURKI INTERIORS
Kat Burki
340 Pequot Avenue
Southport, CT 06890
203.254.2908
Fax 203.254.2928
www.katburki.com

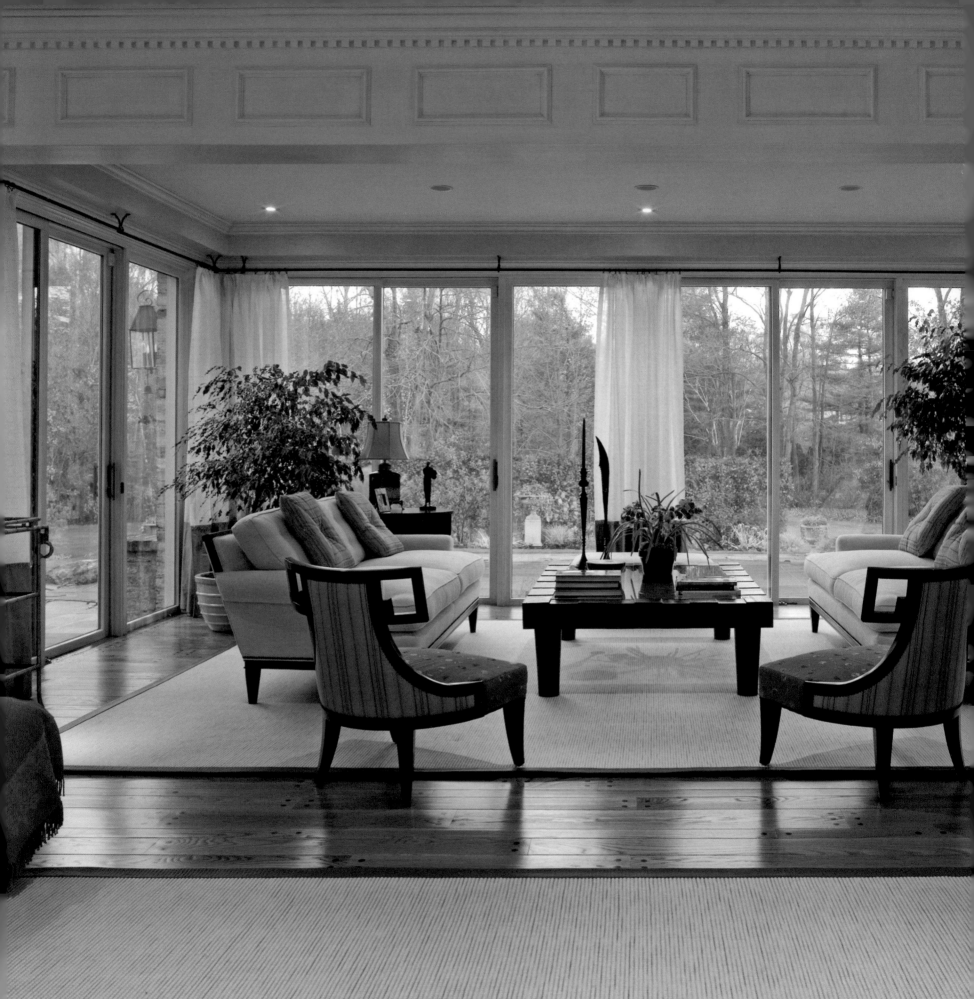

MARTI EASTON

MARTI EASTON INTERIORS

" If you want to make people happy, make a reality out of their dreams." This is Marti Easton's philosophy, and with over 25 years of design experience, she has done so for many people. Building on the fine arts degree she earned from the University of Washington, she spent her early years in the world of high fashion, designing clothing lines for several well-known firms. This background, combined with her extensive travels throughout Europe, honed her knowledge of and fueled her passion for art and architecture, ultimately leading her to her true vocation, interior design.

Marti lends this expertise to each new home design or renovation project she undertakes. Her clients find her understanding of antiques and fine art invaluable, and they greatly benefit from her remarkable eye for scale and proportion. But it is Marti's insistence on collaboration with her clients that brings her designs to life. She works closely with her clients from the outset to find out not only their style preferences but their backgrounds and inspirations, as well. In so doing, Marti tangibly expresses her clients' personalities and desires.

Marti's love of home design is a product of her upbringing. Her mother frequently rearranged furniture in the middle of the night—a habit Marti inherited—and her parents designed and built multiple homes, all of which Marti and her siblings helped construct. Thus at a very early age, Marti was exposed

LEFT
Neutral colors give this light-filled, tranquil family room in the home of Melissa and Roy Salameh its calm, serene ambience. Marti Easton designed the intricate archway and columns, which were produced by W&W Construction. The linen and silk curtains were made by Designs by Town & Country, and Ruggles Workroom produced the matching wool sisal rugs with four-inch leather binding.
Photograph by Timothy Bell

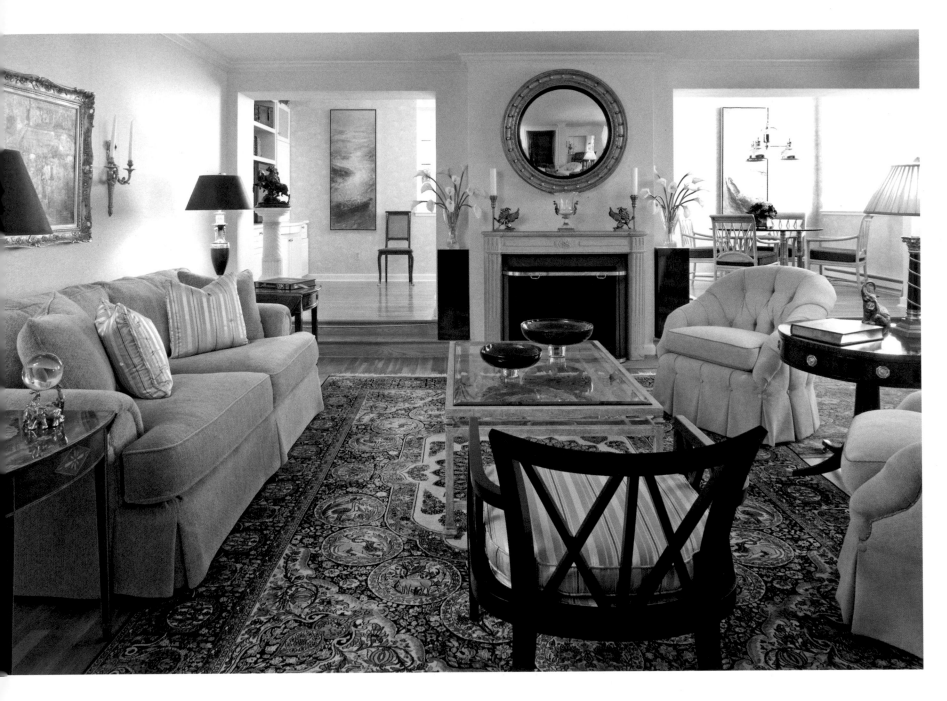

to a variety of new interiors and sundry furniture arrangements, which would prove to profoundly affect both her sensibility and her future.

Her mother, a surgical nurse with a love of sewing, had taught Marti to sew when she was very young, and Marti became quite a talented seamstress. While this talent led to her early work as a clothing designer, she maintained a deep love for residential interiors, and the publications to which she subscribed were always shelter—not fashion—related.

In 1997, she became increasingly restless in her clothing design career and felt the need for a change. A close friend who had long taken note of her passion and talent for home design suggested that she consider turning it into a career. Taking her friend's advice, Marti had a business card made and placed an ad in the local paper, instructing her son,

ABOVE
Starting with an almost empty penthouse, Marti created a home filled with fine antiques, paintings, Oriental rugs and an eclectic mix of furnishings for the owner, Frank Brokaw. A lovely painting by William Hankey is centered between 1880 French bronze sconces, and floral arrangements from Evelyn's Greenwich Gift Shop accent the fireplace.
Photograph by Timothy Bell

FACING PAGE LEFT
Grass cloth covers the dining room walls, with Jim Thompson silk upholstery on the chairs and comprising the curtains. The elegant window treatment was produced by Designs by Town & Country, and all painting and wallpapering was done by Ambiance Painting. Evelyn's Greenwich Gift Shop designed the centerpiece in an antique cache pot.
Photograph by Timothy Bell

FACING PAGE RIGHT
Finding the perfect antique for a client is one of Marti's greatest pleasures. This rare Louis VI marquetry inlaid lady's desk is signed and dated 1870 by Diehl, the premier furniture designer in Paris during the mid-19th century. Above the desk hangs an exquisite Georges Jacquet painting of a young girl.
Photograph by Timothy Bell

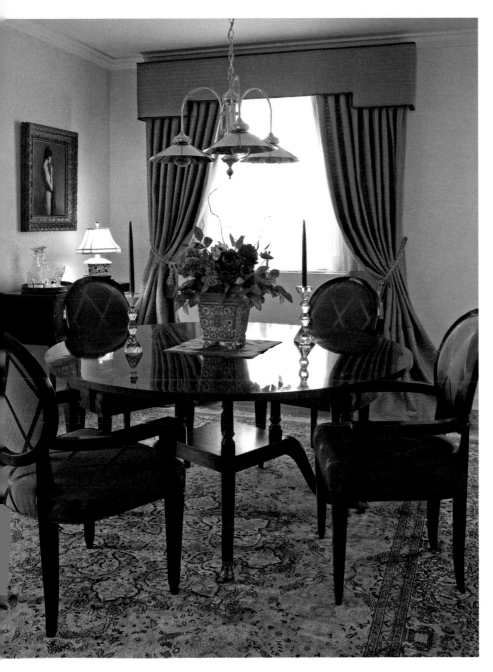

Michael—who was in graduate school and living at home at the time—to call her at work if she got any response. Within days, her son phoned with the message, "Mom, you got one." He proceeded to inform her that he had told the caller in his best English accent, "So sorry, but Ms. Easton is out in the field at the moment."

Elated, Marti returned the call to discover that she would be designing a room for the publisher of prominent national magazine. She agreed to the job immediately and embarked on her first design project, to which she devoted her evenings and weekends, as she still held a full-time job. Marti Easton Interiors thus got its start, and Marti has since gone on to do several homes for her first client along with many other projects across New England.

Marti's initial success was largely due to her fearlessness. Her first client recalls the confidence and energy with which Marti turned to her and said, "Well, shall we get going?" And get going she did—Marti completed the construction and design project in five weeks, a remarkable feat for its magnitude. Her energy and steadfast devotion to the work expedited the project's completion, as did her belief that it could be done. And Marti was largely aided by the intimate knowledge of color, proportion and fabric her background afforded her.

Marti has not lost any of her initial zeal or faith in her ability. Indeed, these have only been bolstered by her continued achievements in the industry. Her designs have earned her multiple appearances in local newspapers and magazines, establishing her as a well-

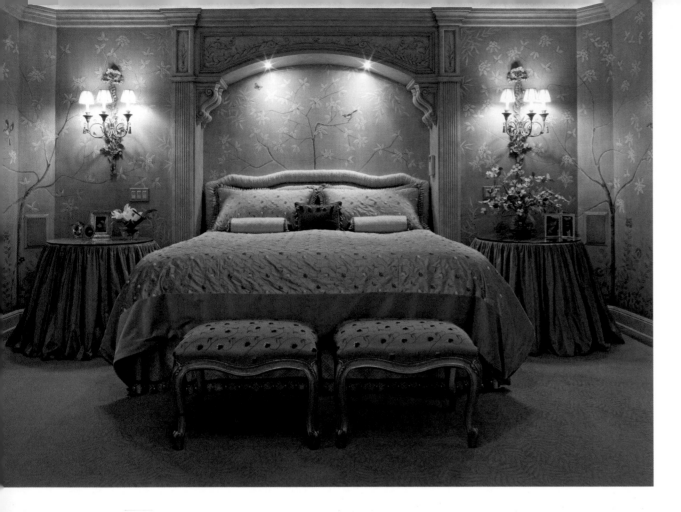

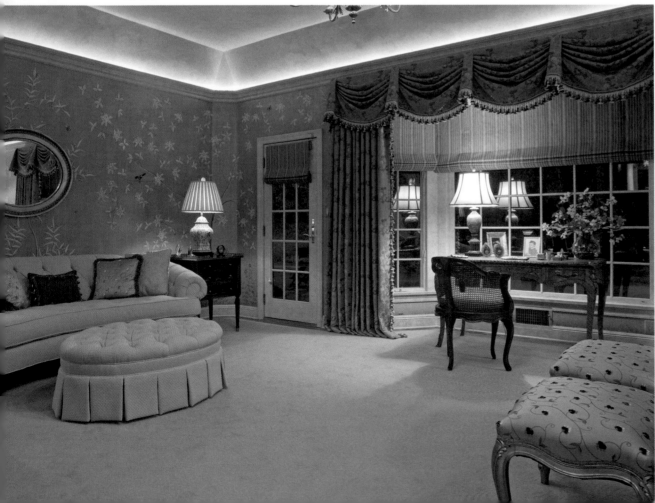

known designer in the area. But Marti has also made a name for herself due to her activity in the community. She frequently auctions her firm's services and donates her time to the American Red Cross, the Bruce Museum and the Greenwich Family Health Center, and she has served as decoration chair for various local charities, including the Greenwich Symphony Orchestra. In giving back to the community, she provides opportunities for the less fortunate to realize their dreams, as well.

Marti calls herself a "chameleon," able to take on others' skin and assume their points of view. She has the ability to design in a wide array of styles and moves fluidly from contemporary to classic. As a result, each project she completes is far different from the last. But one thing remains constant: Marti's genuine enthusiasm and love for her work.

TOP & BOTTOM LEFT
At the end of the day the Salamehs retreat to this exquisite bedroom suite filled with flowers and birds hand-painted by Goldbrush Décor. To accent the beautiful walls, Marti chose embroidered silk and velvet fabrics for pillow and bedding treatments. Fabrics came from Marshall Randolph, LTD., and the bedding ensemble was made by Designs by Town & Country. Exceptional 1890 antique benches from Hiden Galleries have gold-leaf legs that pick up the gold touches throughout the room.
Photographs by Timothy Bell

FACING PAGE
Frank and Barbara Manley looked to Marti to design a room that accents their magnificent view of the sound. A hand-carved mantle with marble surround dressed up the original fireplace, and two peach-and-cream loveseats with matching damask swags add splashes of color.
Photograph by Timothy Bell

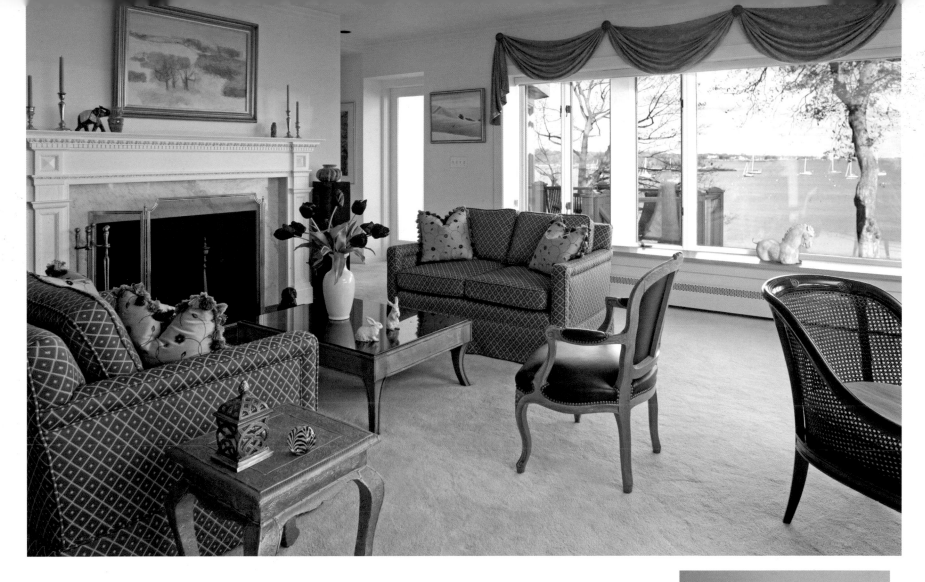

Q&A

MORE ABOUT MARTI ...

MARTI EASTON INTERIORS
Marti Easton
One Strawberry Hill Court
Stamford, CT 06902
203.274.6761
Fax 203.316.8525
www.martieaston.com

WHAT IS THE BEST PART ABOUT BEING AN INTERIOR DESIGNER?

While I'm sad when a project is completed, seeing the end result—the order and beauty coming out of chaos and the pleasure on my clients' faces—makes all of my hard work worthwhile.

WHAT PERSONAL INDULGENCE DO YOU SPEND THE MOST MONEY ON?

Clothes and books. I love to read, and I'm in the process of building a library.

WHAT IS THE ONE THING MOST PEOPLE DON'T KNOW ABOUT YOU?

I am an avid photographer and enjoy documenting my designs.

WHO HAS HAD THE BIGGEST INFLUENCE ON YOUR CAREER?

Certainly my mother, but also the mother of my best childhood friend. She had an incredible sense of style and subscribed to all the chic shelter magazines. Her home made a lasting impression on me.

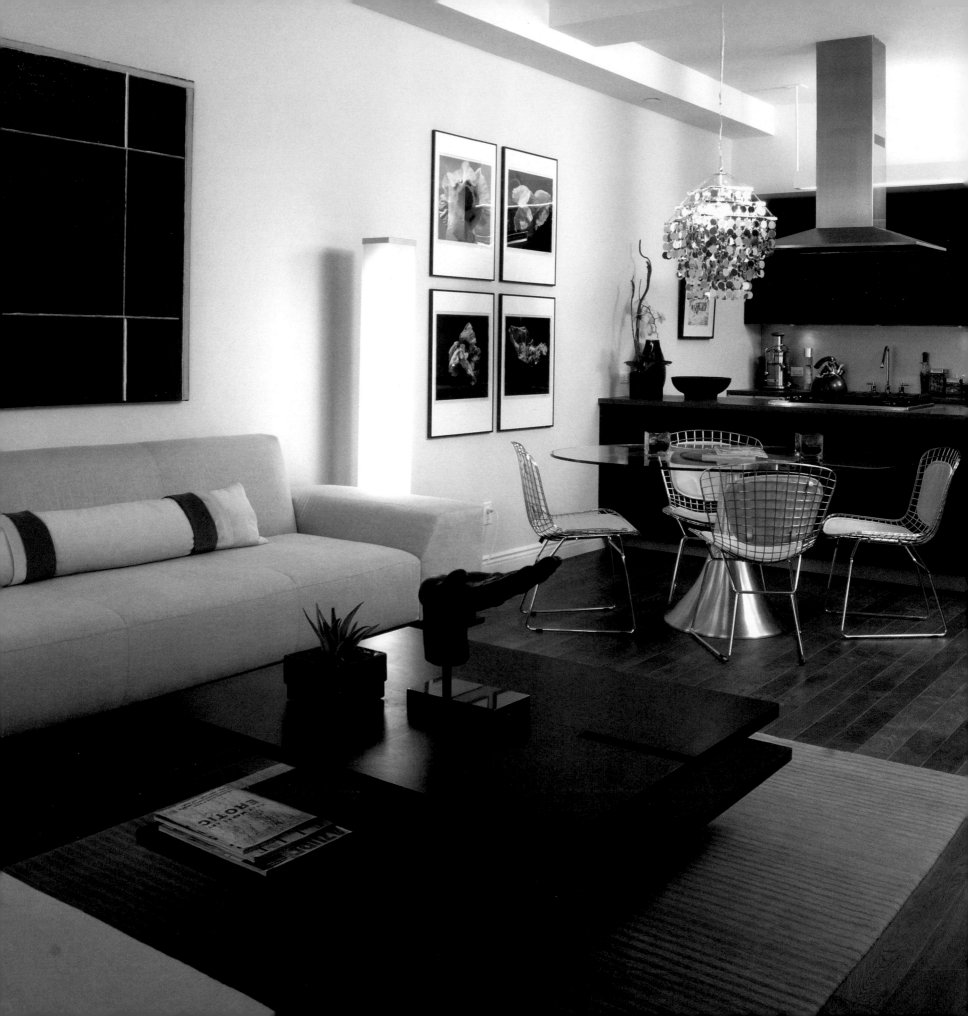

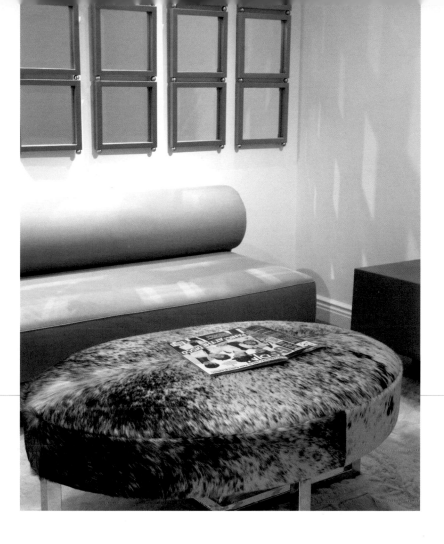

JULIE HOLZMAN

HOLZMAN INTERIORS

Sensitivity to her clients' needs and environments characterizes the work of Julie Holzman, founder of Holzman Interiors. Having spent many years in fashion design, Julie returned to school and earned her degrees in interior design and business before opening her firm in 1993. She has since built a solid reputation in Fairfield County and in New York City, in which she has a second office and to which she is moving in the very near future. Her ability to successfully execute both urban and suburban designs demonstrates not only her spatial awareness but also the kind of creative flexibility that has earned her repeat business and a multitude of referrals.

With projects ranging in size from 650-square-foot New York lofts to 10,000-square-foot Connecticut homes, Julie has the opportunity to fully explore a range of styles and a broad color palette. The smaller, sparer city dwellings present her the unique challenge of maximizing space while incorporating all of the clients' desires. In the newer condominiums, she has the opportunity to design from what is in essence an empty shell—she adds everything from the light fixtures, wall colors and cabinetry to furniture, accessories and artwork—while working to open up the rooms to provide the utmost comfort and livability.

While she works alongside construction companies to design homes from the ground up, her work in Connecticut also involves remodeling projects, clients wishing to update their existing homes to reflect the cleaner lines and more monochromatic color schemes characteristic of today's style preferences. While the elements of a room are becoming less busy, the artwork is becoming more expressive, and Julie is thrilled to have numerous occasions to work with fine art. She frequents the art galleries that pepper the streets of Chelsea to find bold, unique pieces representative of her clients' desires and personal collections

ABOVE
Tucked away behind sliding glass doors is a hideaway suited to listening to music or chatting on the phone without interruption. The pony skin ottoman makes you just want to kick up your feet.
Photograph by Lorin Klaris

FACING PAGE
Enlarging small spaces can be a challenge, but in this locale, keeping monochromatic tones adds to a cohesive and soothing environment.
Photograph by Lorin Klaris

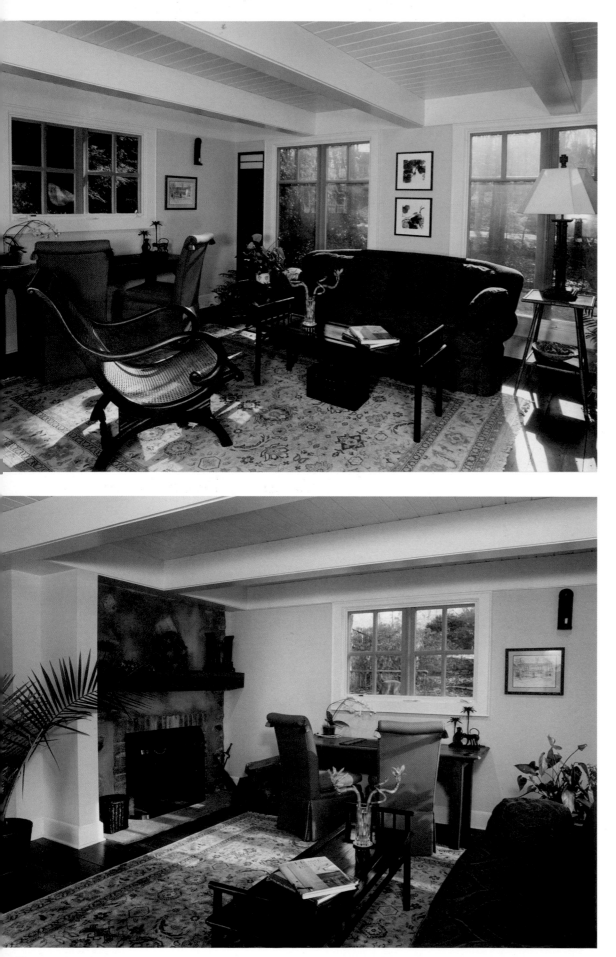

Julie's background in fashion affords her a keen eye for color combinations and a broad understanding of the composition, textures and various uses of textiles. Having been involved in clothing manufacturing, Julie traveled to Asia, India and Thailand, and she continues to spend a great deal of time working in Italy. Her travels lend her an understanding of both the origins of design materials and the aesthetic and architectural preferences unique to specific regions. Along with her international acumen, she offers her expertise in custom cabinetry—she represents two cabinet manufacturers—and her close working relationships with manufacturers and vendors, such as full-service furniture retailer Fairfield Interiors.

Julie strictly adheres to the philosophy that good design insists upon a partnership between client and designer—her goal is to keep clients involved in and comfortable with every aspect of a project, from the planning to the polishing stage. Whether the project is large or small, new construction or renovation, Julie fully entrenches herself in each home, maintaining an unwavering focus on the wishes and lifestyles of its residents.

TOP LEFT
This room acts as an indoor/outdoor room surrounded by full-length windows on two sides. The addition of a Balinese influence adds to the warmth of the room.
Photograph by Mary Ellen Hendrix

BOTTOM LEFT
Nestled in a warm country cottage, this room was added as a multifunctional family room, the perfect spot to just close the doors and hook up your laptop or snuggle on the sofa and light the fireplace.
Photograph by Mary Ellen Hendrix

FACING PAGE LEFT
Decorative painting spurs this architectural interest. With a sneak peak into the living room, one can see how the color tones blend for sophistication.
Photograph by Lorin Klaris

FACING PAGE RIGHT
The decorative work of Wendy Hollender shows how curved walls can be used as a design advantage. The muted tones and scenes enhance the large foyer in this home.
Photograph by Lorin Klaris

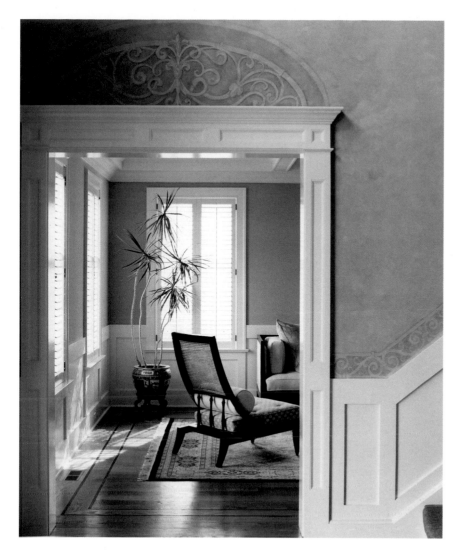

Q&A

MORE ABOUT JULIE ...

IS HOLZMAN INTERIORS A LARGE FIRM?

Actually, I've chosen to keep it quite small—I have one associate. But my close relationships with vendors and manufacturers, alike, provide me ample resources to take on projects of any magnitude.

IN WHAT PUBLICATIONS HAVE YOUR SPECTACULAR DESIGNS BEEN FEATURED?

When you open the book *Dream Kitchens*, you'll see one of my kitchen designs. Another was featured in *Custom Kitchens*.

WHAT IS THE BEST PART OF BEING AN INTERIOR DESIGNER?

Seeing the looks on my clients' faces when they see their dreams come to fruition.

WHAT COLOR BEST DESCRIBES YOU AND WHY?

Green has always been a settling color for me. I use green as a base for a lot of interior color palettes because I look outside for my inspiration. In Connecticut, green is prevalent.

WHAT DO YOU LIKE MOST ABOUT DOING BUSINESS IN YOUR LOCALE?

I love the warmth of Connecticut homes. Most homes have fireplaces, and it's exciting to create seating areas around them that I know will be enjoyed frequently.

HOLZMAN INTERIORS
Julie Holzman, ASID
7 Whitney Street Extension
Suite 2
Westport, CT 06880
203.221.1481
Fax 203.222.0365
NY office 212.685.5797
www.holzmaninteriors.com

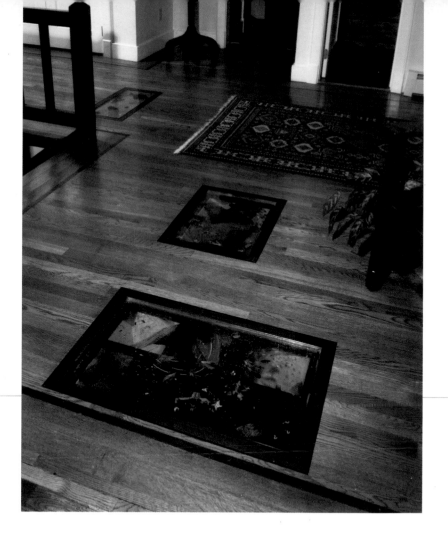

STEPHANIE KOCH

LADD DESIGN, INC.

Blending old and new, history and modernity, is something New England is known for—and something Stephanie Koch strives to do in each home she designs. And with more than 20 years of design experience behind her, Stephanie masterfully fuses the two, delighting in the details that make a project unique.

Stephanie's personal history undoubtedly influenced her career choice—she earned a Master of Fine Arts degree with an emphasis in sculpture from Hunter College in New York City. Her love of artifacts, particularly those made of glass, fueled her desire to pursue a future in interiors. As the shaping of matter requires the same three-dimensional understanding as that of space, Stephanie made this move from sculpture to interior design quite naturally. Launching her career in 1985, she designed residences in Fairfield and Westchester counties as well as in New York City for over a decade before opening Ladd Design, Inc. in 1999.

Anchored in classic design principles, Stephanie takes the pulse of her clients to ensure that their homes fully reflect and articulate their dreams. Fine art is paramount to her design, and she incorporates a variety of antiques, pottery and other artifacts that help

clients build valuable collections. While she frequently features wood and steel elements in her work, her preferred medium remains her long-time passion: glass. Stephanie is intrigued by the spatial illusions glass creates in an interior, especially when integrated into walls. She constructed a wall of etched Belgian glass for one residence, and in others she has added internal windows. These glass divisions eliminate the solidity of wood and plaster walls, creating a diaphanous presence in each home they grace.

In other residences, she has added what she terms "floor lights," tempered glass panes inserted into the floors to obliquely reveal what lies below. Several of these homes feature floor lights in their entryways, exposing the copper and PVC pipes that form the network of internal conduits. These hardware elements lend a sense of texture to the house and a

ABOVE
Floor lights framed in ebony and walnut created by the designer provide an interesting carpet motif in the main entry. Embedded with landscape elements that personalize the outside, they expand space, reflecting light to the floor below.
Photograph by David Sloane

FACING PAGE
Within a converted barn which overlooks 100-acre Green Belt and its wonderful hiking trails, this family room resonates with the landscape. It reflects and punctuates the client's profound love for animals and nature throughout in the antique hand-hewn beams, fabrics, artwork and artifacts.
Photograph by Olson Photographic, LLC

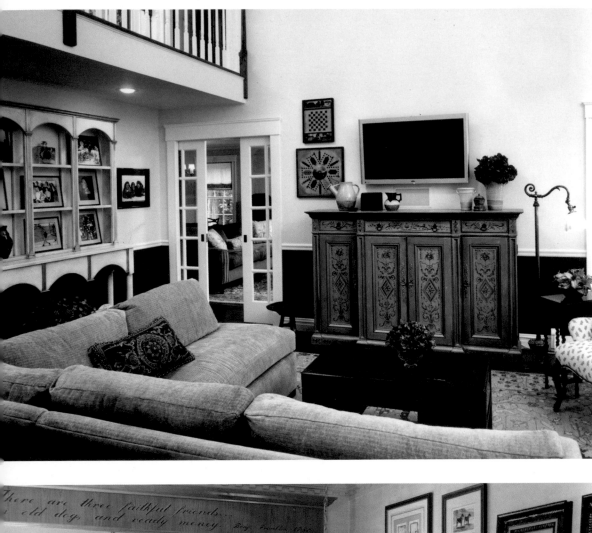

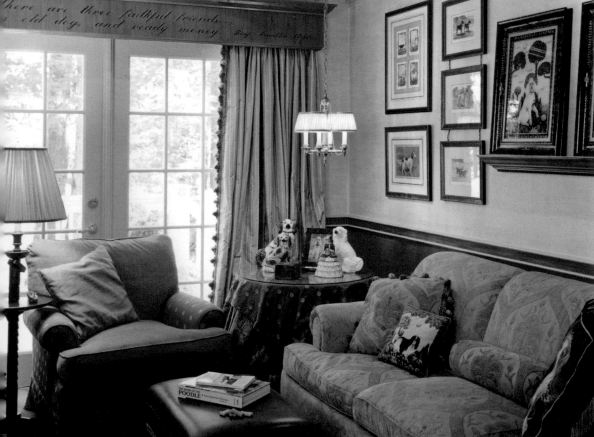

view of the work that goes into not only its building but its operation as well. Stephanie's artistic touch supports her belief that homeowners should celebrate those elements of their homes that form its structure and provide their sustenance.

Along with her signature glass elements, Stephanie also employs Green design techniques in her work, using nontoxic paints on the walls and cork and recycled wood for floors. While Green methods are only now taking hold in Connecticut, residents show an increasing interest in environmentally friendly home design. Stephanie is thus helping to pioneer the movement toward waste-reducing, energy-saving design practices.

While her design techniques are undoubtedly cutting edge, Stephanie incorporates them into modern and traditional homes, alike. In fact, quite a few of the homes she designs date back a century or more. For each new element she adds to these homes, she works diligently to bring in materials contemporaneous with the buildings' origin. In so doing, Stephanie creates a fluidity of time; her designs thus act as windows, offering views of both future and past.

TOP LEFT
A heightened sense of informality prevails in the unexpectedly accentuated, distinctive bijou elements reflected in the furniture, fabrics and artifacts of this two-story great room. Pocket French doors open to the living room, providing unrestricted flow for entertaining.
Photograph by David Sloane

BOTTOM LEFT
French portraits of Bagel and Bialy, the clients' two standard poodles, set the theme in this small study. A Franklin quote on the cornice pays homage to the clients' love: "There are three faithful friends … an old wife, an old dog, and ready money."
Photograph by David Sloane

FACING PAGE LEFT
18th-century beams were acquired to blend in with the structure's original 17th-century beams in this combination butler's pantry/wine cellar inspired by the couple, a professional chef and a wine connoisseur.
Photograph by Olson Photographic, LLC

FACING PAGE RIGHT
Ridgefield, Connecticut's Kinderwood Showhouse benefiting Green Chimneys, an organization supporting Katrina relief efforts, features a hand-painted, mixed-leaf frieze that includes the word Gambaru, the Japanese term for endurance and the will to survive all odds.
Photograph by Olson Photographic, LLC

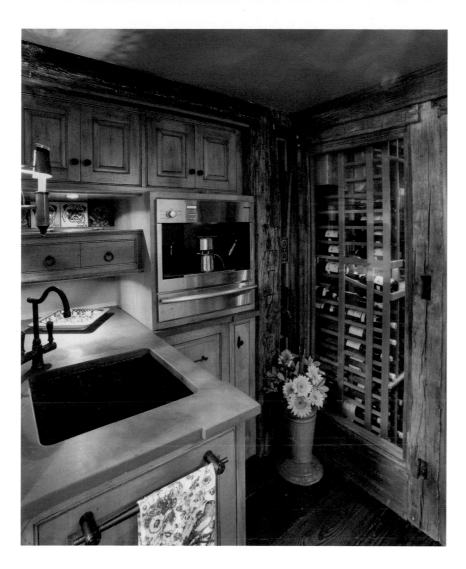

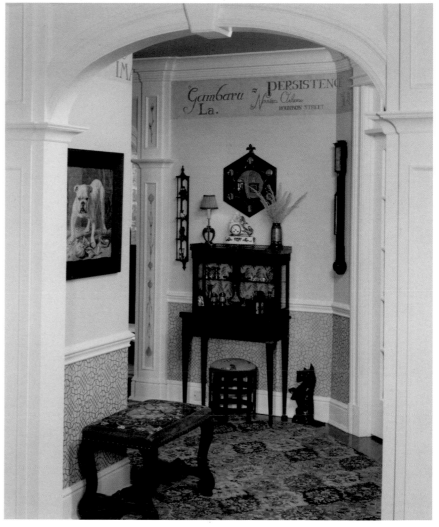

Q&A

MORE ABOUT STEPHANIE ...

WHAT IS ONE THING CLIENTS OFTEN DON'T REALIZE ABOUT HOME DESIGN?

Our homes affect not only our moods but the way we shape our lives. We encourage our clients to view their homes as sanctuaries and places of respite, and we design with that in mind. For, as Winston Churchill pointed out, "We shape our dwellings, and afterwards our dwellings shape us."

WHAT COLORS BEST DESCRIBE YOU AND WHY?

Opals and onyxes, because of their unpredictability—they can change their tones like chameleons, from brilliant aquas to hot rusts.

WHAT IS A SINGLE THING YOU WOULD DO TO BRING A DULL HOUSE TO LIFE?

Find a source of light. Emphasizing light, simply clearing a space to allow it to enter, can turn a house around.

WHAT IS ONE ELEMENT YOU WOULD ELIMINATE FROM DESIGN?

Clutter. Intimacy is critical, but clutter is suffocating. One must work to balance detail and achieve simplicity, which Leonardo da Vinci called "the ultimate sophistication."

LADD DESIGN, INC.
Stephanie Koch, ASID
156 Farm Road
New Canaan, CT 06840
203.966.3032
www.ladddesigninc.com

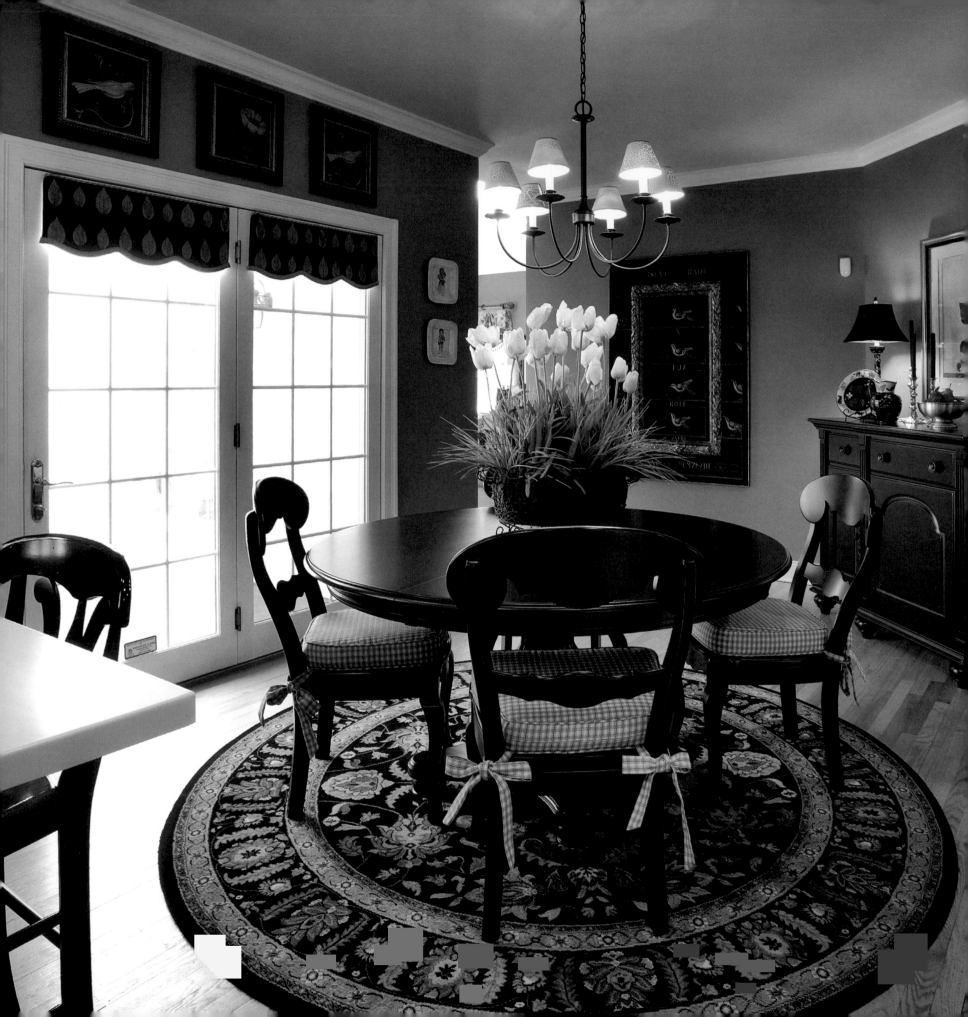

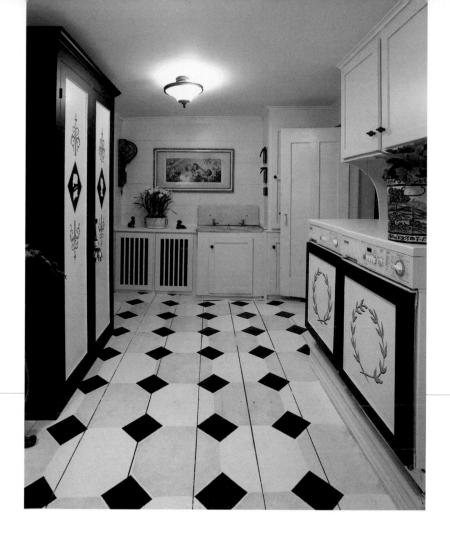

SHARON MCCORMICK

FAIRCHILD HOUSE INTERIORS

W hen Sharon McCormick's husband proposed relocating their family in the mid '90s, she agreed to a compromise. Sharon would give up her dream job if she got to choose her dream home. With that, the McCormick family moved into their circa 1730 Connecticut Colonial, historically named Fairchild House. It was during the room-by-room process of lovingly renovating their home—with her father in the evenings, after she finished her CPA work—that Sharon discovered a creative passion which beckoned to be explored.

A psychology degree from Williams College and MBA from Western New England College in hand, Sharon returned to school once again. She excelled in her interior design classes at Paier College of Art and was awarded the Outstanding Achievement in Design Award for her graduating class. After apprenticing with two notable designers during her studies, Sharon opted to strike out on her own and has never looked back. Sharon established Fairchild House Interiors in 2002 and has remained faithful to her zeal for residential design.

Drawing from her analytical and creative background, Sharon approaches projects very logically yet with an open mind. She and her energetic and talented team, along with an exceptional network of craftsmen and artisans, believe in doing whatever it takes to ensure a client's satisfaction. This said, Sharon brings an appreciation and broad knowledge of design genres to her work, so that each client's design truly reflects his or her individuality and lifestyle in a lasting manner.

On the occasion that Sharon desires greater familiarity with how to bring a client's wishes into their space, she never hesitates to do research; in fact, she really relishes expanding

ABOVE
Combination laundry/mudroom is graced with a hand-painted floor, armoire and washer/dryer panels. A collection of antique silhouettes inspired the striking color scheme.
Photograph by Olson Photographic, LLC

FACING PAGE
The crispness of black furniture lends sophistication to this eat-in kitchen. Scalloped valances frame the view, while the table shape is echoed in the round Oriental rug.
Photograph by Olson Photographic, LLC

her scholastic and design horizons. She is thoroughly excited about a project that began in 2006 with casual conversation and the exploration of the client's existing space. Immediately upon setting foot inside of the recreation room with deep dormer, Sharon noted that the proportions would be ideal for a sleeping alcove like on an old train. "My client's eyes lit up, and he said that he'd always been interested in trains," noted the designer. And the design was off to a rolling start—through research of antique sleeping cars, she planned a custom mahogany bed, silk portieres, brass luggage racks, authentic tasseled sconces, a hand painted map of the Orient Express route, and that was just the beginning.

Although each project is as unique as its residents are, Sharon is mindful to present clients with warm, inviting, timeless designs, because she respects their investments. She is equally as eager to consult on a single room color or window treatment design as she is to engage in long-term renovations. A favorite type of project is to guide clients through the countless decisions required in new construction. Regardless of a project's depth, Sharon's primary objective is to translate her clients' goals into personality-reflective havens.

TOP LEFT
This night sky mural and Venetian plaster walls by Patrick Ganino of Creative Evolution set the stage for a warm and inviting family room.
Photograph by Olson Photographic, LLC

BOTTOM LEFT
This sumptuous dining room is all drama! The metallic ceiling, inset with wallpapered ellipse, gleams in the reflection of cove lighting. Aubusson rug and silk draperies add elegance.
Photograph by Olson Photographic, LLC

FACING PAGE LEFT
The ceiling mural by Patrick Ganino defines the plush sitting area in this master bedroom. Chinoiserie accents and a vibrant color palette infuse the room with personality.
Photograph by Olson Photographic, LLC

FACING PAGE RIGHT
Stippled walls and a buttercup ceiling create a serene haven for the master bedroom of antiques collectors. Billowy embroidered sheers frame the bed crafted by the husband's father.
Photograph by Olson Photographic, LLC

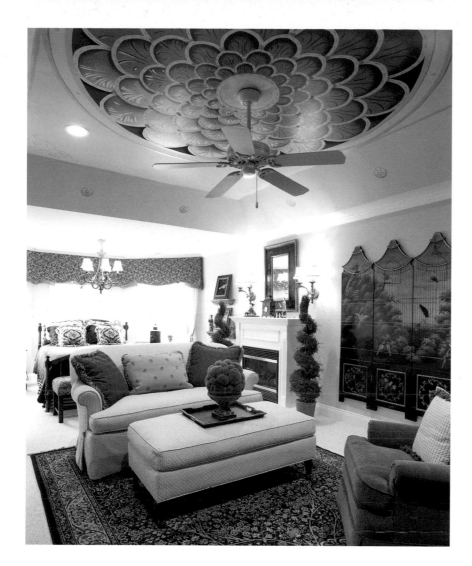

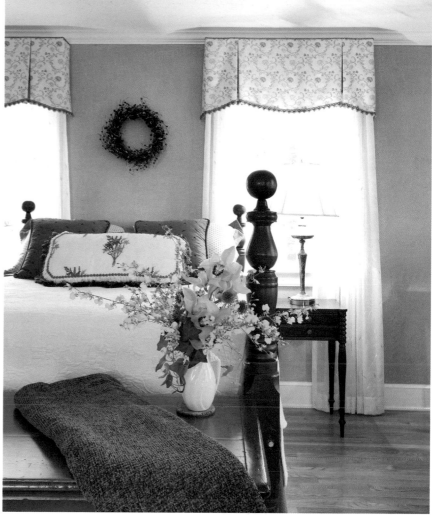

Q&A

MORE ABOUT SHARON ...

WHAT ASPECT OF DESIGN DO YOU FIND PARTICULARLY ENJOYABLE?

The best part of being a designer is collaboration—with clients, artisans, contractors, vendors. I learn something new every single day. I particularly love working with adventurous clients. It is so fun to see the surprise on clients' faces when they are drawn to an object or color they never would have chosen on their own. That's the moment they discover something new about themselves, which results in a more personalized design and the enthusiasm to take more risks.

WHAT IS YOUR GREATEST PERSONAL INDULGENCE?

Without question, books, books and more books! My library includes hundreds of architecture and design books, as well as biographies, novels and business books. I even buy leather-bound books in foreign languages that I don't speak, just because they're beautiful.

FROM WHOM DO THE HIGHEST COMPLIMENTS COME?

While industry accolades are gratifying, the compliments that matter most come from my clients. Spontaneous tears of joy are especially appreciated!

FAIRCHILD HOUSE INTERIORS
Sharon McCormick, Allied Member ASID
40 Main Street
Durham, CT 06422
860.349.1349
www.fairchildhouseinteriors.com

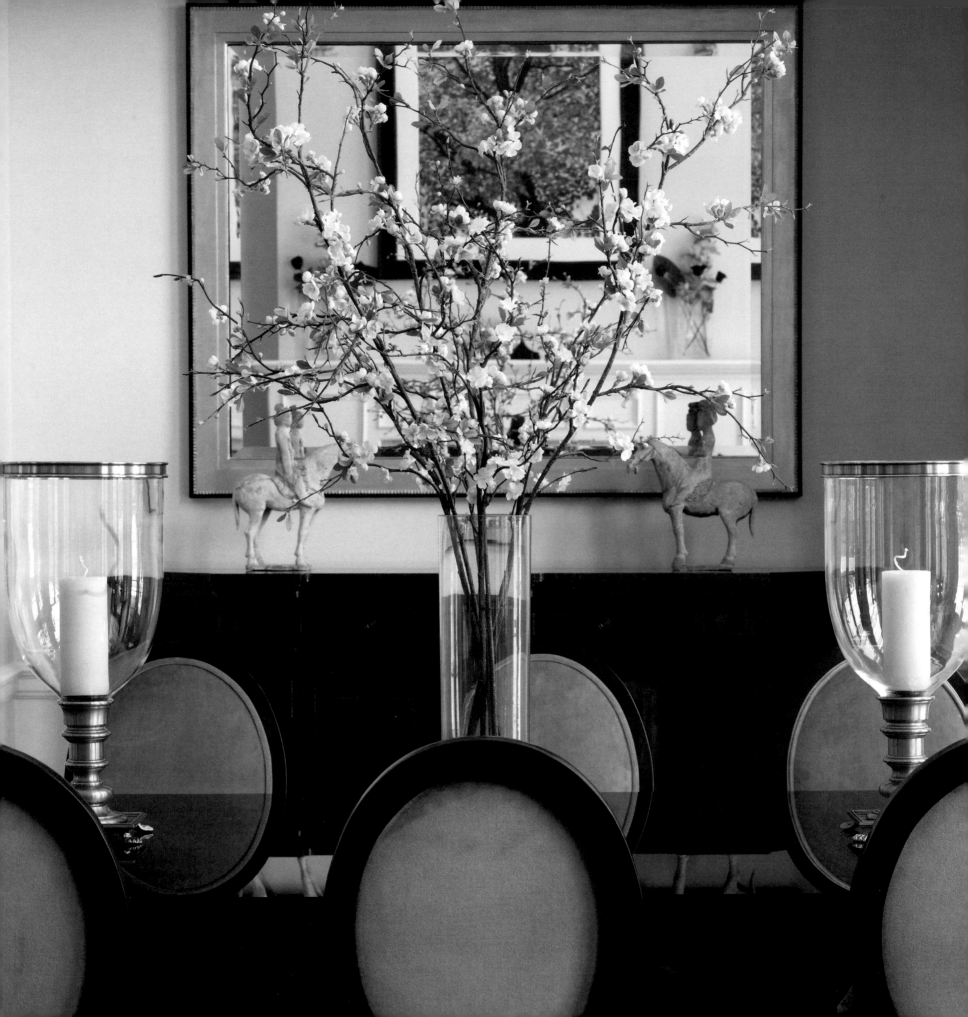

ROBIN MCGARRY

ROBIN MCGARRY INTERIOR DESIGN

Respectful collaboration is the underpinning of all of Robin McGarry's interior designs. She welcomes clients of varying stylistic preferences and requirements. Regardless of the scale or vernacular in which she designs, Robin begins with clients' unique desires and lifestyles as the primary points of inspiration.

Although each design is completely original, all of Robin's creations reflect simplicity, harmony and a sense of restraint. She believes that in the fast-paced world in which we live, it is paramount for people to come home to tranquil spaces where they can be re-energized. This is exactly what her latest client had in mind for his dream home. He relates, "It is a rarity these days for a designer to fully support the client's vision. I applaud Robin for her willingness to subordinate her instincts to really get inside my head. She helped me realize my vision in such a selfless way." Some people wish to be guided wholly by her expertise while others prefer to be more actively engaged in the creative process; Robin enjoys the diversity of her clientele.

This client came to Robin with a very precise vision for finishing out the residence he designed with the assistance of a draftsman. To his vision of an uplifting atmosphere with soft, natural colors that would not "assault the eyes," but rather draw attention to the breathtaking views, Robin responded with a color palette of understated elegance and layout conducive to casual, fine living. Robin has been designing for nearly three decades, so when the man expressed his desire for valances, she knew that a traditional application would not suffice, as the draperies would obstruct the French doors. Using her experience with these types of applications, she used unconventional drapery

ABOVE
A small antique retro walnut occasional table from the owner's collection is complemented with a masculine reading chair, giving a beautiful, tailored feel to the gentleman's master bedroom.
Photograph by Lorin Klaris Photography

FACING PAGE
An ambience of refined elegance is shown with a pair of antique Tang Dynasty pottery blending with the Neoclassic custom chairs. A painting by the renowned American artist Joseph Raffael reflects in the mirror.
Photograph by Lorin Klaris Photography

pockets created with large crown mouldings. She pushed beyond the ordinary to discover an inventive solution that would be both aesthetically pleasing and meet her client's requirements.

As the principal of Robin McGarry Interior Design, Robin personally guides clients through the entire process and delights in opportunities to develop one-of-a-kind pieces that enhance the tailored design. If the ideal solution cannot be found in a catalog, she never hesitates to have it fabricated; this yields furniture tailored to her clients' height and rugs made to a room's exact specifications. An advocate for her clients' dreams, Robin refuses to sacrifice quality for immediate results, so in the case of a restricting budget, she patiently works with them to design the basics first and embellish with the chandelier or artwork of their dreams at a later date.

Some people instantly relate to Robin's philosophy of less is more, but for clients whose visions are in earlier stages of development, she gladly shares her years of knowledge to help them edit their belongings and dreams to realize interior design that truly reflects their lifestyles, interests and stylistic preferences.

TOP LEFT
A pair of family heirloom chests flank each side of the fireplace, secondary only to another breathtaking view provided by French doors only a few feet away from the fireplace.
Photograph by Lorin Klaris Photography

BOTTOM LEFT
The master suite opens to a balcony overlooking the breathtaking views of the serene lake. The soft, natural colors maintain the subdued and noncompetitive spirit to the surrounding views.
Photograph by Lorin Klaris Photography

FACING PAGE LEFT
Again blending new and old, an inviting seating area in the game room continues the feeling of refinement and calmness with the soft color palette.
Photograph by Lorin Klaris Photography

FACING PAGE RIGHT
The waterfall tub is accessorized with the simplicity of calla lilies and a tailored window treatment that gives privacy while still allowing in the natural light and view of the lake setting.
Photograph by Lorin Klaris Photography

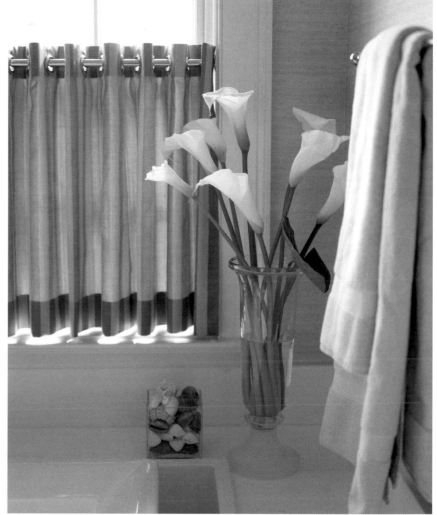

Q&A

MORE ABOUT ROBIN ...

HOW DID YOU DECIDE TO PURSUE DESIGN?

My father has always recognized my artistic talent, so when I wasn't doing well in my high school Latin class, he agreed to let me drop the course as long as I replaced it with an art class. Coincidentally, I won several awards for my paintings and was encouraged to continue my studies with a four-year program in Florida.

HOW HAS THE INDUSTRY CHANGED SINCE YOU BEGAN DESIGNING IN THE LATE '70s?

What once took dozens of people can now be accomplished with just a few because of technology. Before it was commonplace, I recognized the value of having a home computer. When I worked for a large firm, I'd take my notes home to type up purchase orders and design specifications. I've always stayed up-to-date with technology, so my business is efficient and my designs reflect the best products available.

WHAT SETS YOU APART FROM OTHER DESIGNERS?

For the first 10 years of my career, I practiced corporate contract design, which required me to be unbelievably precise with regard to the budget and in terms of communicating my design plans. My residential clients benefit from not only my genuine desire to help them achieve beautiful interiors, but also from my unique set of skills.

ROBIN MCGARRY INTERIOR DESIGN
Robin McGarry
11 Riverfield Drive
Weston, CT 06883
203.454.1825
Fax 203.454.9999
www.robinmcgarry.com

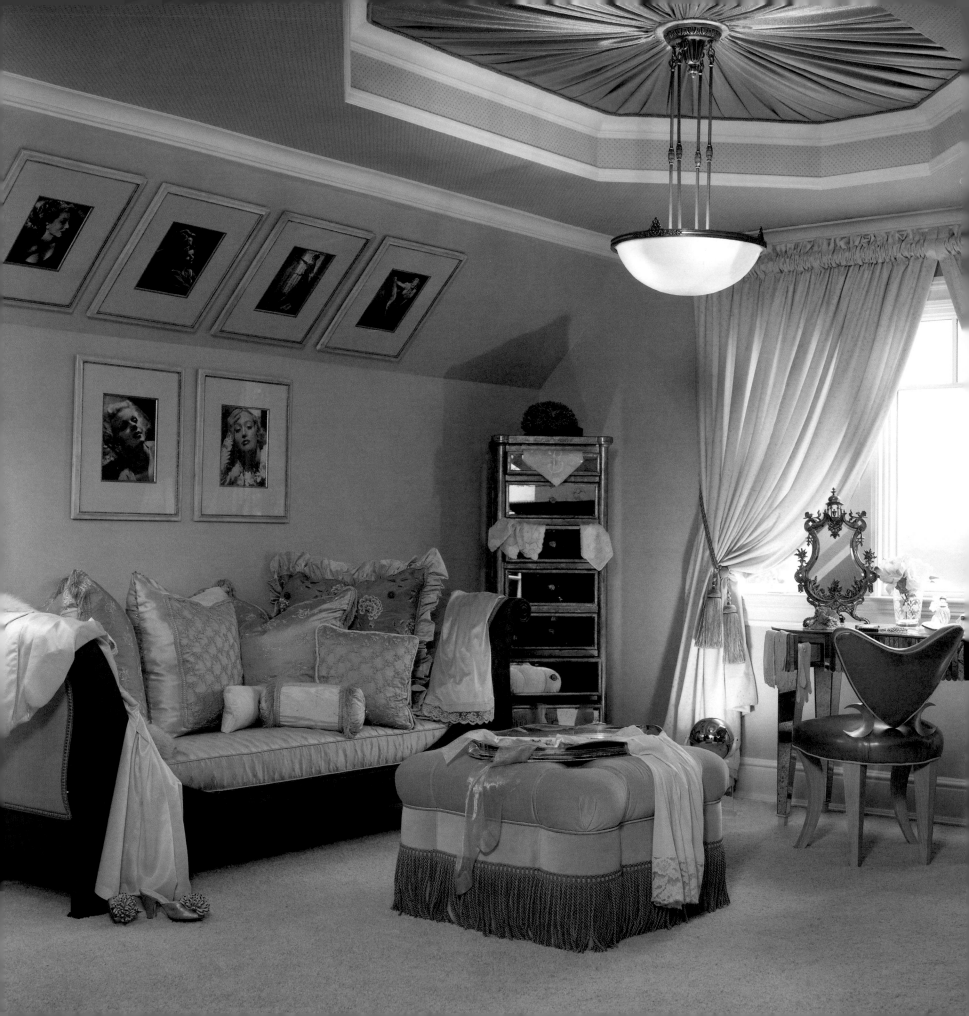

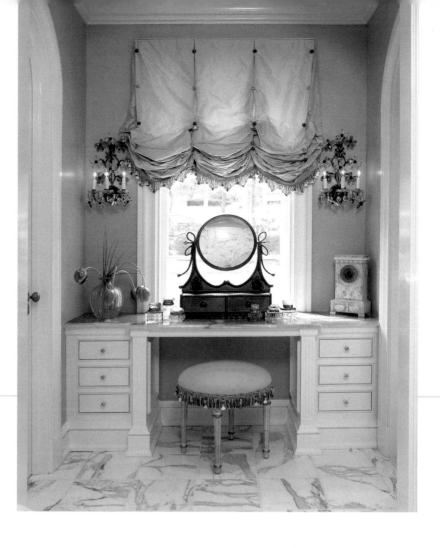

SUZANNE NOVIK

SUZANNE NOVIK INTERIORS

Suzanne Novik relies heavily on the firm belief that art is everywhere—one can simply look outside to see the way colors and textures naturally come together to produce harmonious landscapes. A former art teacher, Suzanne now lends her artistic eye to the beautifully balanced designs she creates with Suzanne Novik Interiors, the firm she opened in 1994 and now runs alongside office manager Linda Natale, assistant to the designer Laurie Siegel and design assistant Jan Bullard.

When designing a home, Suzanne looks outdoors for inspiration in order to choose colors and patterns that create a continual visual flow from the outside in. For instance, a coastal landscape insists on lighter colors—blues, whites and soft taupes—as opposed to bolder jewel tones, such as deep reds, greens and purples. By creating aesthetic continuity with the environment, Suzanne's designs foster in residents feelings of balance and connectedness.

Suzanne cultivates this design continuity between rooms as well. When beginning a design project, she works with clients to select a theme to tie each room together, a neutral color such as taupe, gray or camel that will appear throughout the home in various forms. By relating the rooms through color, Suzanne can move freely through various historical and stylistic periods to fuse potentially disparate elements in a unique and cogent way.

After establishing and building a theme, Suzanne adds a surprising twist to the design, something unexpected that gives a room a distinct flair. She will add an antique light fixture in a contemporary room, a bold floor pattern in a kitchen or an eye-catching

ABOVE
The floral theme of this master bath is adorned with 20th-century amber and clear crystal sconces with a flower motif. Vintage buttons on the balloon shade add a unique detail.
Photograph by Pam Soorenko, Photogroup

FACING PAGE
Suzanne designed this sitting room for the Kinderwood Showhouse as a dressing room inspired by her mother's collection of vintage hats, suits and accessories. Black-and-white movie stars' photos from the '30s, '40s and '50s add to the glamour.
Photograph by Pam Soorenko, Photogroup

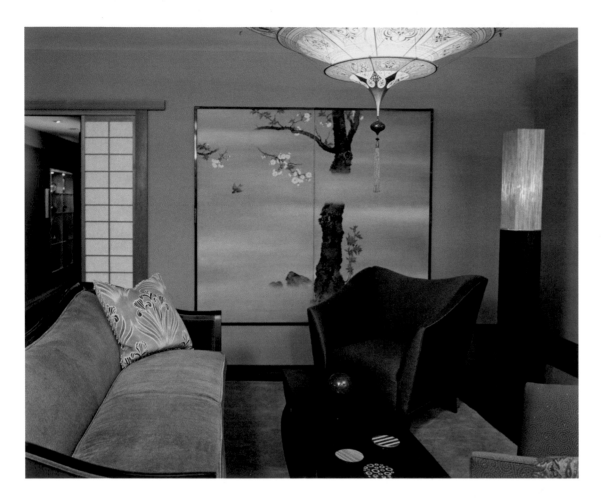

ceiling covering in a dining room—an element that evokes interest and delight. An especially memorable example is her addition of leopard-print chairs to a traditional library with dark cherry wood walls and furniture and a prevalent mix of neutral autumnal colors throughout. The leopard pattern enlivened the room, lending to it a sense of unpredictability that the clients loved. Distinctive designs like this one have appeared in such publications as *Fairfield County Home Magazine*, *Connecticut Home & Garden*, *Ridgefield Magazine*, *All About the House Magazine*, *Weston Magazine*, *Westport Minuteman* and Ralph Kylloe's *Adirondack Home*.

Suzanne's designs are proof of her belief that rooms should embody their specific purposes—bedrooms should emanate restfulness and calm; dining rooms ought to fill one with a sense of warmth evocative of family gatherings. She fully explores each space from floor to ceiling to reach this goal. Indeed, she states that a home is like a sculpture one can move through—it is a three-dimensional space, and every surface is important in establishing its atmosphere. Thus in her clients' homes, art literally is everywhere.

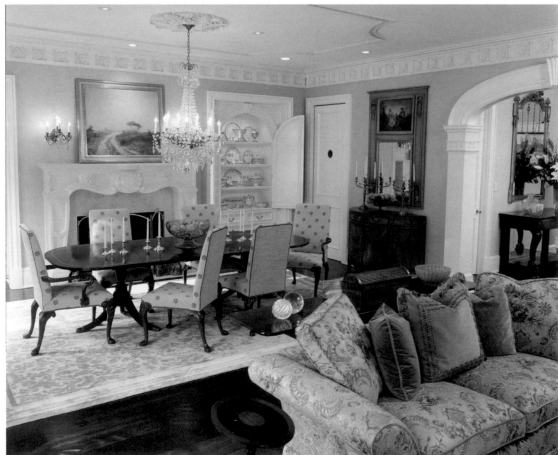

TOP LEFT
This Asian-style New York apartment living room is the epitome of serenity. The large Japanese painting dictates the neutral colors and sets the tranquil mood.
Photograph by Pam Soorenko, Photogroup

BOTTOM LEFT
By request of the client, this living room is open to the dining room for entertaining large groups. The antiques are juxtaposed with the reproduction dining table in a timeless and classic balance.
Photograph by Pam Soorenko, Photogroup

FACING PAGE
Two opposing stone walls in this exceptionally high cathedral-ceilinged family room dictated the monochromatic taupe and gray palette, emphasizing texture. The faux chinchilla throw on the mohair sofa completes the luxurious and relaxing mood.
Photograph by Pam Soorenko, Photogroup

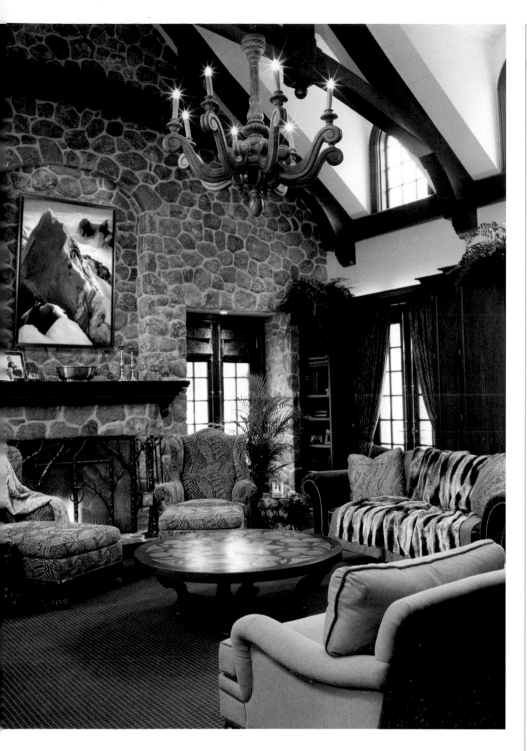

MORE ABOUT SUZANNE ...

WHAT PERSONAL INDULGENCE DO YOU SPEND THE MOST MONEY ON?

Clothes, shoes and accessories. If I hadn't pursued a career in interior design, I would have chosen one in the fashion industry.

WHAT COLOR BEST DESCRIBES YOU AND WHY?

My favorite color, lavender. It denotes creativity and is also the color fine artists use in the shadows of their paintings of nature, which represents my artistic background and love of things natural. Moreover, lavender is a subtle neutral that coordinates with most other colors, as I am a person who relates to most other people.

WHAT IS THE HIGHEST COMPLIMENT YOU'VE RECEIVED PROFESSIONALLY?

I brought together a couple at odds in taste and style to a happy conclusion, only to be informed at the end that he was a doctor of psychology and was most impressed with my ability to accomplish this goal.

WHO HAS HAD THE BIGGEST INFLUENCE ON YOUR CAREER?

Ralph Lauren. His timeless style with a twist is genius.

SUZANNE NOVIK INTERIORS
Suzanne Novik, ASID
4 North Avenue
Weston, CT 06883
203.454.5557
Fax 203.454.5537
www.suzannenovikinteriors.com

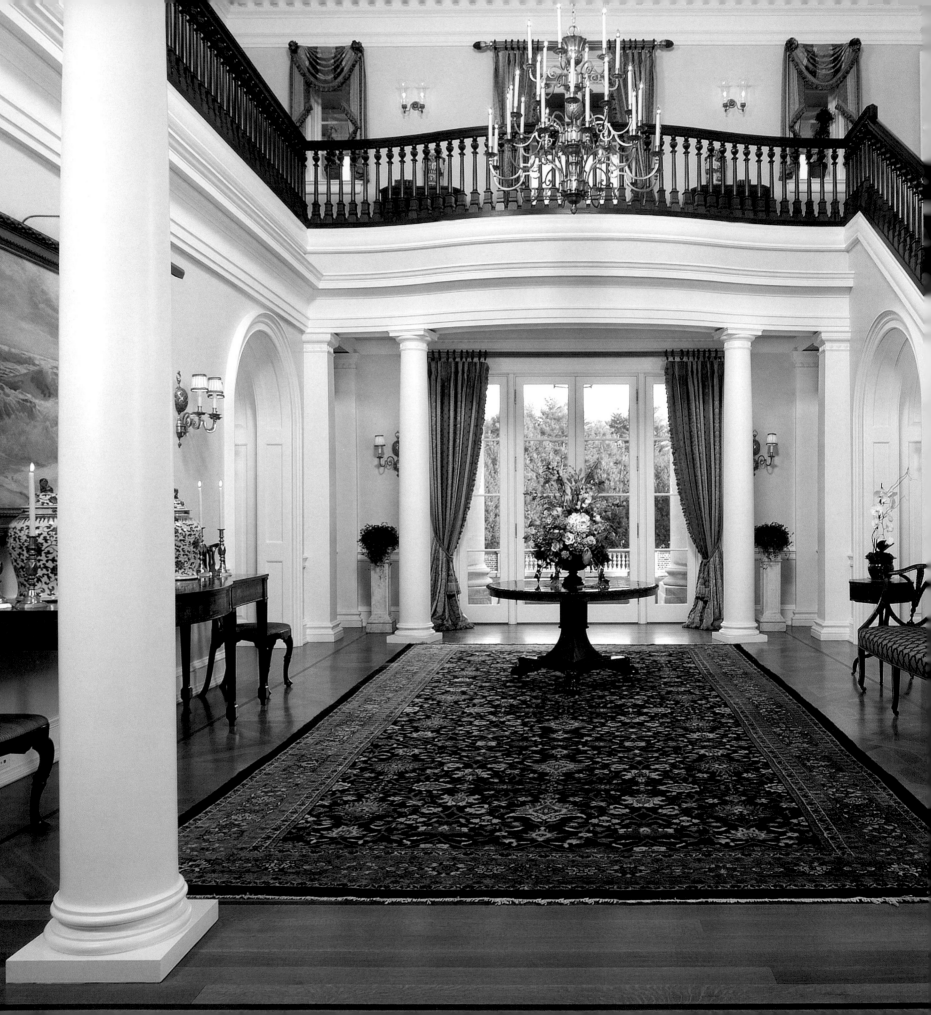

LINDA RUDERMAN-ROSIER

LINDA RUDERMAN INTERIORS

Linda Ruderman-Rosier firmly believes that the journey a homeowner embarks upon with his or her interior designer should be both enjoyable and educational, and her focus on clients' needs and desires coupled with the substantial background and extensive knowledge she brings to each project ensures her success on both counts.

The foundation of Linda Ruderman Interiors in 1981 was the culmination of a natural progression for Linda. As a child, she was surrounded by creativity and craft. Her grandfather ran textile mills in Pennsylvania, and her father worked therein, repairing and maintaining the looms. Her mother, an accomplished seamstress, made Linda's clothes until her daughter was in her 20s, and she taught Linda to sew as well. From grade school, Linda chose her own fabrics and patterns and often created new designs, choosing, for example, a sleeve from one pattern and a collar from yet another to create an original garment.

Fascinated by architecture and the opportunity presented by a bare room, Linda focused her interests on interior design, a field that combined her exposure to textile manufacturing and experience working with fabric with her love for structural design and construction.

Linda bolstered her formal education with independent study courses in art history, drafting and perspective drawing, extensive travel and lectures given by prominent antiquarians from around the

LEFT
A beautiful Persian Ziegler Sultanabad, circa 1880, welcomes guests in this grand entrance hall, which features a custom chandelier and sconces designed by Linda Ruderman Interiors (LRI), elaborate shield-shaped-back settees and an unusually large George III Hepplewhite period mahogany side table, circa 1780.
Photograph by Tom Young

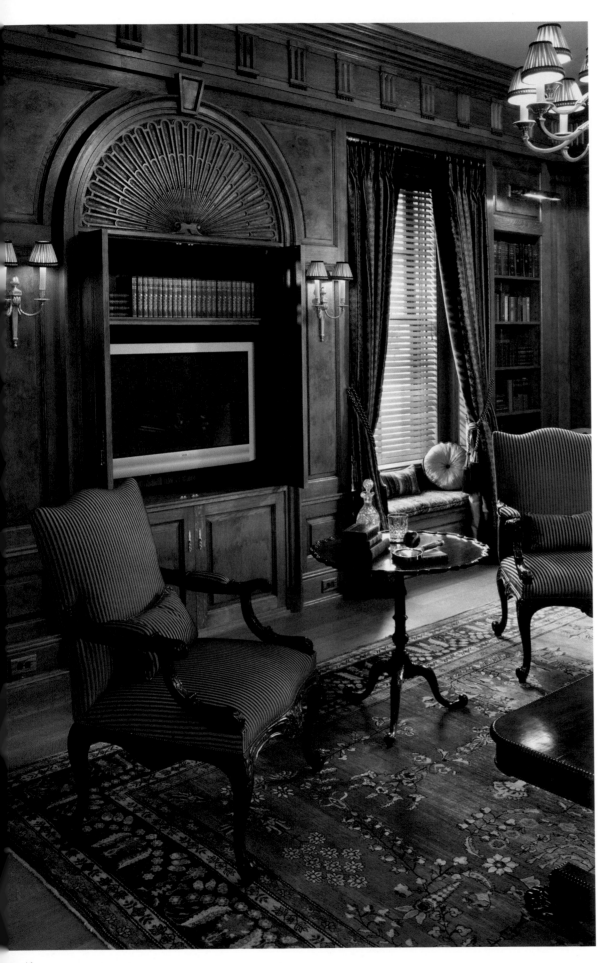

world. She also had the great fortune to meet and work with a world-renowned antique dealer from Paris from whom she garnered a command of French antiques. She went on to study antiques from the world over and fostered a love of English and Asian furniture, art and accessories. Her expertise has earned her a number of commissions to establish valuable collections for clients, and she is noted for her prolific use of ancient Asian artifacts in her designs.

In 1980, Linda had a fortuitous encounter with Victor Belcic, a New York City–based Romanian architect. He was also a professor of architecture and had a profound impact on her career. Both happened to be working on apartments in the same building at the same time and thus got to know each other. The two eventually teamed up on Linda's project and went on to collaborate on several other projects over the years. Linda states that her experience working with him helped hone her eye for scale and proportion and refine her architectural knowledge, skills that contributed greatly to the evolution of her career.

Linda's professional success is due in large part to her seemingly uncanny ability to make a design look as though it has always been in its environment. She works very closely with her clients to ensure that their interior spaces clearly articulate their own histories and passions, often by incorporating into the design heirlooms and treasures collected during their travels.

To achieve aesthetic timelessness, she often designs custom pieces—chairs tailored to a client's height and support needs and

LEFT
Period detail fuses with modern-day technology in this elegant, burled oak–paneled library, replete with George II mahogany arm chairs, a Chippendale pie-crust table and custom fabric and trim by Tassels and Trims. Architecture by Dinyar Wadia.
Photograph by Jonathan Wallen

FACING PAGE TOP
Custom-designed window treatments offset brilliant blue strie walls in the opulent living room of this English Country–style home. A George III mahogany cabriole sofa sits atop an Oushak carpet, circa 1890.
Photograph by Tom Young

FACING PAGE BOTTOM
Linda added bright purple accents and new, textured upholstery to give this classic living room a sophisticated modern twist. Long draperies cascade from custom bronze poles, complementing the John Boone coffee table and silver accent tables.
Photograph by Tom Young

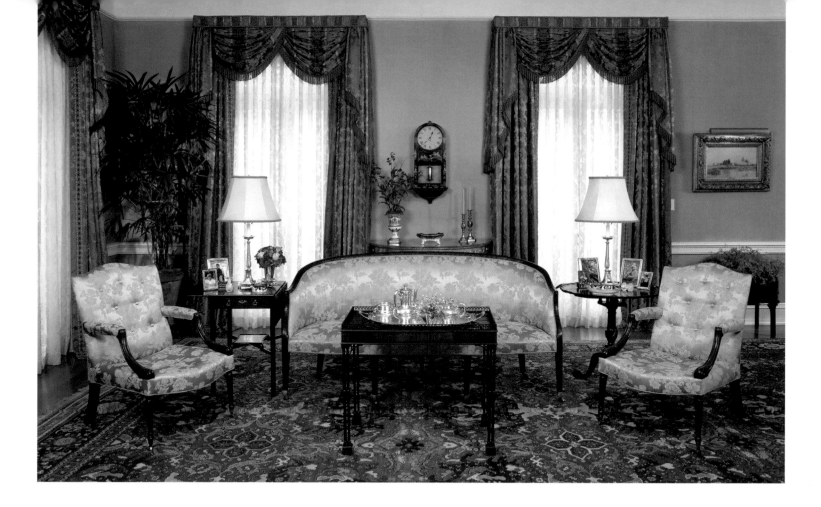

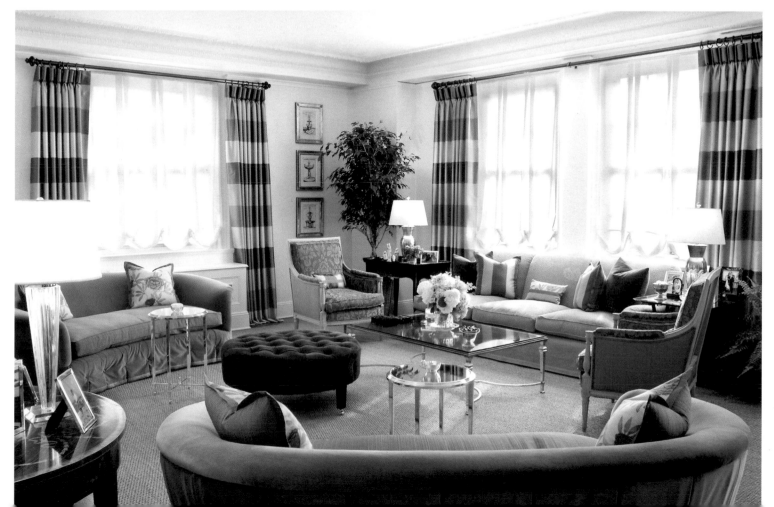

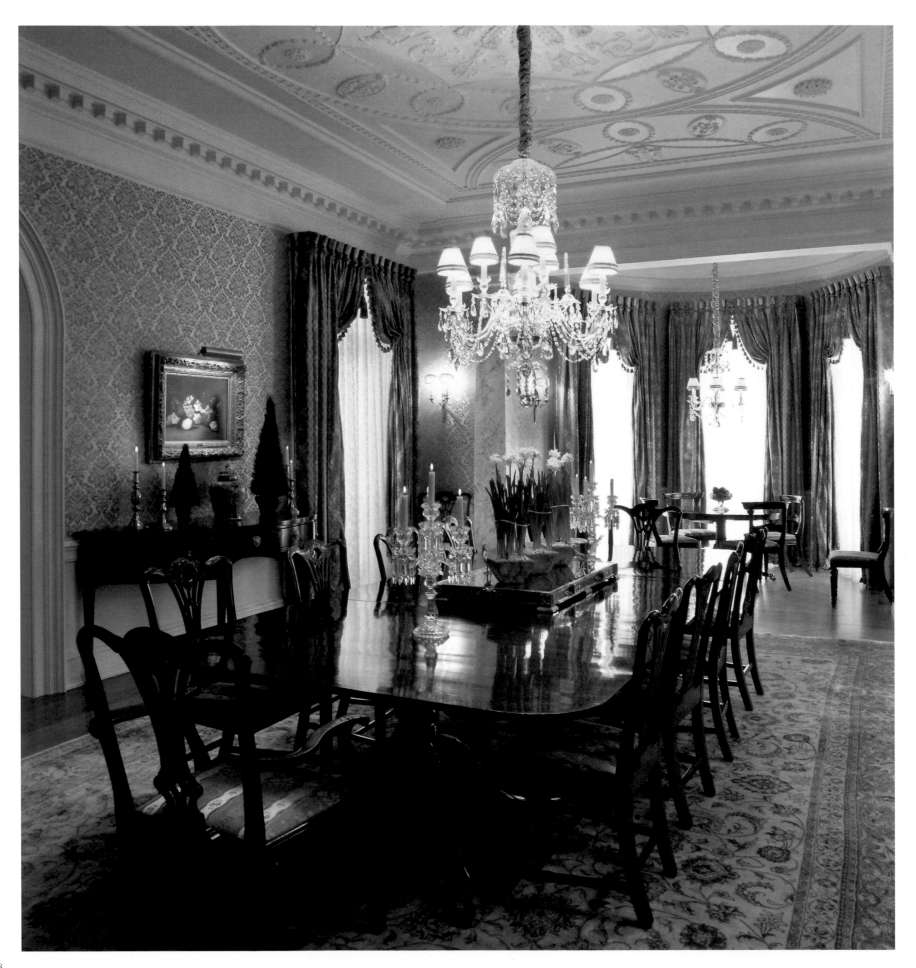

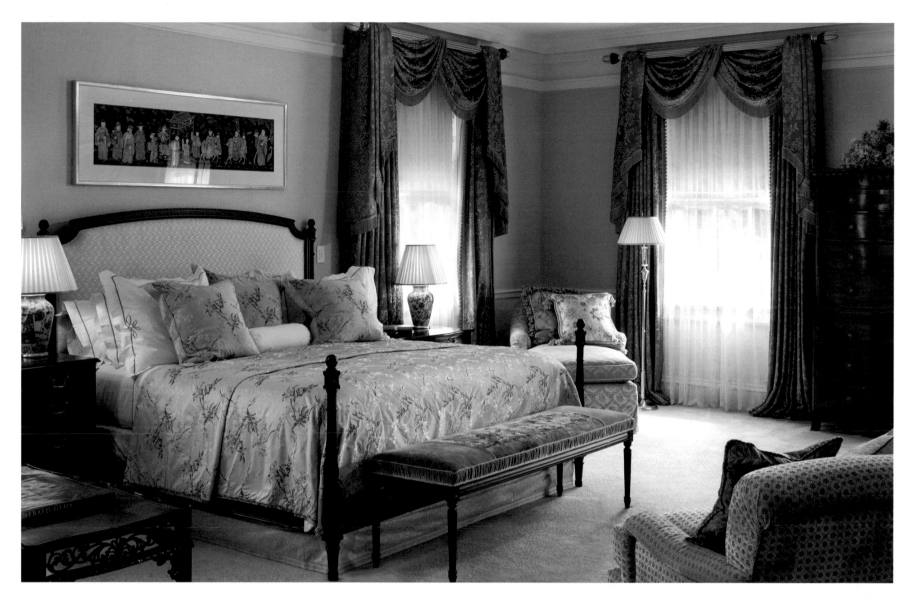

carpets and fabrics that bring together all of the various pieces of a room. Linda takes painstaking care by choosing each detail of the design to ensure the most natural size, shape, color, and patina for the space. Insisting on teamwork in every aspect of a project, she customizes each interior to the client, and each is therefore unique. Acknowledging that creative endeavors are futile without steadfast attention to follow-up and organization, Linda and her structured team of designers, accountants and support staff ensure that every aspect of a project is handled as efficiently as possible.

ABOVE
Muted green and gold in the window treatments, upholstered walls, Julia Gray custom bed, and LRI custom-designed chaise and chair upholstery lend serenity to this master bedroom. French decalcomania vases, circa 1880, have been made into lamps. Architecture by Dinyar Wadia.
Photograph by Jonathan Wallen

RIGHT
The exterior of this stately Georgian brick home beautifully complements Linda's elegant interiors. Architecture by Dinyar Wadia.
Photograph by Jonathan Wallen

FACING PAGE
Two Waterford chandeliers, circa 1790, hang from the very elaborate Adam ceiling supported by faux marble columns in this formal dining room. Custom-designed wall upholstery fabric, window treatment fabric, and trims frame garden views. Architecture by Dinyar Wadia.
Photograph by Tom Young

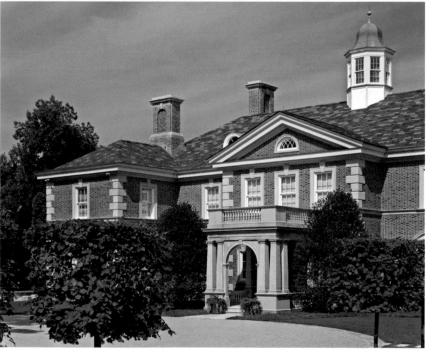

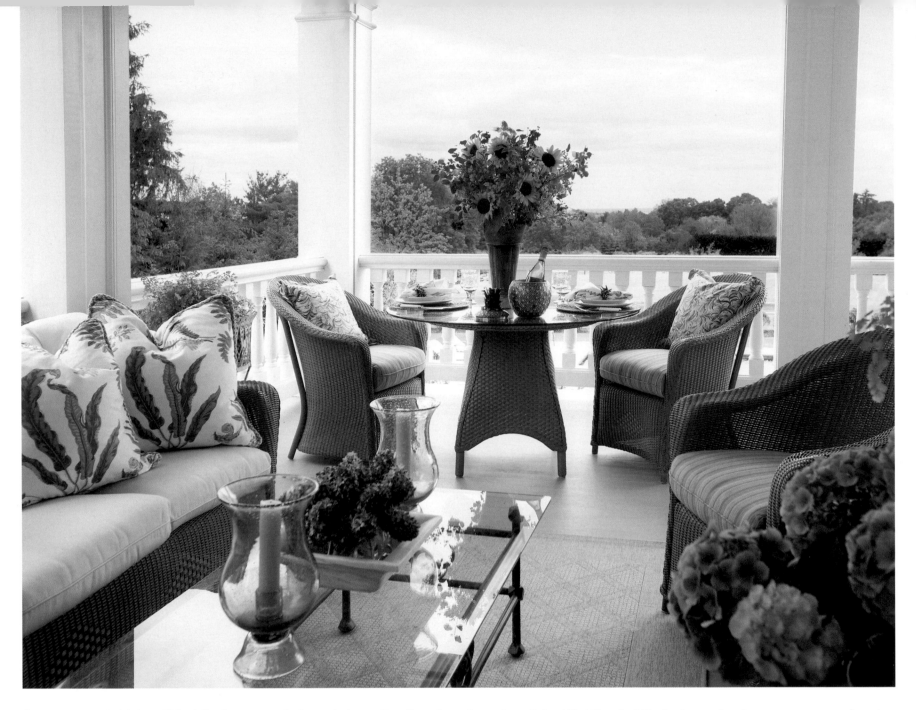

A testament to Linda's incredible ability, her spectacular home designs radiate from the pages of numerous local and national publications, including *Westport* and *Greenwich* magazines, *Fairfield County Home, Avenue, Manhattan File, The New York Times, At Home* and *Cottages and Gardens* magazine, and she has also appeared on segments of local talk shows to discuss interior design. While it is certainly a treat to see her work in print, Linda's true pleasure comes from educating her clients as to the various options and wealth of resources available to them and teaming with architects, craftspeople and her talented staff to ultimately create the environments her clients seek.

Despite her busy schedule, she also devotes time to the community, frequently presenting lectures and sitting on various local committees—recently a panel for the Coleman Group, an organization that fosters career development in young women.

A member of the Allied Board of Trade, she employs interns every year and receives numerous accolades for this mentorship program. Clearly, Linda's operational excellence is matched by her steadfast commitment to the Greenwich community.

ABOVE
This porch features a phantom screen system which allows the family to comfortably dine outdoors and enjoy the spectacular view of Long Island. Outdoor wicker furniture by Walters, covered in Scalamandre fabric.
Photograph by Neil Landino Jr.

FACING PAGE LEFT
A strong, cut stone fireplace and cherry beams and columns set the stage for this family room, featuring a prized, eagle-topped convex 18th-century mirror. The custom-sized walnut coffee table by Emanuel-Morez is a favorite of LRI.
Photograph by Bob Capazzo

FACING PAGE RIGHT
Warm beige and green crewel fabric from Nancy Corzine on the sofa and the sisal carpet create a relaxing atmosphere in this light-filled, airy sunroom. A Holly Hunt table holds a collection of books and an antique mercury vase.
Photograph by Bob Capazzo

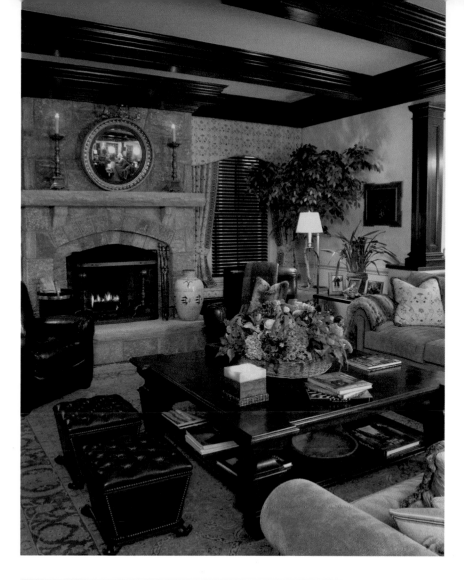

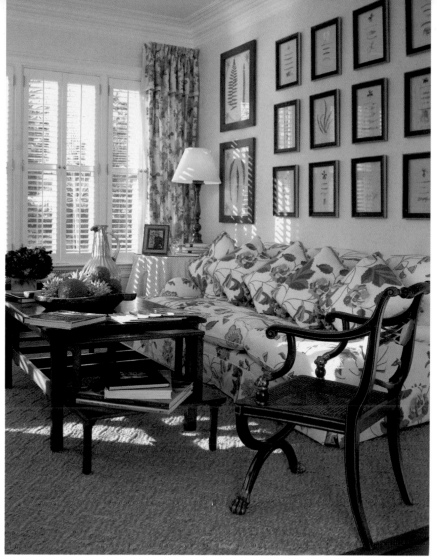

Q&A

MORE ABOUT LINDA ...

WHAT DESIGN PHILOSOPHIES HAVE YOU STUCK WITH FOR YEARS THAT STILL WORK FOR YOU TODAY?

I have focused on creating classic interiors and emphasized attention to detail, versatility, client relationships and service in every project I have undertaken.

WHAT IS THE BEST PART OF BEING AN INTERIOR DESIGNER?

First and foremost, it's the pure craft of interior design—I love what I do. Getting to know the clients and creating their ideal interiors just adds to the pleasure. There is nothing more rewarding than creating an environment for a family to live in, grow in and grow up in. Knowing that I have designed an interior—often from the ground up—that everyone is proud of is an unbelievable high. That's the addiction; that's what keeps me working in this business.

WHAT DO YOU LIKE MOST ABOUT DOING BUSINESS IN NEW ENGLAND?

New England has a special quaintness and charm that inspires me, as does the incredible history that is attached to each town, the beautiful landscape and the architecture—namely the clapboard, shingle and stone houses with green shutters and natural stone walls. I am blessed to have the opportunity to renovate these older homes to fit contemporary lifestyles and also to recreate them in new construction.

LINDA RUDERMAN INTERIORS
Linda Ruderman-Rosier
175 West Putnam Avenue
Greenwich, CT 06830
203.552.9700
Fax 203.552.0732
www.lindaruderman.com

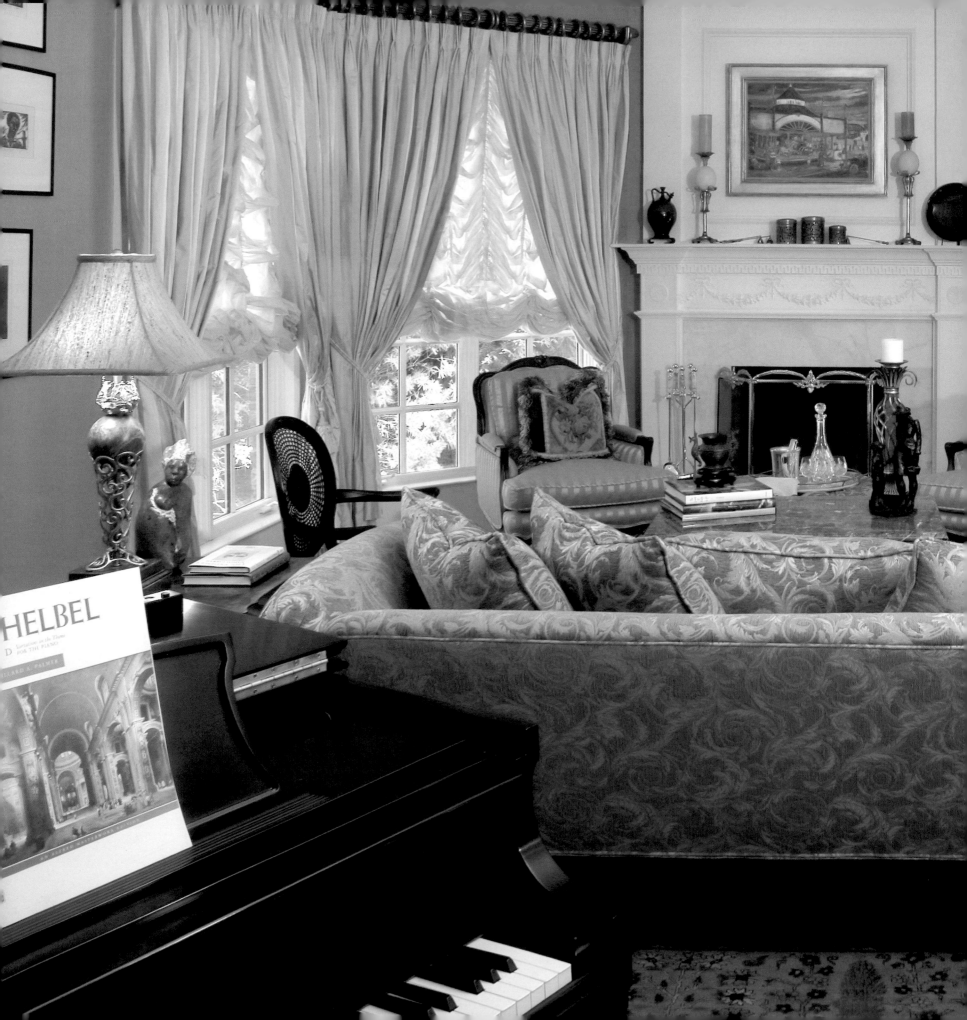

JOYCE K. SHORTELL

SHORTELL INTERIORS

Joyce Shortell's entrée into the world of design occurred while decorating her first apartment right out of college. Of course, it was a challenge to work within such a lean budget, but her roommate's mother loved the apartment so much that she asked Joyce to help redo a few rooms in her own home. Joyce marks this experience as the genesis of her "hobby" in decorating. While pursuing a career in real estate, she received many requests to do design/decorating for new homeowners. It was at this point that Joyce decided it was time to embrace her love for interior design as a full-time career.

After earning a degree in interior design from the Paier School of Art, her career was off to a tremendously well-received beginning. After many years of successful freelancing, Joyce opened her own business in 1997.

A native of New England, Joyce brings a proven talent and rich history of experience to each of her projects. With offices in Connecticut and the Boston area, she has access to the finest resources, vendors, artisans and workrooms available.

LEFT
In this parlor, Joyce mixed rich colors and textures to achieve her signature clean-lined traditional look.
Photograph by Jim Coon Studio

Striving to ultimately reflect her clients' style and personalities, Joyce extends the highest level of professionalism, premium design service, attention to detail and fine quality in all elements, creating a custom look that is striking, functional and timeless. Being an independent business owner and the only designer on staff, Joyce offers her clients intensely personalized attention where understanding of design tastes and interests are discovered and refined. Joyce sees her role as a creator of mood and attitude.

Joyce's ability to balance the elements of space, proportion, color, texture and style has become the hallmark of her rich interiors. She believes that in the collaborative process, the designer's creativity and professional vision should successfully reflect the client.

Through creative thinking, meticulous planning and longstanding professional relationships in the industry, Joyce is able to guide her clients through the process whether they intend to enrich an existing space, decorate a new home or prefer consultation on an hourly basis. To ensure that her clients' chosen design elements are correctly incorporated in the project, Joyce works closely with the architect, contractors

and consultants. Citing that her primary purpose is to interpret the personal needs and desires of her clients into the perfect environment, Joyce remains an integral part from initial consultation through installation and beyond.

ABOVE LEFT
Inspired by an exquisite art collection, Joyce used neutral and subtle faux finishes on the walls as "art to display art."
Photograph by Jim Coon Studio

ABOVE RIGHT
Rich mahogany and strong, deep tones in the fabric selection created a masculine yet warm retreat.
Photograph by Jim Coon Studio

FACING PAGE TOP
Not desiring a "cottage" look, Joyce created a casually elegant environment for her client's Cape Cod home.
Photograph by Sam Gray

FACING PAGE BOTTOM
A fabulous tub to soak in and look out at Nantucket Sound coupled with a bit of whimsy to enhance the tranquil atmosphere.
Photograph by Sam Gray

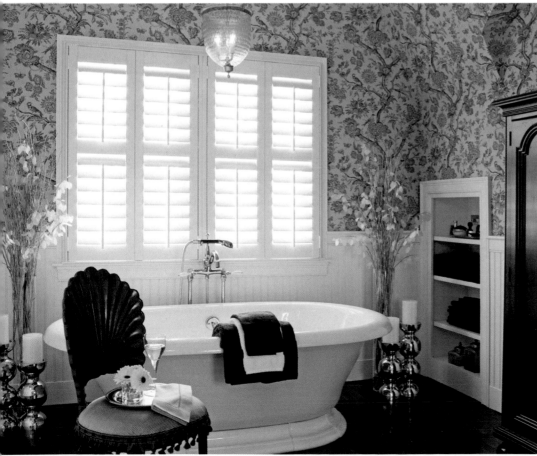

DESCRIBE YOUR STYLE OR DESIGN PREFERENCES.

I don't like being known for just one style or design preference. I have done everything from New England Traditional, casual but elegant beach houses, an Adirondack-style Vermont ski house, to the clean, simple lines of the Transitional style. My work is classic whether it is Traditional or Contemporary. I try to design spaces that are timeless. I constantly challenge myself to implement unique combinations of color, textures and artwork.

WHAT IS THE BEST PART OF BEING AN INTERIOR DESIGNER?

There is tremendous satisfaction in knowing clients are living and entertaining in spaces I helped create for them. And, of course, the shopping! I love scouting for that perfect piece of furniture, accessory, fabric or artwork that will excite my client. I love the conceptual stage of a project because it's the most creative. The end of the project is the most fun because it is an affirmation of your creative vision expressing your client's custom look.

WHAT ONE ELEMENT OF STYLE OR PHILOSOPHY HAVE YOU STUCK WITH FOR YEARS THAT STILL WORKS FOR YOU TODAY?

Listen, listen, listen. Never make promises you're not sure you can deliver. My motto is under promise and over deliver.

SHORTELL INTERIORS
Joyce K. Shortell
50 Mohawk Drive
West Hartford, CT 06117

120 Fulton Street
Boston, MA 02109
860.508.5581
Fax 860.570.0232
www.shortellinteriors.com

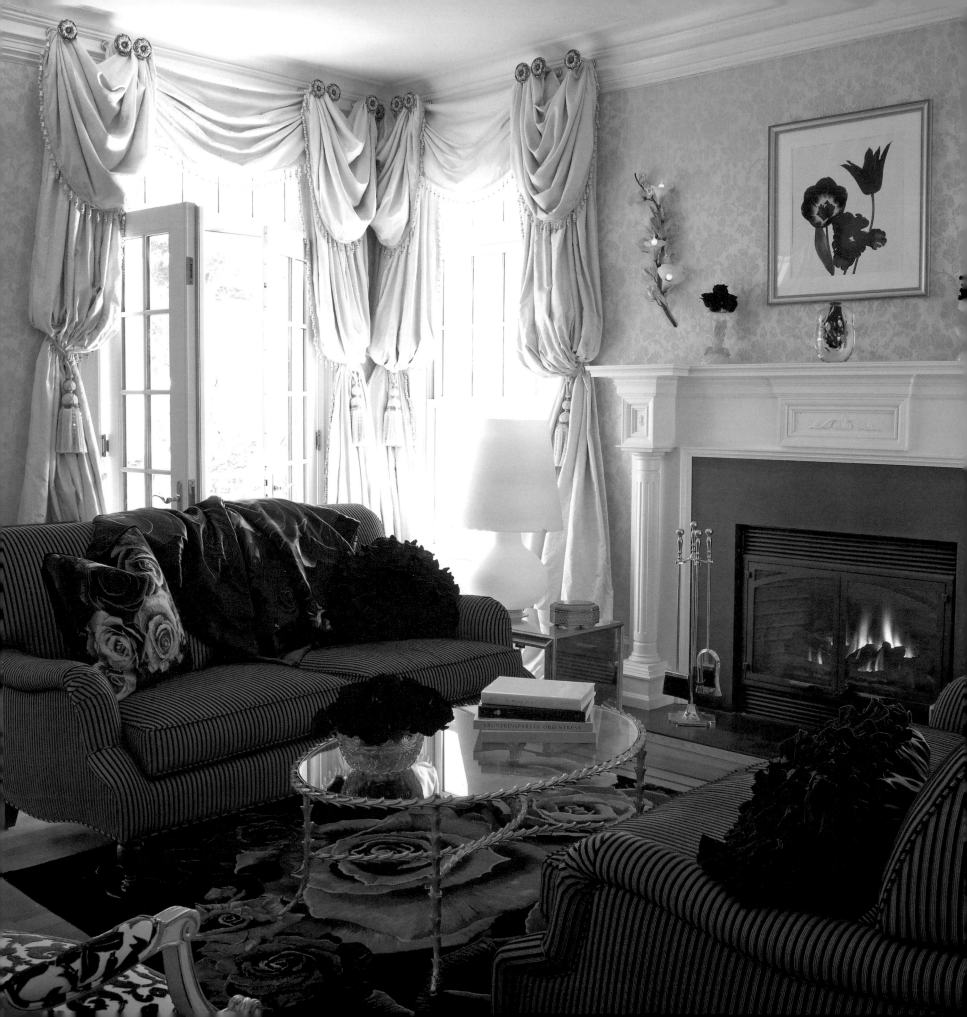

VICTORIA VANDAMM

VANDAMM INTERIORS

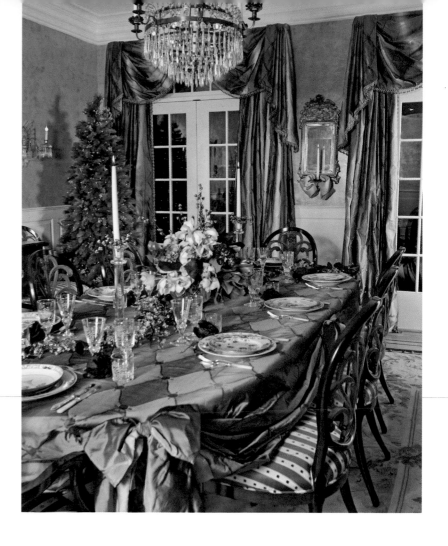

Vivid colors and rich textures evoke delight and comfort—and permeate the homes designed by Victoria Vandamm, an art major with a lifelong passion for creating masterpieces, whether they be paintings or interior spaces. Victoria entered the design field on the retail side in 1978, purchasing a Nettle Creek shop that sold furniture, bedding, fabric and accessories. By 1991, she had moved her shop to Greenwich Avenue and renamed it Vandamm Interiors, focusing on interior design. She recently moved to the design studio of her dreams, featuring huge windows, as she feels that the natural light reveals colors and textures better than artificial light. Despite the size of the job, Victoria feels it is important to make a big impact.

A Connecticut native, Victoria has worked all over the world. She has designed residential and commercial spaces across the country, from Beverly Hills to West Palm Beach to the mountains of Vermont. Abroad, her work can be found in England, France, Monaco and other locations throughout Europe. Yachts and sailboats, which are often second or third homes for her clients, are among her favorite challenges due to the additional considerations of the marine environment.

Victoria maintains that the interior designer is "the glue between the visions of the architect and the homeowner." Intently focused on clients' dreams and desires, she works diligently and enthusiastically to interpret and translate their lifestyles into their spaces, building styles and environments. The lighting and function of space is far different in a Vermont home than in a 16th-floor apartment in Florida or a stately home in Greenwich, and she constantly adapts her designs to reflect those differences.

Paramount to each of Victoria's projects is color. While she believes that a palette of creams and whites can be beautiful and elegant, she prefers brighter, bolder colors. She contends, "Saturating rooms with color can breathe new strength and happiness into them."

ABOVE
A dining room meant to be a feast for all the senses. Layers of colors in the Venetian plaster walls are accented by the opalescent fabrics and family heirlooms, as well as contemporary furniture.
Photograph by Kevin Dailey

FACING PAGE
A color-drenched living room takes high style from the Roberto Cavalli "Dark Lady" silk rug. Damask upholstered walls and ball gown draperies create an opulent surrounding.
Photograph by Christopher Kolk

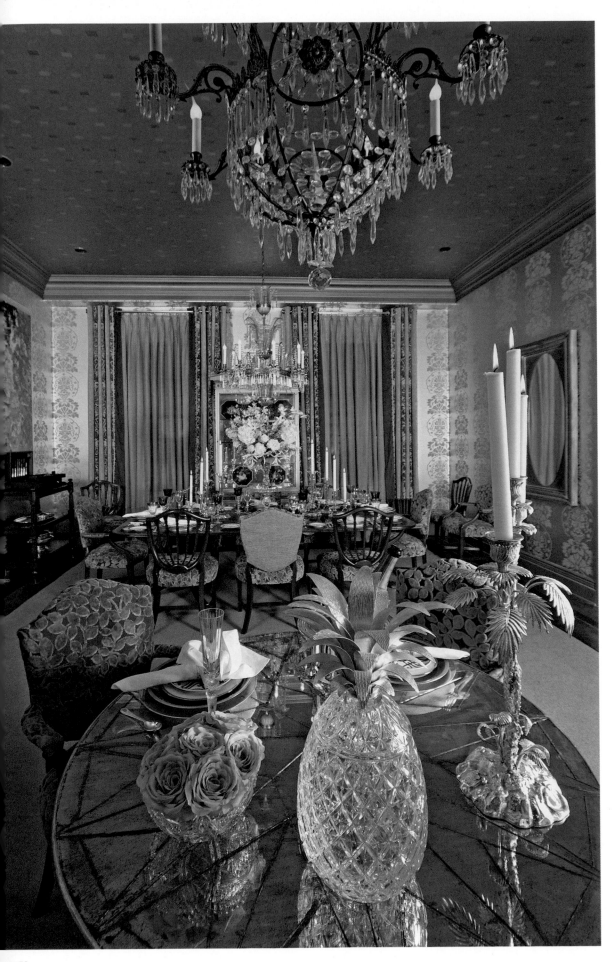

Victoria's expertise in the use of color enables her and her clients to confidently create a strong design statement that yields a unique and impressive interior. Victoria describes her design style as an eclectic, innovative mix of color and texture; her designs range from over-the-top formal to modern conservative to Adirondack mountain casual, and she loves to accent antiques with a modern twist. What results are environments that are both aesthetically compelling and entirely livable.

Victoria's designs have been featured in such publications as *The New York Times, Fairfield County Home* Magazine, *American HomeStyle, Greenwich* Magazine, *At Home* and *Connecticut Cottages & Gardens*. Along with designing for clients, she is a leader in the local design community. She chaired the first annual garden show and the 28th annual antiques show at the Lockwood-Mathews Mansion Museum, a nationally registered historic landmark in Fairfield County. She has also participated in a number of designer showhouses, including the Albert Hadley-chaired "Rooms with a View" event in Southport in 2001 and 2004, Greenwich's Antiquarius House Tour in December of 2005, and most recently, at the Merrywood Designer Showhouse in Greenwich during May and June of 2006. Her true sense of pleasure comes from the immense satisfaction her clients enjoy from the magnificent designs she creates.

LEFT
Twist your mind, rethink space: Two seating opportunities in one elegant dining room. Intimate dining for two or grand entertaining for 24. Pairs that match and pairs that simply complement.
Photograph by Kevin Dailey

FACING PAGE
A Swedish influence in blues and whites. Crisp, warm and a breath of fresh air in a comfortable room meant for relaxing.
Photograph by Kevin Dailey

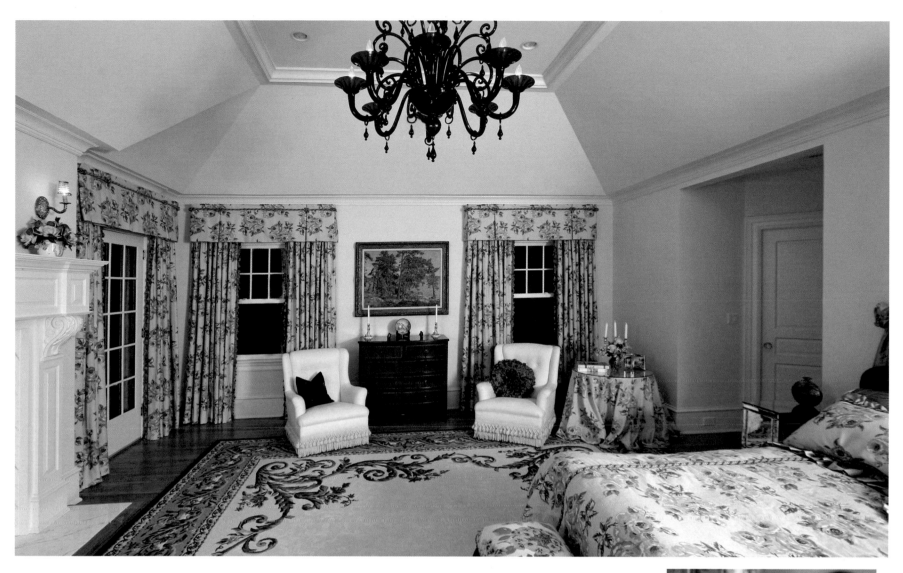

MORE ABOUT VICTORIA ...

WHAT COLORS BEST DESCRIBE YOU AND WHY?

Raspberry and aqua. One is happy and warm, and the other calm and cool. I love the juxtaposition.

DESCRIBE AN UNUSUAL DESIGN TECHNIQUE YOU HAVE USED IN A CLIENT'S HOME.

One client wanted a mural painted on the wall in her hallway. Wanting to ensure that it truly reflected her taste, I looked to her china collection for my design inspiration, reproducing on the wall the birds, bees, flora and fauna that peppered the dining room dishes. Not only is the wall mural completely original and personalized, it solidifies the relationship of the accessories to the home, itself.

WHAT EXCITES YOU MOST ABOUT BEING PART OF *SPECTACULAR HOMES*?

The book is fabulous, and I am proud and excited to have been chosen among such a renowned group of designers to grace its pages with my work.

VANDAMM INTERIORS
Victoria Vandamm
22A West Putnam Avenue
Greenwich, CT 06830
203.622.9070
Fax 203.409.3800
www.vandamminteriors.net

DESIGNER CARTER & CO., page 85

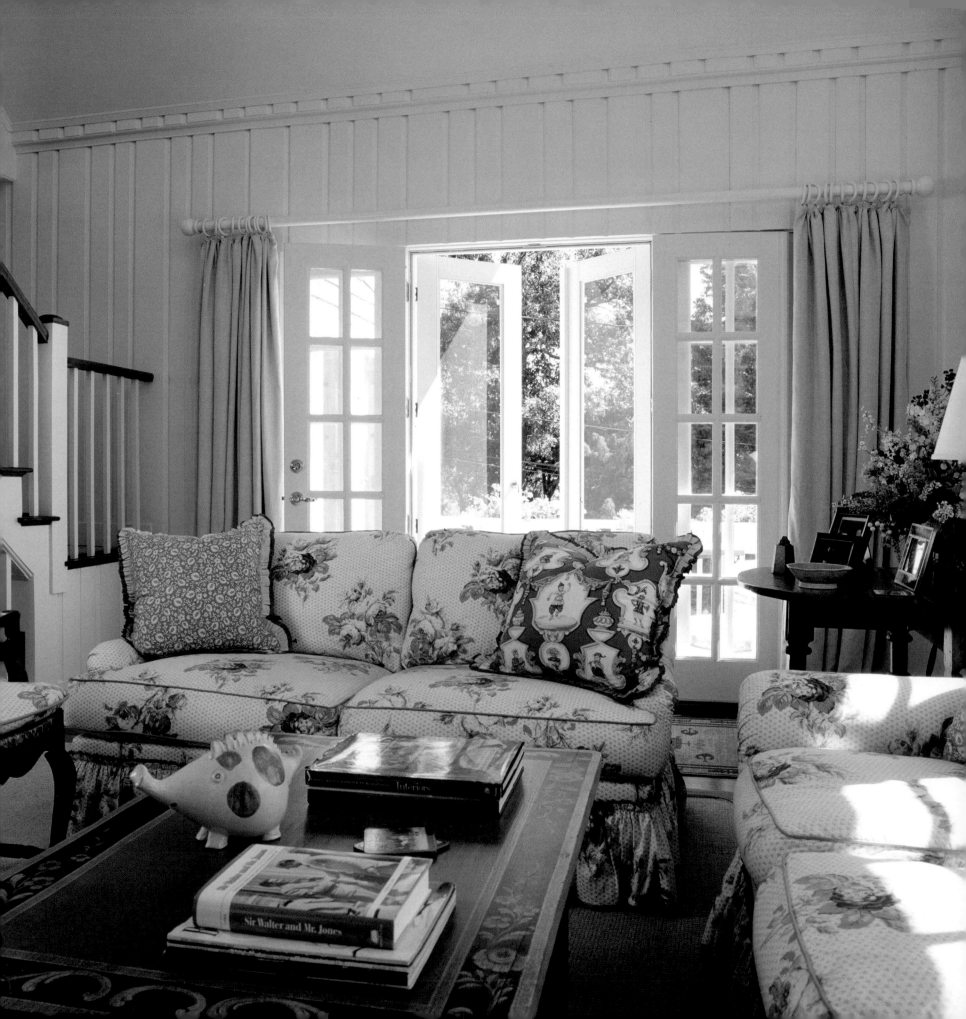

SUSAN B. ACTON

SUSAN B. ACTON INTERIORS

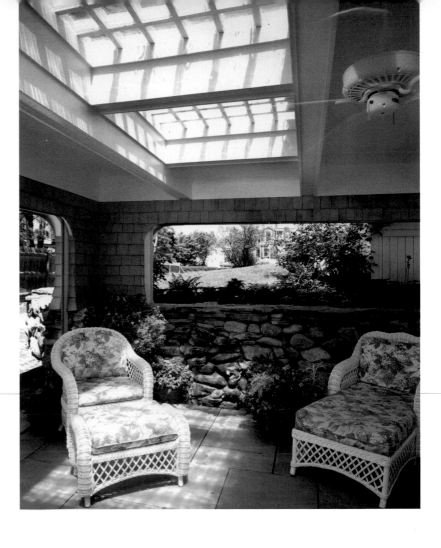

If there's one constant in life, it's that life is not constant. One's life changes drastically from year to year, decade to decade, and one must work to accommodate those changes. For quite a few New Englanders, this means putting in a call to Susan Acton. With 40 years of experience in residential interior design, Susan knows how to incorporate lifestyle changes into a home.

Susan's love of design could possibly be genetic: Her grandmother was one of the 10 founders of AID, now known as ASID, and her father was an architect. Initially, Susan wanted to follow in her father's footsteps. But he encouraged her to pursue her grandmother's field, as he believed Susan would thrive on the personal contact involved in residential interiors. He was right, and upon earning her AA in interior design from Endicott College, Susan launched her design career. She opened Susan B. Acton Interiors in 1989, and she now works alongside her daughter, Elizabeth, to design homes in both New England and Florida, where she lives part of the year.

Susan prides herself on the strong relationships she cultivates with her clients, and she strives to cater to their style preferences and specific needs—her designs range from

Colonial to Contemporary, spurning trends for traditional elements and integrating playpens and PCs as needed. As is true for any relationship, trust is built over time, and some bonds take longer to form than others. One particular client has known Susan for 20 years and only recently called to enlist her services. But the effort Susan puts into making genuine connections pays off. Young and old, those she works with become, quite literally, clients for life.

Not long ago, Susan received a call from a prior patron who needed her home redesigned. The client told Susan that now that her children had moved out and her pets had passed away, she and her husband needed help—desperately. This call was nothing out of the ordinary for Susan. The majority of her young patrons will turn to Susan again,

ABOVE
Designer Susan B. Acton's beach house pavilion with retractable screens.
Photograph by Sam Gray

FACING PAGE
Designer Susan B. Acton's beach house living room.
Photograph by Sam Gray

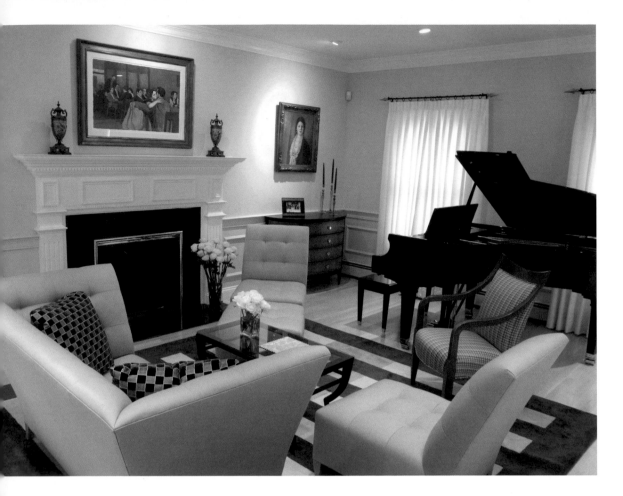

seeking to adapt their homes to support a new stage of their lives. Moreover, many of her New England clients have second homes in Florida and request her expertise with those as well. Her work in both regions reflects her creative flexibility.

While calls such as these come frequently for Susan, they are always immensely gratifying. Being asked to design for a client a second or third time is a welcome reward for her efforts. It affirms the tenacity with which she works to ensure that every home she designs is the best it can be and that every customer becomes—and remains—a close friend.

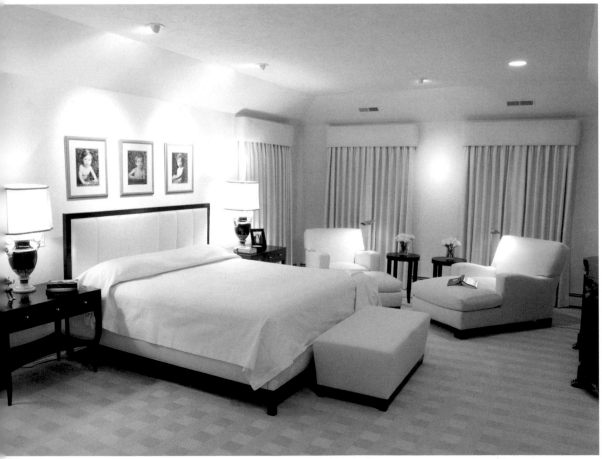

TOP LEFT
Private residence, formal living room in Wayland, Massachusetts.
Photograph by Dan Derby

BOTTOM LEFT
Private residence, master bedroom in Wayland, Massachusetts.
Photograph by Dan Derby

FACING PAGE
Private residence, family room in Wayland, Massachusetts.
Photograph by Dan Derby

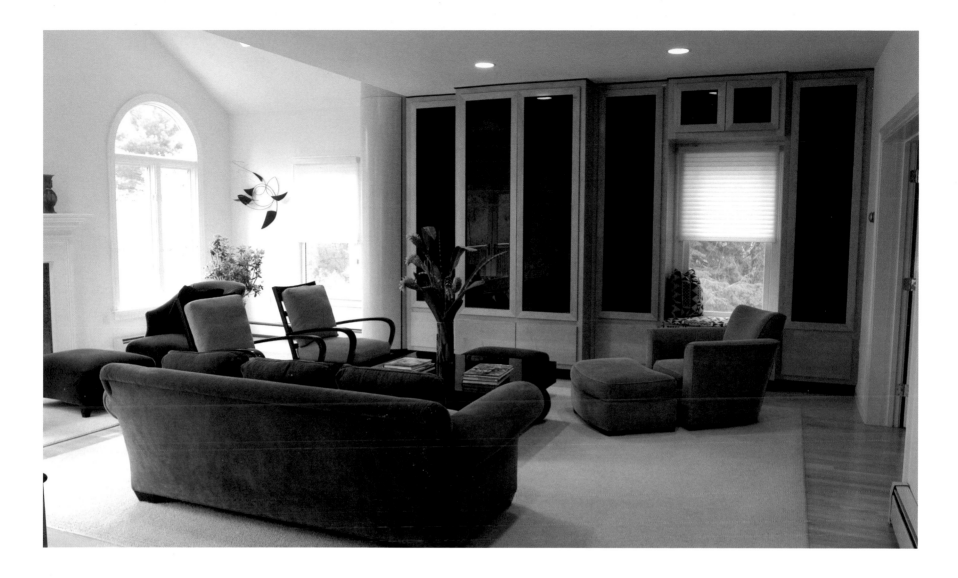

Q&A

MORE ABOUT SUSAN ...

WHAT IS THE MOST MEMORABLE PHONE CALL YOU'VE RECEIVED FROM A CLIENT?

On Thanksgiving morning, a client called to ask me how to stuff a turkey! I guess she figured that my talent at kitchens must reflect my talent in one.

HOW DO YOU GO ABOUT BEGINNING A PROJECT?

I get to know a client's taste before I do anything else. Often I'll have clients show me their favorite items of clothing, pieces of china or paintings to determine their tastes. I also like to ask women if they would have or ever have had a dress made. This tells me whether or not they will trust me to do custom pieces for their homes.

IS THERE ANYONE YOU WOULD LIKE TO SPECIFICALLY ACKNOWLEDGE?

The vendors and workforce behind my designs. Designing spaces to the best of my ability is only possible with a talented team working alongside me to create what my clients and I envision. I appreciate their efforts immensely.

WHAT IS A SINGLE THING YOU WOULD DO TO BRING A DULL HOUSE TO LIFE?

Bring in a dog! As an animal lover, I suggest to many of my clients that they get a pet. Pets bring warmth and humanity into a home.

SUSAN B. ACTON INTERIORS
Susan B. Acton, ASID
PO Box 137
Cohasset, MA 02025
617.247.2420
Fax 781.383.6669
www.susanbactoninteriors.com

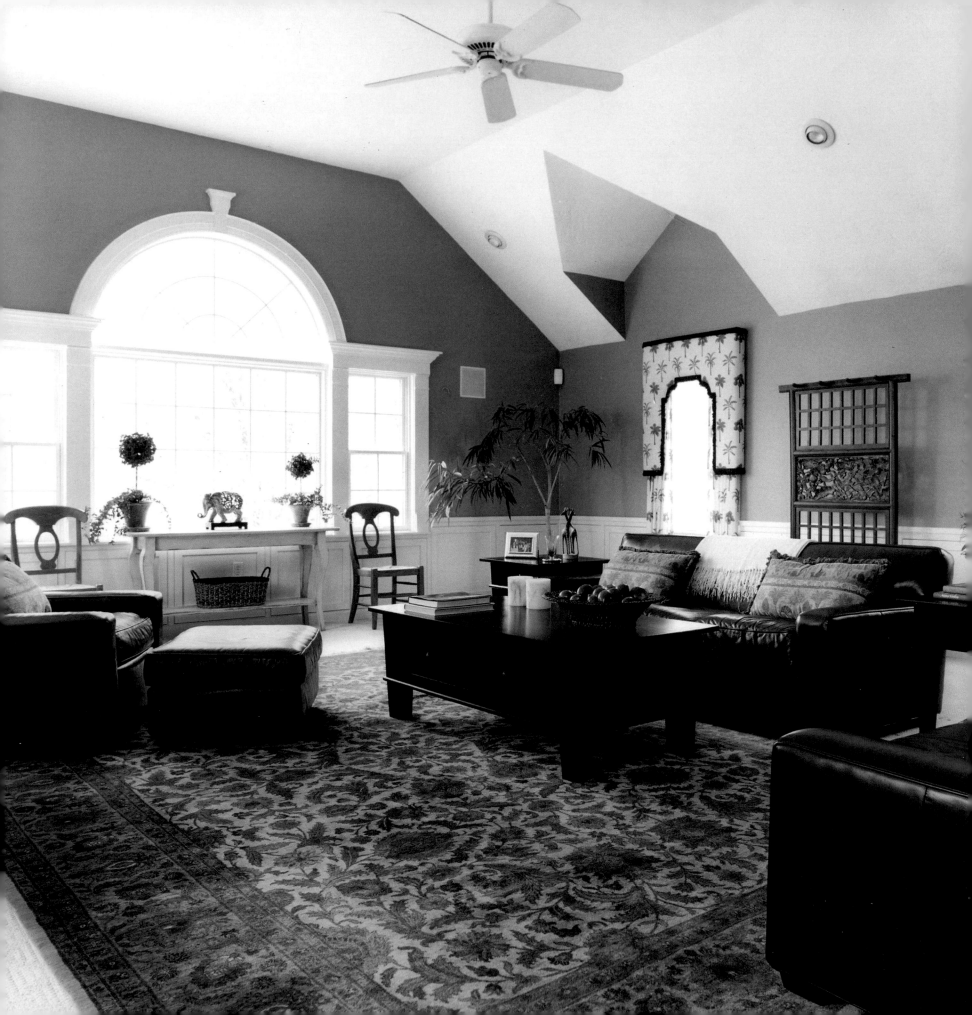

SUE ADAMS

SUE ADAMS INTERIORS

New Englanders are known for their sophistication and pragmatism. And having lived in the area nearly all of her life, Sue Adams is certainly no stranger to this fact. Thus when she opened the doors to Sue Adams Interiors 15 years ago, she knew that to succeed as a regional designer meant marrying elegance and practicality in her work. Today, as her many clients can attest, Sue continues to expertly facilitate this union.

Sue's enchantment with interiors was kindled by a summer internship she did for the Department of American Decorative Arts at the Museum of Fine Arts in Boston. The exposure to crystal, silver, antiques and other such fineries profoundly affected her and forged the way for what was to become a long and varied career in interiors. Starting with a business in contemporary furnishings, she moved on to real estate and then commercial interiors before discovering her true passion, residential design, and launching her own firm.

Although small—Sue is the sole designer and works alongside an assistant—the firm has done remarkable work. Sue's designs have been featured in such renowned publications as *Better Homes and Gardens* and *The Boston Globe*, and Sue appeared for several seasons as a design expert on HGTV.

Sue's down-to-earth personality sets her apart from other designers. So, too, does her intimate familiarity with the regional mindset. Sue knows that New Englanders are grounded in reality; they want substance, not fluff. Thus, her designs are at once elegant and functional, rooms both to admire for their beauty and to enjoy for their comfort.

Her methods are also firmly rooted in logic. She works, quite literally, from the ground up, choosing a rug for a room before considering wall coverings, furniture, or works

ABOVE
The lovely shaped cornice in a whimsical palm tree print beautifully complements the textural brush fringe. An Asian screen and African carving accessorize and complete the exotic motif.
Photograph by Sam Gray

FACING PAGE
Comfortable and gracious at the same time, this family room serves a dual purpose as the primary living space as well as a room for entertaining. The Palladian window's elegance juxtaposed against the leather seating provides an ambience that is both versatile and gracious.
Photograph by Sam Gray

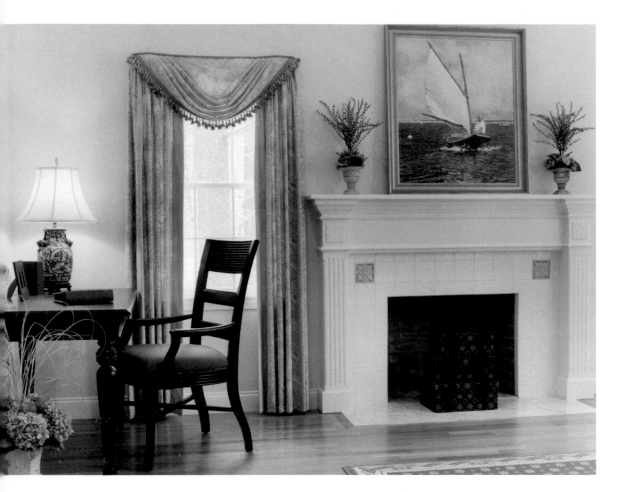

of art. She knows that to match the room to the rug is not difficult, but to match a rug to a room is nearly impossible, often costing much more time and money than her clients want or need to pay. "Better to spend $3,000 on the rug you want than $20,000 on the only one that will work," says Sue, demonstrating the kind of prudence that her clients so appreciate.

Recently, Sue visited a home she had designed to find a wine stain on the living room coffee table. The homeowner apologized, stating that her husband had enjoyed a glass of wine by the fire the previous night and must have forgotten to wipe up the stain. Sue was not offended, however. That her client had found the living room comfortable enough to spend his evening there was proof of a job well done. To her, that is the highest compliment she can receive.

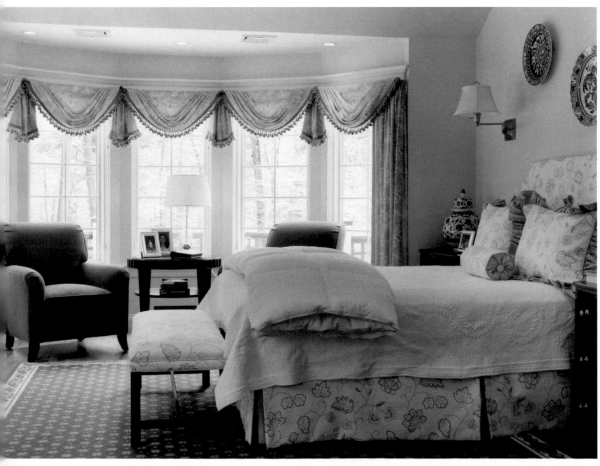

TOP LEFT
Tucked away in a quiet corner of this lovely guestroom, the desk provides the visitor an opportunity to catch up on correspondence. The artwork over the mantel suggests a summer sail on the sound.
Photograph by Sam Gray

BOTTOM LEFT
The rapture of summer resonates in this Nantucket-inspired bedroom ... sky blues and crisp whites evoke feelings of an oceanside retreat. Floating like a cloud, the puff beckons its guest to a restful repose.
Photograph by Sam Gray

FACING PAGE LEFT
With the arrival of spring comes a palpable feeling of "Joie!" Spring green-stenciled floors balance azalea-pink walls in the breakfast nook of this historic sea captain's home.
Photograph by Sam Gray

FACING PAGE RIGHT
The deep windowsills of this historic home are a perfect setting for voluminous fringed balloon shades and a decorative vignette of favorite accessories.
Photograph by Sam Gray

Q&A

MORE ABOUT SUE ...

WHAT IS THE BEST PART OF BEING AN INTERIOR DESIGNER?

I get to do what I love and love what I do. My clients are great fun.

ASIDE FROM DESIGN, WHAT ARE YOU PASSIONATE ABOUT?

Skiing—I've been a professional ski instructor in New Hampshire for the past 13 winters.

WHO HAS HAD THE BIGGEST INFLUENCE ON YOUR CAREER?

Jacqueline Kennedy Onassis. When she redesigned the White House, I was agog. Her sense of classic style sparked my passion for American antiques.

WHAT IS ONE THING YOU WOULD DO TO BRING A DULL HOUSE TO LIFE?

Paint. Not only does it add color and texture, it's also a very affordable way to dress up a home.

SUE ADAMS INTERIORS
Sue Adams, IFDA, Allied Member ASID
89 North Main Street
Andover, MA 01810
978.475.3567
Fax 978.475.0577
www.sueadamsinteriors.com

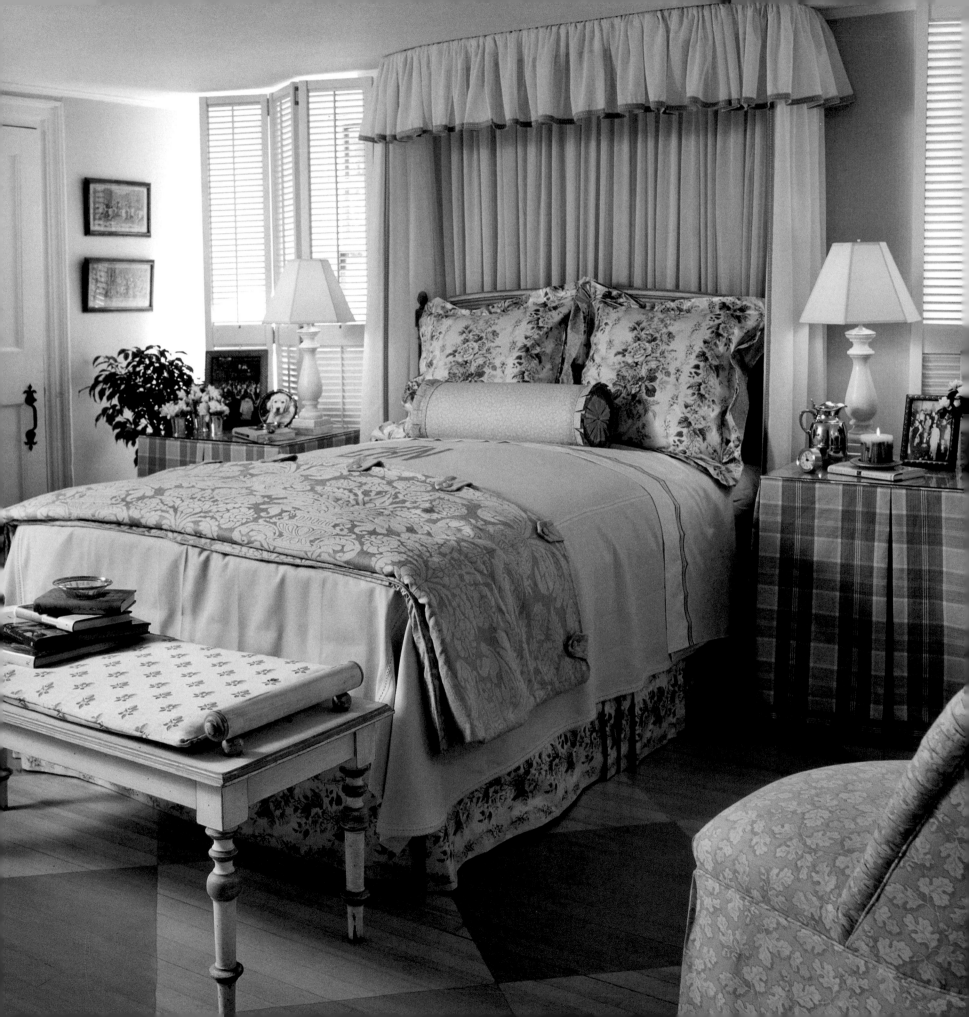

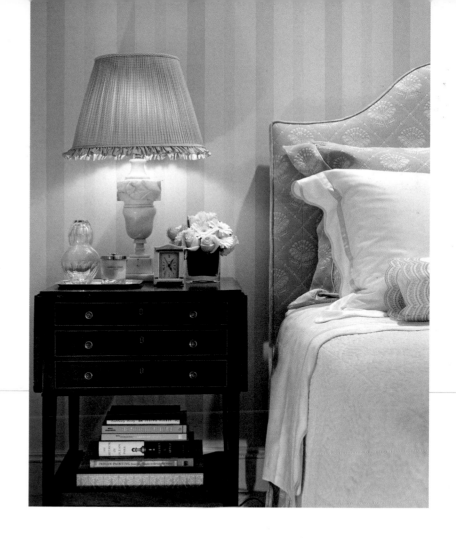

HELEN BAKER

HELEN BAKER INTERIORS, INC.

Cape Cod is an area rich in art and artisans and characterized by an intrinsic beauty that people come from all over the country to experience. For many, it is a home away from home, a place to come to recuperate from the bustle of the city and replenish their stores of energy, creativity and senses of well-being. Those purchasing homes here thus seek interiors that at once embody both their personalities and the resort atmosphere. They turn to Helen Baker, whose 24 years designing Cape Cod homes make her an expert at her craft.

Like most of its residents, Helen is a transplant to the Cape. Raised by an interior designer in Charleston, South Carolina, Helen graduated from Duke University with a political science degree and spent the next two years of her life pursuing that path in Boston. But when her mother asked her to take over control of the fabric business she had started on Cape Cod, Helen welcomed the opportunity to work in a more creative arena. Assuming ownership in 1982, Helen expanded and refined the company's services and turned it into Helen Baker Interiors, the full-service design firm she operates today.

Helen's background in politics taught her resourcefulness, how to structure communication and processes, and her design methodology clearly illustrates this fact. Her methods are rooted in pragmatism and fed by her broad command of textiles, both from a technical and an aesthetic standpoint. This vast knowledge, coupled with her close working relationships with local architects, builders, artisans and vendors allows clients to make educated decisions from her presentations. She maintains an extensive design library, replete with hundreds of books, catalogs and samples from which she draws inspiration. Proficient in a broad range of styles, Helen enjoys her frequent commissions to design homes off-Cape and has worked throughout the East Coast.

ABOVE
An elegant guest room with crisp Italian bed linens and antique side table presents a tranquil and hospitable retreat.
Photograph by Sam Gray Photography

FACING PAGE
A cozy bedroom in shades of green and taupe mixes eight textiles for a detailed and inviting room.
Photograph by Eric Roth Photography

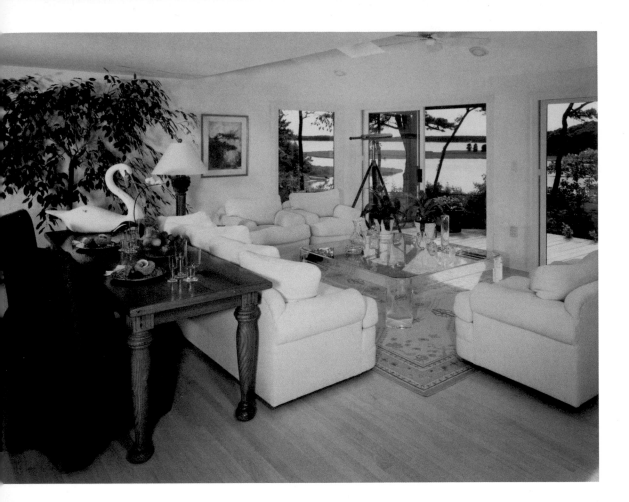

Helen's experience and practical approach has earned her a reputation for excellence and appearances in numerous publications and on television. Helen's immense knowledge impels clients to contact her first when creating new homes and then seek her guidance with architects and builders. Indeed, much of Helen's work begins at the construction phase. She enjoys every aspect of the design experience and remains passionate about the process involved in creating homes that reflect her clients' lifestyles. These clients and countless others recognize that Helen's designs truly capture and enhance the beauty of Cape Cod.

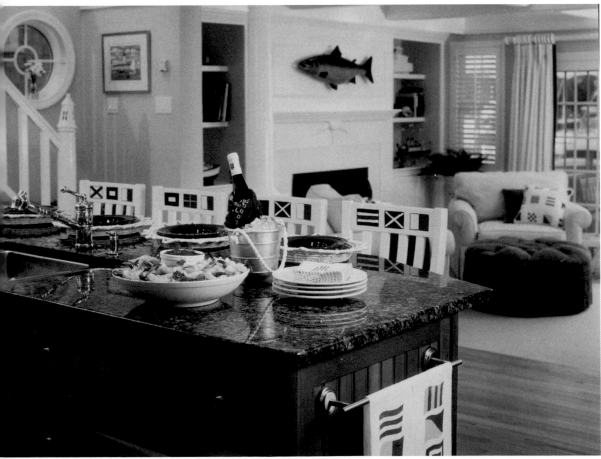

TOP LEFT
A magnificent water view dictates a clean interior accented with a locally made harvest table.
Photograph by Slepchuck and Gallagher Photography

BOTTOM LEFT
A whimsical cottage set on a popular harbor is an appropriate backdrop for nautical commissions from local artists.
Photograph by Terry Pommett Photography

FACING PAGE
A floral linen fabric and European antiques complement a French-inspired living room and its adjoining library.
Photograph by Olson Photographic, LLC

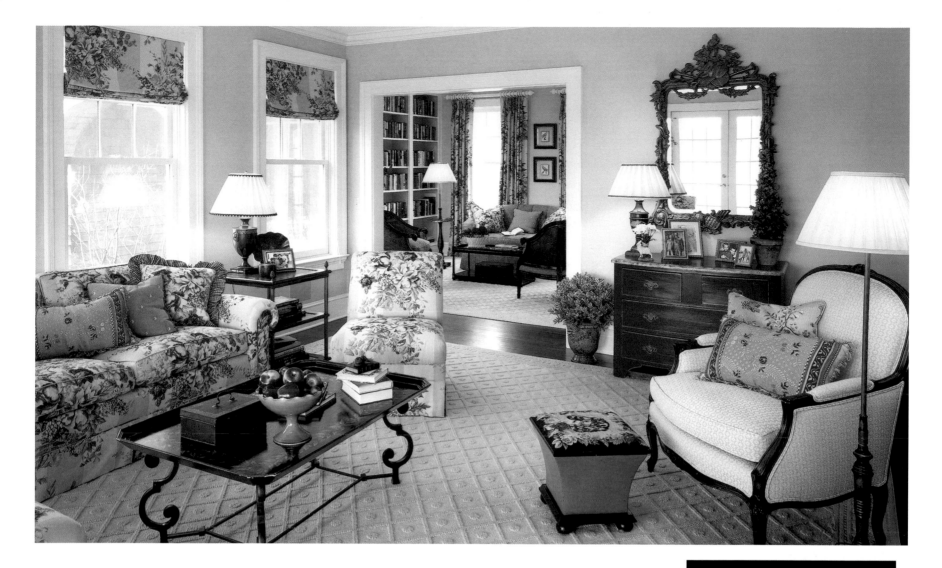

Q & A

MORE ABOUT HELEN ...

WHAT PHILOSOPHY HAVE YOU STUCK WITH OVER THE YEARS THAT STILL WORKS FOR YOU TODAY?

Perry Ellis spoke on career day at my college, and I'll never forget him saying that we should strive to acquire only those things that incite us to say "I love this." My job is to filter design elements for my clients so that those I present to them will elicit that reaction.

WHAT COLOR BEST DESCRIBES YOU AND WHY?

Pink. It's a warm color that has all the passion and fire of red but is lighter and more subdued. In turn, I am a very passionate person, but I also like to laugh and have fun. Pink is also a feminine color, and I definitely still have that feminine graciousness characteristic of the South.

WHAT IS THE HIGHEST COMPLIMENT YOU'VE RECEIVED PROFESSIONALLY?

A very affluent client who was highly accomplished in the business world—he owned multiple luxury hotels—told me I had the best business sense of any designer with whom he'd worked.

HELEN BAKER INTERIORS, INC.
Helen Baker
94 Main Street
West Harwich, MA 02671
508.432.0287
Fax 508.430.7744
www.helenbakerinteriors.com

73

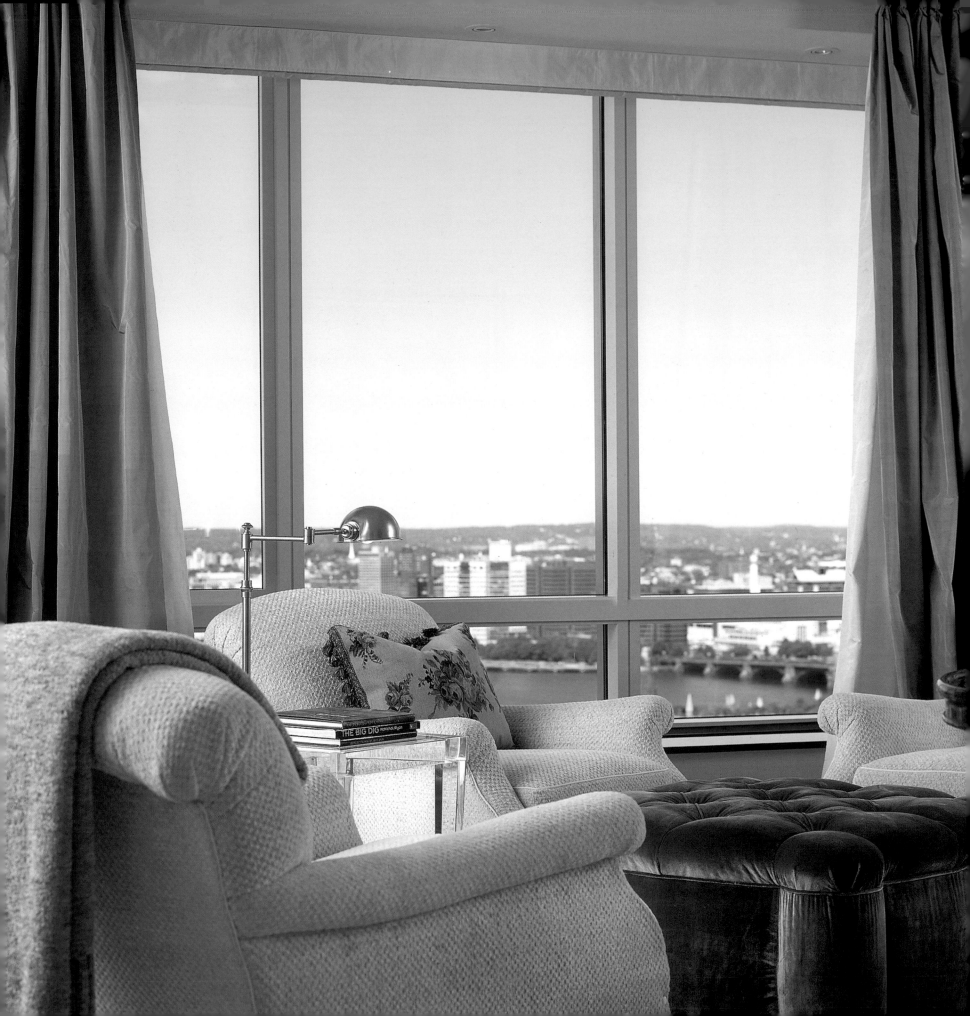

LEE BIERLY
CHRISTOPHER DRAKE

BIERLY-DRAKE

For almost 20 years Lee Bierly and Christopher Drake of the successful Boston-based interior design firm, Bierly-Drake, have held a prominent site on Arlington Street across from the venerable gates to the Boston Public Garden. With neighbors like Hermés and Burberry, and The Ritz Carlton and Four Seasons Hotels, the location has grown in stature as steadily as their own reputation. The firm's sophisticated clientele has helped Bierly-Drake solidify its position among the leading and most prestigious interior design firms in the country.

Whether the look is Palm Beach chic, laid back casual—think Nantucket or Deer Valley—formal and stylish like one of the neighboring Beacon Hill mansions or luxe high-rise condominiums, or the simple casualness of a country home in Easthampton or Lake Forest, Bierly-Drake intuitively understands their clients' needs. With a design firm numbering 12, they are equipped to tackle everything that happens within the confines of walls and often beyond. Whether it is interior architecture or electrical systems, Bierly-Drake has a keen understanding of what it takes to bring a house to fruition. They even have been known to change the entire circulation of a house—relocating kitchen and baths to better define their clients' lifestyle. They add a keen eye even to landscape architecture and the like. "You have to build a body before you put clothes on it," comments Chris Drake.

Drake, son of Bostonians, grew up under the sky-grazing spires of Chicago architecture. His eye for elegance and design was honed while studying in Europe. Bierly, a native of Los Angeles and the more

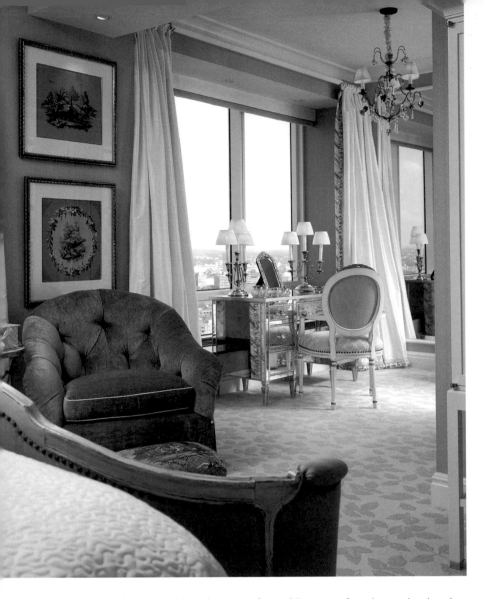

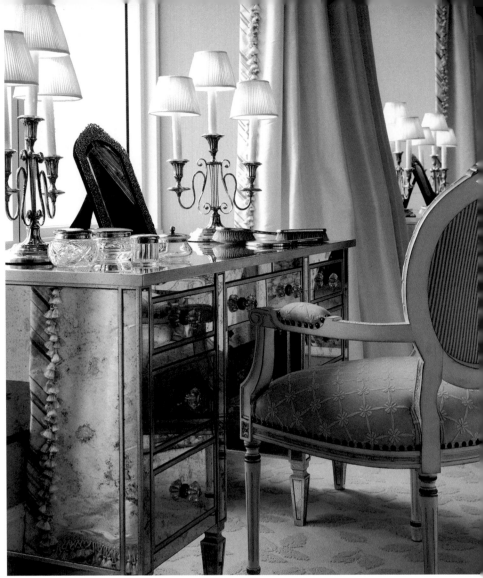

outspoken of the two, spirits a keen eye for architecture, oh-so-interesting interiors and brilliant space planning. Together they create rooms that are subtle and yet filled with meaning—combining color, form and texture with a sophisticated knowledge of art and antiques. Art and antiques culled from shopping London and Paris as well as selected markets across the U.S. complete their rooms adding warmth and personality while balancing easily with interior architectural details. "It is all about layers and the romance of being subtle," adds Bierly. There is simply nothing that smacks of indifference or passé in one of their serene interiors.

While aesthetics are very important, the duo has a reputation for delivering all of their projects, large or small, on time and on budget. "We take what we do very seriously" says Bierly, adding, "…even if we are buying million-dollar paintings for a client in Paris or vastly expensive antiques at auction in London, we're aware of the project as a whole."

Their work, which has been featured extensively in *Architectural Digest, House Beautiful* and *House and Garden,* spans the East Coast from St. Johns, New Brunswick

to Palm Beach, Florida (where they have a home), as well as Chicago, Scottsdale, San Francisco and Honolulu. They recently completed a stunning home in Osaka, Japan. One cohesive element that occurs in their work whether it is Traditional or Contemporary is the abundance of fresh white paint. The pair likens the color to clarity and cleanness and says "it's what makes rooms fresh and crisp." To the homeowners' delight, they even fill containers throughout the house with an array of white flowers and lush leafy greens. "Flowers add grace to a house wherever they are placed," comments Drake in closing.

ABOVE LEFT & RIGHT
This master suite and dressing room is a palette in complements: Carpet is Ashford by Stark Carpet, wallcovering is custom strie by Peter Fasano, custom drapery and motorized shades by Finelines in Christopher Norman "Vincenza Taffetta" with custom "Strasbourg" trim by Beacon Hill. Custom "Marshall Field" lounge chair by McLaughlin in Osborne & Little "Velours Madrigal" with welting in "Diana Taffetta" by Hinson. Custom silver and lead crystal chandelier by Bella Figura with custom shirred silk shades by Blanch Fields.
Photographs by Robert Brantley

FACING PAGE
This living room features cozy corner seating with gorgeous views: Walls in Hinson's "Custom Strel," carpet in Stark "Tristan" and custom Billy Baldwin banquette by McLaughlin. Upholstery in Hinson "Terrazzo Chenille." The adjoining library is warm and inviting: Custom wall upholstery by Finelines in "Wellington Flannel" by Hinson. Wall-to-wall carpet by Stark Carpet.
Photograph by Robert Brantley

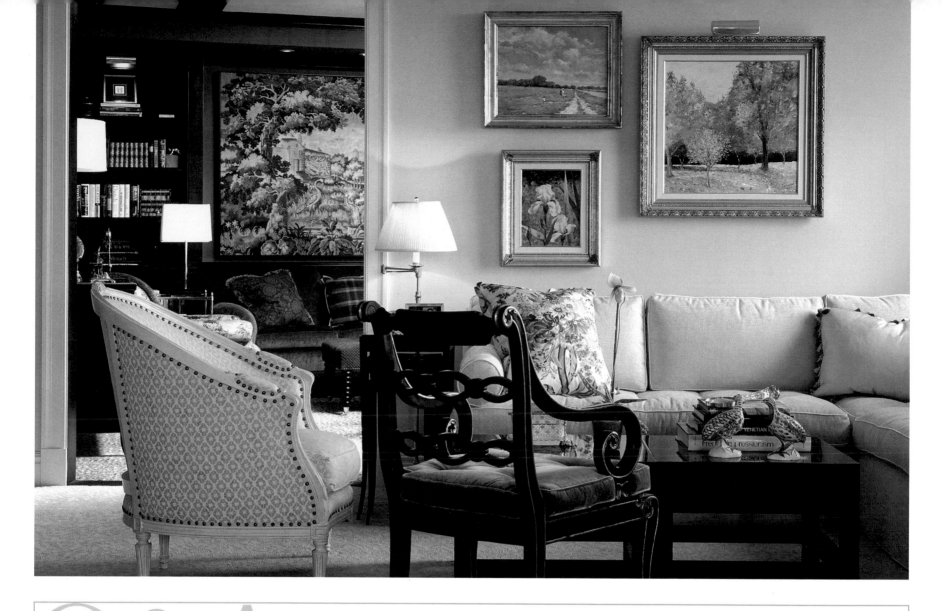

MORE ABOUT LEE & CHRIS ...

WHAT COLOR BEST DESCRIBES YOU BOTH AND WHY?

Lee: Yellow, it's outgoing, sunny, bright, and doesn't hide behind anything.

Chris: White—it brings clarity to any scheme and allows great flexibility.

DESCRIBE YOUR STYLE OR DESIGN PREFERENCES.

We have a clean and tailored approach to design. Great rooms are created around layers of design. No one element pops out. Rooms are about a balance of elements.

WHAT EXCITES YOU MOST ABOUT BEING PART OF *SPECTACULAR HOMES*?

Books of this type give a designer an opportunity to showcase his work.

YOU CAN TELL I LIVE IN THIS LOCALE BECAUSE ...

The value of workmanship. We sell it because it is great design, great quality—that's a Boston thing. People here are value driven. It can't be just attractive. It's got to have value.

WHAT BOOK ARE YOU READING RIGHT NOW?

Chris: A 1949 copy of Addison Misner's biography that a woman in Paris gave me.

Lee: *The Color Purple* by Alice Walker (again).

HOW LONG HAVE YOU BEEN AN INTERIOR DESIGNER/DECORATOR? HOW LONG WITH THIS COMPANY OR IN BUSINESS?

We have both been in design for 30 years. We founded Bierly-Drake in 1980, 26 years ago.

BIERLY-DRAKE
Lee Bierly, ASID
Christopher Drake, ASID
17 Arlington Street
Boston, MA 02116
617.247.0081

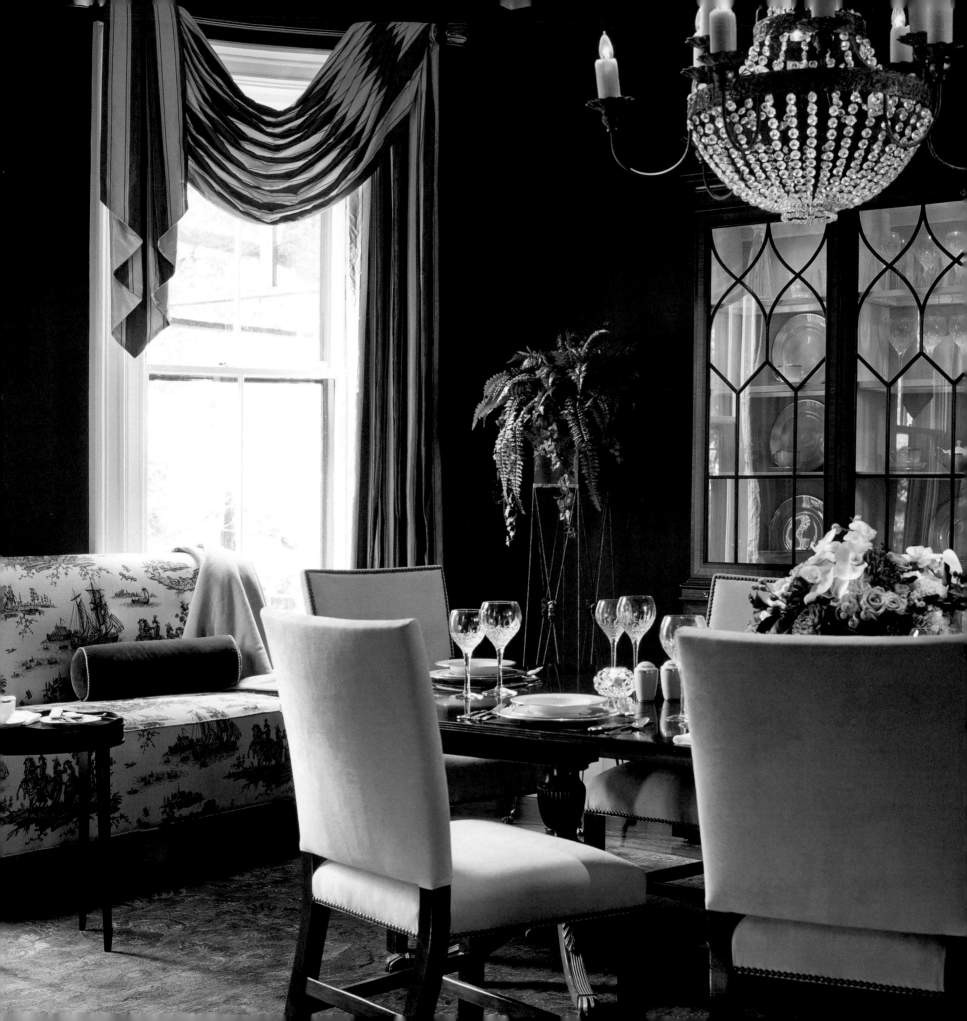

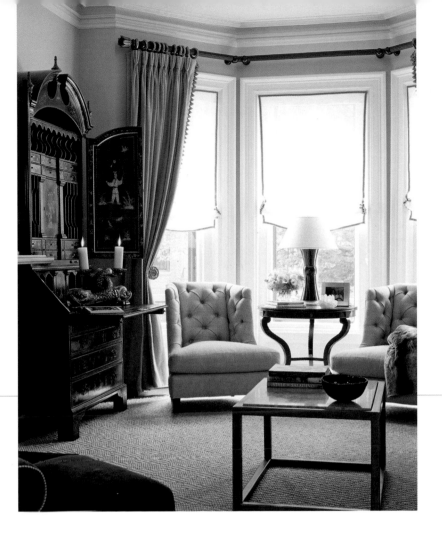

TONY CAPPOLI

TONY CAPPOLI INTERIORS

I nfused with old-fashioned elegance, Tony Cappoli's designs whisper of subdued Hollywood glamour, the clean lines of a well-tailored suit, and just a touch of drama that sets the tone of every room he touches. Custom furnishings, rich fabrics, and subtle colors are hallmarks of the designs Tony has completed. The projects he undertakes range from the very Traditional to the Ultra-Contemporary. His diverse clientele includes "Sideways" writer/director Alexander Payne, Red Sox centerfielder Manny Ramirez, movie producer Michael London, as well as families throughout the country.

The beautiful and unusual textiles and furnishings he discovers on his many travels help to inspire Tony's designs. His keen eye for unique objects often leads him to purchase an item just because he loves it, knowing that he will eventually find the perfect use for it in a client's home. Nothing makes him happier than matching up the right textile, furnishing or piece of art with clients who find the same sense of joy when he introduces it to them. Tony complements these treasures with custom-designed furniture pieces which he tailors to meet each client's needs.

Tony Cappoli, a Boston native, studied architecture and interior design at the Wentworth Institute of Technology. Now in his 10th year of business in Boston, the young designer has recently added an office in Los Angeles to handle clients on both coasts. He has developed a reputation for his ability to combine classic elements with clean-lined furnishings while bringing a fresh eye for efficient space planning. Tony emphasizes that both comfort and a consistent level of details are equally important in creating a space that is as livable as it is beautiful.

Tony's warm personality, easy sense of humor, and ability to transform their dreams into reality pave the way to lasting relationships with his clients. He often finds himself

ABOVE
The original mouldings throughout this South End brownstone mixed with warm colors, textured fabrics and antiques give this home great character.
Photograph by Sam Gray

FACING PAGE
The deep red walls, accented by the chocolate wool and silk Tibetan carpet, creates a unique blend of sophistication and elegance.
Photograph by Sam Gray

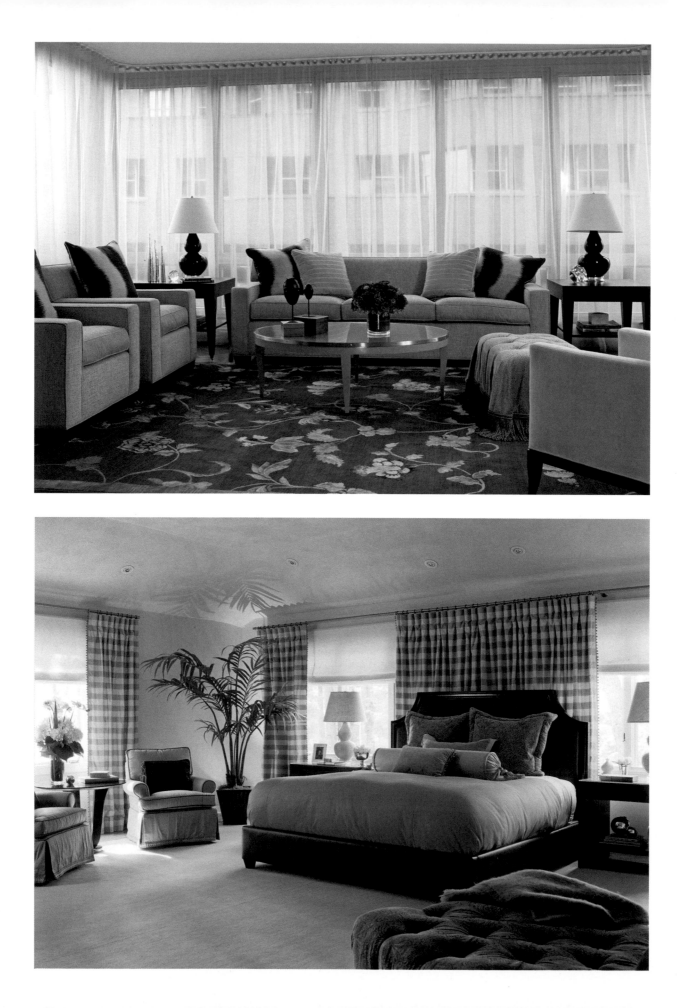

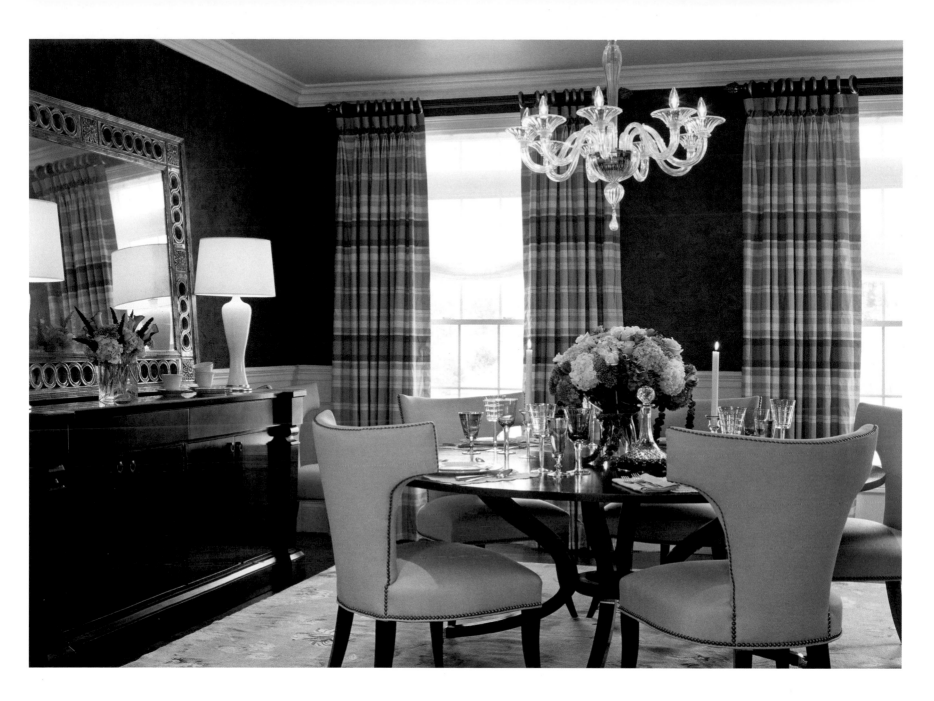

working with some of the same clients on multiple houses, always working hard to ensure that each job has a unique look and responds directly to their needs. This distinctive ability allows Tony to seamlessly transition from a 19th-century brownstone to a contemporary downtown loft. Regardless of the type of project, Tony always strives to create a space that will feel timeless and fresh for years to come.

Tony's work has appeared in national publications such as *Renovation Style* and *Interior Designs* as well as in *Boston Magazine*. Locally he has been featured on "Chronicle," the *Boston Sunday Globe Magazine, The Boston Herald, Back Bay Newbury Street Guide* and *Design New England*.

ABOVE
Raspberry Venetian plaster walls and a soft green ceiling create an elegant and timeless dining room.
Photograph by Sam Gray

FACING PAGE TOP
A Back Bay living room features an interesting mix of furnishings and a color palette that the client fell in love with.
Photograph by Sam Gray

FACING PAGE BOTTOM
Soft colors and rich wood tones helped this master bedroom achieve a complete sense of calm.
Photograph by Sam Gray

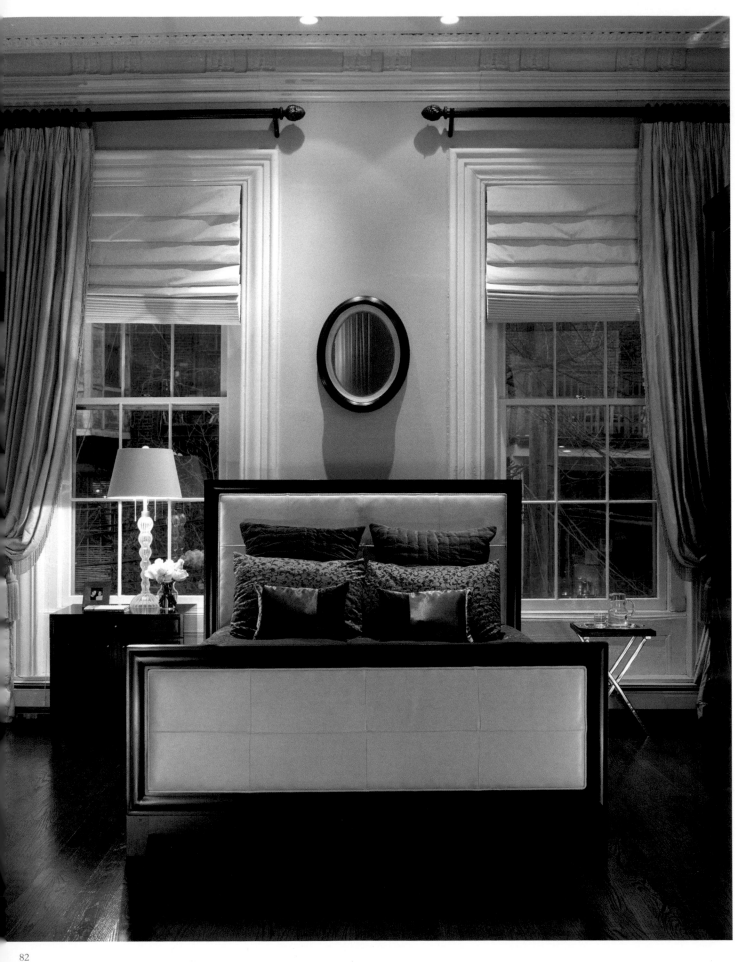

LEFT
This city apartment with its many custom pieces is a unique blend of sophistication and livability. It is a space that always commands attention.
Photograph by Sam Gray

FACING PAGE LEFT
Dining chair fabric reminiscent of a Chanel suit. Clean, crisp and sumptuous is the best way to describe this Back Bay dining room.
Photograph by Sam Gray

FACING PAGE RIGHT
A well-proportioned wenge mirror adds energy to this master bedroom retreat.
Photograph by Sam Gray

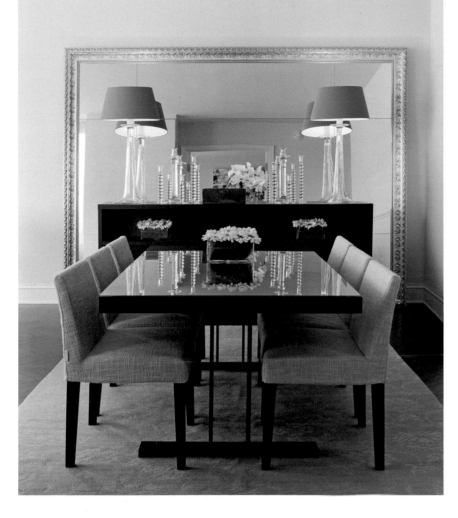

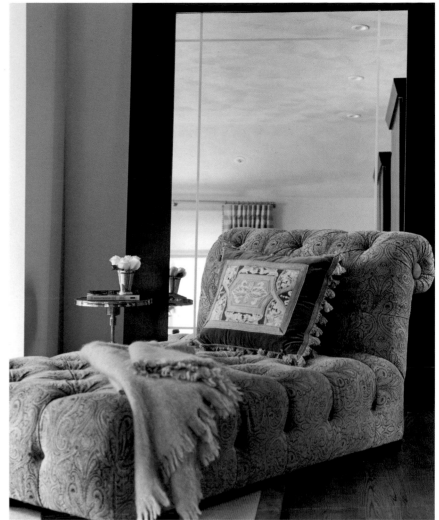

Q&A

MORE ABOUT TONY ...

WHAT SEPARATES YOU FROM YOUR COMPETITION?

We tend to build a great relationship with clients and end up designing not just one but several projects for them. Classic and timeless, every job has a different look specific to that client's needs.

WHAT DO YOU SPEND THE MOST MONEY ON?

Shoes and shirts.

WHAT COLOR BEST DESCRIBES YOU AND WHY?

Camel because it has different characteristics in the morning, late afternoon and evening.

YOU CAN TELL I LIVE IN THE BOSTON AREA ...

By the way I drive!

WHAT IS THE BEST PART ABOUT BEING AN INTERIOR DESIGNER?

Seeing your vision come to life.

WHAT IS THE HIGHEST COMPLIMENT YOU HAVE RECEIVED PROFESSIONALLY?

When clients call you six months after the installation and tell you how much they absolutely love it!

TONY CAPPOLI INTERIORS
Tony Cappoli
535 Albany Street, Suite 405
Boston, MA 02118
617.542.2444
www.tonycappoliinteriors.com

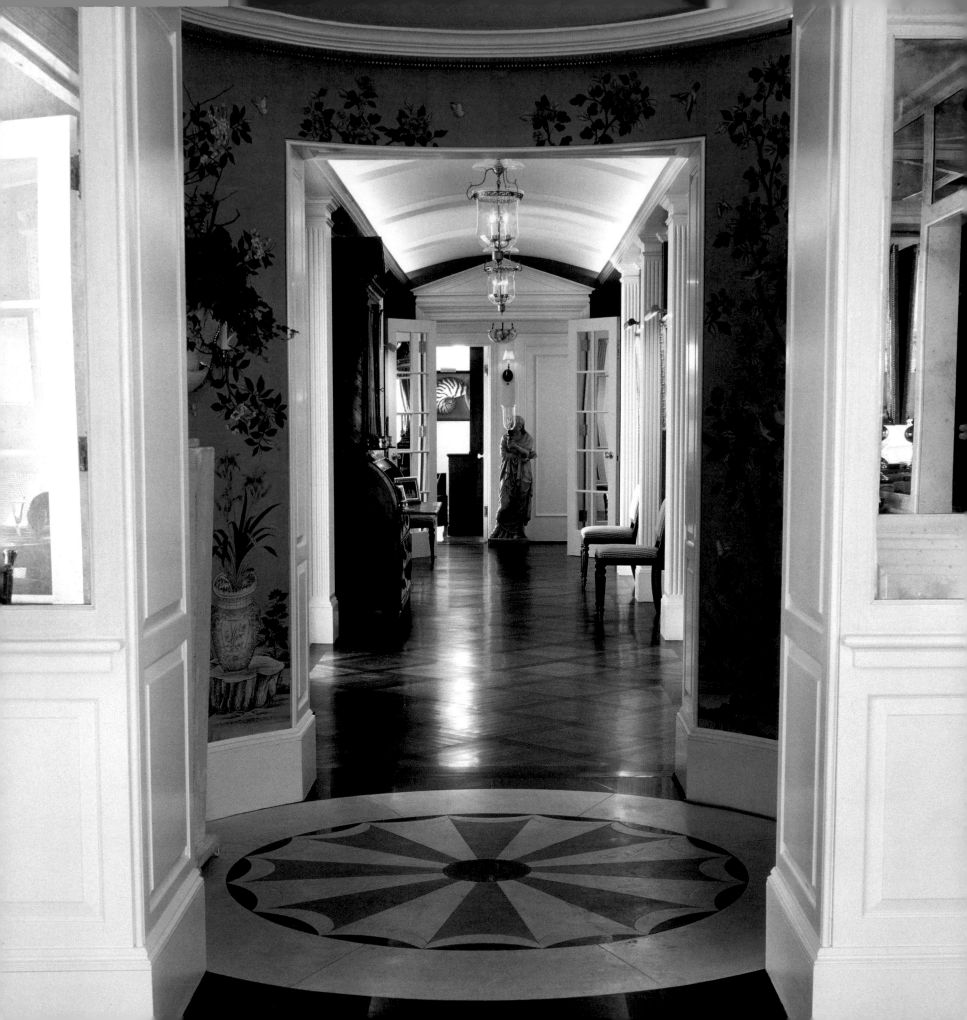

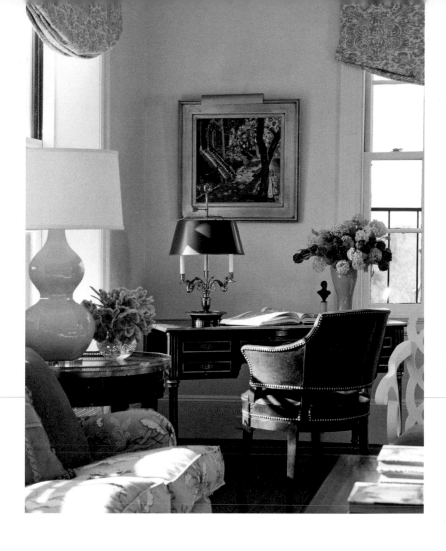

MICHAEL CARTER

CARTER & CO.

Interior designer Michael Carter's artful eye was honed at an early age to be discriminating. As an eight-year-old he purchased his first antique at auction. The 18th-century iron and brass padlock—a two dollar find—rests under a small glass dome in his North Shore home, a reminder of the importance of special treasures and living with what you love.

While other boys played in the dirt, Michael moved every unwanted family antique into his room and used his father's tools to craft crown mouldings, built-in bookcases, and wooden valances. His parents encouraged Michael by enrolling him in art classes and taking him to museums and historic houses. His "moment of illumination," as he calls it, came at age 10 on a visit to Chinqua-Penn Plantation, in the Piedmont region of North Carolina. The private estate with its manicured gardens, European furnishings and antiquities transported him to another time and place.

A passion and respect for traditional design, antiques and architecture form the core of Carter & Co., which the designer founded in 1995. Building on his formative years steeped in the world of antiques (he worked as a director of a fine arts and antiques gallery and owned his own store on Beacon Hill), Michael continuously strives as a

designer to find unusual and distinctive furnishings that complement the sophisticated feel of his interiors. Distinguishing elements—whether they be rock crystal lamps, antique sideboards in mint condition, or stunning chandeliers—are one degree more interesting, one grade more sculptural, and the patina just that more lustrous than anything a client has seen before.

"Great rooms are a product of great bones," says Michael. One of Carter & Co.'s strengths is working to enhance the architecture of a room or—when they are lacking—adding classic architectural elements that give the space the timeless feel of having always been there.

Michael's reverence for architecture and gracious living stems from his Southern roots. Raised in North Carolina, he graduated from Wake Forest with degrees in history

ABOVE
A sophisticated balance of antique and modern elements is enhanced by a lively color palette in a Boston living room corner.
Photograph by Sam Gray

FACING PAGE
Classical architectural elements form the core of this Back Bay penthouse. The entry rotunda features Gracie wallpaper and a custom-designed stone floor.
Photograph by Sam Gray

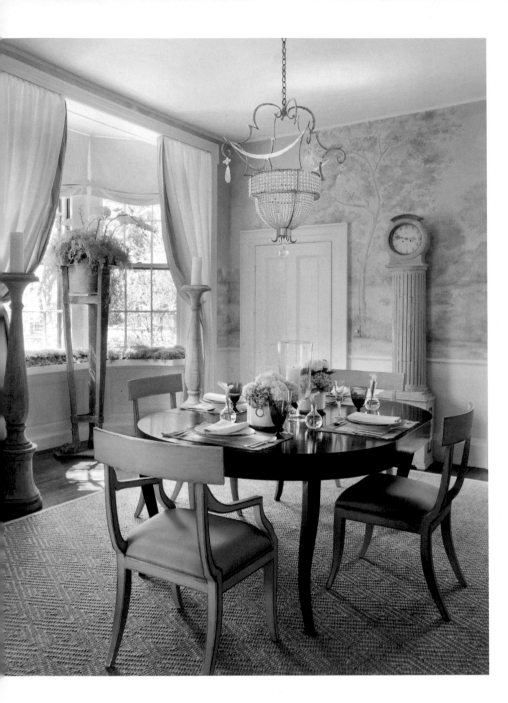

and theater arts. Shortly after graduating from college while on a visit to Boston he was completely taken with the city, its old neighborhoods and homes, and people's respect for tradition. It was then he decided to relocate to New England.

The firm's best work—often historical Beacon Hill, Chestnut Hill, and older homes that need an updated look—stems from its close relationship with the client. Some clients want a fresh, young approach to classic interior design. Others want a more serious look. Regardless, the outcome always showcases the client's own sense of style and aesthetic. The look is both confident and unique to each home.

Michael's rooms mix antiques and modern elements with ease and timeless effect. Sculptural objects, tone-on-tone colors, either bold or muted, and a piece or two that delights, are all

Carter & Co. hallmarks. Exotic touches such as binding an ordinary sisal carpet in navy blue ostrich leather or flanking a tailored sofa with three-foot-high coral red lamps are to be expected.

When the opportunity arises to break away from juggling projects as varied as author Robin Cook's New York apartment to a 4,000-square-foot Back Bay penthouse, Michael travels to places that have historically attracted painters, designers, and musicians. When he can't recharge in Paris, Italy, or New York, he turns to the library of work he's collected on Mark Hampton, Billy Baldwin, and Sister Parish for inspiration. Their timeless appeal fits hand-in-glove with his entire design approach.

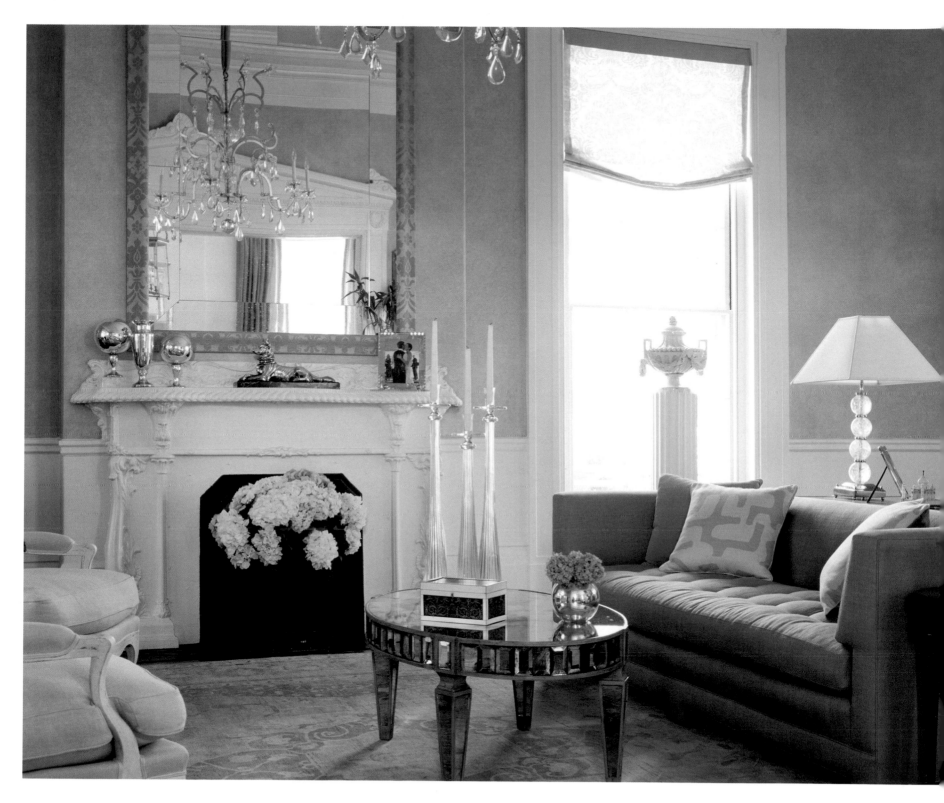

While Carter & Co.'s work has always been the result of word-of-mouth referrals from private clients, the young designer hasn't gone unnoticed by the public. National and regional magazines such as *Traditional Home, Architectural Digest, New England Home, Better Homes and Gardens' Beautiful Bedrooms*, as well as Brunschwig & Fils' design book *Up Close* have all discovered his talents. Michael has also appeared on PBS's "FIND!" and the Discovery Channel's "Trading Spaces."

ABOVE
Michael uses stylish vertical furnishings and decorative objects to highlight the 12-foot ceilings of this historic living room.
Photograph by Sam Gray

FACING PAGE LEFT
Michael asked Boston muralist Susan Harter to create the perfect ethereal landscape as a backdrop to this serene Cambridge dining room.
Photograph by Eric Roth

FACING PAGE RIGHT
Using classical elements in distinctive ways is often a design signature of Carter & Co., as seen in this example of "Winged Victory" overlooking a waterfront living room.
Photograph by Sam Gray

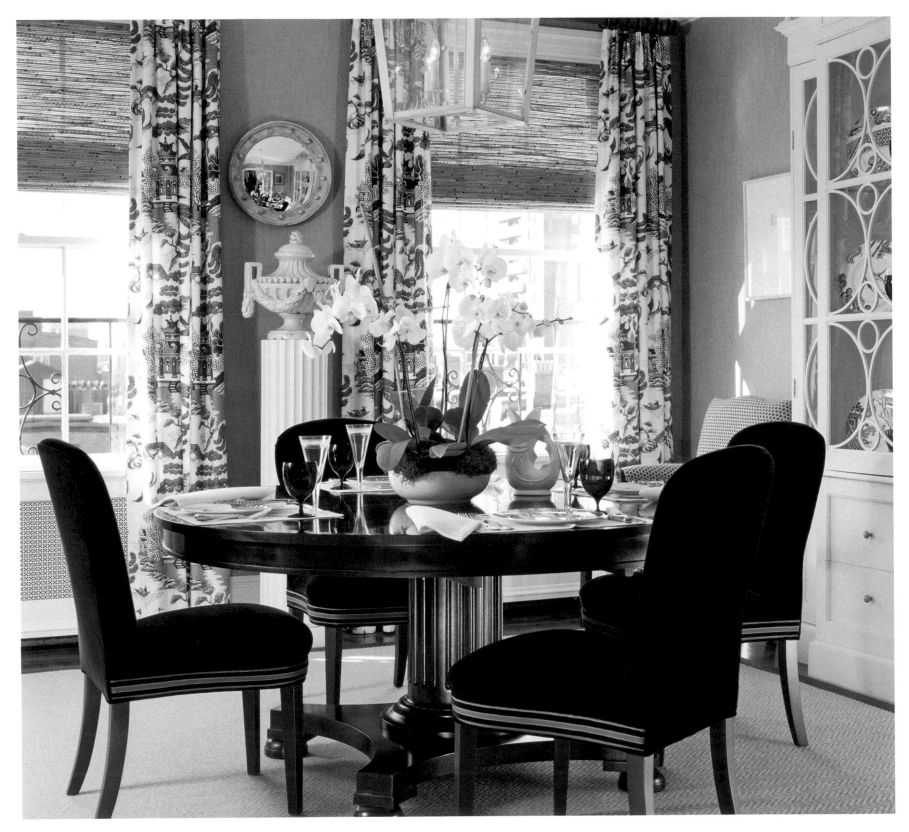

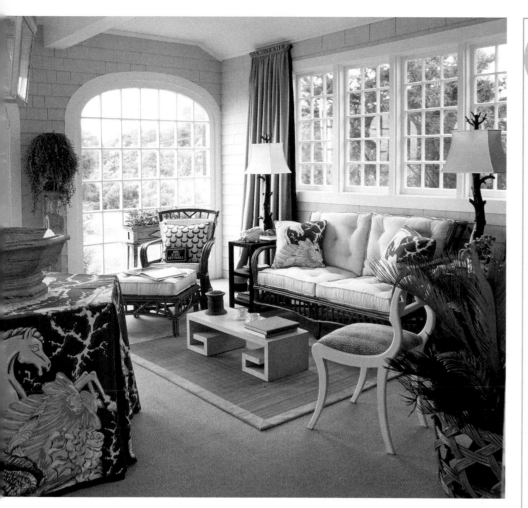

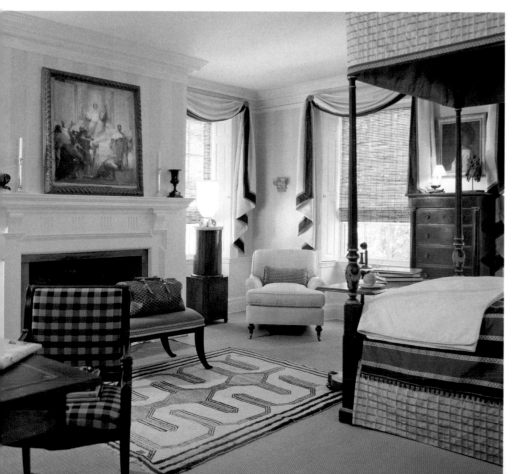

Q & A

MORE ABOUT MICHAEL ...

WHAT IS THE BEST PART OF BEING A DESIGNER?

The best part of being an interior designer is living a life immersed in and focused on bringing beauty to people's lives.

WHAT ONE ELEMENT OF STYLE OR PHILOSOPHY HAVE YOU STUCK WITH FOR YEARS THAT STILL WORKS FOR YOU TODAY?

Quality is remembered long after price is forgotten.

WHAT IS A SINGLE THING YOU WOULD DO TO BRING A DULL HOUSE TO LIFE?

Paint—which is also the least expensive option.

WHAT DO YOU SPEND THE MOST MONEY ON?

For me personally, books; I treasure my design books. For my clients, great objects—antiques, paintings and the perfect chandelier!

WHAT IS THE HIGHEST COMPLIMENT YOU'VE RECEIVED PROFESSIONALLY?

Years ago when I was first starting out as a designer, a well-regarded "society" decorator walked into my antique shop on Beacon Hill, took one look around and told me that if she were to secretly hire anyone to decorate her own home, she would choose me.

CARTER & CO.
Michael Carter
125 Kingston Street
Suite 601
Boston, MA 02111
617.227.5343

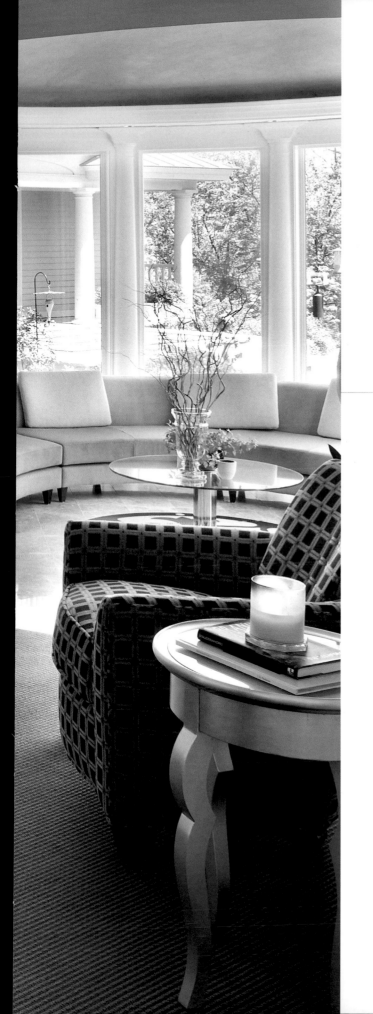

MICHAEL CEBULA

CEBULA DESIGN, INC.
FINE INTERIORS

Michael Cebula always wanted to be an interior designer. Even as a child, he loved fabric, furniture and art. However, he did not initially pursue a career in design. Indeed, after studying art in college, he spent the first years of his professional life as an illustrator for an advertising agency. It did not take him long to decide that graphic design was not the field for him. He felt that his creativity was stunted, and he longed for the freedom to express it. Following his early instinct, he returned to school to study interior design. In 1985, Michael made the decision to open his own business, which would later become Cebula Design, Inc.

Michael's background as an illustrator gave him a solid foundation for his work with interior spaces. His artistic endeavors strengthened his understanding of color theory, line and proportion, all of which figure prominently in residential design. From the onset of his design career, Michael has worked closely with architects and builders. This exposure to the entire process aided him in his work of creating beautiful designs that perfectly complement specific rooms. With his team of five talented professionals, Michael has the manpower to manage multiple projects while maintaining excellent service and attention to detail.

LEFT
The sleek, contemporary, monochromatic scheme with black accents is perfect for entertaining.
Photograph by Michael Rixon

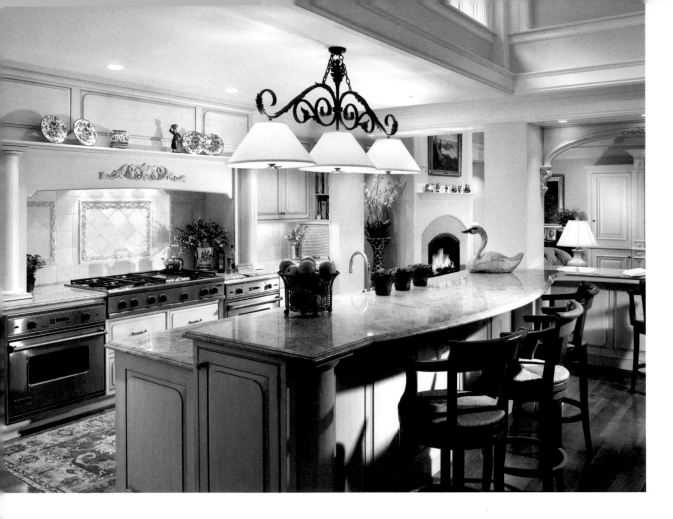

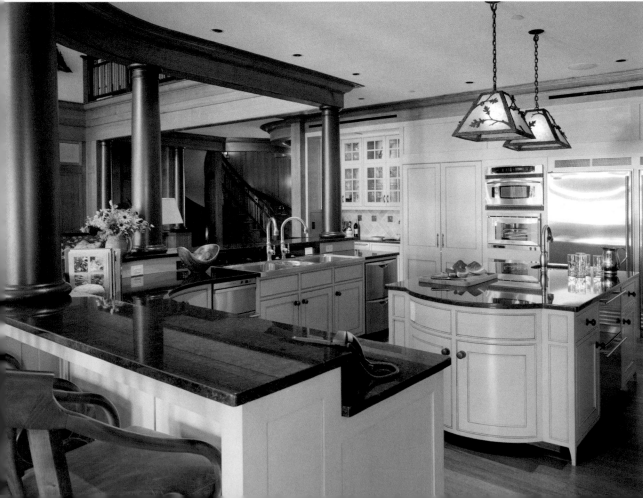

Michael states that his personal style is Traditional to Transitional with an emphasis on color. He explains that color is the least expensive and easiest way to transform a space. With New England's long, cold winters, warm and cheerful colors enliven a home, making it an escape from the grayness outside. Michael's design preferences are secondary to his clients', however. He insists that his job is to express a homeowner's personality and bring it together with his own style to create a unique, custom interior.

One such example is a condominium he designed for a young client in New York City's SoHo district. In the heart of the city's artistic hub, this urban dwelling has a spare, clean feeling. As the client wished to celebrate her Indian heritage, she wanted her home to embody the colors she came to love as a child. Michael thus infused her home with rich colors and textures, invoking Indian saris with window dressings made of imported silk.

While this client knew what she wanted, Michael is quick to point out that there are times when a client will not. In these instances he employs

TOP LEFT
The Country French kitchen boasts pull-out seasoning racks concealed within columns on either side of the cooktop.
Photograph by Michael Rixon

BOTTOM LEFT
The blending of wood and a green glazed paint finish creates a foil for the oak and mahogany throughout the open space and brings color from the outside indoors.
Photograph by Sam Gray

FACING PAGE TOP
This room used to be an indoor swimming pool and was converted to this stately and elegant living space.
Photograph by Michael Rixon

FACING PAGE BOTTOM
Warm wood and warm reds and tans create an inviting library/billiard room.
Photograph by Michael Rixon

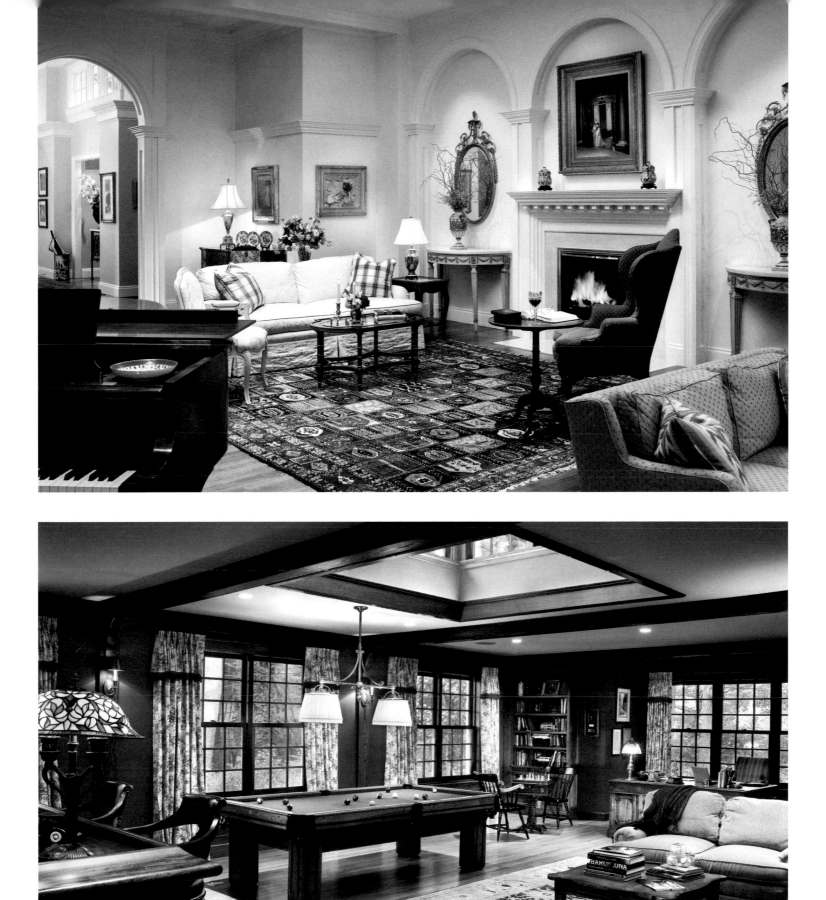

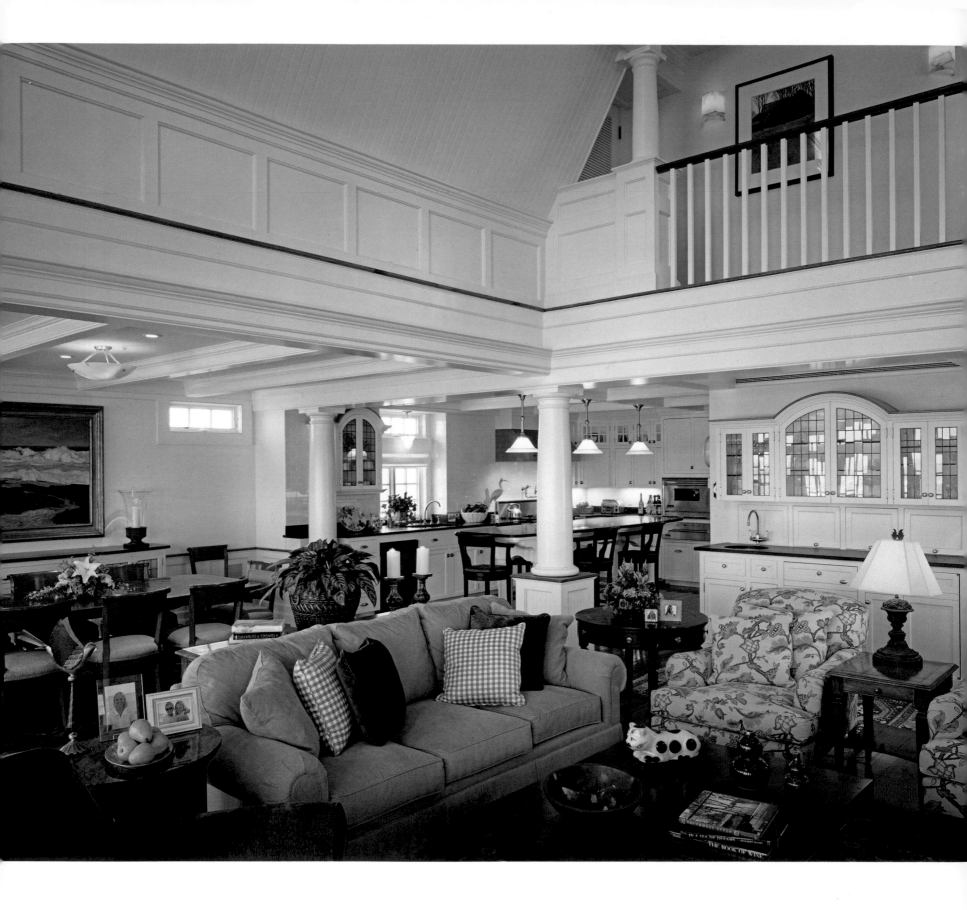

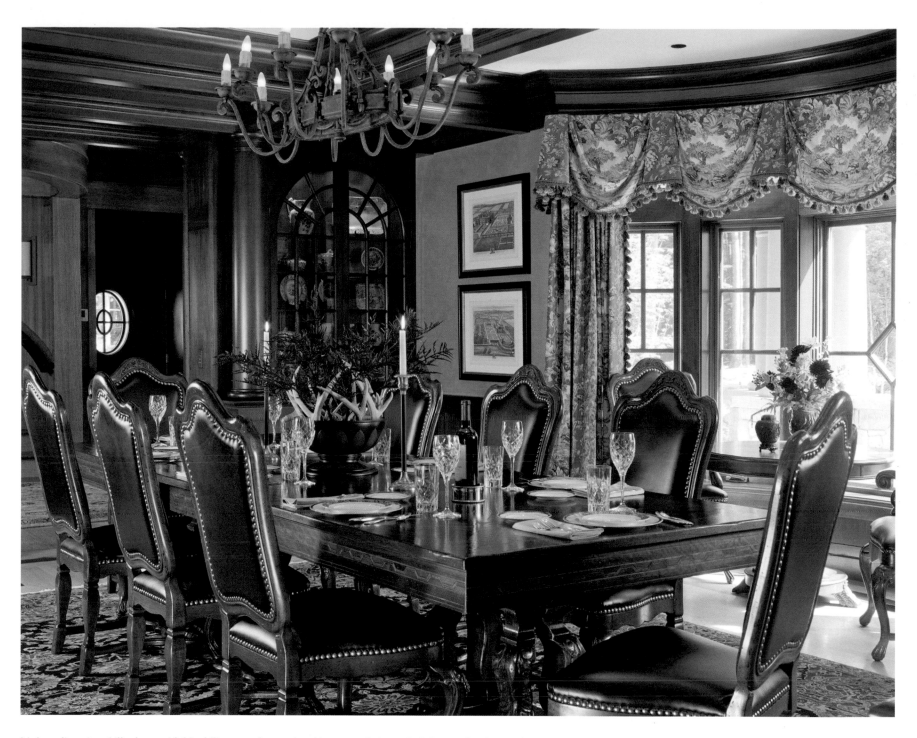

his keen listening skills along with his ability to understand and interpret their needs. It is at this point that his background in visual presentation becomes so helpful. He provides scale drawings, renderings and examples of proposed fabrics and furnishings to aid clients' understanding.

In addition to the team's residential work, Cebula Design also serves the commercial sector. In a period of only five years, Michael worked on seven different banks, one of which presented him with the challenge to create a friendly, less-institutional atmosphere. To accomplish this goal, Michael employed the use of warm yellows, soft blues, casual fabrics and nontraditional furniture. For example, he chose a reproduction trestle table

for the conference room. Because of Michael's design, bank employees and clients now feel more comfortable and relaxed.

Michael and his team adhere to the philosophy that innovation is essential to successful design. They conceive of new ideas for incorporating items that do not necessarily fit

ABOVE
Venetian plastered walls together with a beautiful linen fabric combining cabbage roses and deer grazing and wonderful mahogany woodwork creates a setting for a country house dining room.
Photograph by Sam Gray

FACING PAGE
Beautifully detailed woodwork in this open space makes this room a friendly place to be. The feel was to be light, bright and airy and very user friendly.
Photograph by Sandy Agrafiotis

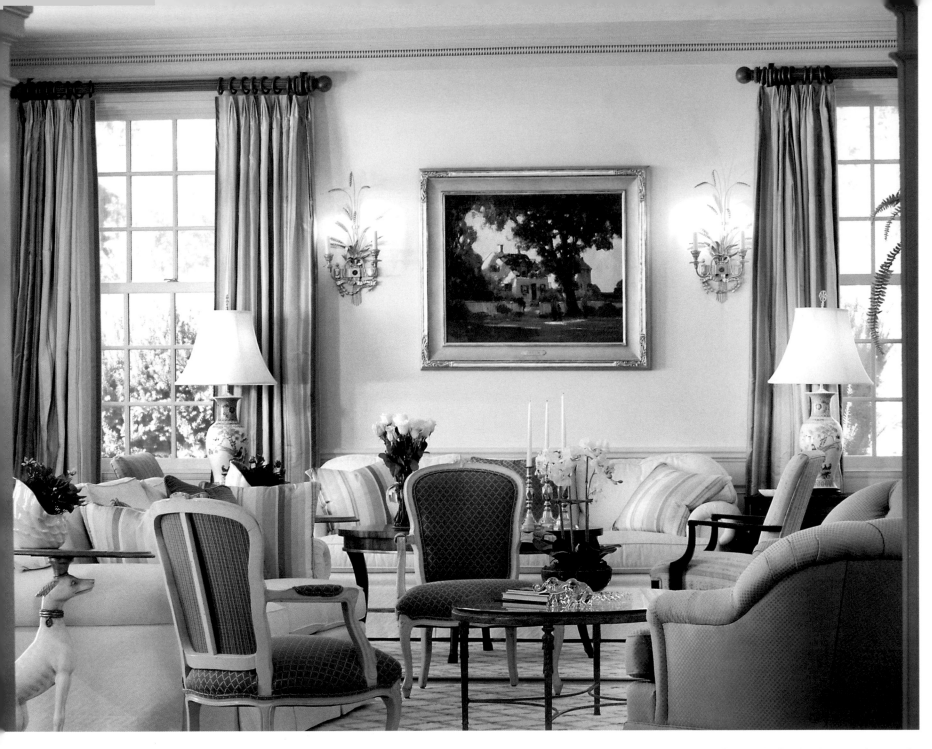

the style of a room, but figure prominently in the lifestyle of a client. One such item is the television. With its wide variety of sizes and formats, the television is as essential to a home as a refrigerator. Yet often the bulk, color or simply the electronic nature of a television competes with a room's feel.

Michael and his team have practical and beautiful solutions for this problem. For many bedrooms, Michael has designed cabinets that hide a television from sight until needed. When a client wants to watch a program, the cabinet's internal elevation mechanism will raise the television into viewing position. Other methods Michael has used to incorporate the television into a room's décor include placing it behind a movable panel

on a wall or covering it with a mirror or piece of artwork when not in use. Whatever the method, Michael makes it work—beautifully. It is one of the many reasons clients come back to him time and again.

ABOVE
A restoration of this house built in the early part of the 20th century—all of the original detail and lighting was restored and was brought up to date with color and comfort in mind. The architect, John Russell Pope, was one of the foremost in the country.
Photograph by Joseph St. Pierre

FACING PAGE
First period Colonial house with all of its beautiful detail intact was lovingly restored for the clients with color and detail. This 17th-century house was decorated in 18th-century style with fine furniture and antiques.
Photograph by Douglas Garrabrants

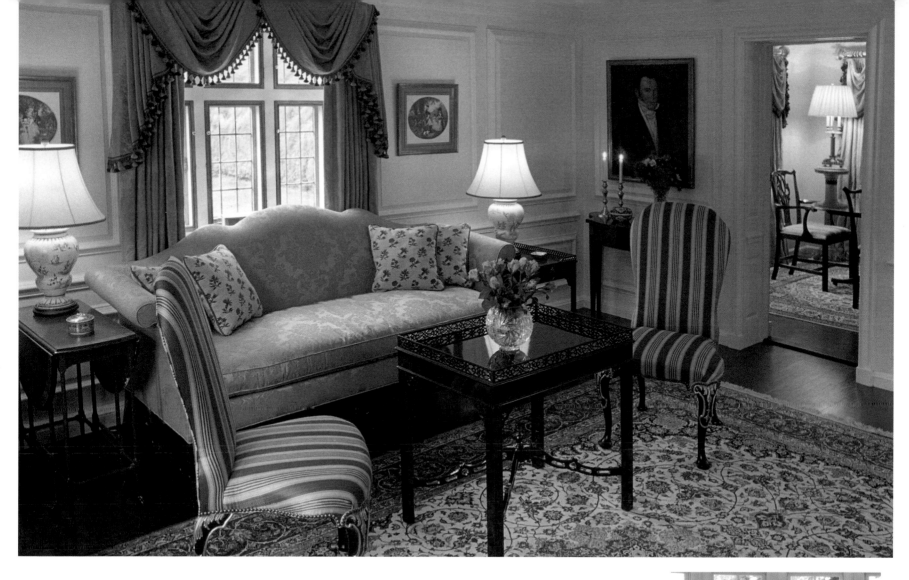

Q&A

MORE ABOUT MICHAEL ...

I LIVE IN THIS LOCALE BECAUSE ...

I have a passion for history and architecture. Newburyport and the New England coast have much to offer in those respects.

WHAT IS THE BEST PART OF BEING AN INTERIOR DESIGNER?

The fact that my job constantly changes is what I like about being an interior designer. Each day—and each client—is totally different from the next.

WHAT IS THE HIGHEST COMPLIMENT YOU'VE RECEIVED PROFESSIONALLY?

Having clients call me back years later to work with them on new projects.

NAME ONE THING MOST PEOPLE DON'T KNOW ABOUT YOU.

I love R&B music.

WHO HAS HAD THE BIGGEST INFLUENCE ON YOUR CAREER?

It is difficult to pick just one person, but if I had to choose, it would be Billy Baldwin. His designs have staying power. I love everything he did.

CEBULA DESIGN, INC.
FINE INTERIORS
Michael Cebula, Designer
Jeffrey Adams, General Manager
18 Liberty Street
Newburyport, MA 01950
978.462.6984
Fax 978.462.6999
www.cebuladesign.com

NANCIE DANGEL

ND DESIGN, INC.

"The best part of being an interior designer is the challenge and satisfaction of putting something together the clients never dreamed of but, somehow, is exactly what they want," remarks Nancie Dangel, principal of Cambridge-based ND Design, Inc. Having earned a Bachelor of Fine Art from Cornell University's esteemed School of Architecture, Art & Planning, she rounded out her studies at the Boston Architectural Center. The resulting practice is a wonderful fusion of technical, architectural and artistic skills.

Nancie knows that the process of realizing successful ideas does not happen automatically. Rather, it requires mutual respect, communication and understanding among all the parties involved. It must be a collaborative effort. She begins by visiting the client's home to discuss their needs, taste and space. A trip to the Boston Design Center is a comfortable way for the clients to further express their likes and dislikes,

what motivates them and how they want to live. Nancie is highly skilled at drawing out her clients' priorities and choreographing them into a composition expressive of their taste and lifestyle. When clients work with Nancie, they will not end up with "her" home; it will be entirely theirs.

According to Nancie, good design is not about assembling a selection of individual beautiful objects. "Anyone can pick out a pretty lamp or sofa. Great interior design is

ABOVE
The stair design connects the more traditional first floor with the more contemporary second level. Convex mirrors set in mahogany articulate the newel posts and frieze.
Photograph by Greg Premru Photography, Inc.

FACING PAGE
The marriage of design, art and color: A silverprint—*Picasso, Cannes* by Andre Villiers—hangs above a curved cabinet of Tamo ash and walnut.
Photograph by Greg Premru Photography, Inc.

the result of carefully constructed relationships among many complex elements. For example, you might admire a paint color in someone's home, but it will never look the same in a different space. It is not about the isolated paint color; rather, it is about how it relates to the light and everything around it. When these relationships are successful, everyone can recognize it, regardless of personal taste."

Nancie integrates layered color, multiple lighting sources, art, rich fabrics and furnishings, scale, space planning and architecture to achieve harmonious balance. She creates functional, aesthetically pleasing environments with a distinctive, seamless rhythm that guides residents and their guests through the home. "If you want people to move through the foyer, bypass the kitchen and enter the living room, good design will take them there," relates Nancie. And to execute her vision, she has cultivated relationships with the area's most talented building and mechanical contractors, electricians, master carpenters, painters, lighting experts, media specialists and furniture

craftsmen, among others. She also prides herself on knowing the best showrooms and resources that offer unique products and finish materials. Because there is a strong bond of trust and respect developed over time between these parties and because the designer has such a keen understanding of the structural and mechanical systems required for her detail-driven designs, plans are carried out with utmost integrity to the very end.

ABOVE LEFT
The carefully designed floor—made of Brazilian cherry, Brazilian walnut and cranberry granite inlay—the coffered ceiling and hidden and decorative lighting result in a beautifully harmonious foyer.
Photograph by Greg Premru Photography, Inc.

ABOVE RIGHT
The library: Beautifully proportioned columns and a hand-crafted oculus provide a perfect setting for books, artifacts and a 19th-century bronze statue of "Narcissus."
Photograph by Greg Premru Photography, Inc.

FACING PAGE
Custom bookcases of purple heart with Brazilian cherry accents bring drama to the display of 16th- to 18th-century Chinese porcelains.
Photograph by Greg Premru Photography, Inc.

Q&A

MORE ABOUT NANCIE ...

WHAT SEPARATES YOU FROM OTHER INTERIOR DESIGNERS?

My understanding of construction and mechanical systems and my ability to design architectural details. What I do is completely surprising yet familiar at the same time. For example, I give energy to classic elements through selecting and applying original finish materials. I've specified copper roof flashing for a kitchen backsplash, inset automotive convex mirrors in a classic mahogany frieze, and inset glass tile into a copper channel as a baseboard cap.

HOW WOULD FRIENDS DESCRIBE YOU?

They'd say that I have a great sense of humor. My "conservative" friends think I am "arty" and my "arty" friends think I am "conservative." Go figure.

DO YOU HAVE ANY FAMILY MEMBERS IN THE INDUSTRY?

My family owned Rapids Furniture Company, the best trade-only showroom in the Boston area, until the mid-1980s. That is where my love for fine furniture and design started. My grandfather, A.B. Fox, provided space for young furniture designers to present their collections. Examples include Paul McCobb and Paul Evans, who are very collectible.

WHAT IS YOUR BACKGROUND IN ART?

I studied sculpture at Cornell and have applied this perspective to my work. My own personal indulgence is my art collection. I have a great appreciation for art as well as an innate knowledge of the impact it will have on a room or a home. I tend to work with people who understand the power of art. They either own it or I work with them to acquire it.

ND DESIGN, INC.
Nancie Dangel
4-B Sargent Street
Cambridge, MA 02140
617.868.6223
www.nddesigninc.com

SUSAN DEARBORN

SUSAN DEARBORN INTERIORS

In Susan Dearborn's world there are as many different design styles as there are clients. Whether she's creating cutting-edge interiors in a Boston condominium or adding the warm elegance of classic architectural detail to a renovated Cambridge home, each project is highly individualized and is tailored to the client's lifestyle and design preferences.

Now in her 28th year of business, Susan says the key to her success and the tremendous amount of repeat clients she receives is the way she and her staff offer service and support during all phases of the design project … whether building, renovating or redecorating.

Susan's design philosophy of master planning, design education and project management ensures that each project's financial and time projections are met and the stress of the project is minimized for her client. Her goal is to ensure that her clients make educated choices which reflect their personal taste and allow them to enjoy the process of design.

Susan's enthusiasm for her work and the energy she brings to projects are matched only by her talent for creating stylishly elegant and livable interiors. Boston born and raised, Susan has lived abroad, travels and reads extensively to further her design knowledge. Susan's work has appeared in numerous publications, including *New England Home, Cape Cod Life, Florida Design* and *Palm Beach Illustrated.*

ABOVE
The living room of this waterfront high-rise is an interplay of texture with the owner artist's paintings and sculptures adding warmth and drama.
Photograph by Sam Gray Photography

FACING PAGE
The ceiling was recessed and radius windows and English cupboard closets were added during a major renovation to this Tudor home; Traditional becomes Transitional.
Photograph by Sam Gray Photography

SUSAN DEARBORN INTERIORS
Susan Dearborn, Allied Member ASID
47 River Street, Suite 210
Wellesley Hills, MA 02481
781.235.2920
www.dearborndesign.com

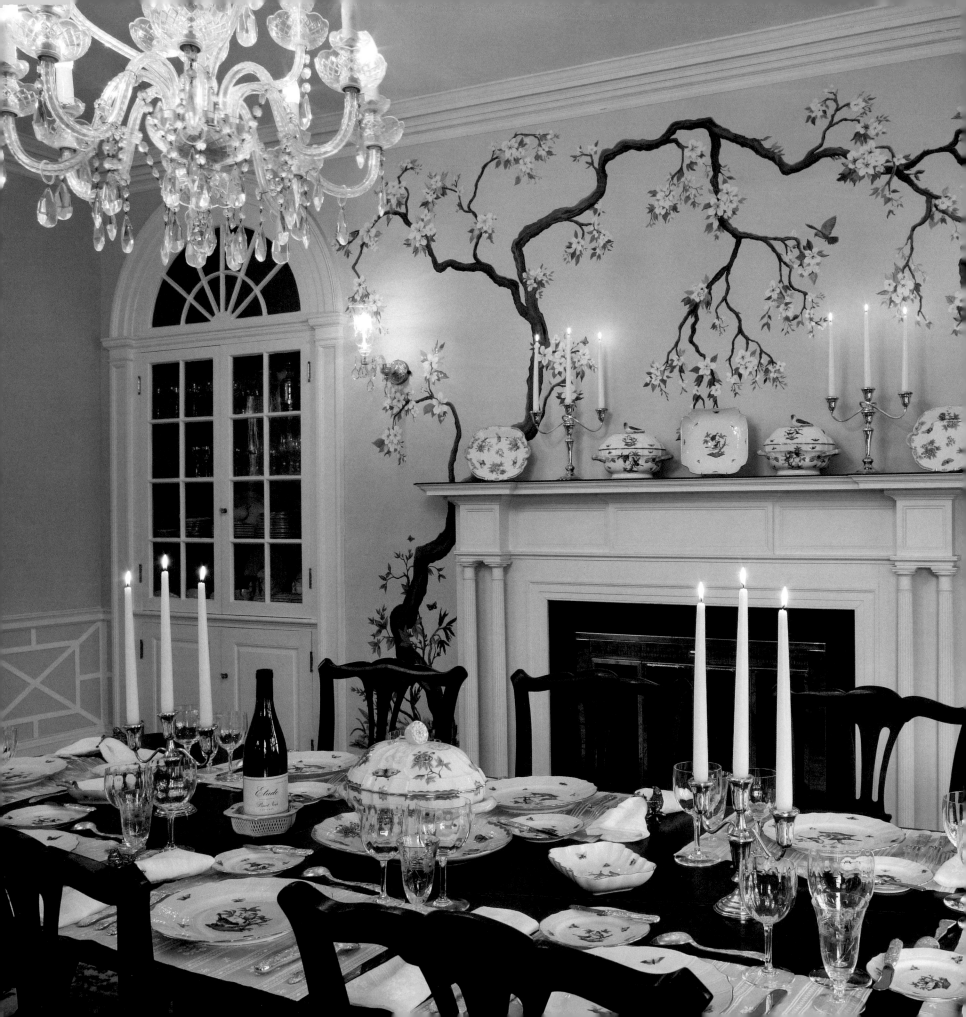

KATE DICKERSON

KATE DICKERSON DESIGN, INC.

Before the furniture, carpet or accessories are chosen for a room, before any color goes on the walls, interior designer Kate Dickerson gathers inspiration from fabrics which will set the mood for a room and for how a family will live, dine, play and love in that room.

The pattern in a print or weave, the dash of a colorful wool plaid, the rich texture of cashmere or mohair, the luscious sheen of silk—all set the designer's creative ideas in motion. Beach houses, suburban homes, urban *pieds á terre* or even her own 1709 home south of Boston have all been enhanced by Kate's savvy with fabrics and wallpapers. Adept at complex orchestration, Kate fearlessly layers patterns for a blend that is stylish, cohesive and unique to each project.

Fabrics make a room. They have been Kate's starting point since she played around with decorating as a child. Growing up in Minneapolis, Kate learned to paint at a young age. Her first interior design epiphany came in junior high school when her mother decorated their new house with lime greens and cobalt blues—a mixture of patterns and colors, which are back in vogue today. Years later, she decided to utilize her artistic and interior design skills in creating homes for clients. She founded Kate Dickerson Design, Inc., nearly a decade ago.

LEFT
This circa 1900 dining room mural was revamped by Kate, who also painted the chinoiserie fencing around the room. The bird and flower theme is continued on the table with Herend china.
Photograph by Nan and Monty Abbott

Living in France while studying fine art, languages, and art history provided Kate's second design epiphany, influencing her mastery of combining Old World sensibility with a dash of modern chic. The sensory sights, sounds, textures, tastes and aromas of France figure into her approach to life and her design projects; hence her company's slogan: "Classic European Styling…*with Pizzazz*." That dash of pizzazz is one of the first things you notice about the designer. Her laugh, her love of living well, and sense of humor immediately encourage a friendly rapport.

A devotee of French, Italian and English furniture styles, Kate loves European fabrics and uses them extensively. Kate shares the European talent for combining antiques with modern pieces in the same room. Living rooms and dining rooms are two of her favorite challenges, "People should really use these rooms," says Kate. "I love filling them with family pieces and art to make them more friendly."

An expert at juggling projects (chalk it up to three kids, a design business, and a retail boutique) Kate and her staff work to include people's existing pieces into their new spaces. She helps choose art (often paintings by her artist husband, Jack Dickerson) and accessories that result in an approachable, warm and lively mix. Even traditional designs in Kate's hands come across as fresh and upbeat.

LEFT
A French Country-style kitchen with trompe l'oeil painting throughout. Portuguese tiles decorate stair risers and backsplashes. Sienna marble countertops and cork flooring.
Photograph by Nan and Monty Abbott

FACING PAGE TOP
The sunroom of Kate's design associate and sister, Elizabeth Gardner. Sheer fabric from Germany is draped with a horizontal stripe for a colorful punch.
Photograph by Nan and Monty Abbott

FACING PAGE BOTTOM
French and English fabrics and furnishings complement Kate's own circa 1709 living room. She painted the faux greenery where the stockings are hung at Christmas.
Photograph by Nan and Monty Abbott

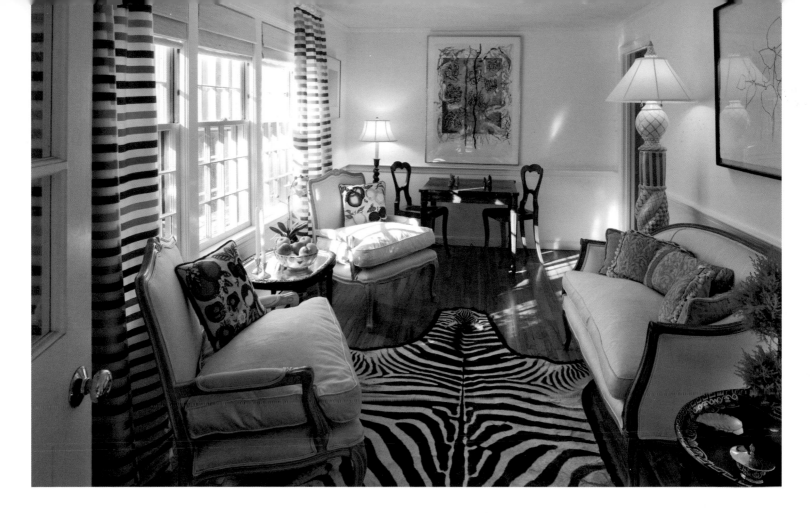

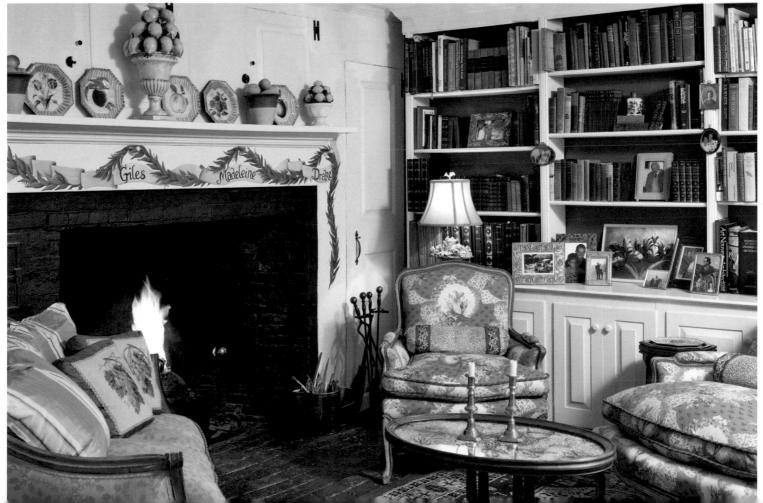

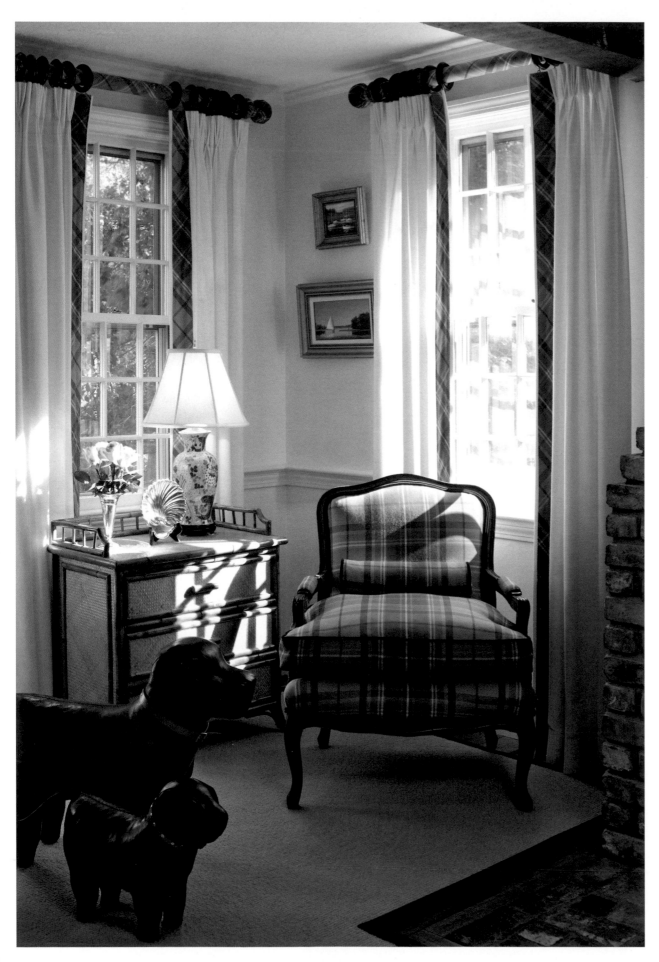

LEFT
The use of a bright and modern colored wool tartan is offset by the simple wool and sisal carpet in this living room.
Photograph by Nan and Monty Abbott

FACING PAGE
Serene hues in this living room are appropriate for its location near the seaside. Silk curtains shimmer when sunlight filters through and complements the homeowner's collection of antiques.
Photograph by Nan and Monty Abbott

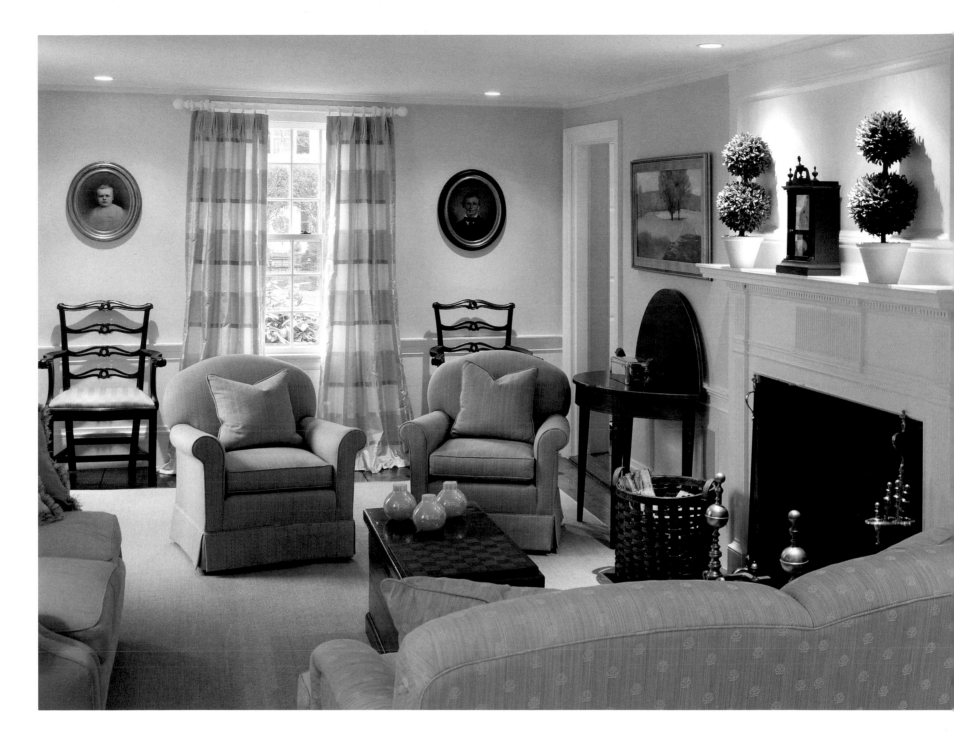

Custom-designed furniture and accent pieces; painted murals and ceilings; silk-trimmed lampshades; hand-designed monograms; custom carpets are all part of her design approach. Whether it is the mixture of toile, checks and stripes in a little girl's room or a colorful French Country kitchen where Kate has painted the cabinets with flora and fauna (Kate paints elegant murals that recall wallpapers of old and delightful *trompe l'oeil* techniques), her style always blends with homeowner desires.

She opened her Hingham Square boutique in 2005, offering an immense choice of domestic and imported wallpapers, trims, and fabrics as well as furniture, lighting, mirrors, window hardware, accessories, art, fine china, crystal, linens and other tableware.

Above all, Kate wants clients to live with and use their beautiful possessions; to take their china out of the cupboard and eat on it and to enjoy looking at their treasures instead of locking them away.

Kate's work has appeared in *Traditional Home, Better Homes and Gardens, Window & Wall Ideas, Kids' Rooms* and *Victoria*. She has also been featured on HGTV's "Kitchen Design" and NECN's "Dream Home" series.

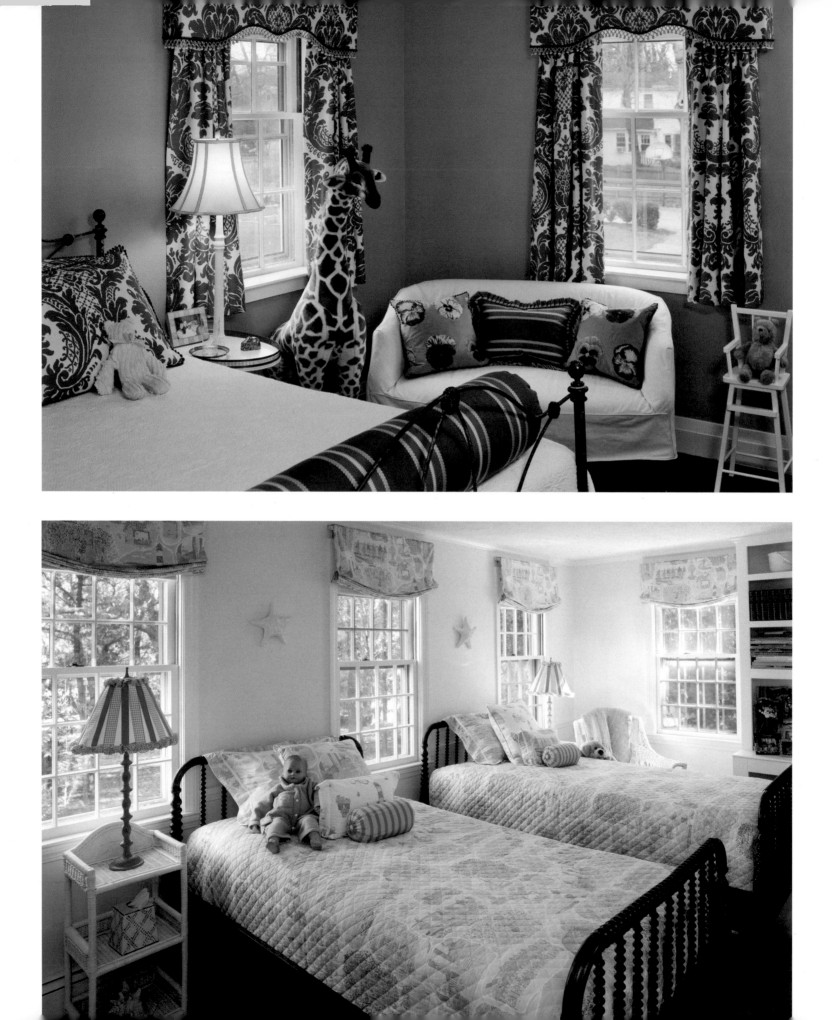

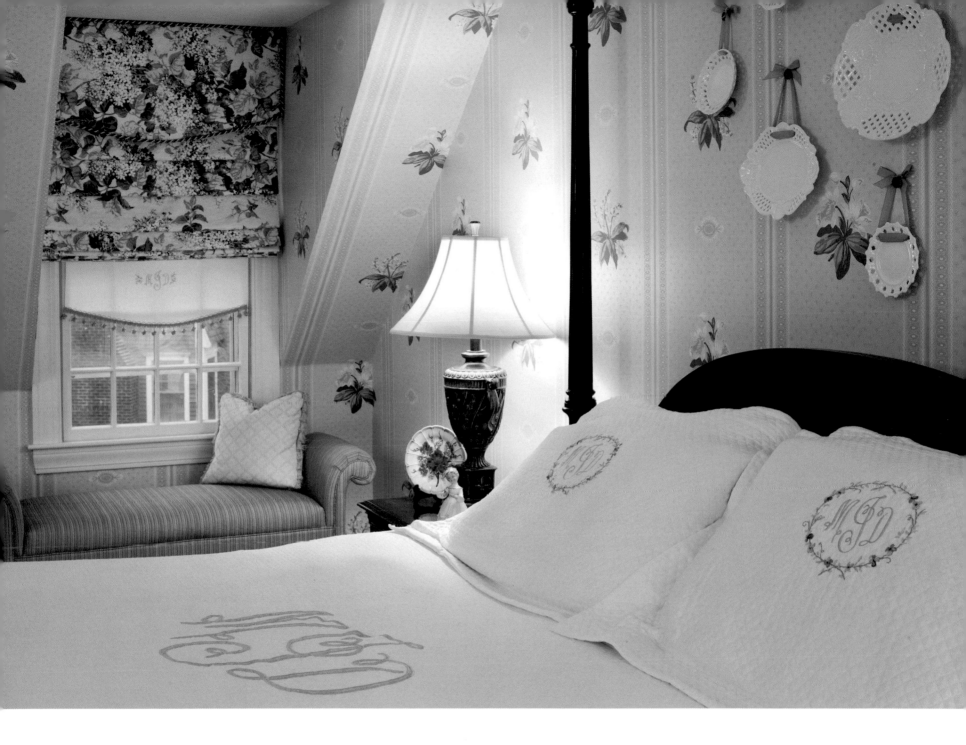

KATE DICKERSON DESIGN, INC.
Kate Dickerson, ASID Industry Partner, IFDA
132 North Street
Hingham, MA 02043
781.749.8899
boutique 781.749.8808
www.katedickerson.com

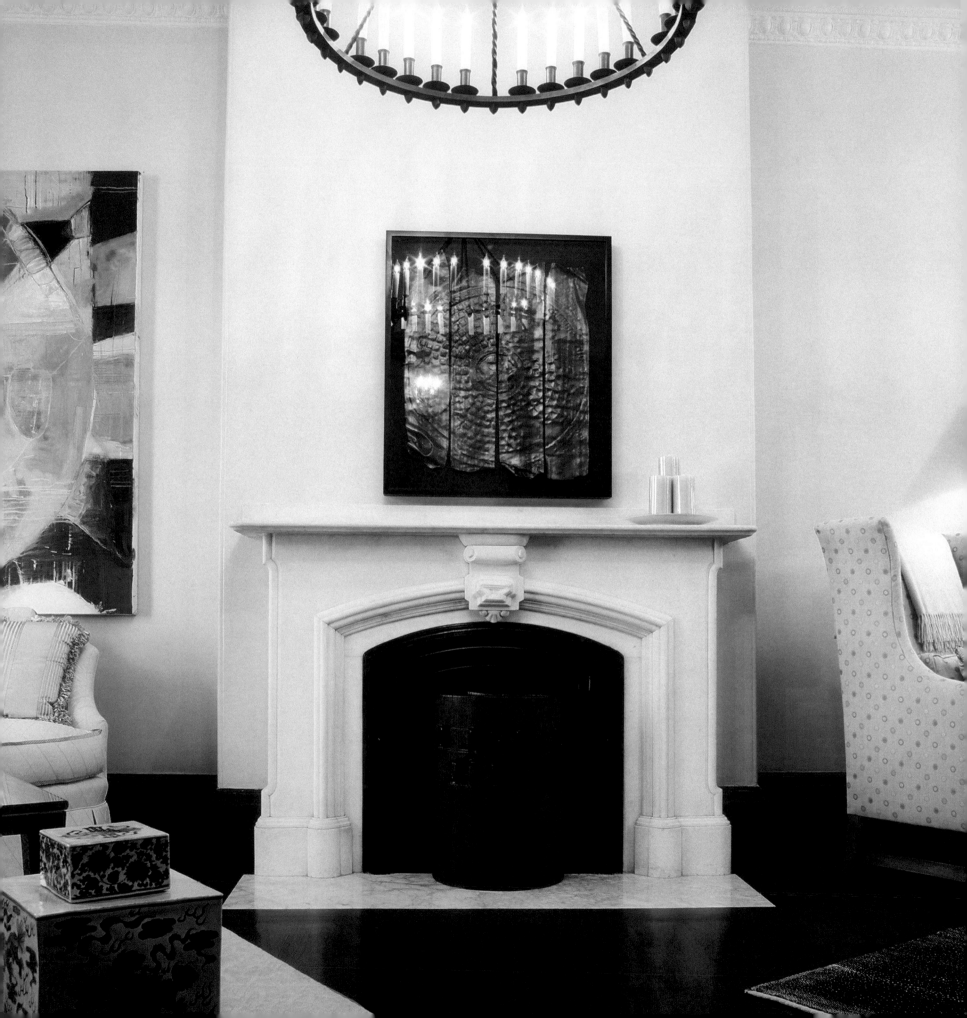

KENNETH D. DIETZ

DIETZ & ASSOCIATES, INC.

You might meet him at an Institute of Contemporary Art event or at Boston's School of the Museum of Fine Arts. Clients who gravitate toward interior designer Ken Dietz all seem to have something in common—a love or developing interest in the arts, a rug collection, an eye for photography, or an inclination for modern glass. Ken, who started his firm in 1989 and who once ran his own drapery workroom, specializes in working with clients to incorporate their personal collections of art and objects. His easy, elegant style, which has appeared in *Metropolitan Home* and numerous Boston magazines, deftly combines eras and styles by using art as a springboard as well as a backdrop for living.

Ken brings his artistic eye to projects as varied as architects' houses to restaurants and commercial spaces and has worked with clients as diverse as home improvement guru Bob Vila and the deans of Harvard's School of Architecture. A one-time gallery curator, Ken encourages his clients to develop their interiors around furnishings and artwork they love and adeptly mixes antiques with Lucite lamps or Murano glass, and Art Deco pieces with modern photography. His flair for texture and pattern brings warmth to rooms on the coldest of New England days.

Ken puts the style and comfort of the client foremost in the design while maintaining a balance within spaces that insures that art is shown to its best advantage. "When my client walks into their new space they should feel like it is the best personal expression of who they are," says the designer.

ABOVE
A long low sofa with a built-in leather covered bookcase creates the perfect setting to relax with a book.
Photograph Michael Weber

FACING PAGE
Ken Dietz was able to successfully transform the floor plan of the narrow traditional brownstone into three comfortable contemporary living spaces, centered around the classic marble fireplace.
Photograph Michael Weber

DIETZ & ASSOCIATES, INC.
Kenneth D. Dietz
27 Adelaide Street
Boston, MA 02130
617.983.2549
www.dietzandassociates.com

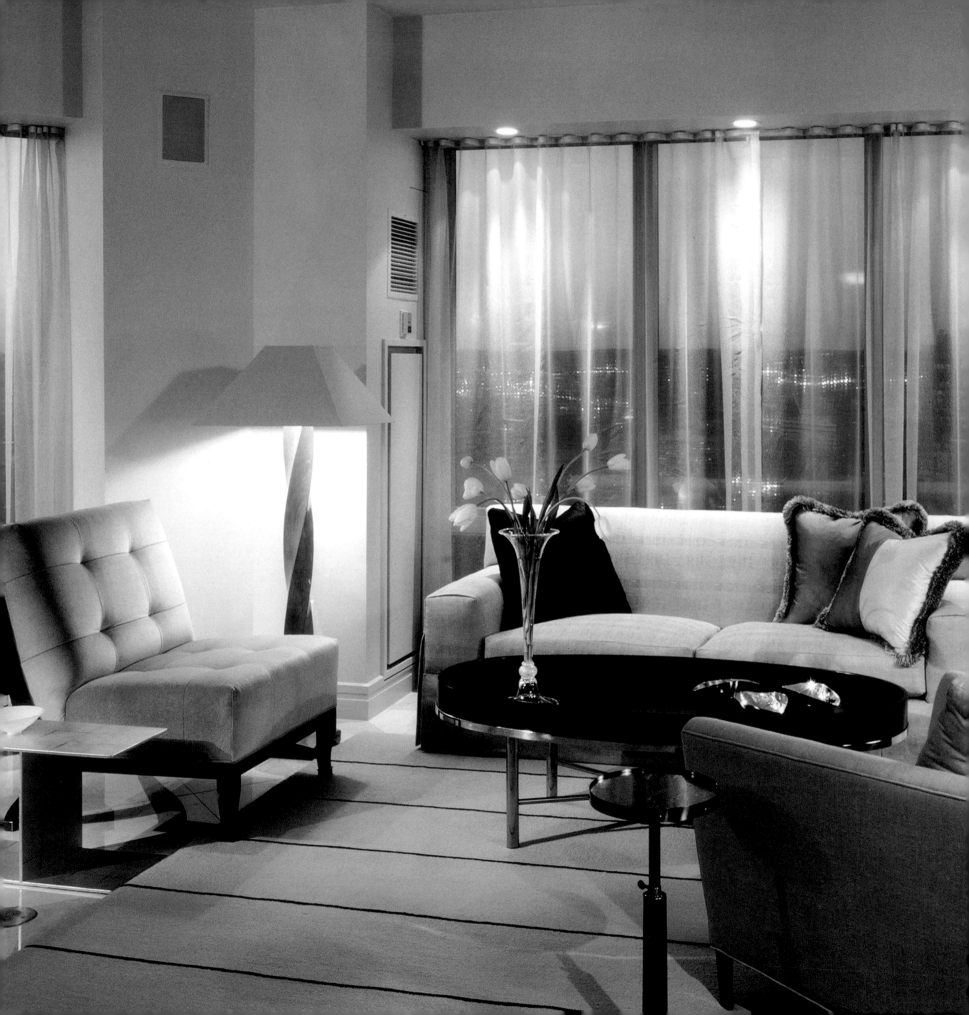

DENNIS DUFFY

DUFFY DESIGN GROUP

To view the work of Dennis Duffy is to begin to understand what defines thoughtful, intelligent design. Clean, cohesive and compelling, the spaces he designs reflect careful planning and radiate a sort of self-awareness, an assertion of each item's distinct qualities as well as the roles they play in the overall design framework.

Dennis had an unlikely beginning to his now wildly successful interior design career. A chemistry major at the University of Miami, Dennis planned to attend medical school and make his living as a doctor. Fate, however, had other plans for him. Upon graduation, he did a vacationing friend a favor by substituting for him at his job in a Miami design showroom. By the end of his short stint, Dennis had discovered his interest for interior design—as had the team at the design center. Dennis was quickly offered a full-time position, which he happily accepted. Eventually he moved to New York City, where he earned his design certificate at Parsons while working at the Decoration and Design building. His studies ultimately led him to establish Duffy Design Group in 1989.

LEFT
Perched on the penthouse level of the Ritz-Millennium Boston, this space could easily be overwhelmed by the view. The Duffy Design Group team strove to provide an area for conversation that combined sculptural interest with quiet luxury.
Photograph courtesy of Duffy Design Group

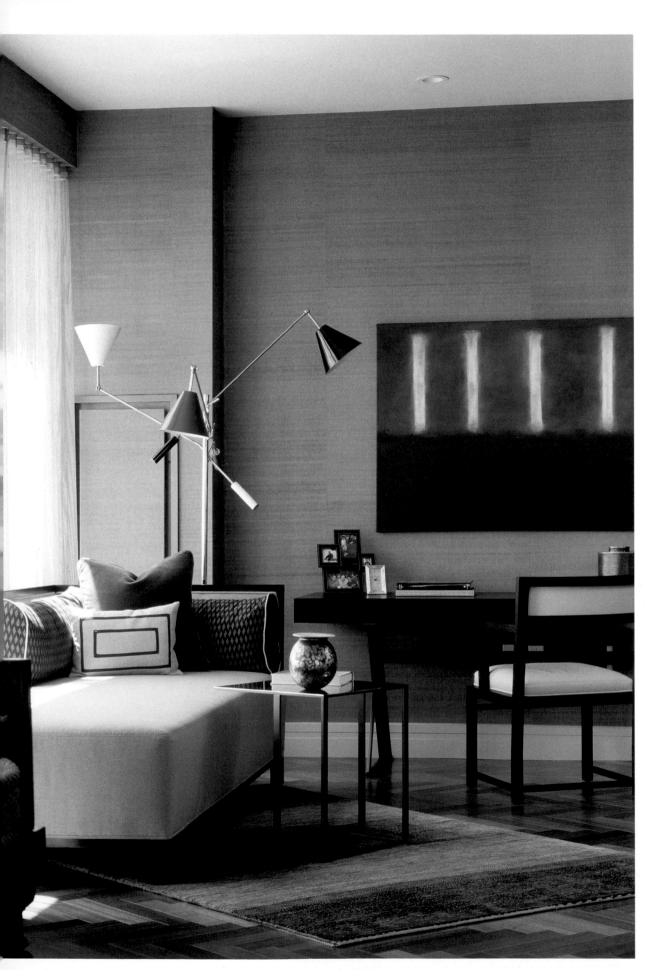

Dennis clearly made the correct career choice. The firm has since grown to house a team of three associate designers and three support staff, with Dennis serving as principal designer. He oversees all of the projects the firm undertakes in each of its three design arenas: commercial developments, hotels/restaurants and residences. Having three areas of specialization allows Dennis to maximize his creative abilities—he works to create environments that appeal to a broad range of tastes in his condominium and rental projects, celebrates fancy and fantasy in hotels and restaurants, which are, by design, entertainment venues, and realizes the functional and aesthetic goals of clients in his home designs.

In all of his work, Dennis adheres to a Modernist design philosophy, emphasizing the relationship of objects to each other and to a larger existing context. Every project is thus very different; yet each space is well balanced and has a definite sense of order— which Dennis describes as "subliminal"—without appearing rigid. He creates a mélange of warm and cool, dominant and recessive, and the confluence

LEFT
This dynamic corner serves several functions—a work area, a comfortable reading lounge and an extra guest bedroom. But the real story is the interplay of the texture, color and graphic—at once stimulating and soothing.
Photograph by Sam Gray Photography

FACING PAGE LEFT
This entry space sets the tone for the whole residence. The client wanted to evoke the spirit of a sumptuous, hip lounge while at the same time acknowledging his cultural heritage.
Photograph by Sam Gray Photography

FACING PAGE RIGHT
Both husband and wife, educated in Paris, wanted this to be a salon in the traditional sense, but still be lighthearted. The baby grand piano stands adjacent to the wall mirror—a modern sunburst of musical notes.
Photograph by Sam Gray Photography

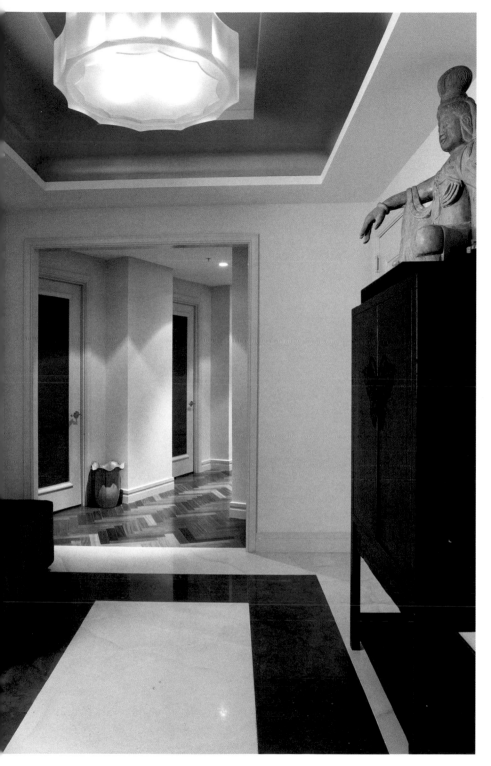

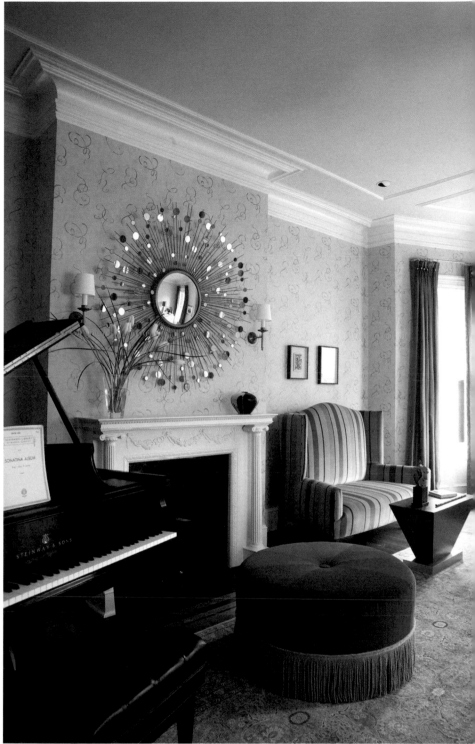

of contrasting elements results in aesthetic harmony. His discerning eye and command of color, texture, scale and proportion allow him to subtly alter a room's atmosphere in accordance with its function. From a soothing, restful ambiance to a striking, dynamic character, each space is masterfully enhanced by Dennis' designs.

In 2003, Dennis was commissioned by a showroom in the Boston Design Center to produce a small furniture collection. This idea was not knew to him—indeed, Dennis frequently creates custom pieces for his clients, stating that it is often easier to design a

desired item than it is to find it. Inspired by the Moderne movement, the pieces reflect his design philosophy, emphasizing the relationships between the different materials used in construction and achieving proportional balance. Dennis has since decided to open his own studio to make his furniture designs available to the general public. His collection will be custom-capable, and he will also represent several lines from South America and Europe. In addition, he will offer a fabric collection and unique vintage pieces.

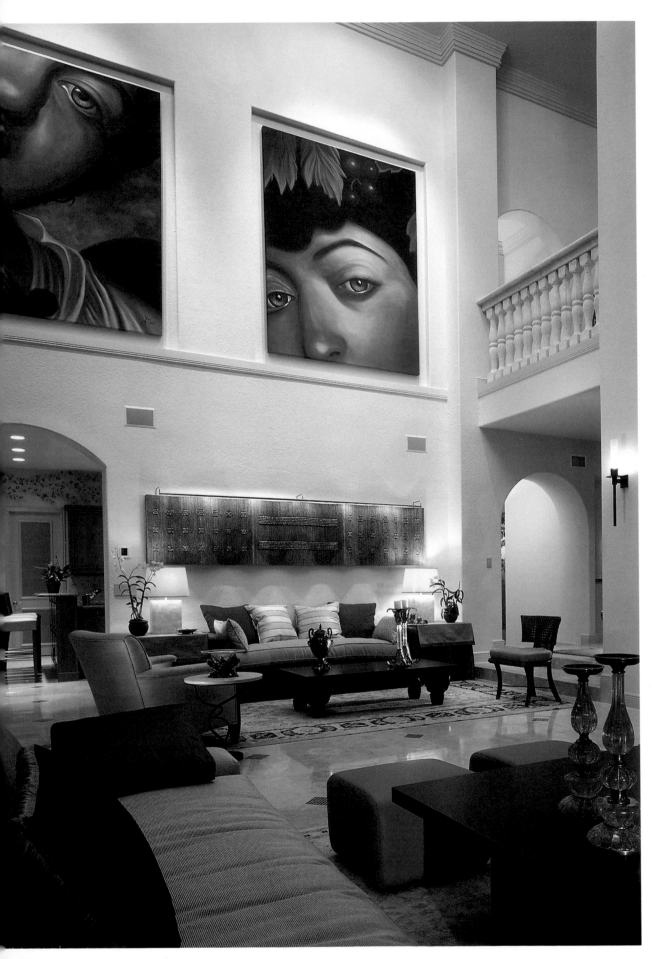

Dennis has received numerous accolades and much media exposure for his remarkable work. Winning *Boston* magazine's Best of Boston awards in 2002, 2003 and 2006, *The Improper Bostonian*'s Best of Boston award in 2002 and the 2002 VOX/*Out* Emerging Voices of Style + Design award remain among his most impressive career achievements. His designs have appeared in local and national publications, alike, such as *Boston* magazine, *Boston* magazine's *Home & Garden*, *The Boston Globe* magazine, *The Improper Bostonian*, *Traditional Home*, *Beautiful Homes* and the book *Complete Lighting Design*.

Insistent that passion for design and pursuit of knowledge are the keys to his success, Dennis strives to further evolve as a designer: "I always want to push the envelope further—that's what helps us grow."

LEFT
Two "Caravaggio" portraits each measuring 9½ square feet (commissioned from Johniene Papandrea) look down on this living space. A wood triptych by David Alcantara defines a sculptured, more human scale.
Photograph by Glenn Daidone

FACING PAGE
The strong profile of the Moderne fireplace is complemented by a pair of "romanza" wrought iron consoles. Silk banners soar to the full 26-foot ceiling height. The bronze and cast glass sculpture is by David Teeple.
Photograph by Glenn Daidone

WHAT COLOR BEST DESCRIBES YOU AND WHY?

From a professional standpoint, grey. Almost every color I work with has grey in it. But personally, I'd say green. I like having green around me.

NAME ONE THING MOST PEOPLE DON'T KNOW ABOUT YOU.

I'm a cyclist. I ride all the time in the summer, often participating in charity rides, and I spin three times a week in the winter to stay in shape.

WHO HAS HAD THE BIGGEST INFLUENCE ON YOUR CAREER?

I have several, but the most prominent is Juan Montoya. He was very much at the forefront when I was just getting my start in New York, and his work profoundly affected my sensibilities.

WHAT IS THE BEST PART OF BEING AN INTERIOR DESIGNER?

Each project is a new horizon. My job changes on a daily basis, and I'm never doing "the same old thing." Design is such a dynamic, challenging and diverse field, and I love the constant opportunities to face new challenges. I also truly enjoy getting to meet and work with new and interesting people.

WHAT IS A SINGLE THING YOU WOULD DO TO BRING A DULL HOUSE TO LIFE?

It depends on what it is that's making the house dull, but color immediately comes to mind. It's the simplest and most powerful way to enliven a space. Light of course is also critical, but color is easier—and we respond dramatically to it.

WHAT PERSONAL INDULGENCE DO YOU SPEND THE MOST MONEY ON?

Dining out. I love to cook but often don't have the time. I'm always up for a new restaurant, and I have a lot of old favorites.

DUFFY DESIGN GROUP
Dennis Duffy
530 Harrison Avenue
Second Floor
Boston, MA 02118
617.542.2074
Fax 617.542.2075
www.duffydesigngroup.com

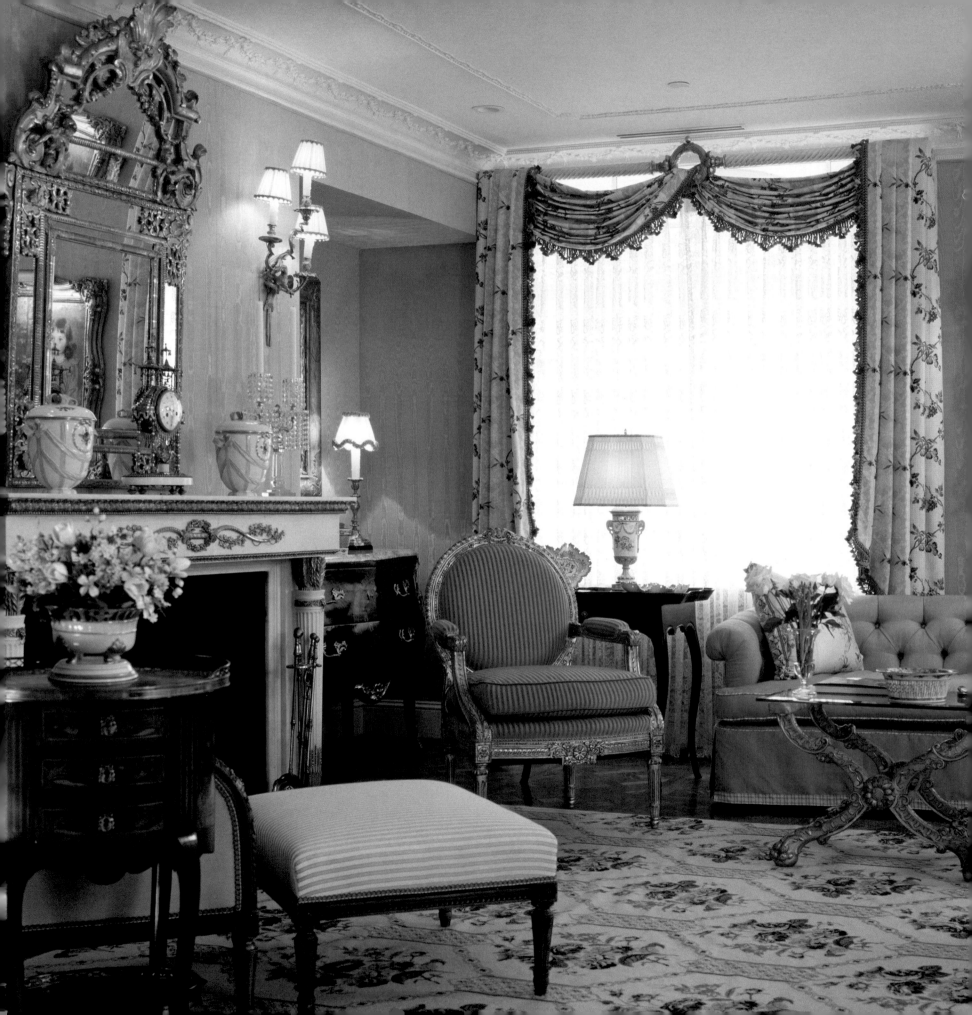

RICHARD FITZ GERALD

R. FITZ GERALD & CO.

Richard Fitz Gerald, who heads one of the most venerable interior design companies in the Boston area knows simple assignments often—like a well-tended garden—grow into years of work. For example, a project that began as a simple hallway redesign led into years of work and the decoration of all three of the clients' homes. Sometimes it just takes one room to lead to another.

Founded 45 years ago, R. Fitz Gerald & Co. considers no jobs too big or too small, from one-room redos to 1,100-square-foot apartments or 25,000-square-foot homes with guesthouses. Architectural detailing and elegant fabrics and furnishings speak to the tastes of the client and how they live, no matter the size of the house.

Exceptional design resides in all aspects of Richard's work. Pilasters, columns, paneling, and mouldings make up the all-important architectural layer of his traditional designs. Smocked lampshades, fabric with special welting and trim, and upholstery details complete the tailored look. Whether they are formal or more relaxed, depending upon the client, the results are sumptuous rooms homeowners can sink into. Antique French

furniture, upholstered walls, needlepoint rugs, domed ceilings, custom closets and the like often appeal to both formal city dwellers and casual country residents.

It is, in fact, the simplest of things that determine the success of Richard's sophisticated spaces. The thoughtfully arranged rooms focus on comfort—tables are in convenient places, good lighting highlights artwork, and homeowners have places to entertain or to relax.

Additions, new construction, and projects featuring reconstruction have one element in common—Richard's love of architectural detail and fine furnishings. From classic English Hepplewhite and Chippendale to American furniture, he nimbly combines the Traditional with modern coffee tables and lamps. His contemporary work feels just as

ABOVE
This oval-shaped music room features a reproduction of a Sebastian Erard square piano and custom-painted Gracie Chinese wall panels. Floor of Thassos, Bottecino and Black Galaxy.
Photograph by Sam Gray

FACING PAGE
This regal living room displays walls upholstered in robin's egg blue silk moiré and French print on matching moiré stripe draperies. The elegant antique marble fireplace with ormolu mounts from Fontainebleau add a lovely focal point.
Photograph by Sam Gray

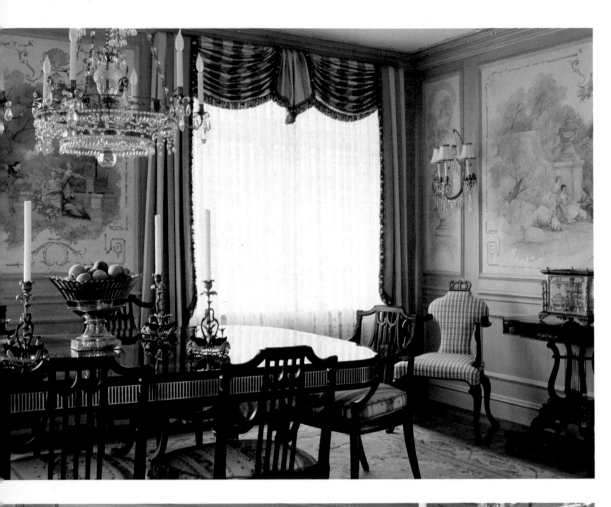

classic with silver leaf walls, marble-topped dining tables paired with canvas-covered chairs, and shag rugs under sectional sofas. What you won't find from Richard are rooms that are so sparse that if you move one piece of furniture it ruins the whole design.

Many clients come to R. Fitz Gerald & Co. based on its long-standing reputation or from the numerous magazines their work has appeared in, including *Architectural Digest, Traditional Home,* and *House Beautiful.* While the firm's work has focused primarily on New England, projects also include homes in Palm Beach, Los Angeles, London and Hong Kong.

For Richard, traveling is always the best Inspiration. The great manor houses of England or the villages of Italy have a way of reviving his creativity. When he can't get away he draws upon his library of volumes, which include tomes on Versailles, New England architecture and designer Jean-Michel Frank.

Interior design by Richard Fitz Gerald in collaboration with Michael J. Lee.

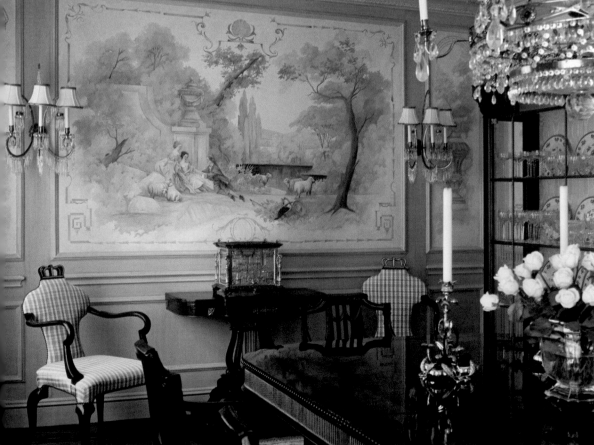

TOP LEFT
Watteau-inspired dining room featuring an antique Russian chandelier.
Photograph by Sam Gray

BOTTOM LEFT
Hand-painted murals by New York artist James Alan Smith.
Photograph by Sam Gray

FACING PAGE
Custom architectural cabinets with French porcelains frame archway to music room.
Photograph by Sam Gray

Q & A

MORE ABOUT RICHARD ...

HOW LONG HAVE YOU BEEN IN THIS BUSINESS?

45 years.

AWARDS, RECOGNITIONS?

Traditional Home magazine award for Designer of the Year.

WHAT DO YOU SPEND THE MOST MONEY ON?

My Scottie dog, Maisie.

YOU WOULDN'T KNOW IT, BUT MY FRIENDS WOULD TELL YOU I WAS...

A gentleman at all times, generous and honest.

WHAT ELEMENT OF STYLE OR PHILOSOPHY HAVE YOU STUCK WITH FOR YEARS THAT STILL WORKS TODAY?

Honesty, relating to the client one-on-one with regard to finances, personal choices, considering the client's lifestyle and creating something that relates to them.

IF YOU COULD ELIMINATE DESIGN/ARCHITECTURAL/BUILDING TECHNIQUES, WHAT WOULD THEY BE?

Aluminum siding, plastic shutters, open kitchens—except in second homes. I would also eliminate glass blocks and fake chimneys.

R. FITZ GERALD & CO.
Richard Fitz Gerald
29 Commonwealth Avenue
Boston, MA 02116
617.266.6500

SUSAN FOLEY-LARSON

INSIDE/OUT, LTD.

Never one to shy away from color, interior designer Susan Foley-Larson knows how to heat up a room. Vivid wall colors paired with sumptuously elegant fabrics, furnishings, and accessories are the designer's calling cards.

Susan's flair with color stems from her love of travel, nature, and her study of art history. In a recent project the sharp greens of plants appeared in the French green silk draperies while touches of reds and gold served as the accents that brought the room to life. Living in New England, with its cold climate and long winters requires some color, whether soft or vibrant, says the designer, who started her firm Inside/Out, Ltd. 22 years ago. A range of saturated hues creates a warm cocoon of colors for her clients.

It was Susan's passion and study of garden design (she first envisioned becoming a landscape architect) which allowed her to integrate knowledgably hearth and home with flora and fauna. Naming her firm Inside/Out, Ltd. was a natural fit. While the focus is on interior spaces and how her clients relate to them, Susan also consults on the integration of landscape projects.

LEFT
This space was renovated with creamy white beadboard, beams and woodwork. Brunschwig & Fils citron French toile on the walls and chairs enlivens this living room, accented with coral, lime green and black. The contemporary painting by Jane Dahmen (Powers Gallery, Acton, Massachusetts) provided the calling card for the infusion of vibrant color.
Photograph by Eric Levin Photography

Her design approach creates livable spaces that invite clients and guests to come in, sit down and relax. Whether in a historic New England home or a contemporary condominium in the city, rooms according to Susan, are meant to be lived in and not to exist as home theater sets. It is Susan's goal that creative, intelligent interior design draws you comfortably through the house and all rooms remain inviting and intriguing for family and guests.

Drawing on her experiences, travels, and knowledge of history, Susan mixes objets d'art, antiques, modern accessories, and beautifully framed art into her interiors. Inside/Out, Ltd.'s clients—it is not unusual for her to be working with different generations within the same family—often have significant artwork or other collections, which are the starting point for her design approach. Accordingly, artwork defines

the color scheme, sometimes calling for more subdued colors such as creamy glazes with subtle texture or conversely for more vibrant, translucent dramatic color to enhance the artwork. Most importantly, this designer knows how to use color to its fullest advantage.

Comprehensive drawings, detailing the interaction of architecture, interior design and landscape comprise her working mantra. Additionally, Susan brings a fresh eye when custom designing furniture, rugs and cabinetry. With an endless list of sub-contractors, she offers a complete interior design service, exciting and beneficial to her clients. Susan successfully juggles projects all over the country, often as a member of an architectural collaborative team.

She draws inspiration from one of her earliest design influences, Frank Lloyd Wright, who embodied Louis Sullivan's famous and oft repeated motto "Form follows function." Susan adds that "creative intelligent design" follows naturally with understatement and drama.

After the last bit of construction dust is swept away and interiors are installed, Susan personalizes every residence so that her clients with unmistakable comfort and confidence can "live" in their home. Susan oversees the installation, finishing every interior with personal touches specific to each client. Flowers abound, beds are made and the fireplaces are ready to be lit.

Her work has been published in *The Boston Globe, Boston Common*, and *New England Home*.

ABOVE LEFT
The walls of this sitting room have been layered with custom yellow glaze, enhancing the commissioned contemporary painting by artist Jesse Blanchard. Blue Heron Gallery, Wellfleet, Massachusetts.
Photograph by Greg Premru Photography

ABOVE RIGHT
This sitting room does double duty and can easily be transformed into a formal dining room for entertaining. The entryway sideboard replaces the loveseat, while antique English chinoiserie dining chairs are paired with a custom pecan wormwood tabletop with a French iron base. This elegant table is easily stored within the house and provides an instant holiday setting.
Photograph by Greg Premru Photography

FACING PAGE
This sitting room was restructured with a Swedish ceiling, heart pine floors and oversized French doors. Details such as the custom mantel, custom yellow Van Gogh walls accented by Pierre Frey country floral fabric, and the rich tones of the Tibetan carpet make this sitting room glow. Antique and contemporary art and furnishings finish the room splendidly. (J.W. Adams Construction, Inc.)
Photograph by Eric Levin Photography

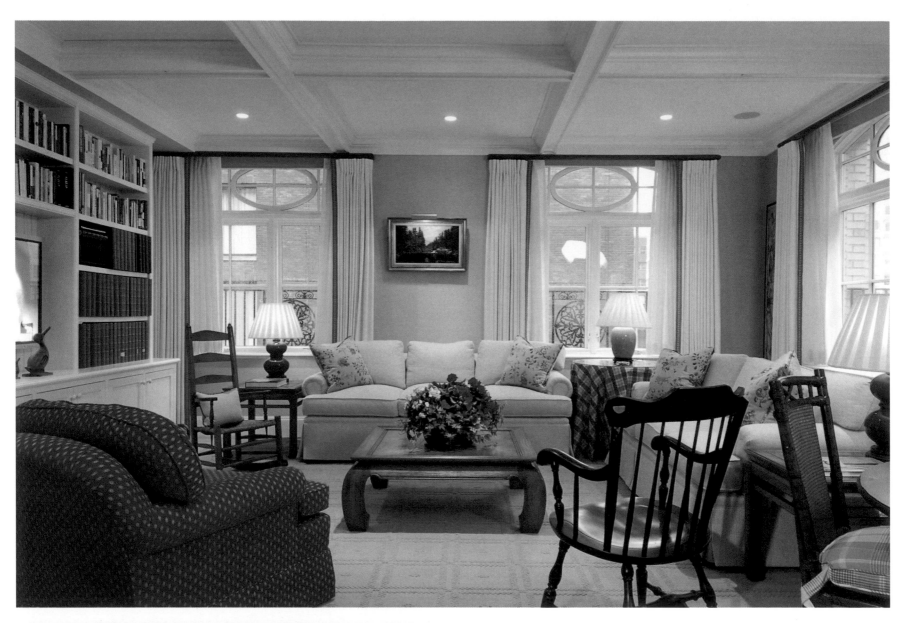

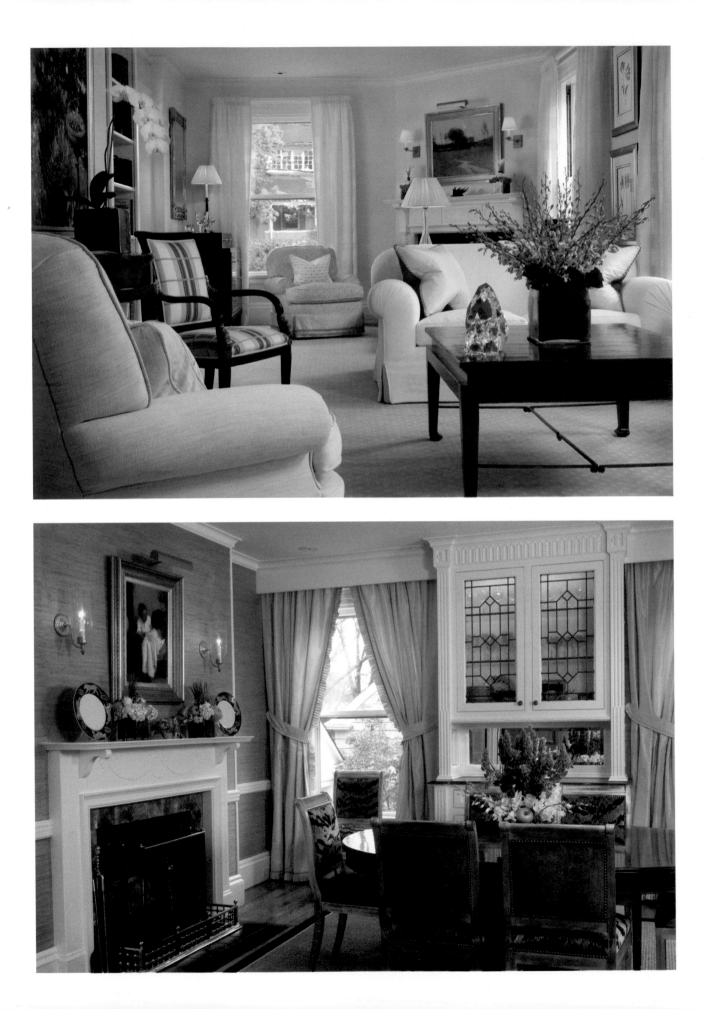

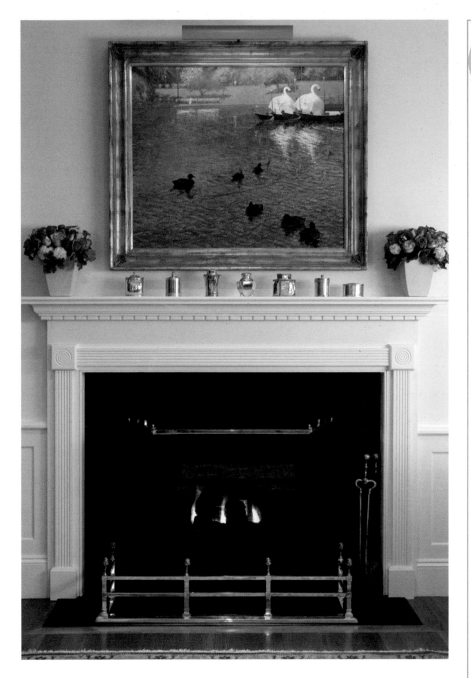

MORE ABOUT SUSAN ...

WHAT SEPARATES YOU FROM YOUR COMPETITION?

I provide my clients with a full turnkey service, from the initial plans through to the mint on their pillow. I develop extensive plans and specifications in all areas of interior architecture and oversee construction through to the end. I work as the sole principal on projects from start to finish. Additionally, I work and consult as a professional member on collaborative approaches with architectural teams. I am detail oriented and am able to see the forest for the trees and vice versa.

WHAT EXCITES YOU MOST ABOUT BEING PART OF *SPECTACULAR HOMES*?

The opportunity to give a glimpse of what I do to my family and to those in the trade who have helped me so much through the years.

DESCRIBE YOUR STYLE AND DESIGN PREFERENCES.

My style is eclectic. Accordingly, I am able to articulate a plan and interior design to fulfull my client's wishes. My projects include everything from the restoration of historical homes to very contemporary work. My clients range in age from 20-somethings to 80-somethings. I work and travel throughout the United States according to project demands.

Photograph by Eric Levin Photography

INSIDE/OUT, LTD.
Susan Foley-Larson
Concord, MA 01742
978.369.2643
www.insideoutltd.net

ABOVE
Susan spotlighted this well-known painting of the Boston Swan Boats by understating the fireplace. The owner's antique silver tea caddy set was simply placed beneath the painting, Winston flowers bring softness and the antique fire fender is elegant. The fireplace and adjacent walls have been faux painted in a soft glaze parchment color, allowing the painting to remain sacrosanct.
Photograph by Eric Levin Photography

FACING PAGE TOP
Working with clients who wanted their Victorian home to take on a decidedly hip edge, Susan took on the complete renovation of their home, infusing the living space with lime greens and accents of Chinese red. Lighting, an important element in any Inside/Out, Ltd. project, transforms the lime green walls with lovely color at night and brings a contented smile to all, whether for a quiet moment in front of the fire or for a large gathering. Custom carpet by Stark Carpet.
Photograph by Eric Levin Photography

FACING PAGE BOTTOM
Across from the living room pictured above is the dining room with walls covered in natural bamboo. Susan added the china built-in with leaded glass as well as the mouldings. The Biedermeier chairs—custom-made by Brunschwig & Fils—in red paint and gold gilt are covered in French velvet lime and black zebra print from Old World Weavers. The luscious lime green of the pleated silk drapes resonates with the lime-glazed walls of the living room. Merz Construction, Inc.
Photograph by Eric Levin Photography

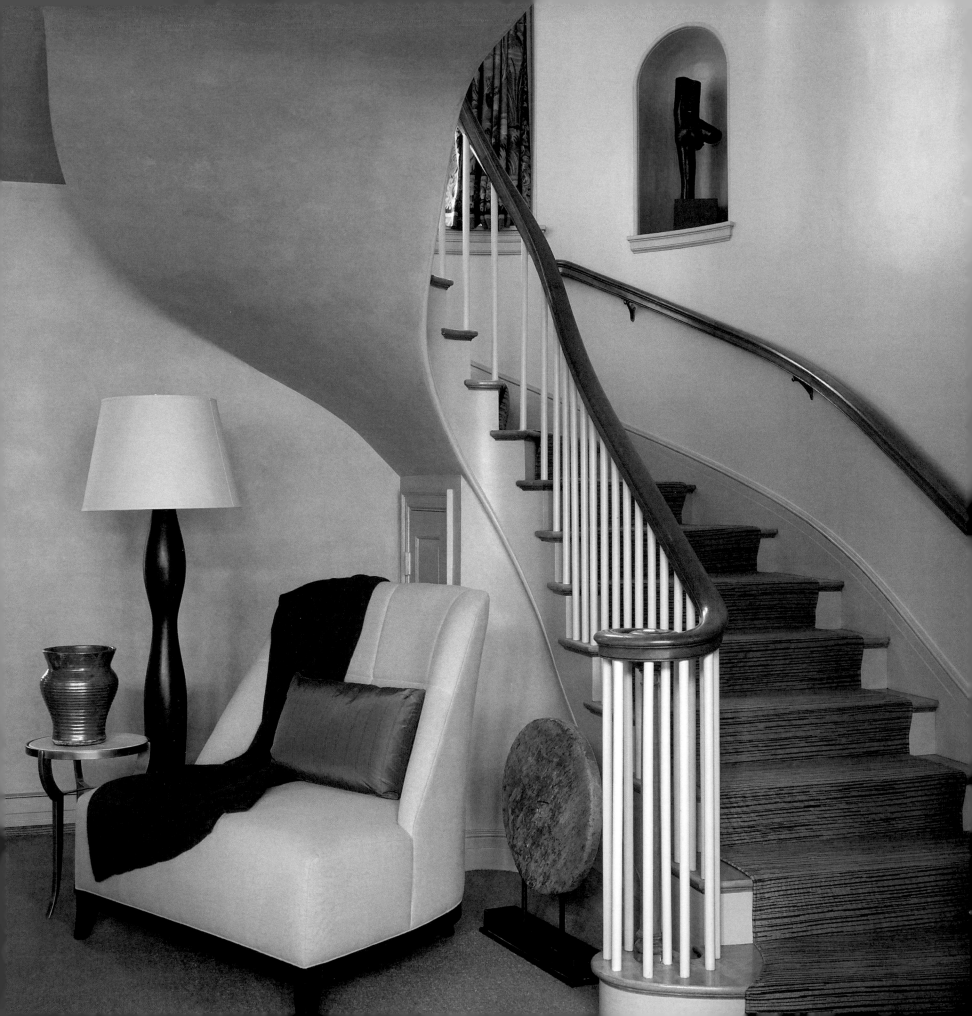

GIGI GOWDY
SUZANNE LOGAN

LOGAN GOWDY INTERIORS

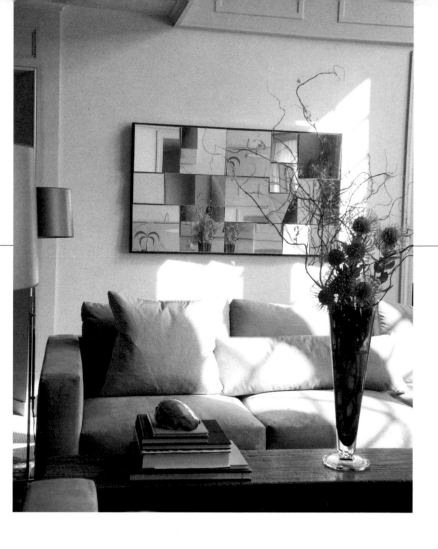

Ludwig Mies van der Rohe's iconic statement, "Less is more," rarely gets much play in the world of interior design. But for Gigi Gowdy and Suzanne Logan, the credo reinforces their stance on living an uncluttered life.

Focusing on classical forms without extraneous ornamentation creates the pair's clean and minimal—but always luxurious—aesthetic. Their residential work, which includes projects as diverse as Back Bay condominium renovations, traditional Capes, and transitional brownstones, benefits from their editing. Rooms of soft colors and fabrics and high-quality furnishings are a textural delight to the touch and the eye.

The two women—principals in Logan Gowdy Interiors, the firm they formed in 2004—include Gigi, an artist, former museum program and gallery curator, and staff designer at Landry & Arcari, and Suzanne, a formally trained interior designer who worked for a stone fabricator, a showroom and other design firms.

Part of the team's success stems from being able to balance creativity with good business sense. Working within a client's budget while still delivering top-notch design is foremost in their philosophy.

Their practical approach to elegance takes into consideration every aspect of clients' lives, including child-friendly fabrics and floor coverings that can hold up to household pets, while encouraging investment in furnishings with classic lines that clients will still want to have around once the latest trend is over.

Logan Gowdy does not overburden clients with unnecessary accessories that have little meaning, which leads to another of their favorite sayings made famous by Louis Sullivan: "Form follows function."

ABOVE
The Junior League of Boston selected the historic Prowse Farm as its 2005 Showhouse. The combination of bold artwork and stunning furnishings makes this living room exquisite.
Photograph by Eric Roth

FACING PAGE
A curvilinear stairway winds upward from Prowse Farm's entry hall. The sitting nook boasts beautiful lines and a splash of color.
Photograph by Eric Roth

LOGAN GOWDY INTERIORS
Gigi Gowdy
978.578.1353
Suzanne Logan
617.216.9697
www.logangowdy.com

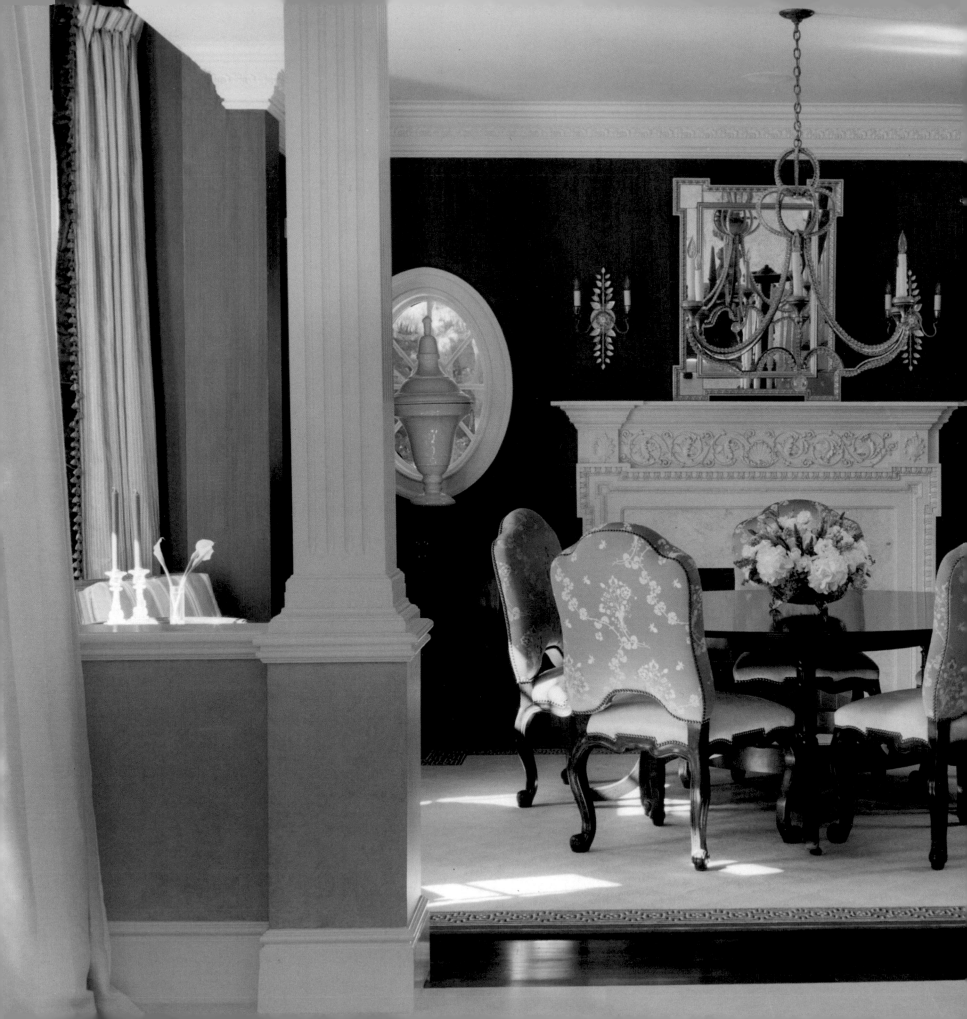

MAUREEN GRIFFIN-BALSBAUGH

GRIFFIN BALSBAUGH INTERIORS

Sure Maureen Griffin-Balsbaugh has worked on projects for Grammy winner John Legend, the president of Epic Records and president of Sony Urban Worldwide, but don't take her for a completely rock 'n' roll girl. Her laid back California vibe also easily translates into incredibly elegant interiors.

"Comfortable modern, not stark," is her mantra when it comes to projects as varied as island homes, Los Angeles offices, stately historic homes or New York apartments. Whether it is a sleek South Boston loft or a 200-year-old sprawling Brookline estate, Maureen pays homage to the architecture as she weaves together rooms made for living. In her designs you will always find plenty of places for people to cozy up or land after a long day. Comfort defines the furniture she chooses. Her elegant rooms embrace an ease for living, giving rooms that "slouch around in your bare feet" feeling.

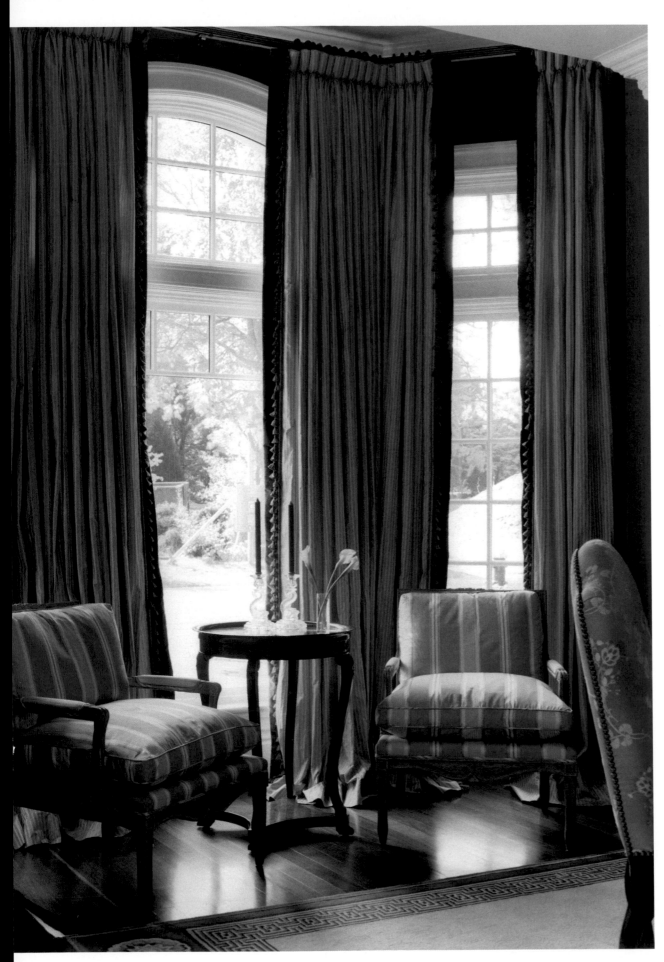

The designer, a Connecticut native in tune with the New England aesthetic but not confined by it, first moved to the Boston area to study art and fashion design, but felt drawn back to her collegiate roots after stints working in Los Angeles and New York. The cities, as well as the East Coast-West Coast influences, developed her eye for combining Traditional and Contemporary touches. But she'll be the first to admit she doesn't impose her style on anyone. "I try to lead clients in the right direction," she says with a smile.

After working as a designer for a denim company, she started working on the interiors of her boyfriend's house and bells went off spurring a career change. "I was working on it, thinking I could do this," she recalls of the epiphany.

Maureen started her interior design business seven years ago, completely devoting herself to bringing about clients' dream homes. That includes searching with homeowners for just the right antique armoire in France or the perfect light fixtures in London. Maureen frequently finds herself on the road in such locales as Los Angeles, New York and Nantucket looking for the finishing touches that take a room from pretty to wow.

LEFT & FACING PAGE
This private Brookline estate in Chestnut Hill features a lovely, intimate sitting area in soothing blue hues as well as a posh living area which focuses on a whimsical painting.
Photographs by Sam Gray

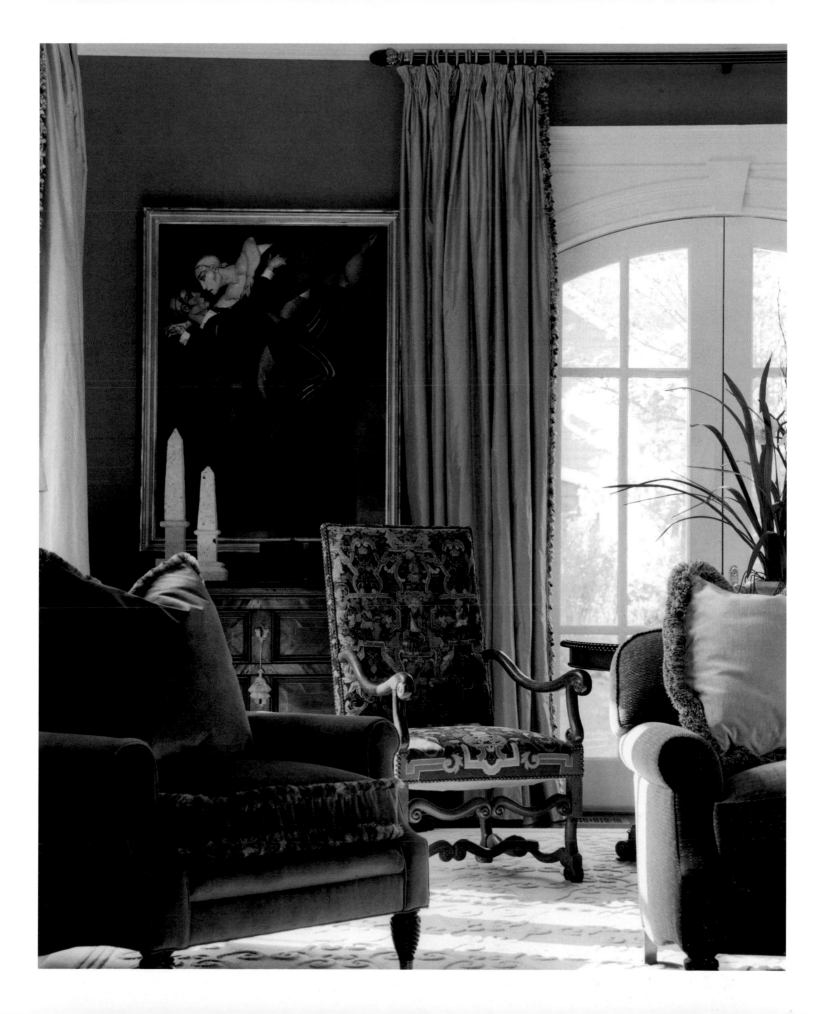

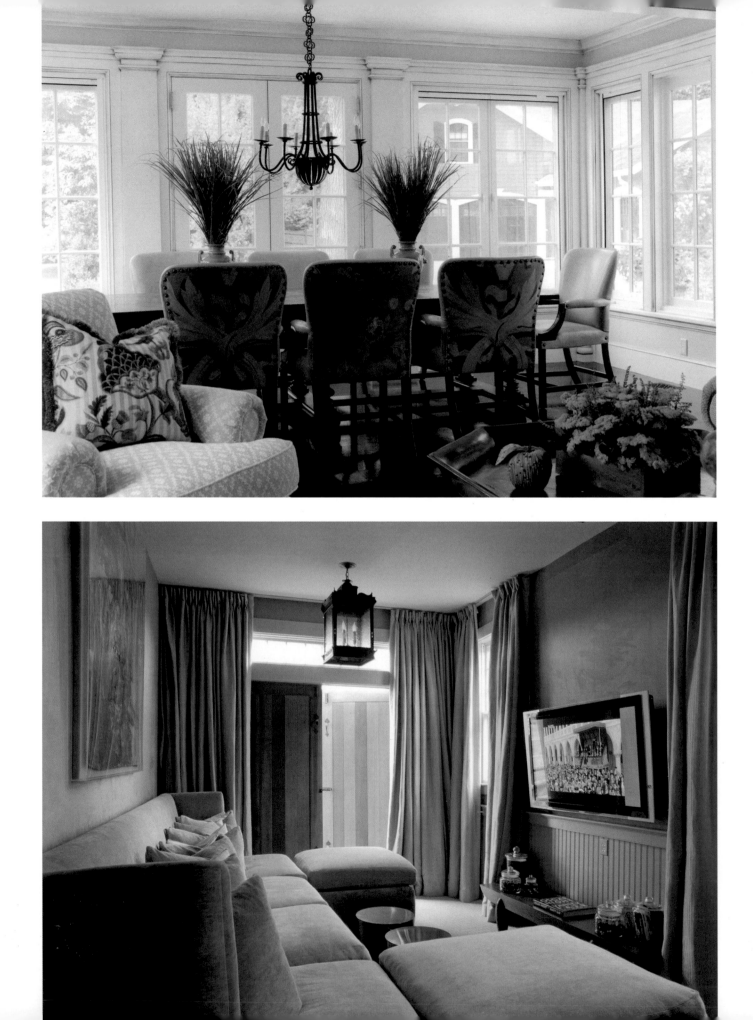

Maureen's own stately Brookline home has been her biggest incubator for ideas. The 1776 manse with its Murano chandeliers, collection of Juarez Machado paintings, antiques, marble entry, and sumptuous fabrics that her golden retriever, Dublin, has no qualms claiming for her own, embody her refined taste with a touch of California cool.

What Griffin-Balsbaugh's designs are about—whether they're influenced by traditional or modern design—is comfort. Luxurious fabrics, woven rugs, and pillows add punches of color and texture and adds to their approachability. "Home design isn't life or death," says the designer. "It's a fun process."

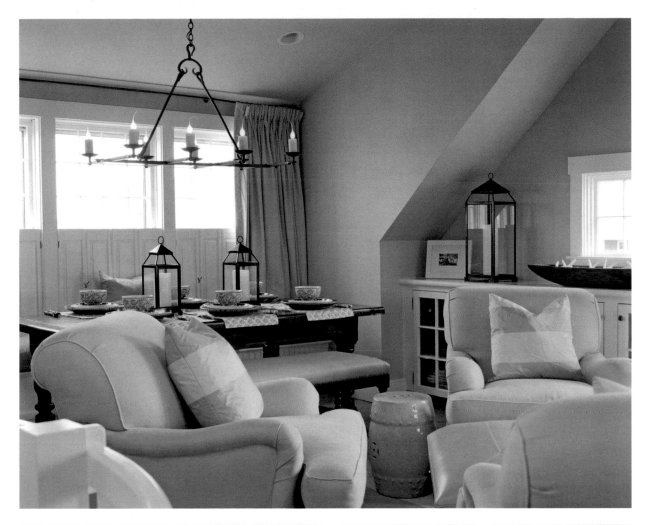

Photograph by Keller & Keller

TOP & BOTTOM RIGHT
The clean lines of the spaces within this Nantucket residence add charming and appropriate ambience.
Photographs by Sam Gray

FACING PAGE TOP
The breakfast room of this private Brookline estate in Chestnut Hill welcomes in the light while keeping the area inviting in yellows, greens and browns.
Photograph by Sam Gray

FACING PAGE BOTTOM
The media room of this private Nantucket residence keeps the focus on the screen while residents and guests lounge in comfort.
Photograph by Sam Gray

GRIFFIN BALSBAUGH INTERIORS
Maureen Griffin-Balsbaugh
130 Warren Street
Brookline, MA 02446
617.264.9006
cell 323.632.2355

139

PHILIP GUARINO

ARCLINEA BOSTON

Many believe that the kitchen is the heart of the home. It is the source of nourishment, a place for gatherings of family and friends, evocative of warmth, comfort, intimacy and fond memories. Why not, then, treat a kitchen as a bedroom, emphasizing comfort and tailoring it to fit the needs and personalities of those who spend their time therein? The team at Arclinea does just that. Founded 80 years ago in Vicenza, Italy, Arclinea has grown to be one of the most widely recognized kitchen manufacturing firms in Europe. Designed by Antonio Citterio, a highly acclaimed Italian architect and furniture designer, Arclinea's six fully customizable kitchen models form the Arclinea Collection and successfully marry practicality and art. Thus it was only natural that the company would make its way to the United States, which it did when Philip Guarino opened Arclinea Boston in 2001.

The genius behind Arclinea's kitchen designs lies in the fact that every aspect is customized and tailored to the clients' needs and to the homes, themselves. Each member of the team of talented architects and architects-in-training in the Boston showroom consults with clients to discover how they work in the kitchen, how often they cook, what storage needs they have and how much they entertain. The team then translates the clients' needs to the designs, using patented technology to establish an ergonomical scale that best utilizes space. All of the kitchen furniture—the cabinetry, countertops, islands and

LEFT
An Arclinea kitchen is the highlight of this historic Boston residence. Clean lines and bright finishes reflect and amplify the gorgeous natural light, seemingly floating over the rich hardwood floor.
Photograph by John Horner

the like—is manufactured in Arclinea's Italian factory, and several pieces are handmade, giving the firm an extreme level of quality control.

Clean lines, proper proportions and a variety of high-quality materials characterize the kitchen designs, each of which offers different benefits and underscores different materials. Philip is quick to note that the different designs are merely foundations, and often his team will finish a project unable to categorize the final product as an *Italia* or a *Ginger* kitchen. Their difficulty is due to the fact that all materials and furniture styles are available to all clients, and every project is, by nature, unique. Yet common to all Arclinea kitchens is an overwhelming display of intelligence. Unlike the typical American practices of placing cabinets on walls above counters and displaying every available appliance, the firm brings storage spaces down to reachable areas, adds deep drawers and incorporates rail systems and appliance garages—units closed off by shuttered doors—that get items off of countertops, freeing space for meal preparation and cultivating a relaxing ambience. Similar to furniture, the kitchen in effect becomes part of the home.

The variety of materials and innovative construction techniques employed speak to Arclinea's demand for excellence. Stainless steel, marble, teak, oak, aluminum and glass, as well as a proprietary material known as solid ray, comprise the various kitchen elements. The materials

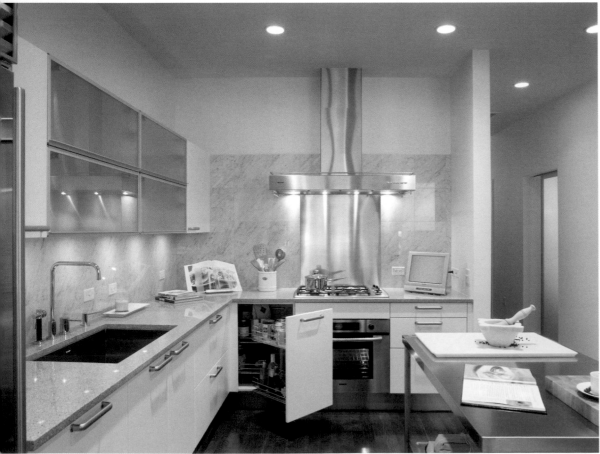

TOP LEFT
Sleek white lacquer cabinetry and stainless steel appliances are complemented with matching steel grips. Acid-etched glass cabinets gracefully rest above granite countertops.
Photograph by John Horner

BOTTOM LEFT
This efficient kitchen, filled with dynamic storage solutions, features items such as an innovative pull-out unit to maximize space utilization and ergonomics.
Photograph by John Horner

FACING PAGE
This exceptional space combines a unique blend of light and dark materials that reflect tone and light within the house. Abundant countertop space and the intelligent positioning of work areas make this kitchen remarkably functional.
Photograph by John Horner

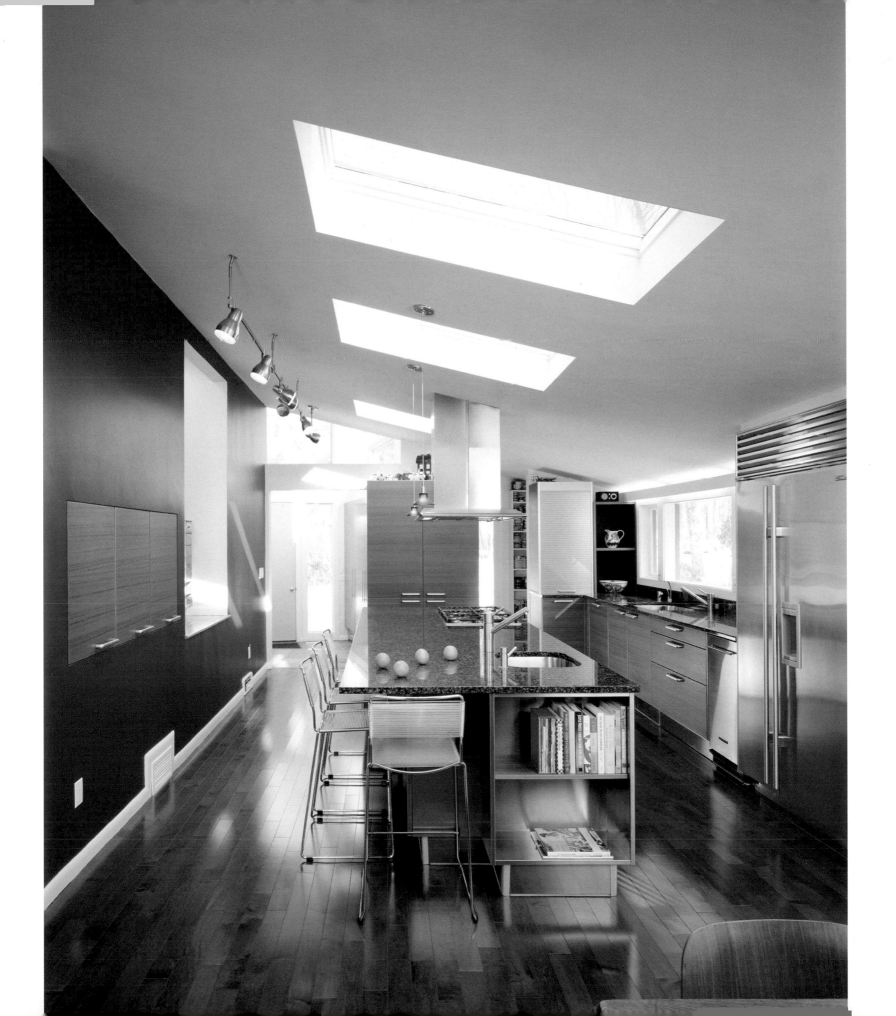

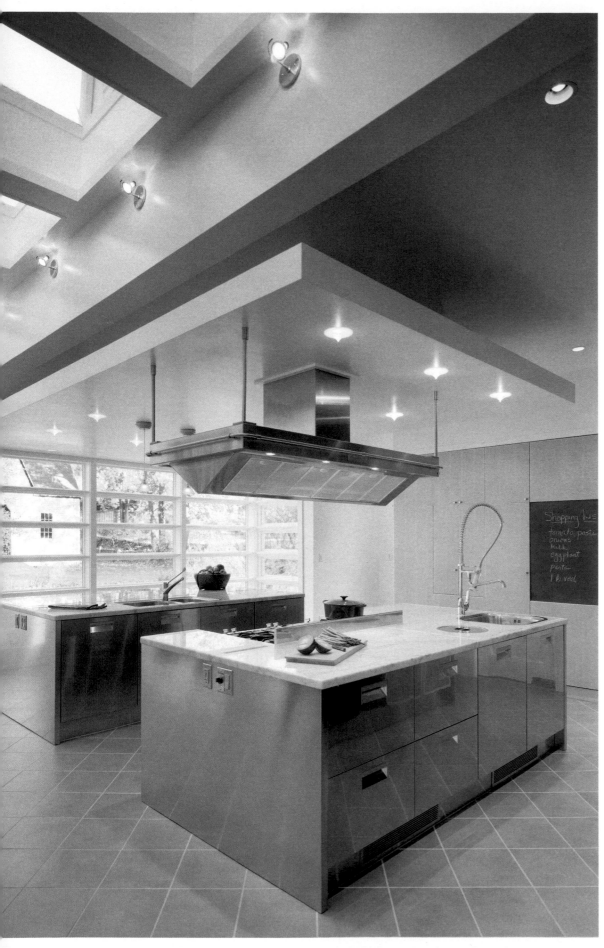

chosen are specific to each project: White lacquer cabinetry and light-colored marble countertops emphasize light and warmth in one kitchen, while reflective steel and blue solid-ray walls recreate the feel of a kitchen at Le Cordon Bleu culinary school in another. Arclinea's manufacturing process allows them to create seamless surfaces, a quality unique to the industry. They add drip guards to the edges of preparation stations and frequently integrate tables into islands, allowing residents to freely move from cook spaces to entertainment areas.

Arclinea's kitchen designs now grace traditional and contemporary homes throughout New England, across the United States and into the Caribbean. Many celebrities and world-renowned chefs have prepared their meals in Arclinea kitchens, as do a variety of homeowners who demand the best in quality and understand good design. The firm has won a number of distinctive awards for their innovative remodeling and new-construction projects, including the Sub-Zero and Wolf 2006 Kitchen Design Contest, *Boston* magazine's Best of Boston 2006 Best Kitchen Designer award and two *Qualified Remodeler* 2006 Master Design Awards, and they have received wide media exposure in the likes of *The Wall Street Journal*, *The Boston Globe*, *Metropolitan Home* and on HGTV. For their beauty, for their artistry and for their thoughtfulness of design, Arclinea kitchens truly belong among the worlds' elite.

LEFT
An exquisite kitchen for a Cordon-Bleu trained chef uses two stainless steel islands with Carrera marble tops, flanked by tall units (not shown) to create a dramatic space. The islands provide easy access to storage and facilitate comfortable movement.
Photograph by John Horner

FACING PAGE
Streamlined movement was essential in this fastidiously laid-out kitchen. Abundant storage and easy access to a multifunction island allow the owner, an avowed baker, a pleasurable experience.
Photograph by John Horner

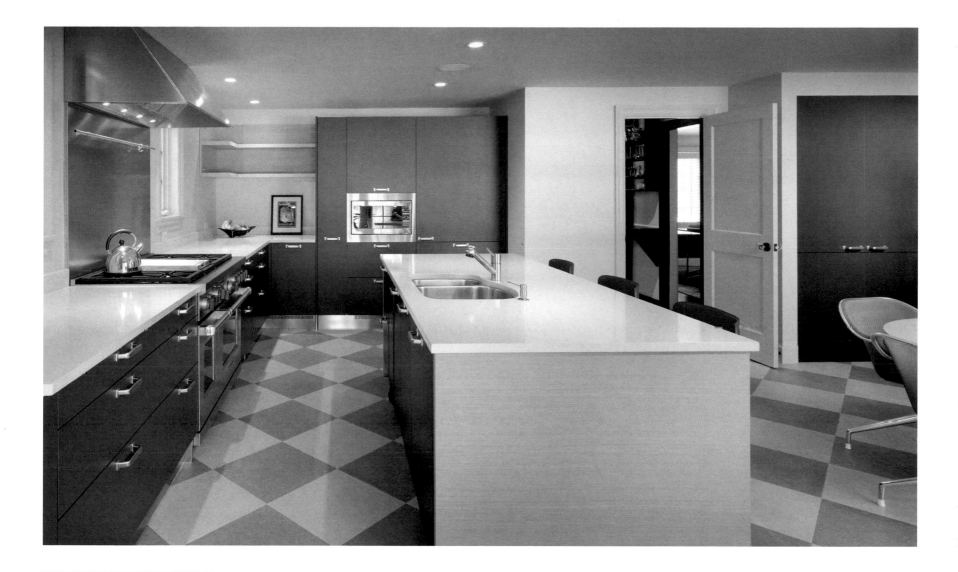

Q&A

MORE ABOUT PHILIP ...

WHAT IS THE HIGHEST COMPLIMENT ARCLINEA BOSTON HAS RECEIVED?

We have the ability to help someone visualize something new and innovative, and upon viewing the project, the client says, "Wow!" That is most gratifying to us. Clients have even sent us flowers to celebrate the first anniversary of their kitchen. It's great to know that our kitchens and space design so greatly affect people's lives.

WHAT ONE PHILOSOPHY HAVE YOU STUCK WITH FOR YEARS THAT STILL WORKS FOR YOU TODAY?

Continuous product innovation, creativity in the materials we use and Antonio Citterio's knack for sensing the shifts in the world in general. He is always one step ahead of what the market is asking for—he came up with the idea to reintroduce teak into the kitchen a few years before it rose to the forefront.

IN WHAT STYLES OF HOMES DO ARCLINEA'S KITCHEN DESIGNS WORK BEST?

Due to our strict adherence to the preservation of architectural integrity, our kitchens work well in any home. Many potential clients show initial concern that our styles may not suit their traditional homes. We always remind them that our company got its start in Italy: If our designs can look great in 15th-century *palazzi*, they will look equally great in Victorian homes. With many materials and custom designs, Arclinea kitchens have worked well in many different environments.

ARCLINEA BOSTON
Philip Guarino
10 St. James Avenue
Boston, MA 02116
617.357.9777
Fax 617.357.9707
www.arclineaboston.com

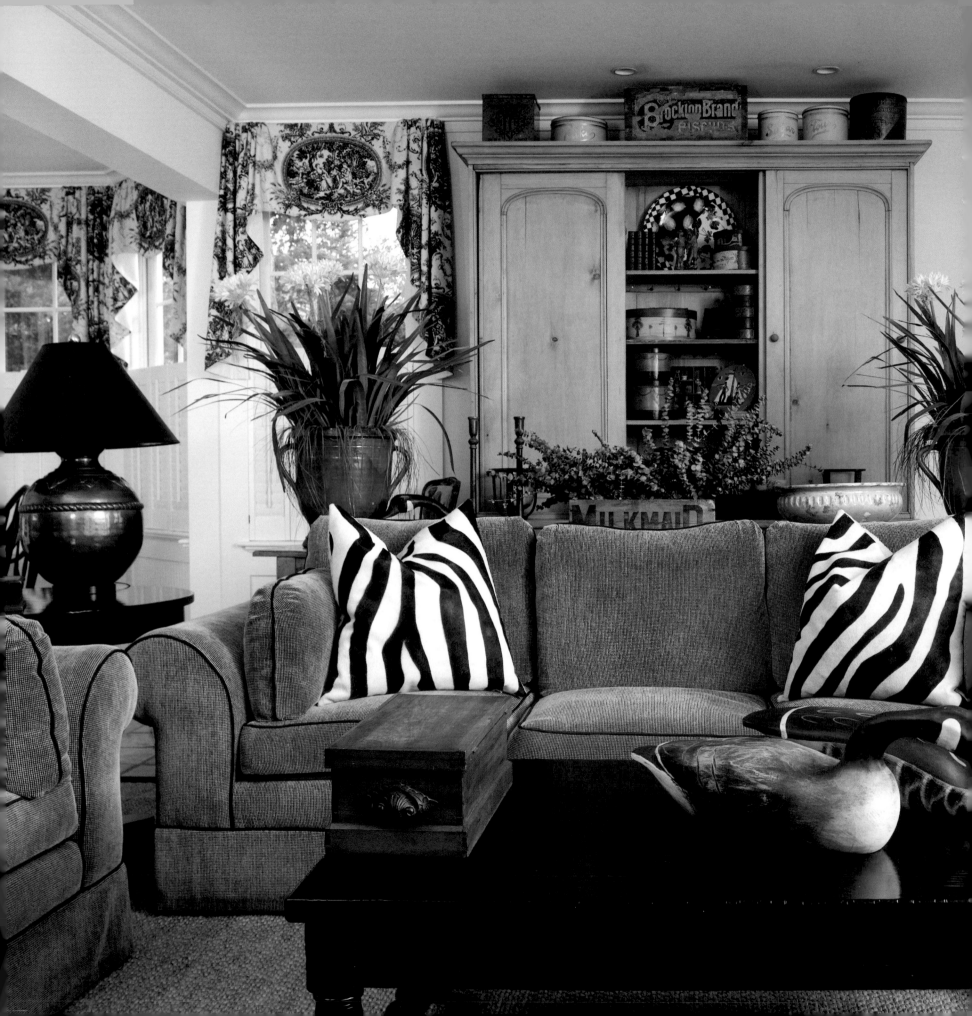

MARGIE HUGGARD

MARGO'S

Margie Huggard has a natural knack for finding interesting decorative pieces and combining them in fresh compositions, tailored to her clients' needs. After a few years of acquiring unique items—from folk art rocking horses to creative lamps and even mirrors made from starfish—for her namesake boutique, Margo's Practically Unusual, she decided to offer interior design services, a venture which has grown exponentially since the mid-'90s. Her design firm no longer bears the Practically Unusual name, yet Margo has remained true to that mantra, considering both aesthetic and functional quality for every creative decision.

Margo begins each project by assessing magazine clippings that appeal to her clients. From these cues and those gathered through casual conversation and observation of their apparel choices, Margo creates a story—a design plan that represents their stylistic preferences. Like an architect, she creates the interior framework before delving into specific details such as colors and textiles. Margo often draws inspiration from her clients' existing pieces, and has designed whole homes around heirloom furniture, collections of art and even religious artifacts. Because she respects her clients' history and wishes for the future, Margo is willing to go the extra mile to incorporate things that will make residents feel at home, even if it means completely refinishing or reupholstering furniture and designing pieces to complement.

LEFT
Part of the great room, this cozy family room overlooks the water of Nantucket Sound. Rogers and Goffigon fabrics blend nicely with the touches of black throughout the home.
Photograph by Terry Pommett

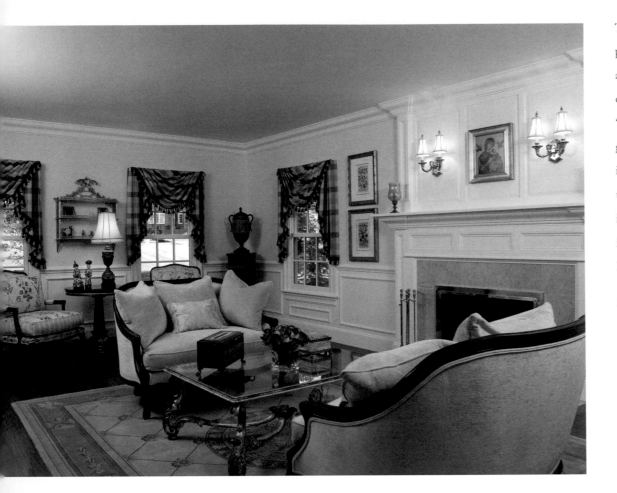

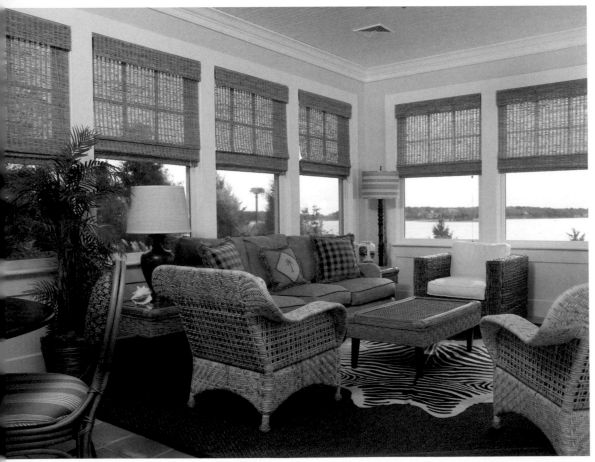

The talented designer enjoys translating her clients' personalities into beautifully designed spaces. For one client, a brunette woman who surrounded herself with intensely colored clothing, Margo created a vibrant interior and notes, "From the minute you walk in her door, it feels like her; you get the full story." Margo places great importance on first impressions and has made a habit of moving every which way through her clients' home to ensure that whether they come in through the back door, happen to catch a glimpse of the interior from the patio or enter a living area via a less traveled hallway, a beautiful vista awaits them.

She feels that homes should welcome their residents, and once inside, the layout, furniture and colors should all bolster daily routines and lifestyles. Petite people see the things quite differently than their taller counterparts, so Margo is mindful to hang artwork, design layouts and even create custom furniture to meet their needs. Because Margo gets to know clients so well, she is aware of whether they prefer to sit or lie while watching television, if they need bedside reading lights and even how close they like to be to a glowing fireplace. Likewise, she designs floor plans that live as well for two as when the house is full of friends and family.

Each design represents the culmination of Margo's creativity and her clients' uniqueness. Though every home is as original as its residents, and ranges from Traditional to quite Contemporary, the body of Margo's work is bound by a sincere desire to enhance their lives with beautiful, functional design with an eclectic twist.

TOP LEFT
The use of bright yellow velvet on a period piece gives a contemporary feel to this otherwise traditional Concord, Massachusetts living room. Antiques make the room appear as though it has been there forever.
Photograph by Terry Pommett

BOTTOM LEFT
A serene ambience fills the air of this exquisite all-season sunroom, which boasts panoramic views of the water and surrounding foliage.
Photograph by Terry Pommett

FACING PAGE
The master bedroom of this South End loft condominium has an urban appeal. A decorative painting by Gerard Wiggins introduces a sophisticated color palette, as echoed in the fabrics and custom rug, which give the space a comfortable and livable feel.
Photograph by Terry Pommett

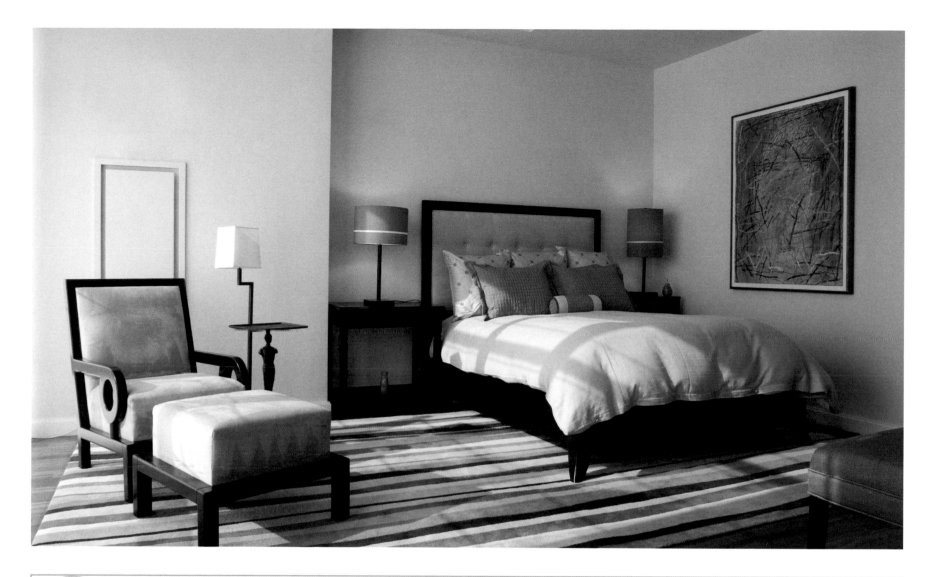

Q&A

MORE ABOUT MARGIE ...

WHAT IS ONE OF THE MOST CHALLENGING PROJECTS YOU'VE COMPLETED?

I designed a Boston home's interior and it was very tricky to give the residents privacy and a cozy setting, as the bedrooms overlooked fire escapes. In one room, I called for chocolate brown walls, and even though it was a small space, the color actually expanded the room— I love exploring the unexpected.

WHAT IS THE BREADTH OF YOUR DECORATIVE PAINTING SERVICES?

From basic strie to Venetian plaster, murals or anything else my clients and I dream up, I have a fabulous network of artisans. Because I formerly practiced decorative painting, I can easily communicate my vision to the people performing the work. The same goes for sewing; I manufactured children's clothing many years back and know how to achieve quality custom textiles.

HOW DOES YOUR OWN HOME REFLECT THAT WHICH YOU WANT TO CREATE FOR YOUR CLIENTS?

It's beautiful, functional and mixes new ideas with things I've collected over the years.

WHEN DID YOU FIRST REALIZE THE POWER OF INTERIOR DESIGN?

Before I established myself in the industry, I'd worked with many designers on my home. The late Reid Cannavan truly inspired me because his portfolio pieces were completely different than what he created in my home. Working with him opened my eyes to the importance of a client's input and power of an interior designer's professional guidance.

MARGO'S
Margie Huggard
28 Wianno Avenue
Osterville, MA 02655
508.428.5664
Fax 598.428.1317
www.margoshome.com

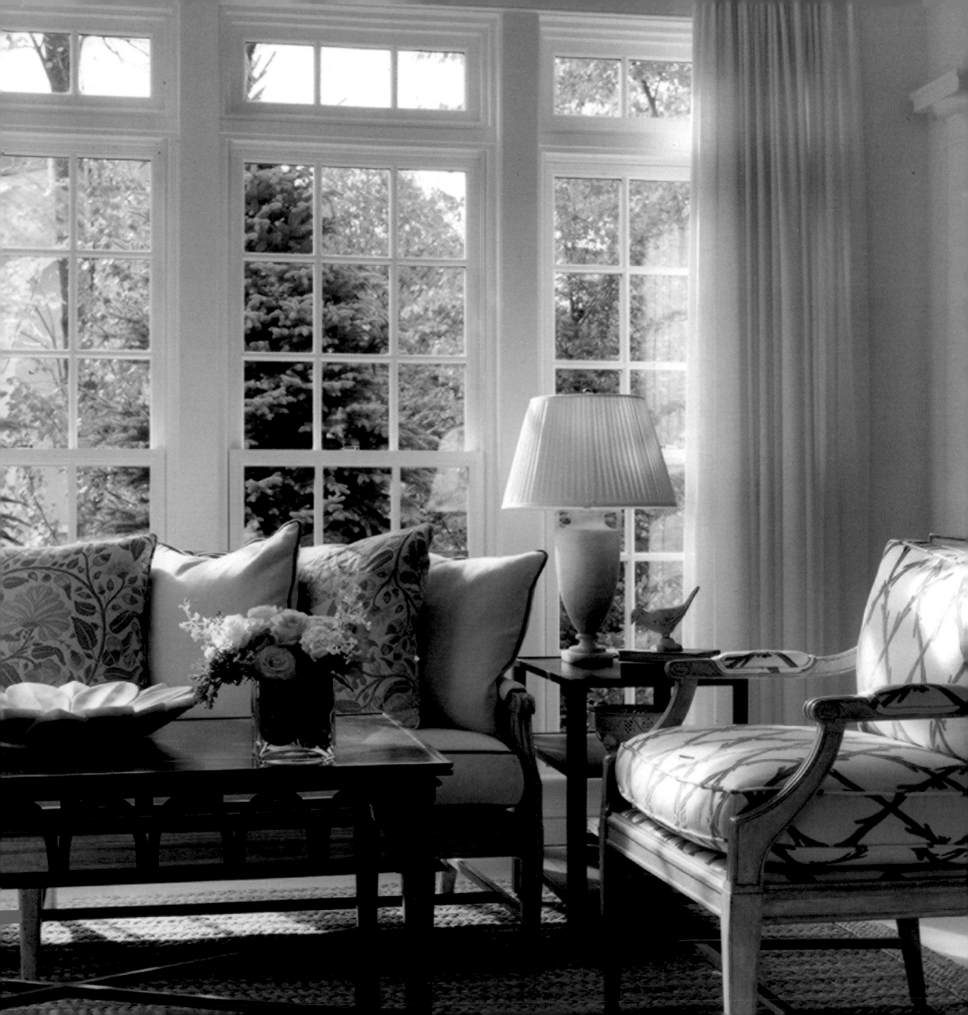

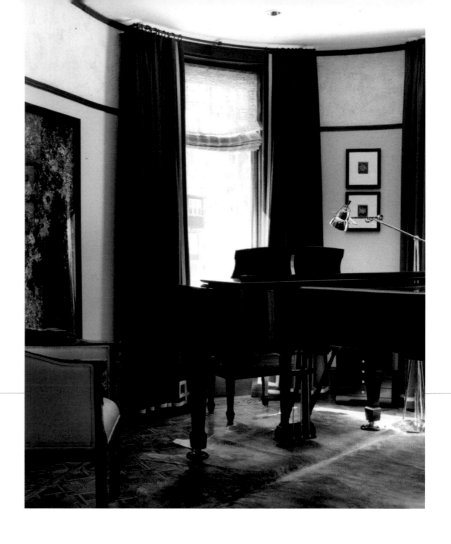

MOLLIE JOHNSON

MOLLIE JOHNSON INTERIORS

Living in Berlin and Paris and moving from one historic residence to another, interior designer Mollie Johnson grew up exposed to beautiful things. Her father, a general in the army and an ambassador, moved the family often, but always to luxurious homes: An experience that inculcated in her an appreciation of architectural detail, classical form, and decorative scale. Mollie can to this day recall the rooms of her childhood residences in great detail. The mosaic walls of the turreted entrance; the painted cherubs that danced across the ceiling; the gentleman's smoking room with its white leather chairs and the ceiling of stars that lit up at night in the homes of her youth are vivid images in Mollie's mind that continue to endure.

After living abroad for much of her childhood, Mollie returned to her southern roots, living in Charleston, South Carolina and Virginia throughout her teenage and college years. Embracing the area's deep sense of history, the designer took inspiration from the period furnishings that surrounded her as she began to decorate and select the colors for her own rooms. The spaces in Charleston offered an interesting juxtaposition to those of the European rooms to which she had become accustomed.

While the years she spent living in Europe and the South may have informed Mollie's creative sensibilities, it was not until settling in Boston in 1991 that she established Mollie Johnson Interiors and found her niche in high-end residential interior design.

Today Mollie's interiors embody a classic, simplified elegance. Her color palettes feature muted earth tones, which she often accents with touches of gilding. Through her use of soothing colors and lush textures, as well as her incorporation of antiques and fine art, Mollie creates calming interiors that speak to the grace of another age.

ABOVE
A brindled cowhide floor covering softens a Victorian music room, while long chocolate wool drapery panels with sailor's knot trim details add a contemporary twist to a classic space. Newton, Massachusetts.
Photograph by Sam Gray

FACING PAGE
This light-filled conservatory with wrap-around views of the gardens maintains a sophistication, while architectural details are reflected by the furniture and fabric selections. Lexington, Massachusetts.
Photograph by Sam Gray

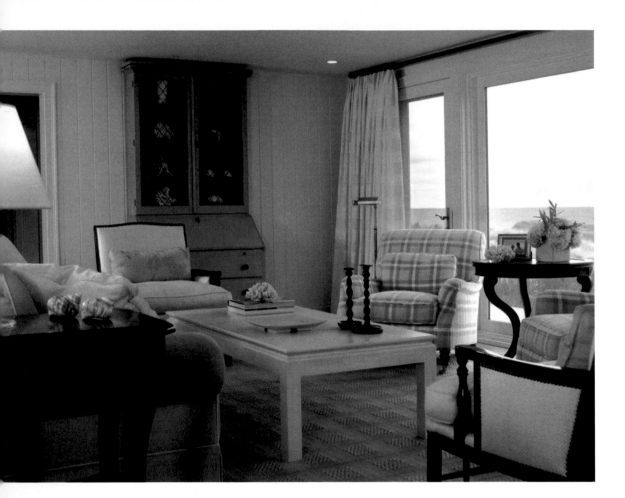

Primarily working in collaboration with architects on new construction and large renovations, Mollie's projects—while chiefly confined to the Boston area, Cape Cod and Nantucket—have also included residences in New Hampshire, Connecticut, New Jersey, Florida and Kiawah Island, South Carolina. Currently Mollie Johnson has an office in Wellesley, Massachusetts where she employs four design professionals. Her designs have been published in *House Beautiful*, *Boston* magazine, *Charleston Home*, and *Wellesley Weston* magazine and have appeared on HGTV.

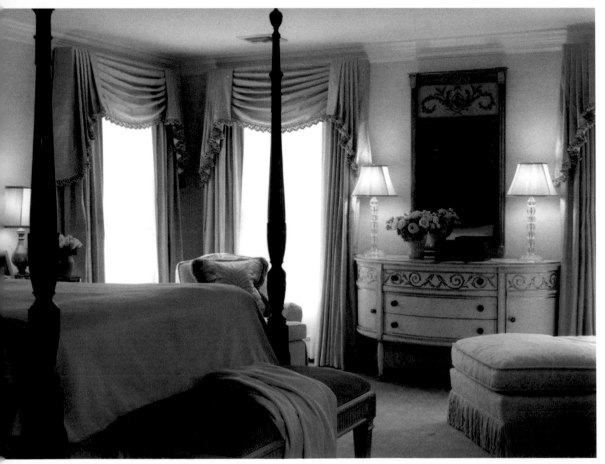

TOP LEFT
A tailored and edited Cape Cod living room allows for a practical living space while maintaining an emphasis on the breathtaking view. East Dennis, Massachusetts.
Photograph by Sam Gray

BOTTOM LEFT
A master suite in a palette of celadons and creams offers an understated elegance with added touches of hand-painted furniture and an antique trumeaux mirror. Lexington, Massachusetts.
Photograph by Sam Gray

FACING PAGE
Luxurious textures and subtle patterns in neutral tones bring warmth to this city living room, complemented by antiquities and artwork. Newton, Massachusetts.
Photograph by Sam Gray

Q & A
MORE ABOUT MOLLIE ...

WHAT IS THE BEST PART ABOUT BEING AN INTERIOR DESIGNER?

Working in a creative field where you get to see your visions come to fruition and working on an array projects with all types of people.

WHAT ELEMENT OF STYLE OR PHILOSOPHY HAVE YOU STUCK WITH FOR YEARS THAT STILL WORKS TODAY?

Classical design and flow of color.

IF YOU COULD ELIMINATE A DESIGN/ARCHITECTURAL/ BUILDING TECHNIQUE, WHAT WOULD IT BE?

I prefer classic design elements as opposed to stark contemporary styles.

WHAT IS THE MOST BEAUTIFUL/IMPRESSIVE/UNIQUE HOME YOU HAVE BEEN INVOLVED WITH AND WHY?

The house I lived in in Berlin, Germany at the age of 10. The grandeur of this home influences my design sensibilities to this day.

WHAT DO YOU LIKE MOST ABOUT DOING BUSINESS IN THE BOSTON AREA?

It is a big city, but has a small feel.

DESCRIBE YOUR STYLE AND DESIGN PREFERENCES.

Classic, simple and elegant.

WHAT IS THE SIZE OF YOUR COMPANY? NAMES?

Four employees: Susan Schaub, Scott Bell, Kalah Talancy and Katherine Fortier.

MOLLIE JOHNSON INTERIORS
Mollie Johnson
One Hollis Street, Suite 102
Wellesley, MA 02482
781.431.2289

DIANA KIKER-KEARNS
STICKS & STONES

Interior designer Diana Kiker-Kearns is known for her uncluttered look. She shies away from overdone window treatments, and avoids overstuffed rooms, preferring her design to be focused and well-organized. She'd much rather have clients save their money to purchase a wonderful piece of art or a really lovely antique than to spend it on unnecessary accessories.

But give her an opportunity and she'll indulge her fondness for chairs—French fauteuils for their rounded shapes, and beautifully carved straight-backed chairs for their versatility—on her frequent trips to France, where over the years she's developed relationships with a number of dealers; it is chairs as singles, pairs or sets that catch her eye in Paris or in the villages of the south of France. Diana continues to hone her eye for unique pieces by tending to another passion—museums, including her favorite, Musee Nissim de Camondo in Paris for its stunning furniture collection.

Her clients—always referrals from clients past—include young families in the suburbs as well as those relocating to apartments in the city. Whether Diana is adding a contemporary kitchen to an antique home or trying to use every spare inch in a penthouse apartment, she's happiest when she and her on-staff architectural designer, Janet Heyde, have a role in the a project from the beginning. The firm's collaboration with architects and builders has yielded the best results.

Diana typically juggles a half dozen projects at a time that can have her restoring an 1800's Beacon Hill townhouse or adding custom mouldings to a suburban home. Besides the Boston area, she is also tackling projects in Atlanta and San Antonio and represents Plain & Fancy custom cabinetry. For the hardworking Diana, the focus is always the client and accomplishing whatever is necessary to carry a project forward.

ABOVE
Graceful accessories complement this charming area. On either side of the fireplace, a pair of antique mirrors are mounted on Chinese pewter panels by Roger Arlington.
Photograph by Bruce Nelson

FACING PAGE
Boston Junior League Showhouse 2006 in a house built in 1851. Diana combines the historic and antique with contemporary art by Carrie McGee in the original owner's study. The curtain fabric is by the Twigs from the textile collection of the Royal Museum of Ontario.
Photograph by Eric Roth

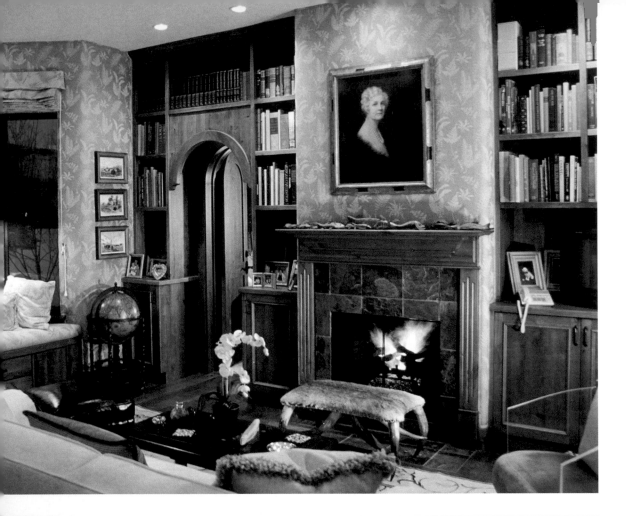

After two decades as an interior designer in Washington, D.C., Diana moved to Boston 10 years ago. With her she carried the name of her former Georgetown store, Sticks & Stones. Her understated work incorporates soft colors and soothing textures with beautifully patinaed antiques and upholstered pieces. She loves to add glass or Lucite tables so clients always have somewhere to set drinks and food or stack their favorite books. She encourages homeowners to keep rooms flexible by including chairs that can be moved around to form different conversation areas. And in lieu of elaborate window treatments, she is more likely to recommend the clean look of woven shades, or shutters and simple panels.

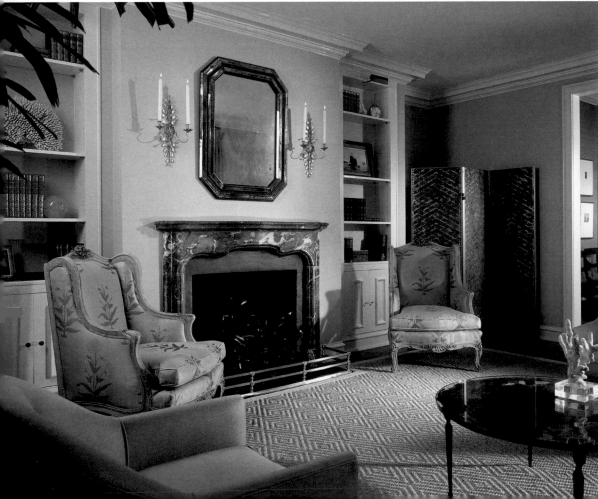

TOP LEFT
This cozy library with its paneling and upholstered walls is the perfect foil for the snowy scene outside.
Photograph by Fred Lindholm

BOTTOM LEFT
A young family's living room combines antique French chairs and sconces with moderne upholstery, screen and coffee table. Diana's signature Stark sisal carpet pulls everything together and gives the room a crisp, clean feel.
Photograph by John Umberger

FACING PAGE LEFT
A view from the living room through the open kitchen to Diana's Back Bay dining room. The 18th-century armoire, restored architectural elements, 1955 Marino print and Rose Tarlow's faux marquetry chest are cleverly pulled together by Diana Cook's stained checkerboard kitchen floor.
Photograph courtesy of Sticks & Stones

FACING PAGE RIGHT
The charming sepia mural depicts a fanciful history of this 250-year-old house from its earlier days to the present owner's grandchildren. Original valances are highlighted by the simple roman shades and the antique table and crewel slip-covered chairs by the sisal rug.
Photograph by Bruce Nelson

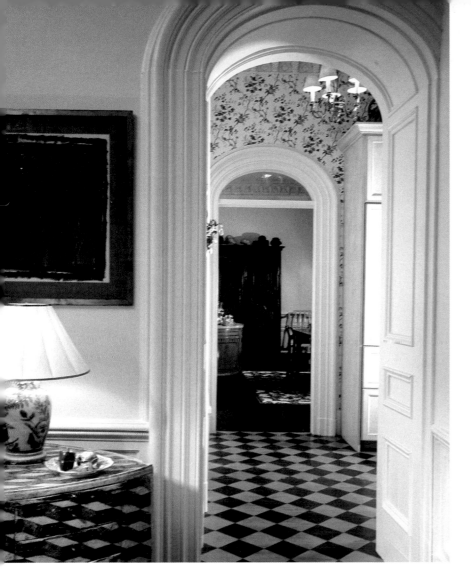

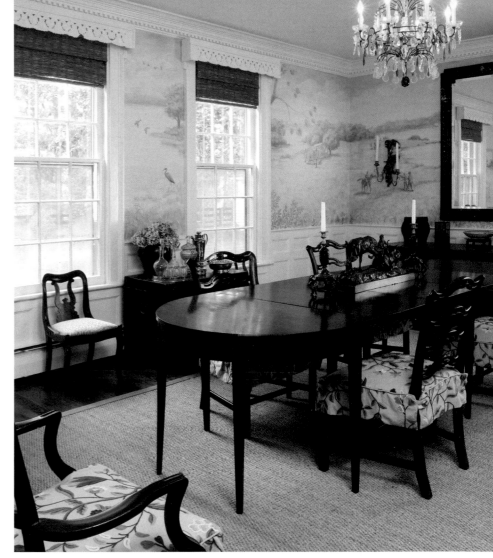

Q&A

MORE ABOUT DIANA ...

YOU CAN TELL I LIVE IN THE
BOSTON AREA BECAUSE ...

I have had to give up my high-heeled
shoes to navigate the brick sidewalks.

WHAT SEPARATES YOU FROM YOUR COMPETITION?

I have always had clients in various locales. Recently, Sticks & Stones has designed homes in Atlanta, Georgia; Sun Valley, Idaho; Tidewater, Virginia; Washington, D.C. in addition to Sunapee, New Hampshire, Chatham, Nantucket, Wellesley, Concord, Carlisle, Newton, Dedham and Boston, Massachusetts. As a constant traveler, I have developed many unique resources for my clients.

WHAT DO YOU SPEND THE MOST MONEY ON?

Soap. I love expensive soap made in small batches with dried herbs and scent. I am instantaneously walking through a garden.

STICKS & STONES
Diana Kiker-Kearns
280 Commonwealth Avenue, Suite 310
Boston, MA 02116
617.247.1412
Fax 617.247.0845

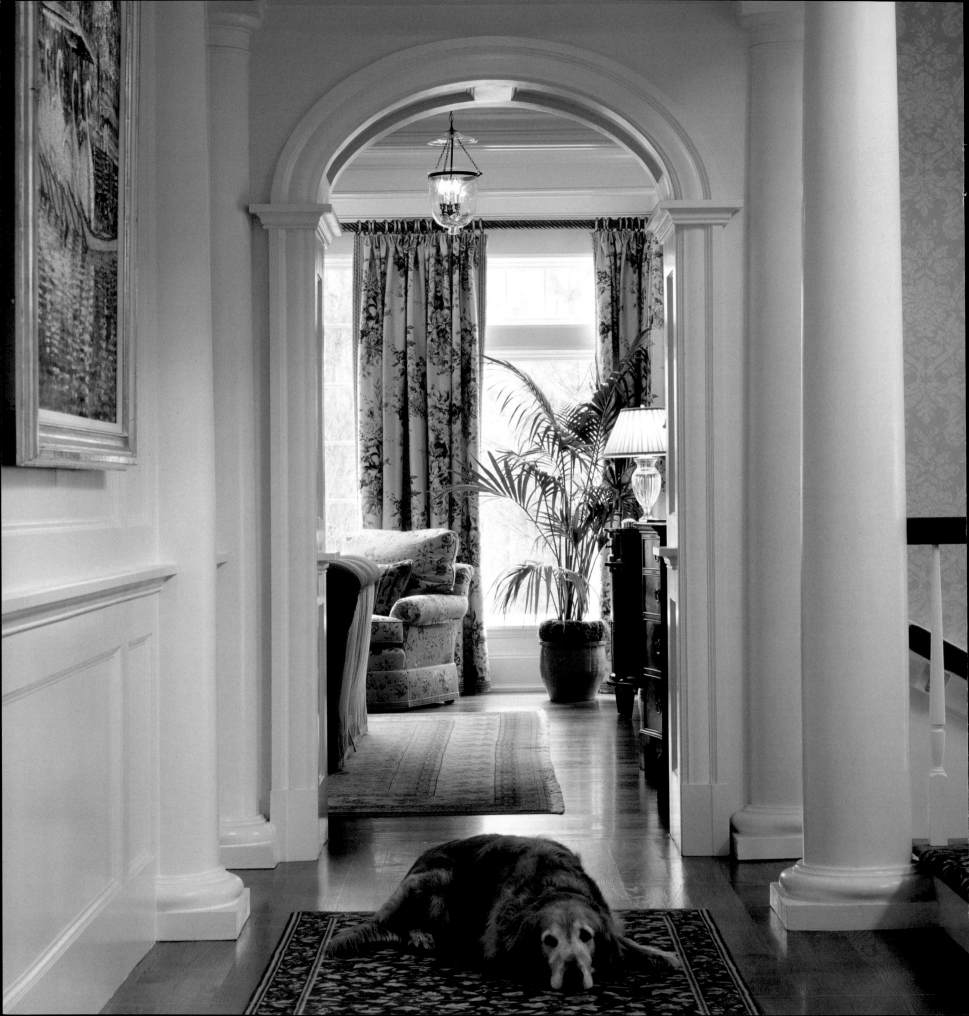

BARBARA KOTZEN

TAPPE & KOTZEN INTERIOR DESIGN, LLP

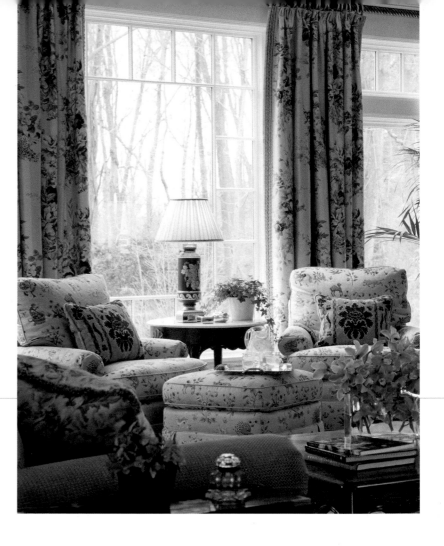

Barbara Kotzen of Tappe & Kotzen is a well-known and respected designer from the Boston area. Barbara prides herself with her unstoppable design knowledge as well as her detail to design. Her meticulous approach starts at the beginning of a project, collaborating with the architect and client to refine floor plans, design millwork and cabinetry. It extends to the finishing touches on furniture, draperies, rugs and to the custom wall colors she masterfully creates.

Barbara has the ability to achieve the finishing touches that sometimes get overlooked. Her draperies typically have a custom-designed trim and the skirts on sofas and chairs will also be adorned with custom trim, which carries her signature.

Barbara leaves nothing to chance when it comes to interior architectural details, rugs, drapery and fabrics. "Whatever I design, I work hard to incorporate the final touches that make my rooms stand apart from others."

The touches may include leg and drawer details or rustic finishes and color to add character, which make her built-ins look like furniture. Whatever the style, it is reflective of the type of house and the personal tastes of the clients. Traditional or Contemporary, Barbara strikes a balance of color, texture and pattern to complete a room. "Whether it is casual elegance, Traditional, Transitional, or Contemporary, it has to be sophisticated," says Barbara.

ABOVE
Pattern and texture combine with appropriate scale to add warmth and create an inviting effect in this grand living room.
Photograph by Sam Gray

FACING PAGE
A beautiful cased arch draws you from this gracious entry hall into the well-appointed room beyond.
Photograph by Sam Gray

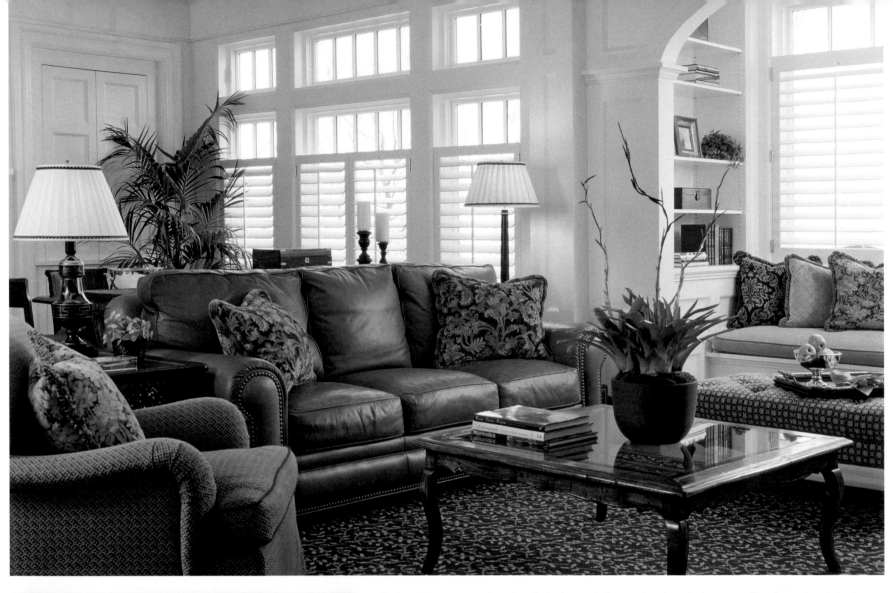

Barbara incorporates her client's design style by tapping into their personality, the style of the house, the age of their kids, favorite colors, and the level of formality in which they want to live. From monochromatic homes to those that are abuzz with color, she focuses on always being respectful of her clients' personal tastes.

Typically involved with whole house projects, through referrals of past and current clients, often she will work on their second homes, their parents' or their children's homes.

Tappe & Kotzen has been published in *Traditional Home, Better Homes and Gardens, Beautiful Bedrooms* and *Beautiful Window Treatments*. Barbara has recently completed work on *Boston* magazine's "Design Home."

ABOVE
Warm tones adorn this family room adding richness to this classically designed space.
Photograph by Sam Gray

LEFT
Warm wooden beams and wine racks interact beautifully with the rugged wall and floor texture, while the illuminated recessed wine niches add unique drama.
Photograph by Sam Gray

FACING PAGE
The designer used scale, rhythm, pattern and color to create impact in this comfortable media room.
Photograph by Sam Gray

TAPPE & KOTZEN INTERIOR DESIGN, LLP
Barbara Kotzen
7 Beverly Road
Wellesley, MA 02481
781.235.1740
Fax 781.237.9643

LINDY LIEBERMAN

LINDY LIEBERMAN LIVING SPACES

Lindy Lieberman is renowned for her impeccable design, style, extraordinary versatility and competence. Distinguished by her attention to detail, a deep respect for each of her clients' individuality and her work ethic, she is discerning and perceptive of their wishes. Lindy Lieberman has become a connoisseur of design during her very successful 25-year career in interior design.

Her credo "to create spaces for living" is incorporated in the name of her company, Lindy Lieberman Living Spaces, LLC, founded in 1981.

Her fascination and love of children, including the child's artistic development, led her to a study of the history of art and style, evolving into her true passion and ultimate vocation in interior design.

Her company has grown to support three staff members. Lindy's award-winning designs now grace the homes of Boston, New York City, the shores of Cape Cod and elegant Florida winter homes.

Lindy believes in lasting style that is well edited. She avoids prevailing trends. Her succinct spaces convey sincerity that is real for today's lifestyle. She combines simplicity

with what she calls "strong bones of design": work that is well-scaled and proportioned, uncomplicated color, careful use of texture and lighting and attention to functionality.

Combining both luxury and comfort, her style appears effortless and poised. A remarkably innate sense of color and the impact of varying materials enable her to weave intricate combinations of tone, luster, texture and pattern and yet maintain an end result that appears uncomplicated and inviting.

Lindy believes very strongly that art is not just meant for museums; rather, art is for everyday living and enjoyment, surrounding us with beauty. For Lindy, art is one of the keynotes that blend the elements presented in a space. She works to celebrate her patrons' collections, showcasing their unique artifacts.

ABOVE
Cleverly glazed, the "porcelain teal-blue" wallpaper enhances the ethereal quality of this warm living room. An 18th-century Venetian mirror reflects the tailored, slip-covered furnishings, and lush carpeting adds warmth to the antique mercury glass collection.
Photograph by Eric Roth Photography

FACING PAGE
Stylish and charming, this grand entry features a trellis-motif wall, Palladian windows and a painted floor cloth reminiscent of the 18th and 19th centuries. The elegant furnishing, antique fan-shaped mirror, Italianate candelabra and grand topiaries add sophistication.
Photograph by Eric Roth Photography

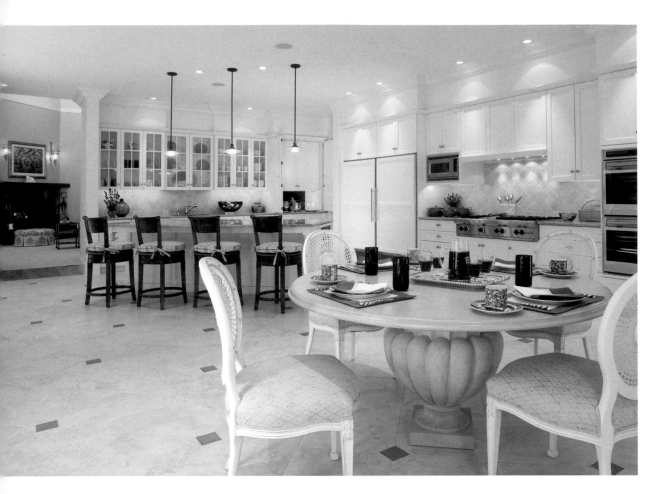

Eminently stylish, she harmonizes all the design elements, creating pleasing "living spaces" that capture the spirit of her expertise. Her beautiful designs, which range in style from Traditional to Contemporary and exciting combinations thereof, reflect her very high standards and precise execution. They appear at once spontaneous and natural, as though the homes have always been just as they now appear.

Lindy's interiors have been featured in *Traditional Homes*, *Better Homes and Gardens*, *House Beautiful* and *Design Times* as well as two books published by a highly esteemed textile house. She has been featured in television interviews and multiple newspaper articles related to her design. A testament to her commitment to excellence, Lindy has been asked to design many showhouses. She has been the recipient of the Junior League's Pineapple Award and an industry foundation award, among others.

For Lindy, the greatest reward is the opportunity she has had to meet so many wonderful people. She is most proud of the loyalty of her satisfied clients who repeatedly commission her to create spectacular new spaces.

TOP LEFT
Beauty and utility meld in this striking kitchen/breakfast room replete with a glass tile-accented limestone floor, charming and classic cabinetry and state-of-the-art appliances.
Photograph by Eric Scott Photography

BOTTOM LEFT
The dazzling, sapphire-blue tile, glowing Murano glass sconce and the mirrored walls combine to create the illusion of space and add drama to this washroom. Daring, modern fixtures create an exotic and enjoyable environment.
Photograph by Eric Scott Photography

FACING PAGE
The fern-print walls of this peaceful library complement the distinctive 19th-century American documentary cotton-and-linen sofa upholstery. Cleverly treated Palladian windows provide privacy while simultaneously maintaining light, and an important collection of art and eclectic African artifacts complete the room.
Photograph by Eric Roth Photography

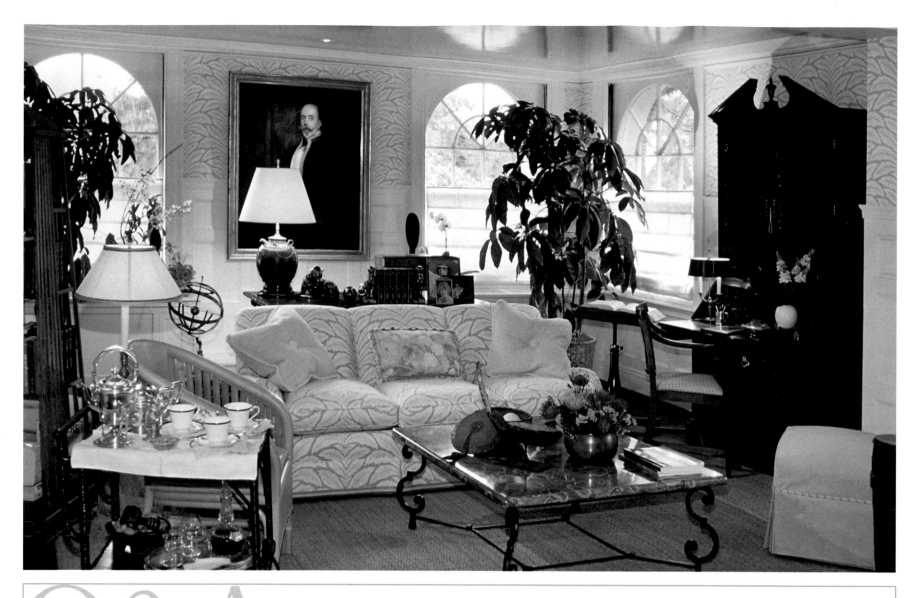

Q & A

MORE ABOUT LINDY ...

WHAT PERSONAL INDULGENCE DO YOU SPEND THE MOST MONEY ON?

Art. I believe that everyone should come home to an appealing environment including accessories, art being one of my favorites. Surrounding oneself with objets d'art that appeal to the individual has a wonderfully positive effect on one's inner soul and daily living!

WHEN IT COMES TO PURCHASING FURNITURE, WHAT ADVICE DO YOU GIVE HOMEOWNERS?

Look for lasting style, not gimmicks that will date and are easily tiresome. Select colors that are uncomplicated and easy to live with. Combine comfort and luxury, furnishings that are real for today's lifestyle.

WHAT IS THE HIGHEST COMPLIMENT YOU'VE RECEIVED PROFESSIONALLY?

Restraint and refinement are two comments that are often credited to my design style. Editing is one of the most important aspects of design that I appreciate and respect.

WHAT IS THE BEST PART OF BEING AN INTERIOR DESIGNER?

The ability to learn and grow as a person and a designer; exposure to all of the wonderful people, art, furnishings, textiles, lighting—everything that's out there. Design is a process of continuous learning, and the more I learn, the more knowledge I have to share.

LINDY LIEBERMAN LIVING SPACES, LLC
Lindy Lieberman
145 Gay Street
Westwood, MA 02090
781.329.6045
Fax 781.329.7772

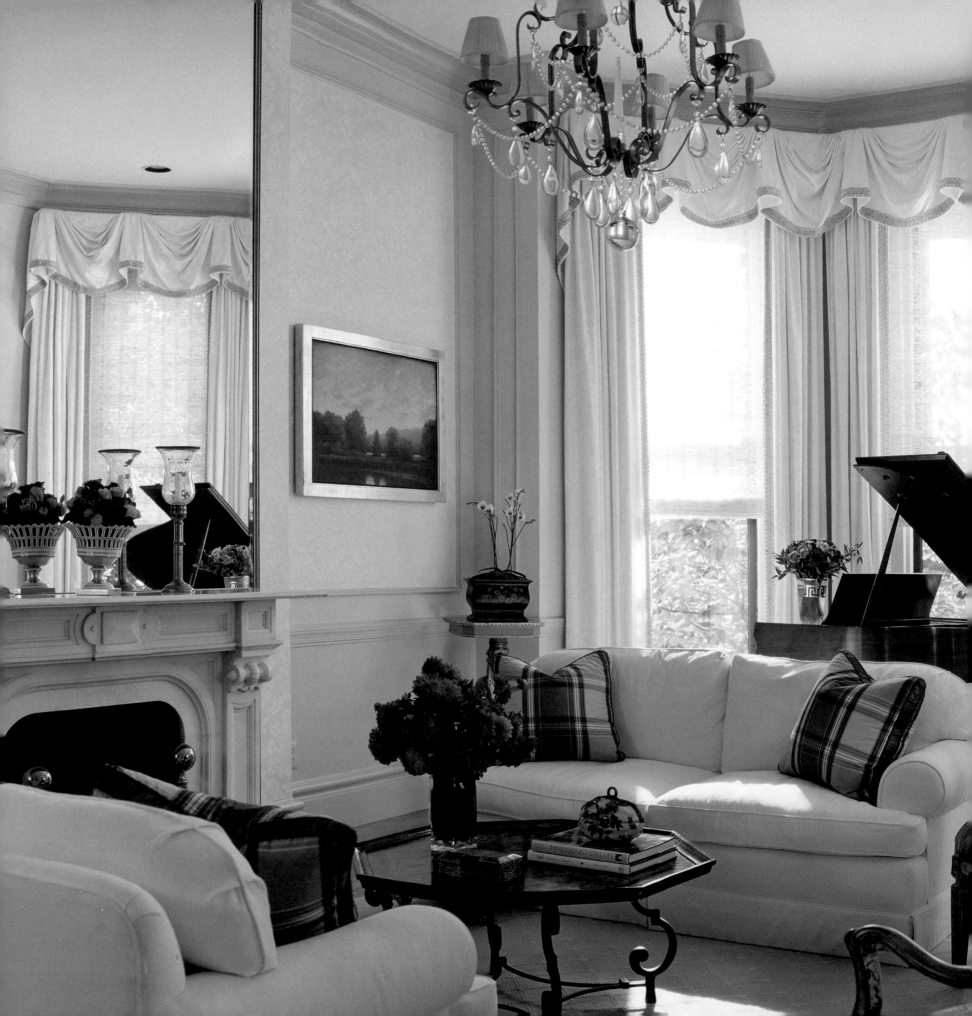

SUZANNE LITTLE
SUZANNE LITTLE INTERIORS, INC.

Suzanne Little is as much a historian as she is a designer. Indeed, her passion for historic homes encouraged her decision to pursue a career in home design 24 years ago and continues to inform the research and work she does today with her company, Suzanne Little Interiors. Suzanne's insistence on helping clients establish their own styles for their homes and her appreciation for and knowledge of New England history have earned her a large following throughout Massachusetts, New Hampshire and Maine, where she now offices. Indeed, patrons are so pleased with her expertise that they often ask her to design second, third and even fourth homes for them in such coveted locales as Jackson Hole, Wyoming and Delray Beach, Florida.

Suzanne credits her tenacious pursuit of education for her success. She has frequented the classes offered by the Boston Design Center and Historic New England, formerly SPNEA, on topics including art history, fabric and textile history and production and furniture construction, and she has thus become adept at distinguishing real antiques from reproductions. Her studies have afforded her the ability not only to apply all she has learned to the homes she designs but to teach residents the history behind the styles of design elements they choose for their homes.

Suzanne strives in her remodeling projects to preserve the heart of historic homes while successfully realizing the clients' desires. While recently working on a B&B dating back to the 18th century, Suzanne uncovered old swatches of three wallpapers, one with characteristics of the Arts-and-Crafts period. Carefully removing them, she brought the samples to an antique-wallpaper expert she knew from her years on the properties committee of the historical society. Once he had overcome his initial shock at Suzanne's rare find, he told her that one of the wallpapers originated in Boston in the 1780s. Although the B&B's doorways were widened and old woodwork was replaced, Suzanne preserved its history by framing its old wallpaper and hanging the swatches in the rooms in which she discovered them.

ABOVE
The painted floor and casual antiques in the entry set the tone for the rest of this Cape Cod summer home of a Boston couple.
Photograph by Sam Gray

FACING PAGE
For their primary residence, an old Boston brownstone, the couple wanted an updated yet fitting look for the glorious, high-ceilinged living room. Color pops from the silk pillows and beautiful artwork.
Photograph by Sam Gray

Suzanne's preservation efforts are not limited to history. She does her part to maintain the environment as well. She avidly reads *Environmental Design + Construction* and applies the principles therein to each home she designs, encouraging clients to reuse what they already have as much as possible. In new construction projects, she strives to suggest Green design ideas for flooring, windows and lighting, and she works with the community to ensure that environmentally friendly measures are observed in civic structure construction. Her philosophy for the Earth is thus the same as that for each home she designs: We must pay homage to those who have come before us while striving to restore and beautify our home for ourselves and our progeny.

TOP LEFT
Whimsical blue-painted stripes along with yellow and white hues make for a joyful retreat in this Cape house master bedroom.
Photograph by Sam Gray

BOTTOM LEFT
The antique lamp base antique corbels high on the bookcase and large coffee table, on which to rest one's feet, make this Cape house living room a lovely place to relax.
Photograph by Sam Gray

FACING PAGE LEFT
The quiet walls and soft furnishings in this Boston townhouse master bedroom provide a restful retreat from busy city life.
Photograph by Sam Gray

FACING PAGE RIGHT
The owner of this Cape house loves to entertain in the dining area set off by a painted floor, lovely artwork, an antique cupboard and a Nantucket basket.
Photograph by Sam Gray

Q&A

MORE ABOUT SUZANNE ...

WHAT COLOR BEST DESCRIBES YOU AND WHY?

I love coral. It's a pastel with a great deal of life—it's never boring. It's warm, but at the same time calm and restful. If I had to live in a cocoon, I'd choose coral as its color.

WHAT SETS YOU APART FROM OTHER DESIGNERS?

I listen very closely to my clients to get to know their personalities and tastes. When I recently embarked on a fourth project with one of my clients, she and I brought the same magazine photographs to our initial planning meeting!

WHAT IS ONE THING YOU LIKE ABOUT DOING BUSINESS IN YOUR LOCALE?

People here are thrifty and quick to reuse older items in their homes.

MY FRIENDS WOULD TELL YOU I AM ...

The busiest person they know! When I'm not working as a designer, I am head of the program committee at and a trustee of our local library, I serve as an advisor on the board of our local art association, I'm actively involved in our church and I've served on the properties committee of the local historical society.

NAME ONE THING MOST PEOPLE DON'T KNOW ABOUT YOU.

I love to paint. I have taken numerous studio art courses in both oil painting and water color, and I painted murals on my grandchildren's bedroom walls.

SUZANNE LITTLE INTERIORS, INC.
Suzanne Little, Allied Member ASID
PO Box 996
York Harbor, ME 03911
207.363.7527
Fax 207.363.3017

SHERI MATTIUCCI
LEONARDS NEW ENGLAND

Sheri Mattiucci strives for design with drama and Old World panache. "I love rooms that look as though they have been in a home forever, rooms that captivate you and make you want to stay," says Sheri. Bringing an unparalleled skill to the process, Sheri expertly sees the possibilities of a space, envisions it from top to bottom and then sets about implementing that design down to the finest detail. Boasting a sterling educational background, Sheri studied at La Sorbonne in Paris, France, The Rhode Island School of Design and is a proud graduate of the University of Rhode Island holding a bachelor's degree in Textiles, Merchandising and Design, with a minor in French.

Her natural ability to combine color, texture, shape and style create sophisticated, layered interiors that are complex yet uncomplicated. Sheri is able to move with equal dexterity among many different styles, tailoring each to the specific needs and desires of her clients. Providing invaluable service, Sheri helps to guide them to their ultimate vision, opening their eyes to ideas that they never imagined, and that once installed, find they can't imagine living without.

Important aspects of Sheri's thoughtful design are layers and depth. "The most interesting people I know have many layers to their personality and the same goes for great interiors," she says. A combination of the right colors, textures, and special collections all add to the definition and atmosphere. Everywhere you look there is something beautiful, something perhaps not seen before, something wonderful to discover. Art and accessories exhibit an introspective look, exemplifying the time

ABOVE
Hand-painted DeGournay wallpaper is the backdrop for exquisite fabrics in soft shades of pink, lavender, blue, burnt orange and green.
Photograph by Chris Vaccaro, Courtesy of Schryver Publications

FACING PAGE
Heavily adorned window treatments frame and soften the large windows, while balancing the tall ceilings and extensive millwork.
Photograph by Chris Vaccaro, Courtesy of Schryver Publications

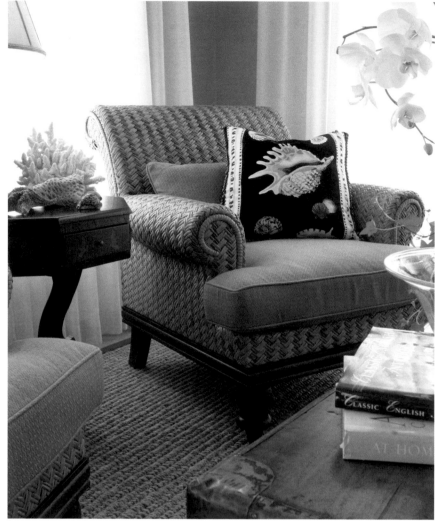

and affection taken to pull them together. Additionally, incorporating antiques adds importance and life, especially into small spaces. "There is something so amazing about an antique piece; where it came from and who owned it. An antique will outlive us and we are lucky to be a part of its journey through history."

Always going with her instincts, Sheri encourages her clients to do the same, reminding them that if they are drawn to something, they should purchase it. That willingness to take a risk also serves as the inspiration, innovation and imagination that sets Sheri apart from her peers. Modest about her achievements, Sheri feels that the highest compliment she has received professionally was a happy and well satisfied client who, touched by the personal touches and insightful details, cried tears of joy. Sheri has also received numerous industry recognitions for her exquisite work including features in *Southern Accents, Southern New England Homes Magazine* and *New England Home Magazine* and was also a highlighted guest on the Keno Brother's PBS series, "Find."

ABOVE LEFT
Faux-painted burl wood walls in rich shades of cognac and chocolate envelope the large space, making it warm and inviting.
Photograph by Olson Photographic, LLC

ABOVE RIGHT
A West Indies-style chair and antique inlaid rent table from Nantucket suggest a tropical feel in this seaside home.
Photograph by Rachael Girard, Courtesy of Schryver Publications

FACING PAGE LEFT
Rich earth tones and plush upholstery help create a cozy sitting area ... even for the clients' beloved Pug.
Photograph by Rachael Girard, Courtesy of Schryver Publications

FACING PAGE RIGHT
This playful room is filled with fun, frills and fantasy—certainly fit for a princess.
Photograph by Rachael Girard, Courtesy of Schryver Publications

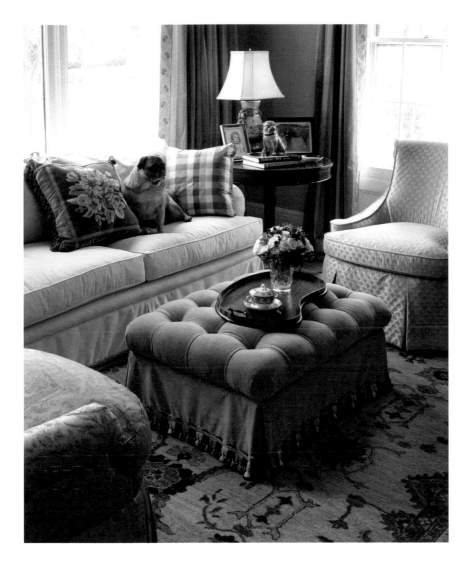

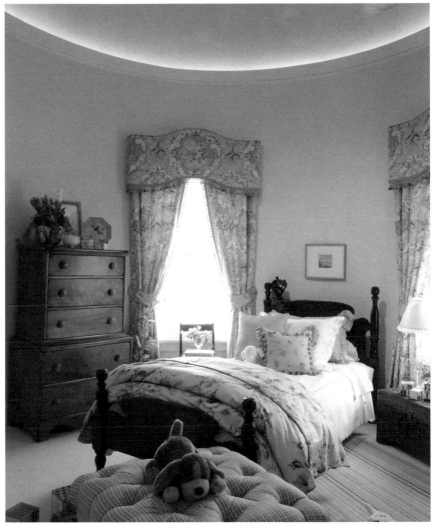

Q&A

MORE ABOUT SHERI ...

WHO HAS HAD THE BIGGEST INFLUENCE ON YOUR CAREER?

Mario Buatta, Charlotte Moss and Cindy Rinfret have had a HUGE impact on my design style. Their beautiful rooms and layered details captivate and motivate me to do what I do. Also, Jeff Jenkins has had just as big an impact on my design from a career standpoint. He pushes me to be my best, teaches me every day and inspires me with his generosity and wisdom. For that, I am forever grateful to him.

WHAT IS YOUR FAVORITE PIECE IN YOUR OWN HOME?

I have several favorite pieces in my home: an Italian gilt-wood mirror (circa 1760), an Adam's Style gilt-wood mirror (circa late 1700s) and a pair of 19th-century beehive and diamond brass candlesticks. They are incredible pieces that have such history and soul.

NAME ONE THING PEOPLE DON'T KNOW ABOUT YOU ...

I make the best margaritas!

WHAT COLOR BEST DESCRIBES YOU AND WHY?

There are two colors that really describe me: gold and chocolate brown. Gold because it's bright, warm and glamorous. Brown because it's deep, strong, elegant, sophisticated, versatile and indulgent.

LEONARDS NEW ENGLAND
Sheri Mattiucci
600 Taunton Avenue
Seekonk, MA 02771
888.336.8585
Fax 508.336.4884
Cell 401.559.6647
www.leonardsdirect.com

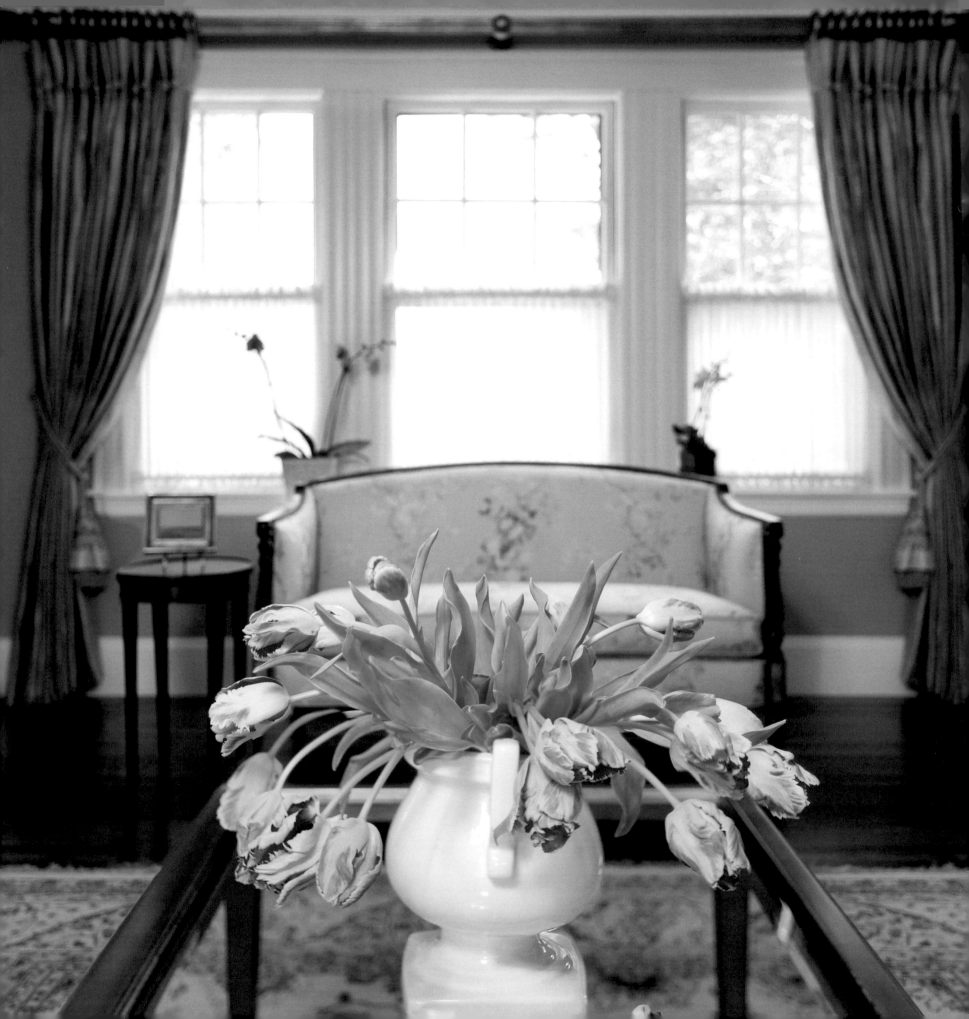

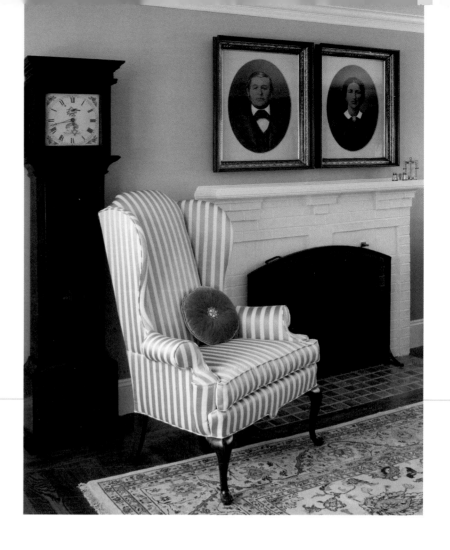

KAREN NEWMAN
JANET PARASCHOS
HEATHER VAUGHAN

PENTIMENTO INTERIORS

Pentimento: Taken literally, it is an art term that refers to an older painting hidden behind a newer painting. But to partners Karen Newman, Janet Paraschos and Heather Vaughan, Pentimento represents the creative journey in which beautiful spaces emerge in their clients' homes.

Clients appreciate that all three designers bring their unique stylistic opinions and professional experiences to every project.

Karen's artful eye was nurtured as a student and graduate of the City and Guilds of London Art School. Janet's work reflects the several years she lived abroad. As a writer for *American Preservation* magazine, she grew particularly fond of historic houses, a passion all partners share. Heather's love of fine antiques, as well as appreciation for contemporary design, provides a transitional perspective to Pentimento's work.

Among the three of them, the full design continuum is covered. Though each partner's viewpoint is unique, a commonality among all of their work is the desire to invent original designs and avoid using the same fabric, fixture or piece of furniture twice. The partners agree there are too many great choices in the design world to be repetitive, and they believe clients deserve uniquely custom results. This dedication to freshness

compels them to think out of the box, from window dressings to furniture and even color palettes. Because the designers strive for uniqueness, Pentimento has developed strong relationships with local workshops to craft custom window treatments, built-ins and freestanding furniture.

The whole team's undivided attention is needed for some of their more encompassing projects, such as the floor-to-ceiling design of a seaside estate. Like many of their clients, the owners wanted an interior that reflected their contemporary desires yet honored their heritage and the building's history. The Pentimento designers integrated cherished heirlooms from the primary residence with fine yet durable finishes in a grandkid-friendly, beach appropriate manner.

ABOVE
With a softened, classic color-palette on the walls and coordinating tile on the fireplace hearth, the client's ancestor portraits found their home.
Photograph by Edua Wilde

FACING PAGE
The inherited antique settee took on new life with a Scalamandré fabric, coordinated with delicious silk window panels, for an understated yet sophisticated look preferred by the client.
Photograph by Edua Wilde

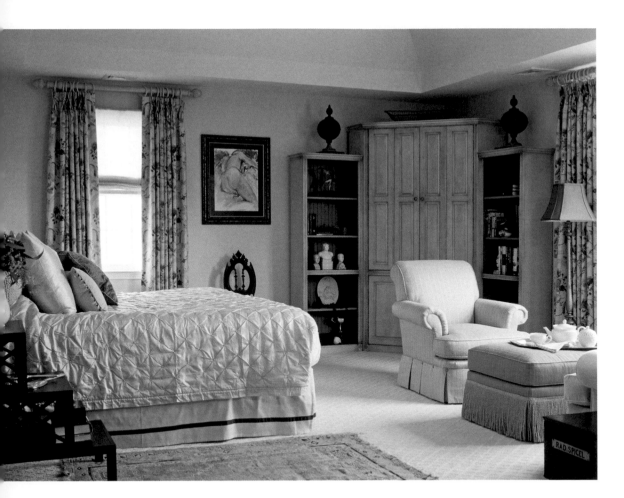

Whether their task is to bring interior warmth to new construction, restore a worker's cottage in historic Boston, or oversee the complete updating of a Berkshire's B&B, the Pentimento partners approach each job the same way: They listen to their clients and pay attention to details all along the way, from the initial brainstorming to final installation. They have learned that design is about more than the right color, fabric or surface; it is about who their clients are, and what their needs and desires are.

From designs that respect historic architecture to the finest details of interior design, Pentimento's clients are ensured an enjoyable process as well as a beautiful end result.

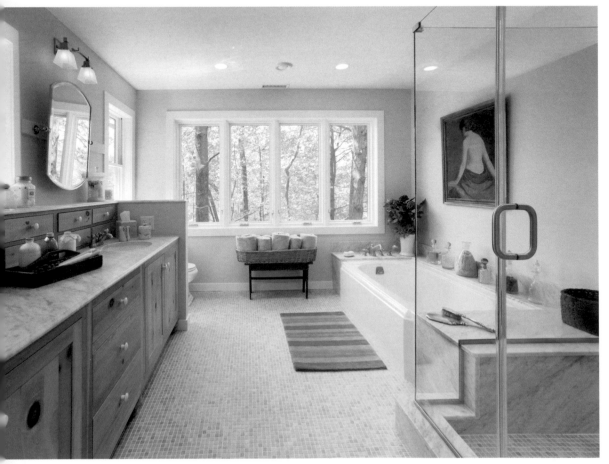

TOP LEFT
The addition of a sitting area and custom-built corner bookcase, which hides a television, creates coziness in this large master bedroom suite.
Photograph by Sam Gray

BOTTOM LEFT
A Berkshire's B&B was transformed by the addition of a private second floor, including this tree-top master bathroom, which features a custom vanity and colors that bring nature indoors.
Photograph by Edua Wilde

FACING PAGE TOP
A former porch overlooking a lake was incorporated into the living area of the Berkshire's B&B, achieving the goal of a "room with a view," which guided design decisions.
Photograph by Edua Wilde

FACING PAGE BOTTOM
Designers in order from left to right: Heather Vaughan, Karen Newman and Janet Paraschos.
Photograph courtesy of Pentimento Interiors

Q&A

MORE ABOUT KAREN, JANET & HEATHER ...

HEATHER, HOW DID PENTIMENTO BEGIN?

Karen and I met while working on a non-profit design job and quickly developed a camaraderie. When Janet moved back to the States, Karen introduced us and we decided that sharing resources, creative and otherwise, would help us as designers and give our clients the benefit of three viewpoints.

HOW DO YOU KEEP TRACK OF EACH OTHER'S PROJECTS?

All of us participate in the initial consult, so the client gets three sets of eyes, ears and opinions. One of us takes the lead on the project, with the other two available as needed. At our weekly business meeting we discuss each client's project. We all have a mental catalog of resources, techniques and concepts, so throughout the process, there's a constant sharing of ideas.

WHAT IS THE BEST PART OF BEING INTERIOR DESIGNERS?

Hunting for and finding just the right element to make a room come together. And then, standing with a client in the doorway of a just-finished room and reveling in the mutual satisfaction of an inspired project.

HOW DO CLIENTS RESPOND TO THE FINISHED PRODUCT?

We make our clients' wishes our top priority. As a result, we end up with a room that reflects our client's desires and we quite frequently hear, "This room looks like me!"

PENTIMENTO INTERIORS
Karen Newman
Janet Paraschos
Heather Vaughan
One Leighton Road
Newton, MA 02466
617.559.0450
Fax 617.965.2874

EILEEN PATTERSON

THE PATTERSON GROUP

When Eileen Patterson relocated from Florida to Massachusetts over 20 years ago, not only was she in for a bit of a culture shock, the experience offered the perfect opportunity to broaden her talent for design. At that time, Eileen's experience with Florida's very contemporary tastes contrasted with classical New England. In response, she discovered just the right balance of each genre's best design elements and in doing so began a legacy of solution-based, livable and stunning interior design in New England.

An early chance to design condominium models for Boston's prestigious Four Seasons hotel and then Heritage on the Garden quickly proved that inherent talent and design acumen easily transcend locale. Joining forces with the late John Olsen in the mid 1980s led to an enhanced practical "education" of New England design and tastes, infused with Eileen's own experience and flair. The partners practiced from their firm on Newbury Street until Eileen opened her own namesake firm in 1990.

Today the firm includes four full-time designers directed by Eileen. Though the firm has completed commercial projects, their primary focus is residential design. The Patterson Group keeps its work well-focused and familiar, giving each client the personal attention they deserve and the attention that good design necessitates. The firm has carved out a niche in New England design by offering guided solutions to the interiors of their clients' homes as well as conceptual architectural design. Eileen relishes nothing more than to have a set of blueprints in which she can address lighting patterns, plumbing and general

LEFT
A total renovation without construction. The firm removed all of yesterday's dark paint, fabrics, rug and draperies and renovated with today's light fixture, light colors, textures and cleaner lines.
Photograph by Sam Gray

flow of the as of yet, moldable shell of the home—the soft goods follow suit. She regularly works with highly regarded area architects and contractors who value the insight she brings to their work.

With design conception truly a part of who she is, Eileen even has her hand in product development for several different companies, developing everything from furniture to tableware and accessories—accoutrements which designers need to "polish off" their installations. Due to a void in the current marketplace, designers and clients alike find there is most definitely a need for these products.

Traditionally, the thought of New England interiors conjures visions of Queen Anne furniture and dark, heavy materials. Eileen remarks that while she might understand that stereotypical image, it is an image from the past. The design climate of New England is ever-evolving and one of which Eileen is delighted to be a part. Eileen finds that New Englanders are educated, well-traveled and open to new ideas, making her vocation that much more enjoyable.

Inspired by the clean-lined and fresh designs of the 1930s and '40s, elements that remain classic, Eileen introduces her interpretation of Transitional. It is a pleasing style that perfectly toes the line between Traditional and Contemporary, emphasizing the importance of commanding pieces including brilliant works of art and stunning antiques, all in harmony to create a comforting and warm living space.

If queried, the sense of refuge and enjoyment Eileen creates for her clients is the most important facet of her work. Thrilling clients with her original designs is her driving motivation—from the active family who desires elegance but whose everyday dynamic requires durable fabrics to the empty-nesters who hope to transform their bedroom into a haven—Eileen savors the challenge.

ABOVE
Minimal and clean-lined style prevailin this totally renovated family room. The firm streamlined the fireplace and mantel and built a wall unit with upholstered sliding panels to conceal the television.
Photograph by Sam Gray

FACING PAGE LEFT
Practical and elegant, this dining area features a table surrounded by leather/wood chairs, perfectly blending custom banquette upholstered walls and limestone floor. Signed photos of some of Hollywood's greatest stars enhance the entrance to the home theater.
Photograph by Sam Gray

FACING PAGE RIGHT
A classical composition decorates the living room, ideal for entertainment or relaxation.
Photograph by Sam Gray

Q&A

MORE ABOUT EILEEN ...

WHAT DO YOU LIKE MOST ABOUT DOING BUSINESS IN YOUR LOCALE?

Boston affords us the opportunity to do sophisticated downtown condominiums, drive two hours north and do a ski house or drive an hour south to the Cape for a beach house.

IF YOU COULD ELIMINATE ONE STYLE FROM THE WORLD, WHAT WOULD IT BE?

I would eliminate costly, trendy styles which won't make sense in a few years.

WHAT IS THE BEST PART OF BEING AN INTERIOR DESIGNER?

Adding beauty to my clients' surroundings both on a residential and commercial level.

WHAT COLOR BEST DESCRIBES YOU AND WHY?

Cinnabar: zest and passion for life, lively but tasteful, bright but not over the top.

THE PATTERSON GROUP
Eileen Patterson
One Design Center Place
Boston, MA 02210
617.443.4904
Fax 617.330.6712

LISA PENNICK

LISA PENNICK INTERIORS

"Friends and clients would characterize Lisa Pennick as "classic." Dressed in jeans, a white shirt and an Hermès scarf, she possesses a confidence that is evident in her interior design and architectural work.

Lisa's decorating career was thrust upon her while doing Summer Stock work in Vermont at Saint Michael's College. The set decorator did not show up for the "Belle of Amherst" and Lisa and the producer stepped in to create the set.

Feeling inspired with the world of decorating, Lisa worked for various decorating firms and soon landed in the Beverly Hills Ralph Lauren store. After a few years on the West Coast Lisa returned home to her New England roots and started her own business in the beautiful seacoast town of Marblehead, Massachusetts.

Now in its 11th year of business Lisa Pennick Interiors uses decorating to encourage her clients to live more simply and beautifully among the things they love.

Lisa's design philosophy is that homes should not feel too formal but rather possess a "barefoot elegance." Her mantra to her clients is "you must love it!" That means each room should have a unique signature. That could be a painting, a beautiful rug, a cherished antique, or the all important lead fabric. Her clients' individual tastes rule the essence of Lisa's designs. She feels strongly a house should be a haven full of little luxuries to rejuvenate her clients. Rooms should never look too new, even if they are, but should feel as if they evolved over time.

ABOVE
Lisa's client's fondness of red dictates this dining room's "farmer chic" feel.
Photograph by Terry Pommett

FACING PAGE
In this summer guest house, Lisa went for a nautical feel to fit the setting.
Photograph by Terry Pommett

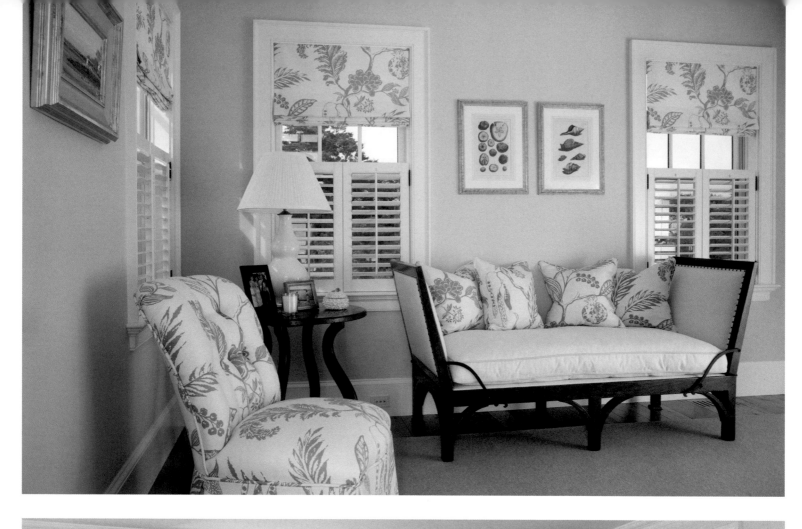

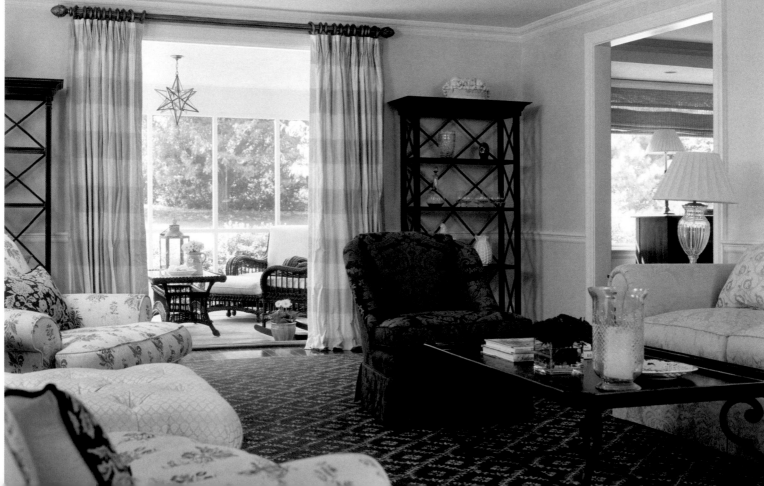

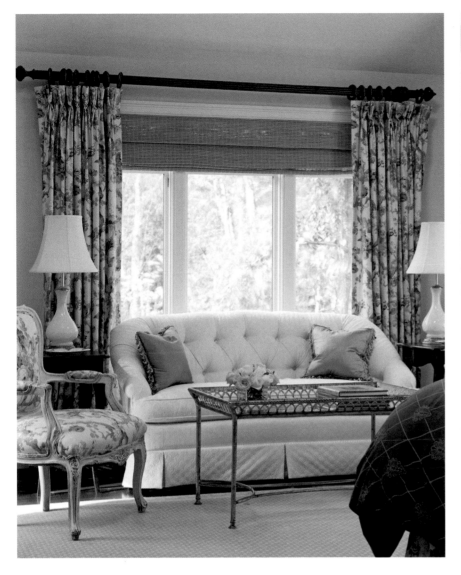

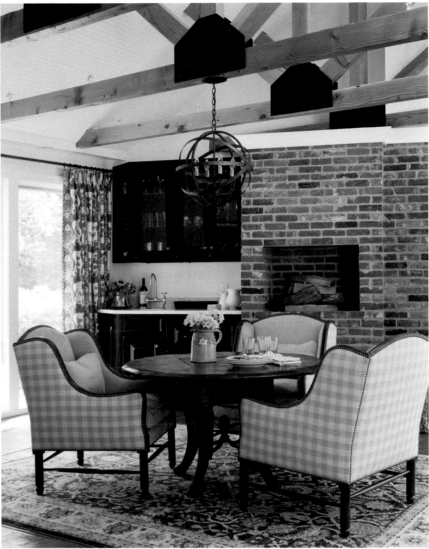

Most important to Lisa is the relationship she develops with her clients. She strongly encourages her clients to be a part of the decorating adventure. This helps her in discovering something new about them and incorporating their needs in their homes. Her decorating goal? Rooms should be relaxed beauties for the perfect fit for her clients.

Along with her interior design expertise, Lisa also does complete building plans, renovation work and individual room layouts while working closely with the building team.

These projects take her wherever her clients are located. Whether it be a complete renovation of a "classic Cape" in New Castle, New Hampshire, a building of a summer home on Nantucket, new construction in Hingham, updating classic homes in Weston, or soup to nuts projects in Marblehead.

Lisa finds that inspiration in other aspects of her life helps keep her fresh in her interior design business. Her love of music, books, movies, and working out helps keep her

in the moment. Lisa writes poetry and is co-writing a screenplay with her brother Jay Pennick, a writer and working actor.

Lisa is currently working on renovating her own home and loving every part of the process. Her favorite part about the world of design? "What can be conceived can be created."

ABOVE LEFT
The goal of this master bedroom was to offer Lisa's client a soft haven at the end of her day.
Photograph by Sam Gray

ABOVE RIGHT
Lisa transformed a small breezeway into a game room for her client's active lifestyle.
Photograph by Sam Gray

FACING PAGE TOP
In the guest sitting room, a Manual Conovas print sets the tone for this soothing retreat.
Photograph by Terry Pommett

FACING PAGE BOTTOM
This living room combines color and comfort to create understated elegance.
Photograph by Sam Gray

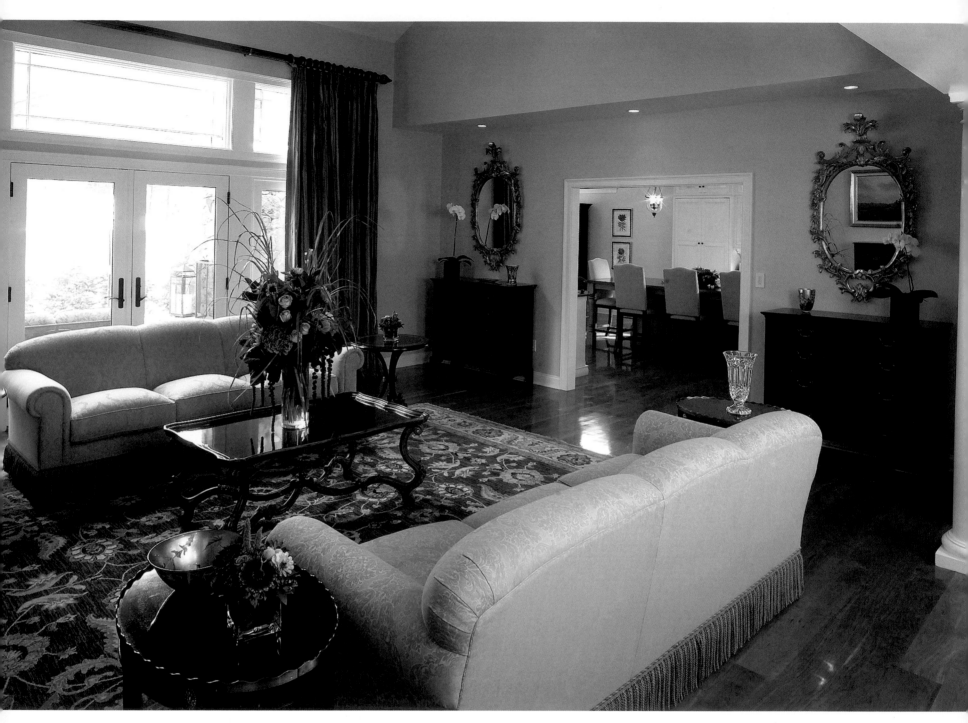

ABOVE
This recently built great room reflects her client's classic style.
Photograph by John Ferranone

FACING PAGE
Bright, airy and functional design makes this kitchen the entertainment center of Lisa's client's home.
Photograph by Sam Gray

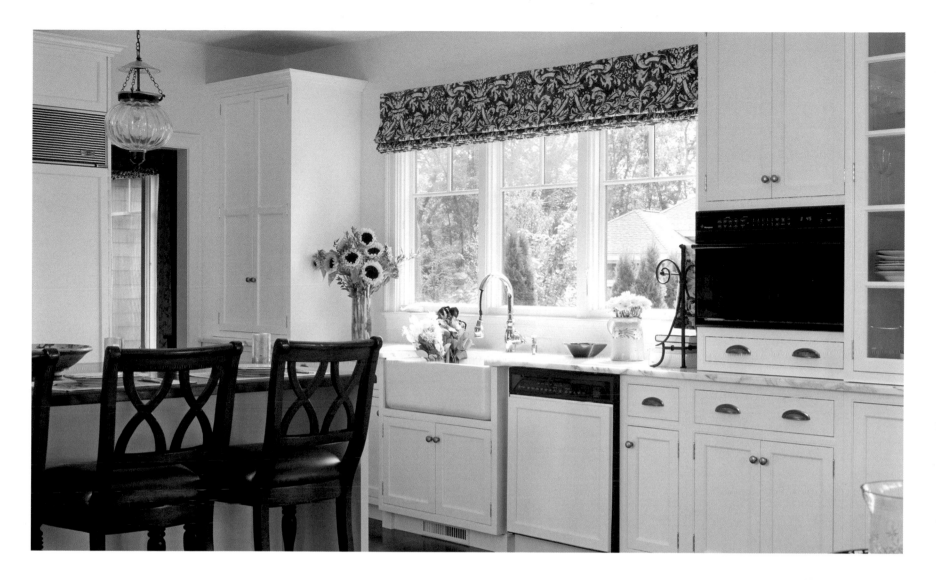

Q&A

MORE ABOUT LISA ...

YOU CAN TELL I AM FROM BOSTON BECAUSE I ...

Am a proper 100% cotton improper Bostonian.

WHAT SEPARATES YOU FROM YOUR COMPETITION?

Heart and enthusiasm.

WHAT ELEMENT OF STYLE OR PHILOSOPHY HAVE YOU STUCK WITH
FOR YEARS THAT STILL WORKS TODAY?

When in doubt, keep it classic.

IF YOU COULD ELIMINATE A DESIGN/ARCHITECTURAL/BUILDING
TECHNIQUE, WHAT WOULD IT BE?

I love and appreciate all styles of design. I would eliminate run down and re-do it!

DESCRIBE YOUR STYLE AND
DESIGN PREFERENCES.

Farmer Chic, Barefoot Elegance.

WHAT IS THE HIGHEST
COMPLIMENT YOU HAVE
RECEIVED PROFESSIONALLY?

One client told me that I not only made
her feel better in her own home but I
also made her feel better about her entire
outlook on life.

Photograph by John Ferranone

LISA PENNICK INTERIORS
Lisa Pennick
40 Cloutman's Lane
Marblehead, MA 01945
781.631.1522
Fax 781.639.1711

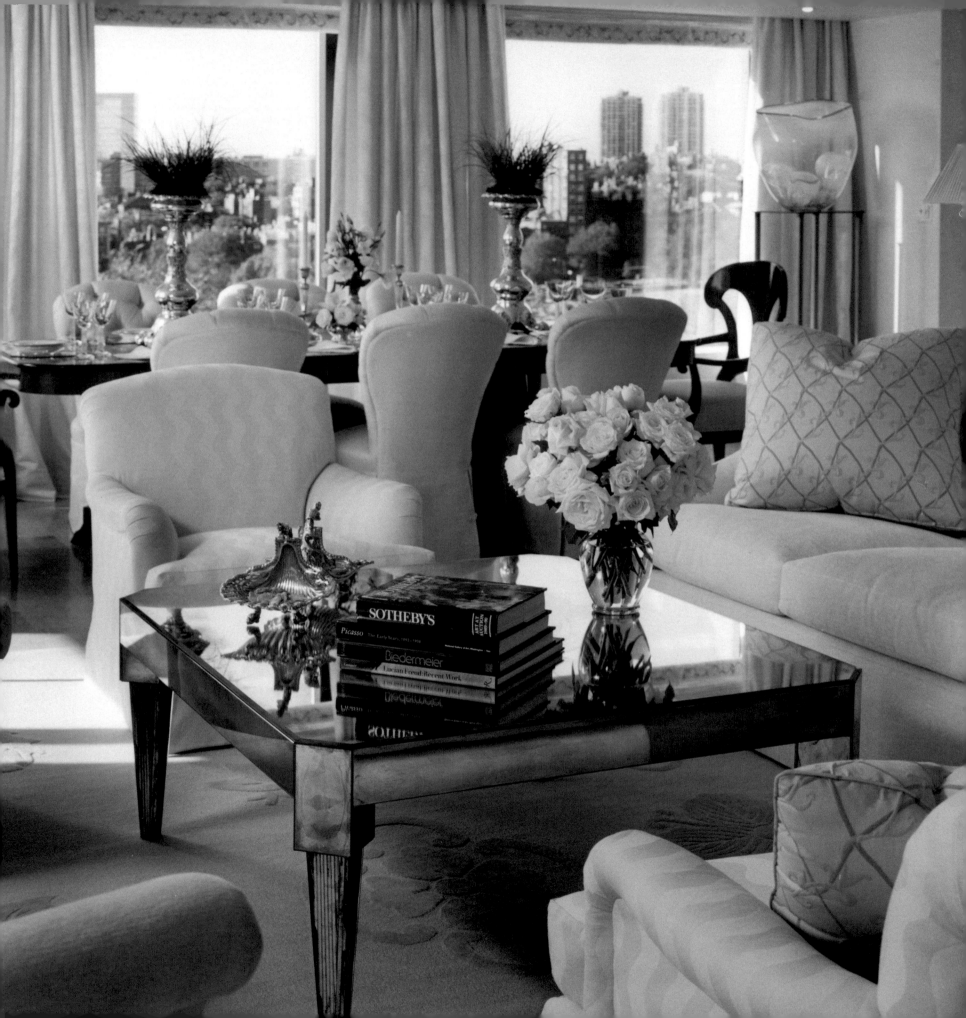

JUDITH ROSS
JUDITH ROSS AND CO., INC.

Situated on the bustling corner of Newbury and Arlington near the heart of Boston's famed shopping area, the design studio of Judith Ross and Co. is a gathering place of unique ideas. With more than 25 years of experience, principal and founder Judith Ross leads a team of 10, which includes project designers and interior architects, in the quest to create meaningful spaces that bring out the best in people.

Clients describe Judith as friendly, down-to-earth and genuinely interested in their unique needs. Part of this approachability undoubtedly stems from her background in theater. Before she discovered her passion for design, Judith studied acting quite extensively and performed with the Theatre Company of Boston and theaters in New York. During these formative years, she learned the trades of lighting and set design, became quite familiar with various time periods and social customs, and developed an overall sense of aesthetics. As a master of how people interact with space and each other, she approaches interior design as if she were dressing a theater, because she is, after all, setting the stage for her clients' lives to unfold.

Although Judith works in an ever-changing variety of styles—from French Country to Contemporary Zen, English or Eclectic—all of her projects have an underlying presence of softness, warmth and edited elegance. Through the process of distilling the essence of her clients' preferences and the design itself, she finds that clients are left with a delightful result: contemporized traditional design.

Projects to her name run the gamut. Judith is unreservedly dedicated to high-end residential design, yet by popular request, she has branched out to country clubs,

ABOVE
Surprise elements include custom plaster walls, curly maple columns designed by Judith Ross, a French clock, and an antique Biedermeier cabinet.
Photograph by Richard Mandelkorn

FACING PAGE
Sophisticated Boston living.
Photograph by Richard Mandelkorn

corporate offices, common areas of condominiums and even a 175-foot yacht, which was drafted in England, built in Amsterdam and won an international award. Further diversity has come with the design of clients' vacation homes in California, Florida and St. Barts Island and even an incredible property in Israel. Wherever Judith designs, clients are assured complete discretion, as privacy is a keynote of her organization. She finds joy in all of her projects, yet a particularly rewarding commission was an 8,000-square-foot Colonial in Weston, with tasteful design, an unassuming presence, and children running through the courtyard. Nothing compares to the satisfaction of a family reaping the benefits of beautiful design.

Judith aims to please, so if the ideal fixture or piece of furniture cannot be found, she and her staff simply draft the plans and have it made. Having interior architects as members of her team serves clients well because such great attention is placed on "building a good box" that the décor side of interior design can be wholly savored by

Judith's patrons. Her uncanny ability to visualize completed rooms before the design is even underway is a tremendous asset to clients because while they are involved with the detail decisions, she keeps the big picture in mind. Judith conveys, "Simplification is an art, and if even one thing changes, we re-evaluate the whole," and with this commitment to thinking through the design until a perfect solution is attained, it is no wonder that clients regard her so highly.

ABOVE LEFT
Lalique lighting warms the entry.
Photograph by Richard Mandelkorn

ABOVE RIGHT
Juxtaposition of old and new—the office includes an antique Biedermeier desk and new custom cabinetry.
Photograph by Richard Mandelkorn

FACING PAGE
Simple and grand—this bedroom was designed for comfort.
Photograph by Richard Mandelkorn

MORE ABOUT JUDITH ...

ARE THERE ANY DESIGN STYLES THAT YOU WOULD LOVE TO ELIMINATE?

Even if I think something looks awful, at least it shows what not to do. Because of the growing practice of building homes that are too large for the land, I really appreciate areas where homes have space to breathe.

DESCRIBE THE INTERIOR OF YOUR DESIGN STUDIO.

We've utilized every inch of our 1,800-square-foot studio that overlooks the Boston Garden. The style is more or less eclectic, with contemporary work spaces and a conference room that boasts black cement floors, an Italian overmantel and chairs from Sweden, France and the Orient. It's not fussy, just comfortable and inviting.

WHAT IS THE BEST PART OF BEING A DESIGNER?

There's nothing better than working with people you enjoy, building relationships and sharing inspiration.

WHAT ARE YOUR THOUGHTS ON COLOR?

Many of our clients are attracted to neutral palettes, but everyone appreciates at least a splash of color within the striations of beige because color represents individuality.

WHAT IS THE GREATEST COMPLIMENT YOU HAVE RECEIVED?

When clients return over and over again or share our name with their closest friends.

JUDITH ROSS AND CO., INC.
Judith Ross
Two Newbury Street
Boston, MA 02116
617.267.5045
Fax 617.267.1163

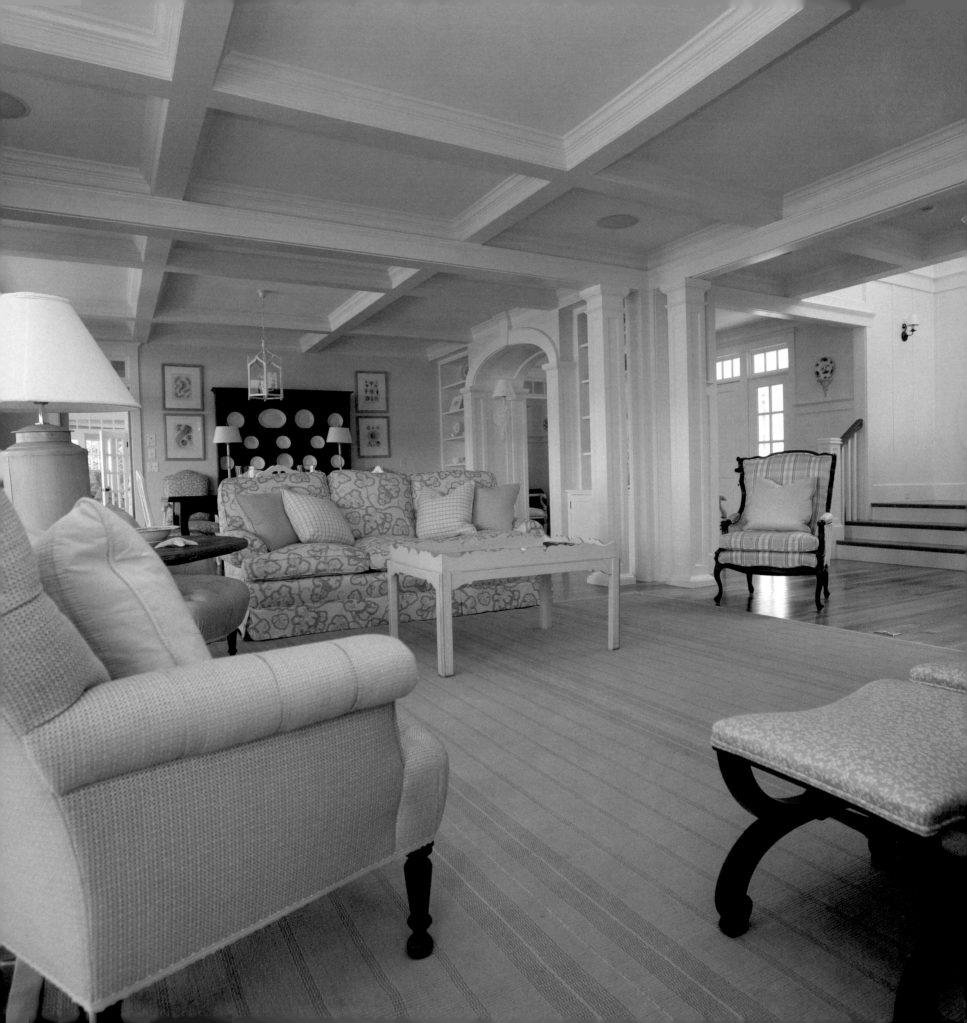

MALLY SKOK

MALLY SKOK DESIGN

Textiles have a way a talking to designer Mally Skok. They are often the Inspiration for the design of an entire room and provide a flowing visual tapestry to her comfortable and unpretentious designs. Whether it is a traditional seaside stripe or an accent pillow made from a vintage fabric she picked up in London, Mally has an eye for color and consistency that goes beyond the every day.

If it is not fabric as muse, it is a single precious object or collection beloved by the homeowner that Mally draws upon. The designer's talent for finding the authentic—she has been flea marketing since the age of six—and layering it into elegant interiors comes from years of travel and an education in the arts. Plus, "You've got to search for the quirky pieces," she says.

Much of Mally's approach is client driven. Her philosophy is that design has too many solutions to be rigid. It should be about comfort, creating the right room layout, and understanding clients' needs by being sensitive to their lifestyle.

The path to happiness in design, according to Mally, is layering the furnishings, rugs, artwork, and collections with the unexpected such as interesting antiques, Pakistani bowls, a mix of patterns, or classic bits of ironstone.

Before moving to New England, the South African-born Mally learned about the design business working with a friend in London. Her work has appeared in numerous showhouses, on television and in a number of regional and national magazines such as *Boston* magazine and *Traditional Home*. Even if it is just freshening up someone's space with the perfect pillows from her Concord, Massachusetts, store, The Good House Shop, Mally brings excitement and enthusiasm to each project.

ABOVE
The back hallway, the busiest place in the house. The family cairn terrier, Nelson, loves to lie on the cool Mexican tile floor on hot summer days.
Photograph by Eric Roth

FACING PAGE
View of the living room looking towards the dining area. Sea glass colors create a relaxed and calming atmosphere. The shelves give the designer plenty of places to display her passion for found objects collected over the years in junk stores or on the beaches of South Africa.
Photograph by David Skok

MALLY SKOK DESIGN
Mally Skok
23 South Great Road
Lincoln, MA 01773
781.259.4090
www.mallyskokdesign.com

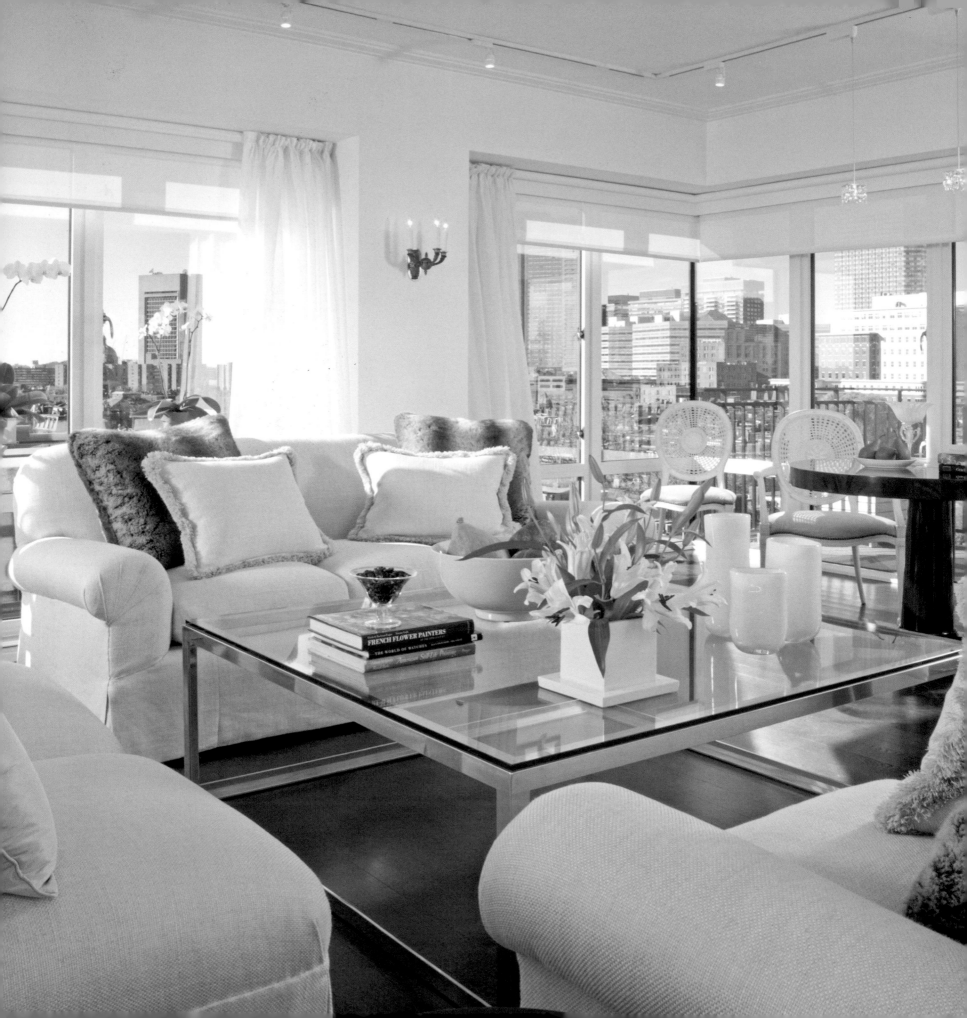

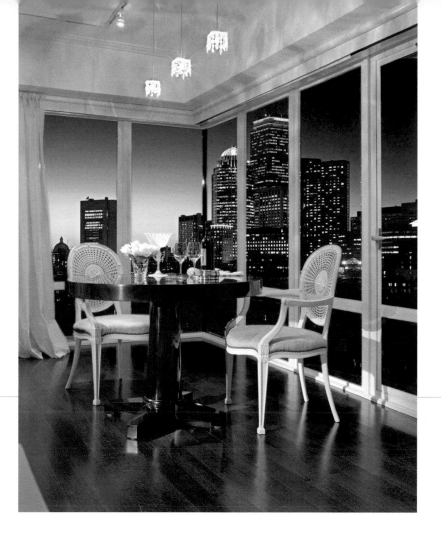

CHARLES SPADA

CHARLES SPADA INTERIORS

The refined, subtle colorations in a Charles Spada-designed room are his calling card. White is a favorite, but beige and warm ivory set the understated tone. Classic, but tailored for today's busy lives, his work incorporates a mix of fine antiques and contemporary furnishings that never appears cluttered, but rather as if it has been well edited over the years.

His skill comes from his training as a fashion designer in Paris. He applies the same disciplined design approach to interiors, emphasizing comfort while incorporating a sense of balance, scale, texture and color. While a sophisticated clientele seeks him out for his quiet rooms, they come away with an appreciation for his talent for layering natural tones and textures and for enveloping them in luxury.

Whether it is an apartment in a newly built high rise or an antique Colonial, Spada's rooms maintain a sense of history without feeling stodgy or over-decorated. In fact, he calls his style "under-decorated." He allows texture to tell a story, perhaps layering smooth silk pillows atop a textured linen sofa and adding the softness of a cashmere throw. There is nothing frivolous about the look. "My design style is consistently well-edited, pared down," says Spada.

Highlighting and creating great interior architectural elements is also a Spada strong suit. Bookcases, chair rails, mouldings and built-ins infuse rooms with warmth and character. Everything that comes after—unless it is an antique—he designs and has built. Even his modern creations echo classic lines so that they never appear trendy, but instead timeless. Large or small, every room has a focal point. Rather than look for years for a room's signature piece, Spada more often creates one himself. Layered with lots of books, minimal accessories and impressive artwork, a Spada interior completes a balance between rarified elegance and ease of living. "Good design is innate, when I walk into a room I immediately sense what is correct for the client and the space and I go for it."

ABOVE
The night sky reflects off the flame mahogany custom center table which opens to seat 12 for dining.
Photograph by Richard Mandelkorn

FACING PAGE
Spada kept the living room of this contemporary apartment pared down to take advantage of the spectacular city views which overlook Boston's Back Bay. Spada combined classic upholstered pieces with contemporary furnishings of his own design using minimal accessories.
Photograph by Richard Mandelkorn

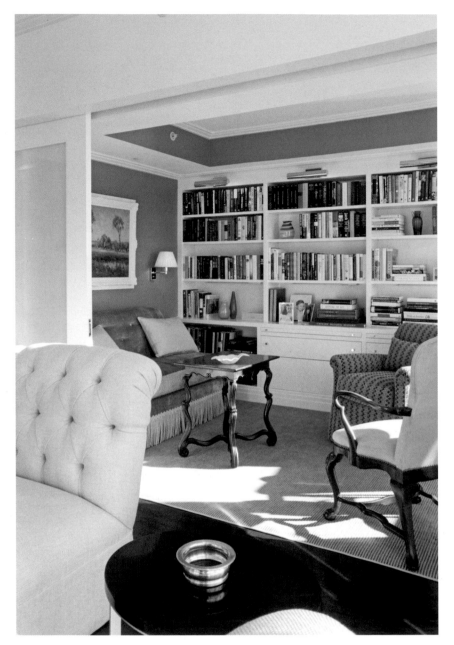

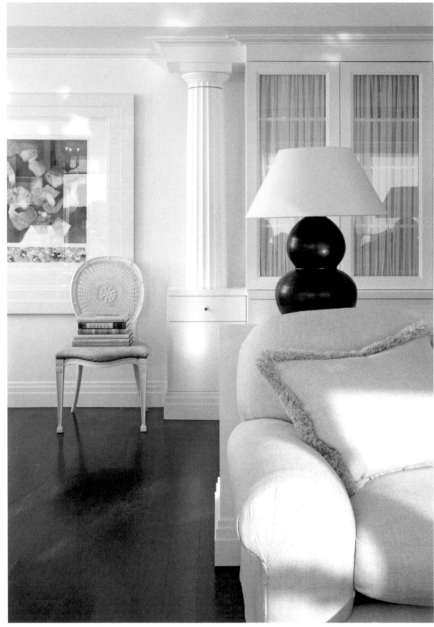

In 1995 he opened Antiques on 5 in the Boston Design Center, a 5,000-square-foot showroom of fine 17th through mid-century antiques—mostly finds from France, Italy, and Belgium—serves designers throughout New England and beyond.

Besides writing for *Veranda*, his design projects have been featured in *Elle Décor*, *Traditional Home*, *House Beautiful*, *The New York Times*, *The Boston Globe*, *New England Home* and *Design New England*. He has made multiple appearances on HGTV and his work has been featured on "This Old House." But perhaps his greatest adventure has been restoring his Louis XIII period home in Normandy, France. Spada is the home's fifth owner since it was constructed in 1652.

ABOVE LEFT
Adjacent to the living room, the library alcove allows for a second conversation area. When closed off by massive pocket doors, the space becomes a guest room or a private place to reflect. The silk velvet banquette opens into a sleep sofa.
Photograph by Richard Mandelkorn

ABOVE RIGHT
Columned, custom cabinetry in the living area provides ample storage, so important to the client, a food writer for *The Boston Globe* and cook book author.
Photograph by Richard Mandelkorn

FACING PAGE
Spada's signature upholstered bed in the master suite offers spectacular views of the city scape and the Charles River beyond.
Photograph by Richard Mandelkorn

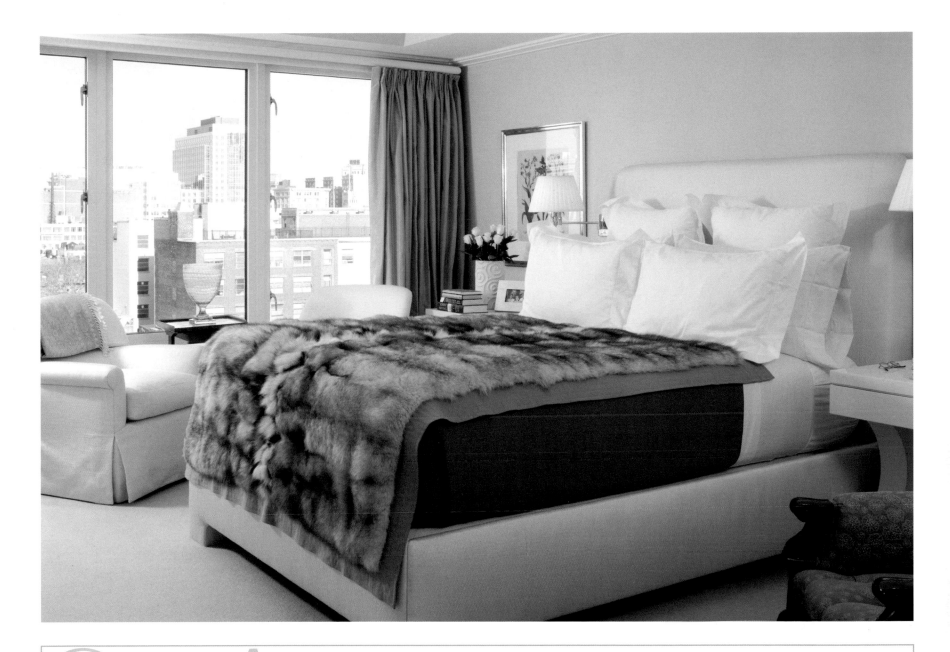

Q&A

MORE ABOUT CHARLES ...

WHAT IS THE BEST PART OF BEING AN INTERIOR DESIGNER?

The people involved and the ever-changing scope of different projects.

WHO HAS HAD THE BIGGEST INFLUENCE ON YOUR CAREER?

My clients, the press and French couturier Hubert de Givenchy.

WHAT IS THE HIGHEST COMPLIMENT YOU'VE
RECEIVED PROFESSIONALLY?

My rooms are timeless and neither masculine nor feminine in that they put both

sexes at ease.

WHAT ONE ELEMENT OF STYLE OR PHILOSOPHY HAVE YOU STUCK
WITH FOR YEARS THAT STILL WORKS FOR YOU TODAY?

Less is more.

IF YOU COULD ELIMINATE ONE DESIGN/ARCHITECTURAL/BUILDING
TECHNIQUE OR STYLE FROM THE WORLD, WHAT WOULD IT BE?

Cookie cutter, trendy, ill-conceived architecture.

CHARLES SPADA INTERIORS
Charles Spada
One Design Center Place, Suite 547
Boston, MA 02210
617.951.0008

LINDA TAYLOR

LINDA TAYLOR INTERIORS LLC

Linda Taylor has a keen sense of how her clients and their guests experience her designs as they move through the home. The one-time choreographer's interiors visually draw you from room to room with their punches of color, graphic motifs, and clean lines.

Inspired by styles ranging from French Moderne to New England Shaker, Linda is expert at distilling rooms to their aesthetic and functional essence. Her clean, well-edited style lends itself to both contemporary and traditional interiors. Fresh colors and a thoughtful lighting plan create the open, cheerful spaces sought by so many of today's homeowners.

Linda's design approach skillfully threads shapes, colors, textures and patterns to produce cohesive and stylish visual references throughout the home. Highly focused on making the most of how clients live in and use the space, Linda crafts visually interesting rooms while being sensitive to the existing architecture and environment.

Known for her ability to juggle large projects, Linda draws on her previous career as a lawyer handling complex corporate transactions. Linda received her interior design education from The New England School of Art and Design at Suffolk University and holds a law degree from Columbia University. She entered the field of interior design in 2001.

An enthusiastic traveler, Linda keeps a sketchpad, notebook, and camera with her whether the destination is Morocco, Japan, Italy, or her weekend retreat in Vermont. Nature and architecture provide constant inspiration.

ABOVE
The master bedroom is fresh, crisp and cheerful.
Photograph by Eric Roth

FACING PAGE
The tropical motif and Art Deco furnishings of the designer's own home were inspired by the building's Hollywood connection as Columbia Pictures' Boston headquarters.
Photograph by Eric Roth

LINDA TAYLOR INTERIORS LLC
Linda Taylor, Allied Member ASID, IFDA
45 Church Street, No. 4
Boston, MA 02116
617.521.9003
Fax 617.521.9006
www.lindataylorinteriors.com

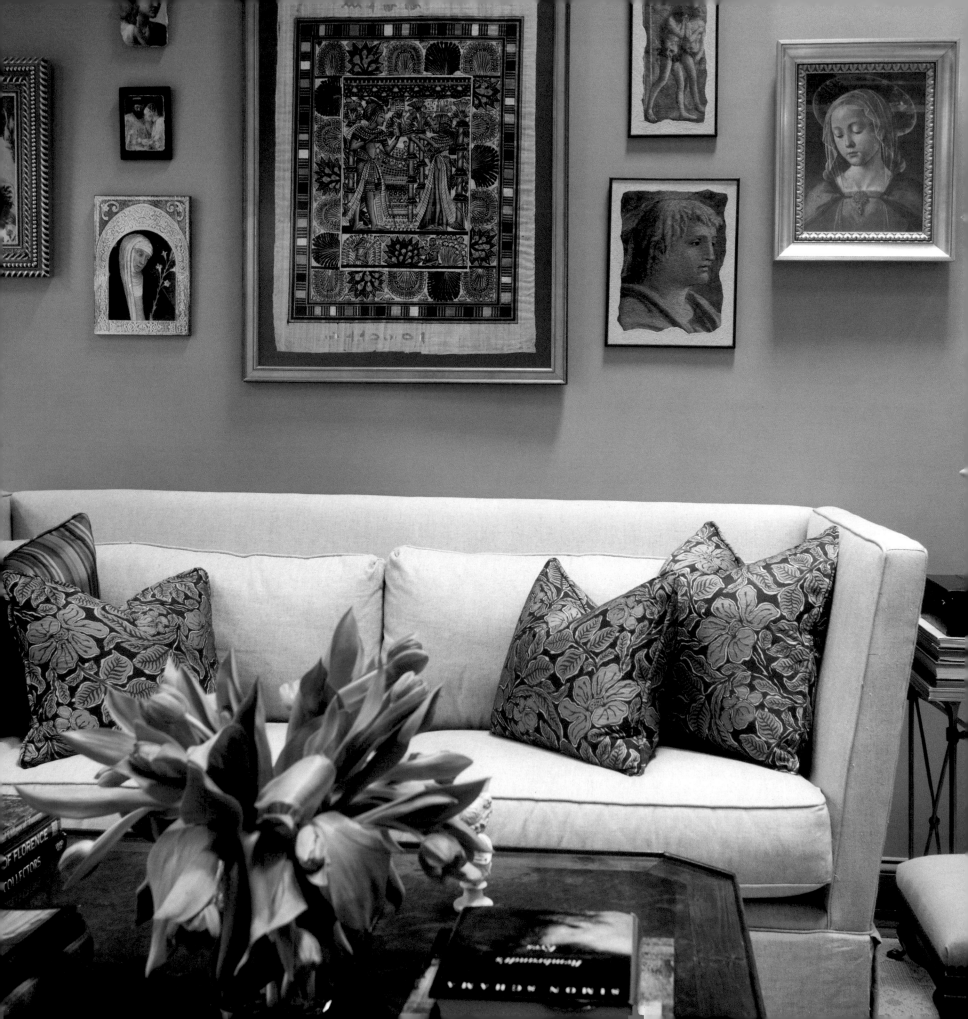

ANDREW TERRAT
DEE ELMS

TERRAT ELMS INTERIOR DESIGN

For Andrew Terrat and Dee Elms, it is as simple as this—interior design is about making life easier and more personal. At least that is the way the talented design duo approaches their craft. For some clients that means a simple reworking of rooms to make them more functional as their family grows. For others, it is leaving it up to the pair to complete a full house, top-to-bottom renovation selecting everything from the crown mouldings and furnishings down to the silverware and bars of soap.

Through their design firm, Terrat Elms Interior Design, the partners tackle projects as diverse as high-rise modern bachelor pads to traditional suburban homes by focusing on flexible designs that creatively mix serious antiques, flea market finds, existing pieces, and a healthy dose of surprise.

After meeting at a party two years ago, Andrew and Dee knew immediately that their creative talents would complement one another perfectly. Both had coincidentally studied interior design following careers in finance. After time spent in New York and on the West Coast, both chose Boston as their home base. Andrew's keen eye for architectural detailing and Dee's amazing touch with patterns, color, and fabric make

for a sophisticated match. They contribute fresh ideas based on their own styles but stay sharply attuned to the homeowners' needs. "We focus on their typical morning for instance," says Andrew. "We love creating spaces that our clients will adore. We consider their unique and personal activities, like their entertaining style, and we frequently carve out quieter spaces if they are more private people."

Hotel design of the past decade has had a huge influence on the firm's approach. So it was fitting that after designing several model apartments for Boston's new Ritz Carlton Residences, Andrew and Dee were selected by clients who saw the models and responded immediately to their clean, comfortable designs. While the firm's look

ABOVE
The Venetian mirror in this powder room offers a strong contrast to the pearlescent mosaic tile and floating vanity. Old and new are again paired with the marble vessel sink and stainless steel faucet.
Photograph by Eric Roth

FACING PAGE
A mix of classic yet modern lines offers the perfect complement to an unexpected installation of this client's appreciation for Italy and its artists.
Photograph by Eric Roth

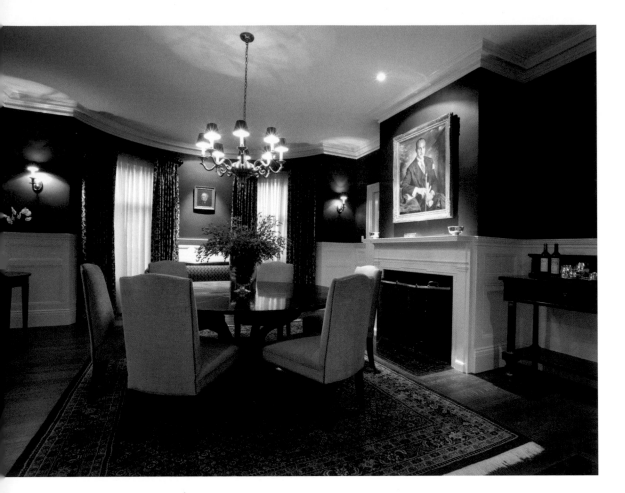

leans toward modern, other influences include legendary interior designers Sister Parish and Albert Hadley. Such design luminaries encourage them to view homes as a series of experiences that go beyond traditional labels and terms. The full-service firm skillfully adds both modern and classic architectural finishes and detailing, providing them with character, warmth and personality. One of their signature designs is a sleek paneled wall treatment delivering a more contemporary look that gives the otherwise traditional treatment a run for the money.

Creative and professional, but never conventional, the pair mixes clean lines and eclectic combinations, along with stunning colors. But, more importantly, the focus is on helping clients find their own style and exploring it to the fullest. In the eyes of these up-and-coming design stars, it really is as simple as that.

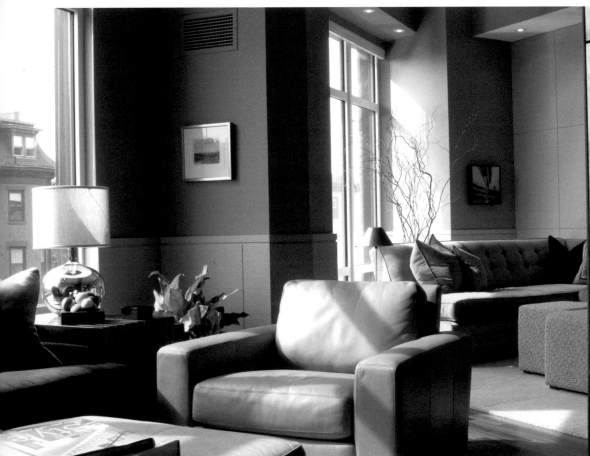

TOP LEFT
Color is the spice of life. This traditional dining room was infused with a bold red wall color to offer a radiant glow at dinner parties and help showcase this home's beautiful mouldings and woodwork.
Photograph by Angela Russo

BOTTOM LEFT
Soaring ceilings can be cold and impersonal, but in this loft a modern take on wainscoting, rich wall color and clean-lined furnishings make it inviting and unforgettable.
Photograph by John Kazar

FACING PAGE
Perched high above the city, this corner of a vast living room was made intimate with a custom-designed window seat and floating sofa, offering the best view in the house; it has become the client's favorite spot.
Photograph by Eric Roth

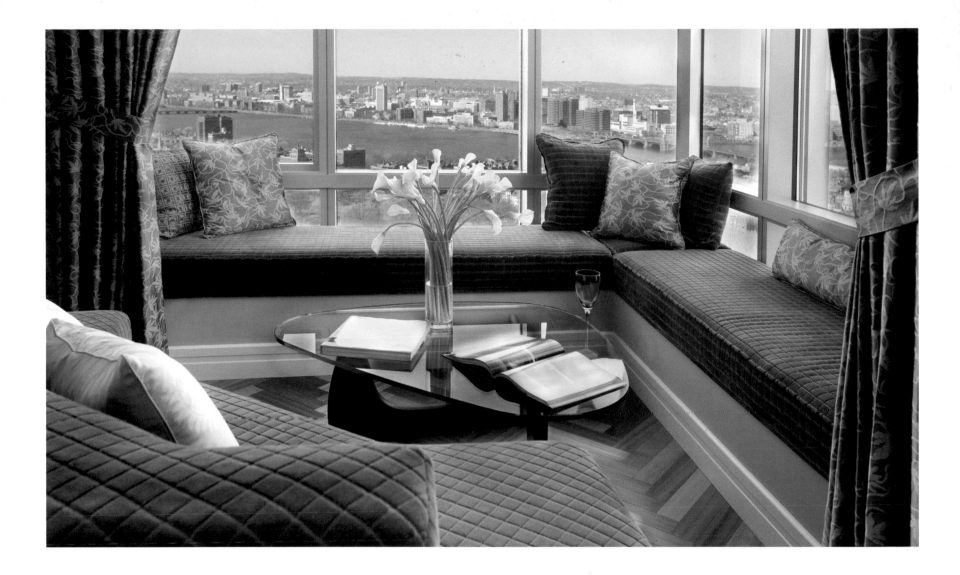

Q&A

MORE ABOUT ANDREW & DEE ...

WHAT ONE ELEMENT OF STYLE OR PHILOSOPHY HAVE YOU STUCK WITH FOR YEARS THAT STILL WORKS FOR YOU TODAY?

If we don't like it, they probably won't either, and go with your gut—it won't lead you astray.

WHAT IS A SINGLE THING YOU WOULD DO TO BRING A DULL HOUSE TO LIFE?

Have a field day with color! Pull the shades—let the light shine in.

WHAT SEPARATES YOU FROM YOUR COMPETITION?

We really listen. Our clients are the ones living in their homes, and we want them to love the special spaces we've created for them.

WHAT IS THE HIGHEST COMPLIMENT YOU'VE RECEIVED PROFESSIONALLY?

When a client said, "We love our home. We're never moving."

WHAT IS THE MOST UNIQUE/UNUSUAL HOME YOU HAVE EVER WORKED ON?

A California-style post-and-beam modern in a Boston suburb; it was built around a massive rock ledge with soaring ceilings and endless expanses of glass—I learned how simple and powerful great design can be.

TERRAT ELMS INTERIOR DESIGN
Andrew Terrat
Dee Elms
535 Albany Street, 4th Floor
Boston, MA 02118
617.451.1555
www.terratelms.com

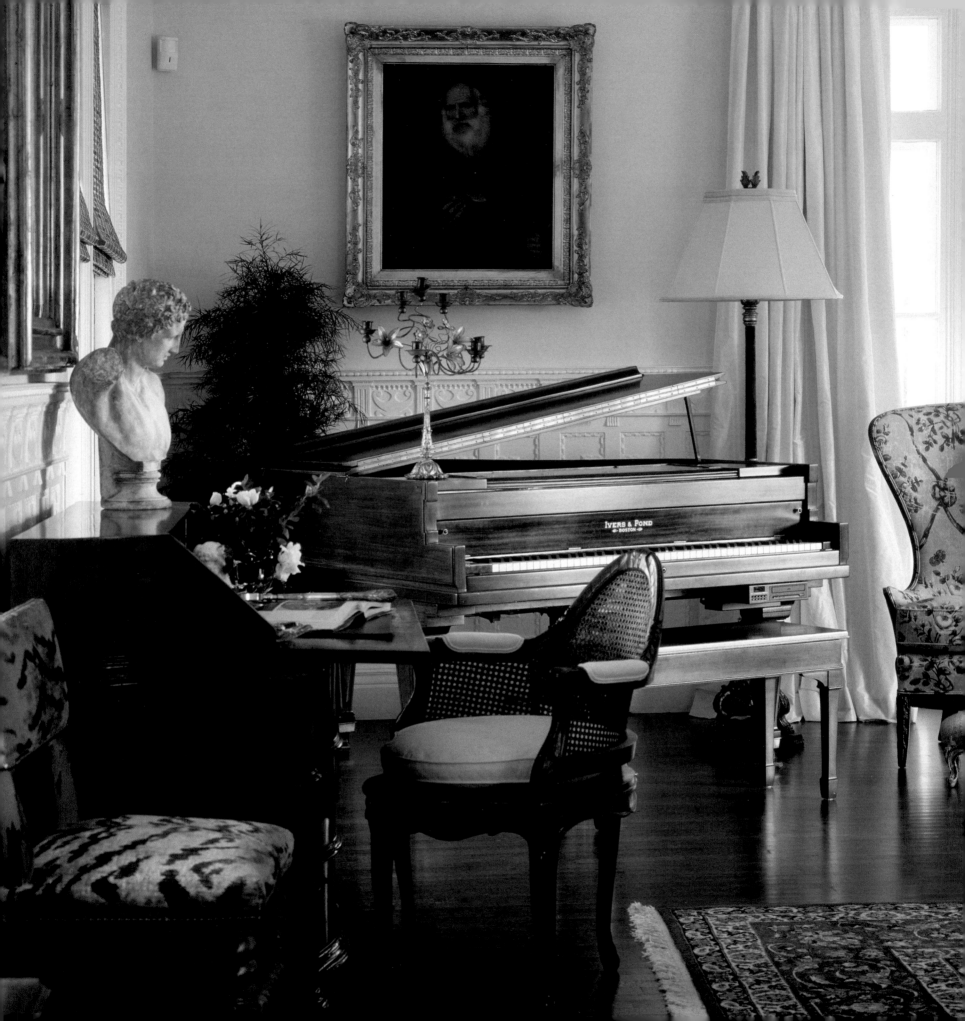

JODY TRAIL

JODY TRAIL DESIGNS

To interior designer Jody Trail, every house reads like a storybook. Whether she's delving into the past of a historic home or studying the furniture that has been with a family for years, Jody searches for the tales she can thread through the rooms. Even new construction takes on the air of generations past when she incorporates the fact that it was once a horse meadow or the grounds of an old schoolhouse into some aspect of the design. These clues, along with homeowner ideas, are what she uses to interpret the space.

Textured textiles and bold colors are just one of Jody's stamps. With nature as her inspiration, mountain homes absorb rustic colors, beach houses reflect water and marshland hues, and farms are tailored in horsey tweeds and barn reds. Whatever the setting, Jody uses the location as her design inspiration.

A home's story—and its history—pops up in the millwork details Jody adds, in the tapestry pillows stitched from pieces of an old Oriental rug or in the artwork on the walls. Coupled with family photos and mementos from homeowners' travels, homes come together as an expression of the clients' life, not their designer's.

Jody, whose work is mainly Transitional in its style, attracts a bevy of high-end clients. Deftly mixing her passion for antiques with contemporary pieces, she tackles traditional homes, waterfront retreats, and contemporary apartments in the city. Whatever the style, the emphasis is on comfort.

Jody has a true gift for helping clients feel confident enough to bring their own ideas to a project. Pulling rooms together with a homeowner's own collections and accessories is central to her design approach.

Perhaps it was her experience owning a furniture importing business and employing her own line of craftspeople, but Jody also has an eye for what furniture can make a room.

ABOVE
The gilt wood mirror with its graceful curves is anchored by the rich mahogany English writing desk, creating a distinguished work space.
Photograph by Sam Gray

FACING PAGE
Bright lemon yellow-colored walls and dupioni silk curtains provide a fresh contrast against the rich wood tones of the stately antiques in this living room.
Photograph by Sam Gray

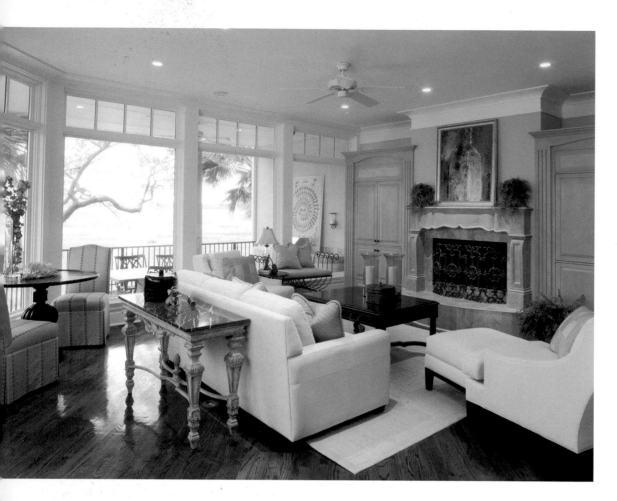

Antiques—particularly the one-of-a-kind variety—stand out on the elegant stage she sets. When she cannot find what she wants, Jody has a talent for transforming older pieces into something new by using color and paint techniques.

Jody has recently expanded her business with an office in Savannah. The historic downtown brick buildings there remind her of the Boston waterfront, while she has taken to calling the resort area of Hilton Head "the Southern Cape Cod" for its seaside village atmosphere. "I have always loved gracious living and designing vacation homes," says Jody. "Now I have an office in both places and feel I can help my clients nest in both environments." Jody's work has been published in *Country Interiors*, *Cape Cod Home* and the book *Room by Room*.

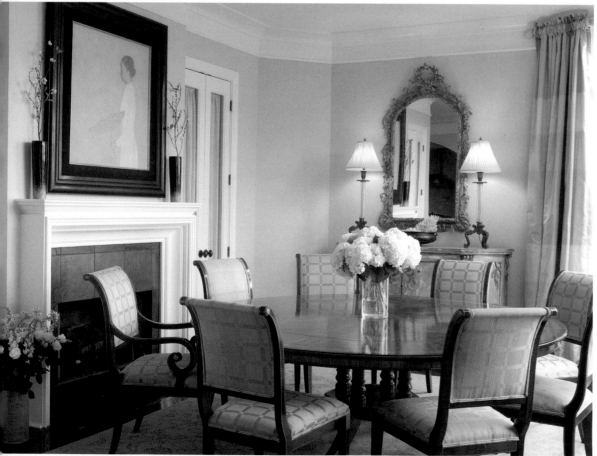

TOP LEFT
A neutral background combined with a variety of textures with vivid accent colors evokes the seaside environment of this home.
Photograph by Paul Nurnberg

BOTTOM LEFT
Richly textured fabrics, a romantic Rococo-style mirror and a graceful painting of a Vietnamese lady add much interest to the neutral background of the dining room.
Photograph by Paul Nurnberg

FACING PAGE TOP
Vibrant floral fabrics create a warm and inviting mood in this room with exaggerated ceilings.
Photograph by Sam Gray

FACING PAGE BOTTOM
The country-style built-in cabinetry and the soaring faux-painted walls give this grand space a distinctly French Country feeling.
Photograph by Sam Gray

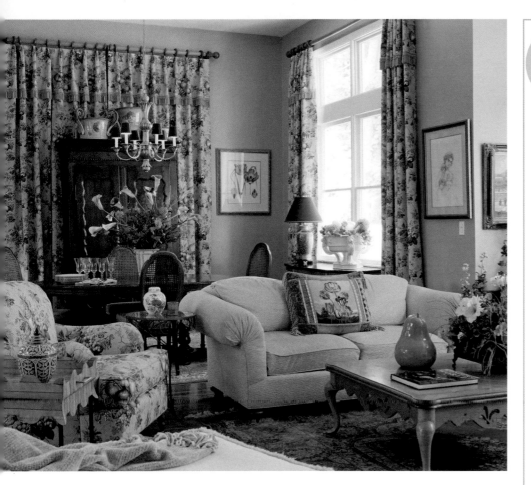

Q&A

MORE ABOUT JODY ...

WHAT DO YOU LIKE MOST ABOUT BEING AN INTERIOR DESIGNER?

I meet such wonderful people and have the opportunity to use my creative design work.

WHAT ONE ELEMENT OF STYLE OR PHILOSOPHY HAVE YOU STUCK WITH FOR YEARS THAT STILL WORKS FOR YOU TODAY?

Mixing the past and bringing it to the present, and being bold with scale.

WHAT IS A SINGLE THING YOU WOULD DO TO BRING A DULL HOUSE TO LIFE?

I would bring the landscaping on the outside in with lots of beautiful pots of blooming plants. I would bring nature in.

IF YOU COULD ELIMINATE ONE DESIGN/ARCHITECTURAL/ BUILDING TECHNIQUE OR STYLE FROM THE WORLD, WHAT WOULD IT BE?

Ultra, ultra-contemporary buildings in the city.

WHAT IS THE HIGHEST COMPLIMENT YOU'VE RECEIVED PROFESSIONALLY?

Luxury living award for a living room and my work published in magazines and books.

WHAT COLOR BEST DESCRIBES YOU AND WHY?

Yellow; it is full of life. I feel as if I am bringing the sun into my rooms.

WHAT IS THE MOST UNIQUE/IMPRESSIVE/UNUSUAL HOME YOU'VE BEEN INVOLVED WITH? WHY?

There are many. I loved the house I did at the highest point of Chappiquiddick Island, a beautiful brownstone on Beacon Hill, an Aspen home in the Colorado mountains and homes on the waterfront on Cape Cod.

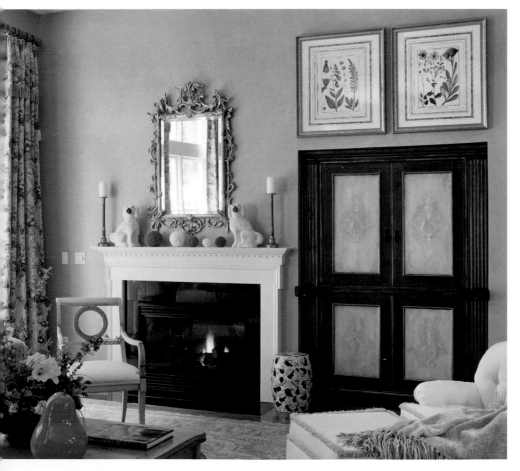

JODY TRAIL DESIGNS
Jody Trail, Allied Member ASID, IFDA
233 Nobscot Road
Sudbury, MA 01776
978.443.3378
www.jodytraildesigns.com

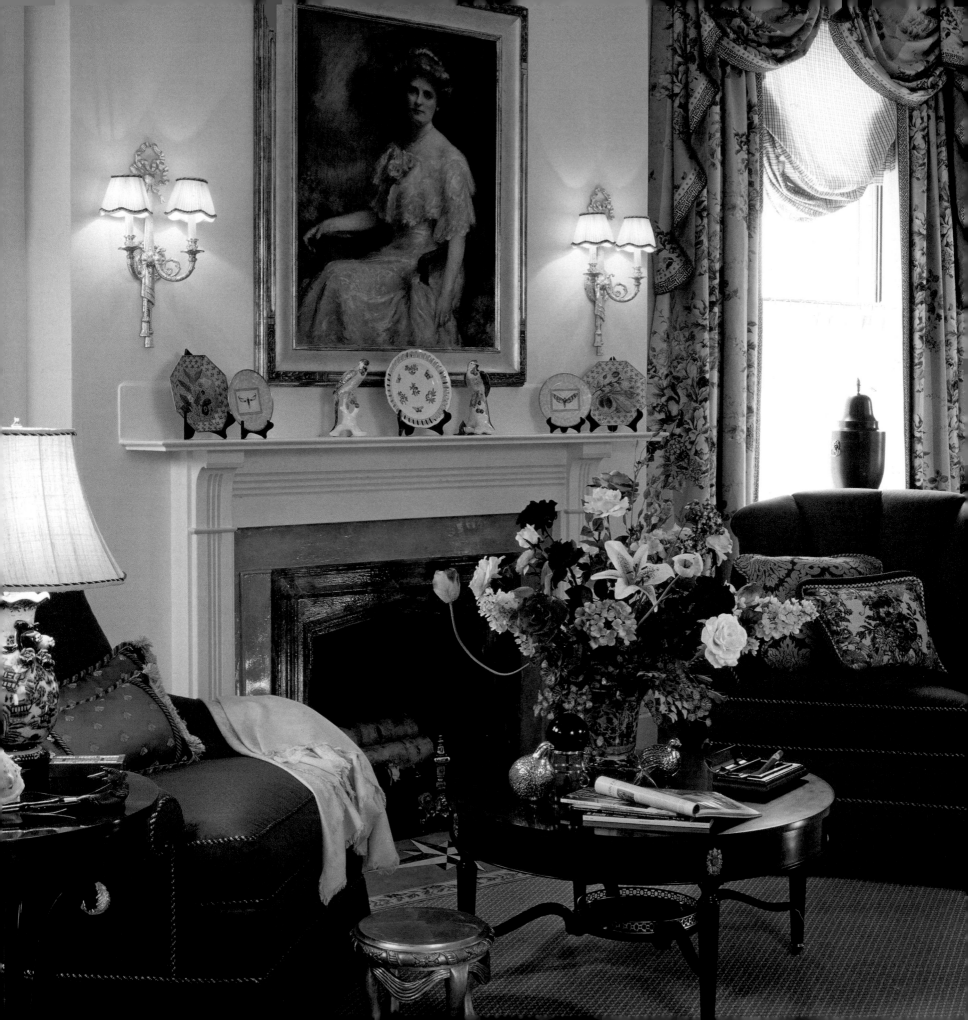

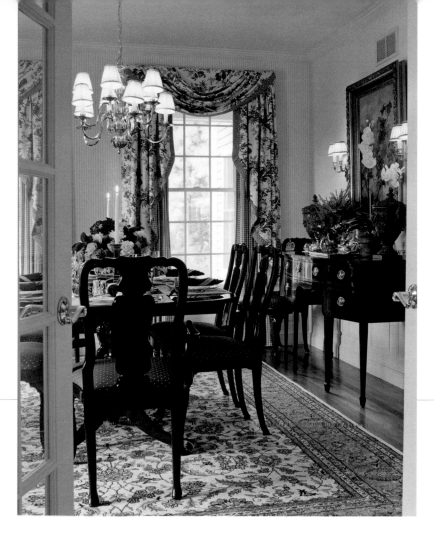

KATHY VENIER

KATHY VENIER INTERIOR DESIGN

nterior designer Kathy Venier has such a passion for fabrics, it has even been said she paints with fabric. She loves to create a design signature of multiple fabric patterns and colors sewn side by side. The combination of elements creates a most unique fabric for her clients. This might be expressed as one bergere cushion or separate components overall for a French chair. They very often appear as narrow contrast drape bandings rather than tassel trim to edge draperies and valances. Kathy attributes this desire to eloquently balance color, textures and light to her childhood love of quilting and sewing. The elegant blend of coordinating textures, patterns and hues in elements such as rug, walls, furniture and accessories creates interest and depth in a timeless manner. Rather like the interest an Oriental carpet holds for a client, this profusion of gentle mixing will keep it all interesting for years to come. Additionally, clients appreciate Kathy's adeptness at designing in any range of styles.

To the seasoned interior designer, creativity is even more than selecting pleasing colors and patterns that put people at ease—it is a an exciting personal journey. Not only is Kathy an innately talented interior designer, she is an expert who genuinely seeks to understand her clients' needs by taking cues from objects they hold dear, actions and reactions she sees, as much as the words they articulate. Kathy looks at the world from her clients' perspectives and familiarizes herself with the intricacies of how they interact with their homes on a daily basis. The underpinning of her creativity is a sincere desire to create a rejuvenating haven to nurture her clients as they return home after a fast-paced day.

The initial design concept stems from an item or pattern that speaks to the client's heart and the decisions that follow are formed from a creative and functional standpoint, to ensure a well-composed interior. The goal is an absolutely exquisite look which provides comfort and maximum functionality.

ABOVE
Celadon and navy is repeated in the narrow drape banding of navy toile swags, lining of jabots and wallpaper border above the chair rail to repeat Oriental carpet colors.
Photograph by Sam Gray

FACING PAGE
Floral drapes provide a palette of raspberry, kiwi, yellow and blue for luxurious chairs, contrast welting and drape bandings, pillows, lower sheers, balloon shades, bordered carpet, and mantel decoupage plates.
Photograph by Sam Gray

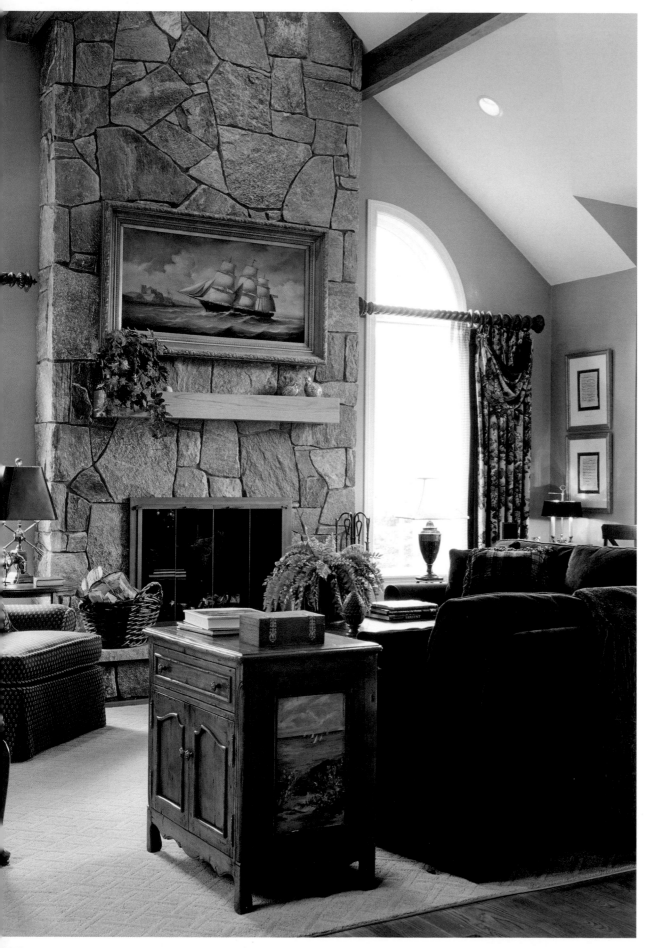

Clients appreciate Kathy's one-on-one approach to design. She gives recommendations and explains the reasoning behind her suggestions, respecting clients as integral members of the design team. This team process of conversation regarding the basics of color, composition and form develops great client skill sets for their future stylistic selections. When clients find treasures while on vacation, they can confidently make purchases.

The esteemed designer considers herself fortunate to have lived in many parts of the country and experienced different people, their styles, perspectives, and how they live. With Midwestern roots, she moved East to earn her interior design degree and there met and married her husband. Settling for good in the Northeast, Kathy loves Boston, the skiing and close proximity to beautiful beaches. It has been a wonderful place to raise a family. She established her design firm in 1982 and has been enriching people's lives ever since.

LEFT
Dynamic draperies and nautical painting fuel the selection of wall color, red drape bandings, contrast swag fabric, chair with welt, and custom-painted chest in foreground.
Photograph by Sam Gray

FACING PAGE
Drape banding, contrast furniture welts and plaid swags repeat the celadon, navy and vanilla of the carpet. Celadon lamps with navy, custom coffee table and inlaid woods are an elegant touch.
Photograph by Sam Gray

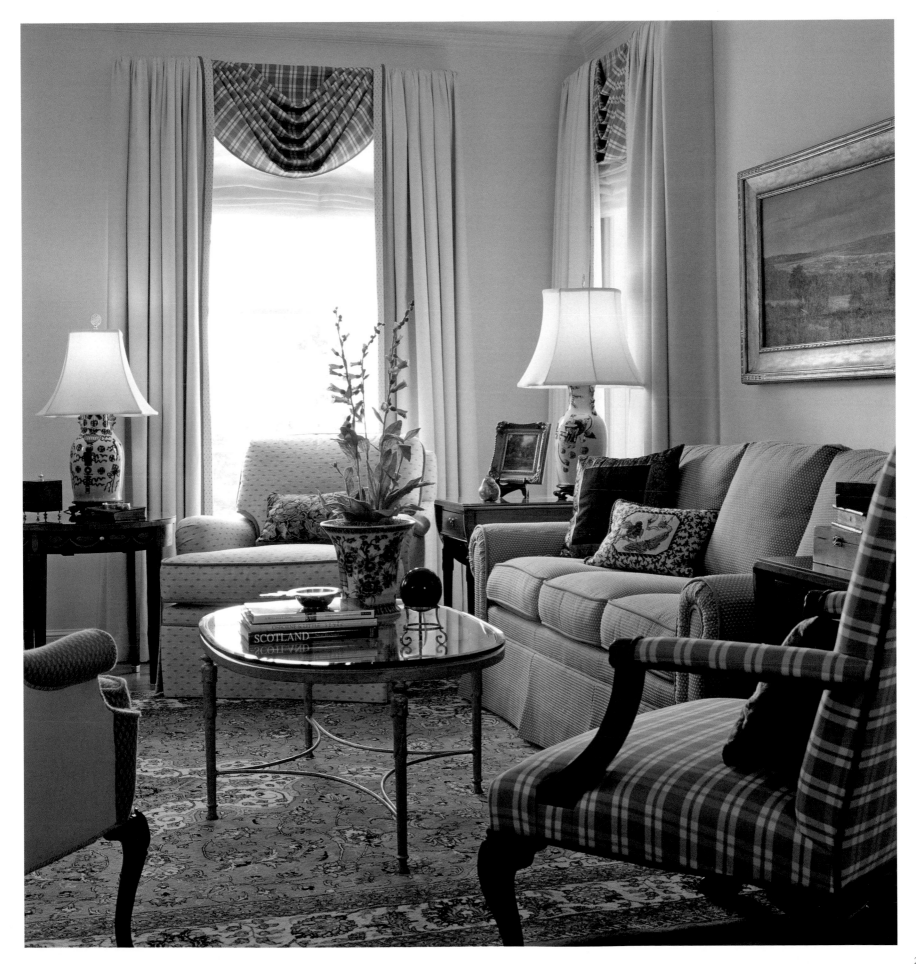

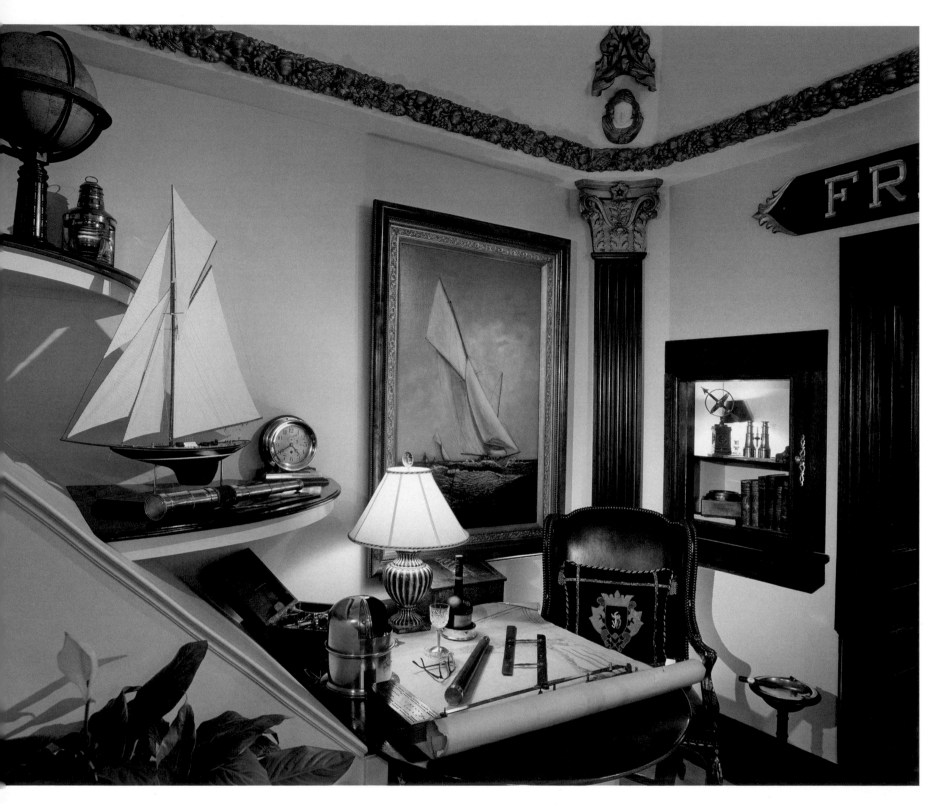

ABOVE
This small, elegant nautical office filled with America's Cup memorabilia is masculine and refined with rich dark woods; a leather chair with nail head; warm gilt accents on paintings; architectural elements and polished brass accessories.
Photograph by Sam Gray

FACING PAGE TOP
The details of painted closet doors; precision shaped, banded canopy with angels painted underneath; decoupage custom lamps and multiple fabric selections gently repeat the colors of floral bed hangings.
Photograph by Sam Gray

FACING PAGE BOTTOM
Gentle peach repeats with navy and deep peach for reserved layer of Austrian shades. Longer custom ottoman creates a chaise-effect with chair.
Photograph by Sam Gray

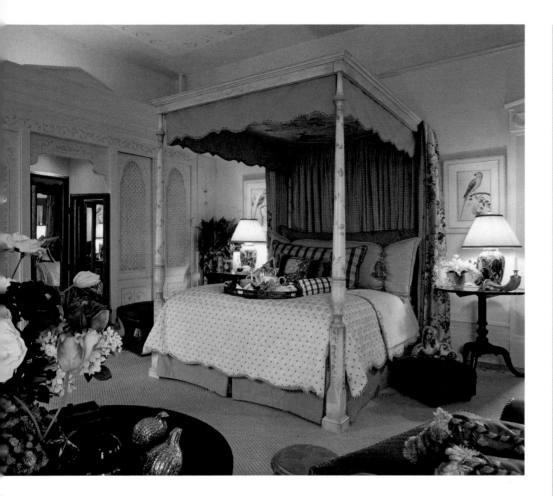

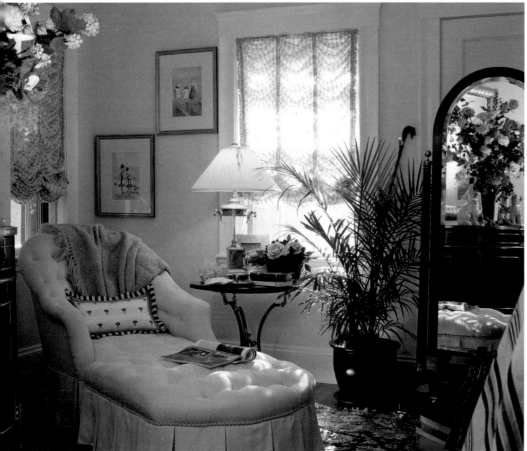

MORE ABOUT KATHY ...

WHAT ARE YOUR GREATEST PERSONAL INDULGENCES?

Fun, laughter, fresh flowers, lemon sorbet and shoes.

DO YOU HAVE ANY SPECIFIC LONGSTANDING DESIGN PRINCIPLES?

To listen, be reasonable, honestly give my opinion, be open minded and willing to try something new, and to keep the experience fun.

WHO HAS HAD THE BIGGEST INFLUENCE ON YOUR CAREER?

Personally my husband, who encouraged me and gave me confidence to pursue and grow; the little grandmother who gave me the first triangle of cotton print to sew into squares for a quilt; my mother for the genetic gifts of creativity, beauty and physical stamina. Professionally, Alexandra Stoddard and her philosophy of creating to feed your client's spirit. I adopted her concept of asking clients to gather photos, clippings, or pieces of favorite colors prior to a first meeting. It helps to distill their stylistic preferences and serves as a platform for questions.

KATHY VENIER INTERIOR DESIGN
Kathy Venier, Allied Member ASID, IFDA
7 Abbott Road
Lexington, MA 02420
781.862.8210
Fax 781.860.0303
www.kathyvenier.com

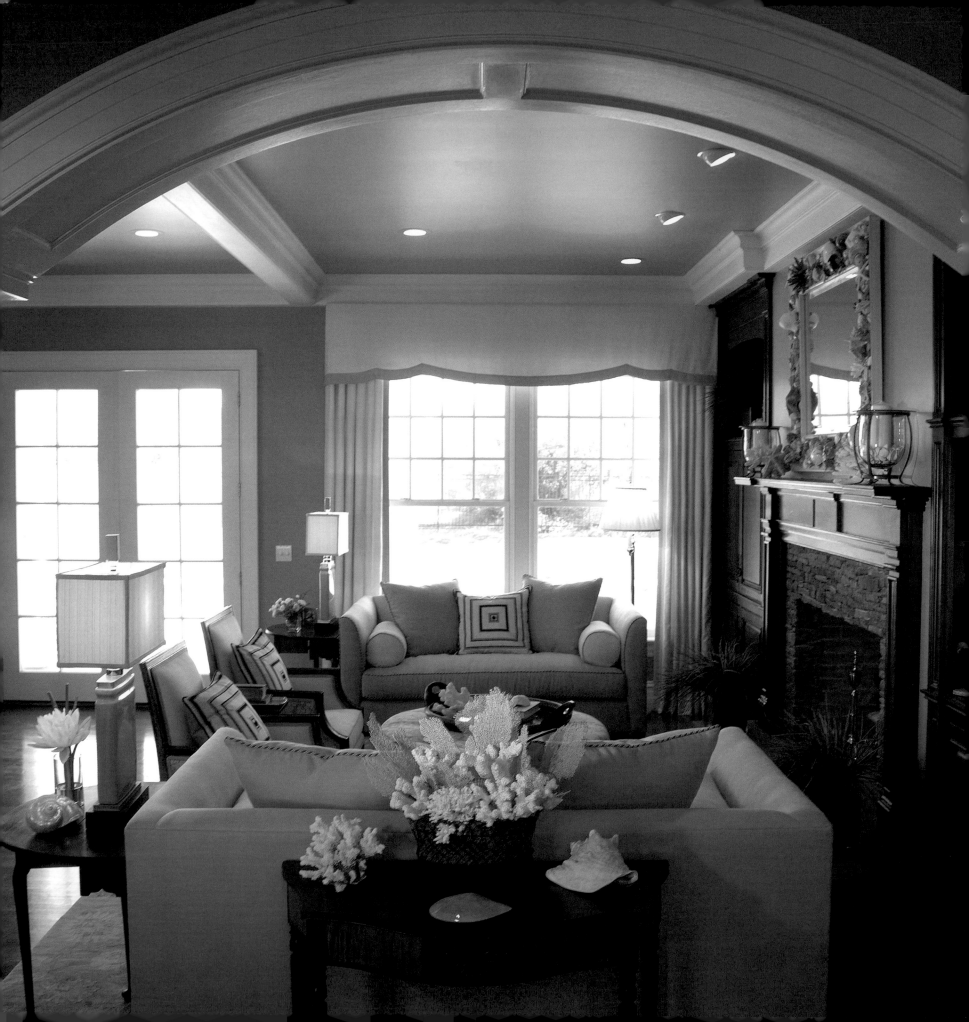

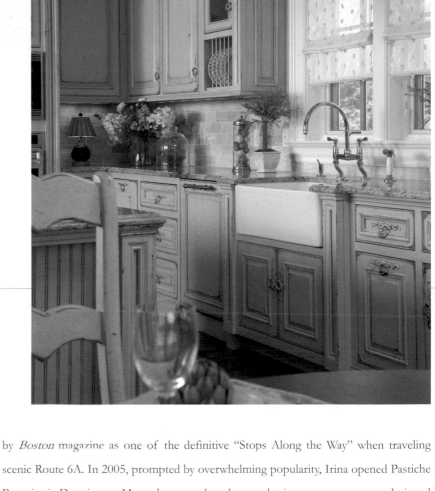

IRINA WEATHERLEY-MACPHEE

PASTICHE OF CAPE COD, INC.

Some would describe Irina Weatherley-MacPhee as a striking blonde with antique diamond rings on both hands and an aura of focused energy, as *Cape Cod Life* magazine once did, while others would immediately spotlight the extraordinary interiors that her innate talent has produced. When clients meet with Irina to visit about their design needs, she invites them to sit back, relax and share every detail of their daily routines that they would like to divulge. She believes that interior design is like breathing and notes, "I envision what a space could look like. The more I know about a client, the more I see. I can't not do it." Irina fully admits to being addicted to her profession, and that sheer passion propels each design into an interesting scope of possibilities, resulting in clients who cannot wait to have Irina back in their homes for the next room, the next home or simply her holiday decorating prowess.

Inspired by childhood memories of afternoons spent adoring the profusion of flowers on the mountainsides in Switzerland, designing fresh floral arrangements for weddings was Irina's first entrepreneurial venture. Growing flowers, looking after the gardens and putting together special orders became so cumbersome that she decided to turn her attention to everlasting botanical design, which has since evolved into a turnkey interior design firm, Pastiche of Cape Cod, Inc., housed in her West Barnstable shop—cited

by *Boston* magazine as one of the definitive "Stops Along the Way" when traveling scenic Route 6A. In 2005, prompted by overwhelming popularity, Irina opened Pastiche Botanica in Dennisport, Massachusetts, where her everlasting arrangements are designed and produced. Pastiche has a third location in Holden, and plans are underway in Newport, Rhode Island as well.

Improving the quality of people's lives by bringing beauty into their homes is the singular goal of Pastiche, which serves "The Source," as Irina has coined, meaning that architect, builder, interior designer and landscape designer are brought together to offer a quality product and process for potential clients. In a refreshingly collaborative manner, the principal and her team of creative minds celebrate each client's individuality by drawing from their cache of unique rugs, case goods, accent pieces and permanent botanicals

ABOVE
Located in the Carnegie Abbey Club in Portsmouth, Rhode Island, the home boasts a custom gourmet, Old World, Country French-style kitchen with furniture-like cabinets that were distress finished in colors of parchment and seafoam.
Photograph by Patrick Wiseman

FACING PAGE
Nature is brought indoors through colors of air, earth and sea, which lend the coastal living room a feeling of casual elegance. The breathtaking composition is adorned with an array of Pastiche Botanica designs, namely a custom shell mirror and unique coral display.
Photograph by Patrick Wiseman

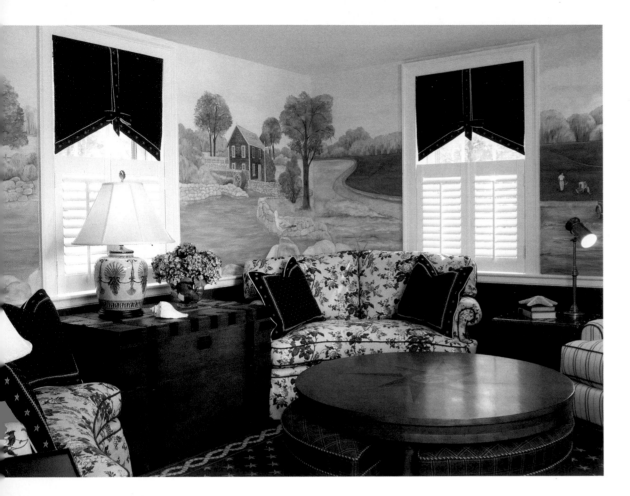

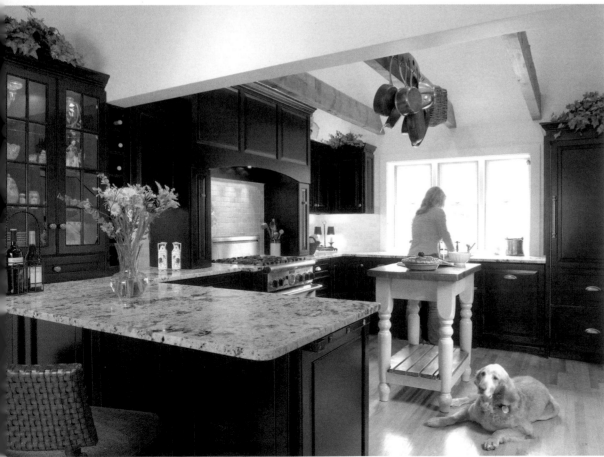

to create havens for relaxation and rejuvenation. Irina believes that nature can be therapeutic, and whether scattering a few seashells across a table or filling a vase with flowers so realistic that their soft hues and subtle scents delude even the keenest observers, she and her team employ organic elements as colorful accents, corner fillers, textural elements and sophisticated focal points alike. No matter the size or style of a project, Pastiche of Cape Cod offers a full complement of creative services, which makes the design process smooth and enjoyable.

Irina's wildly creative designs have garnered significant media attention from *Cape Cod & Islands Home*, *Cape Cod Life* and *Traditional Home*, among other publications, and led to the opportunity to be featured on HGTV's popular series "Designers' Challenge." It was a whirlwind experience between the information submission and countless hours of filming before and after footage, but Irina thoroughly enjoyed being chosen to redo the living room of a 1700s' sea captain's house. Televised or not, Irina and her team approach each project with the same care, to achieve for their discerning clientele the casual elegance of the desirable Cape Cod lifestyle.

TOP LEFT
As featured on HGTV's "Designers' Challenge," the living room is appointed with a cocktail table with extra seating beneath, designed by Irina, and an antique captain's chest, which reflects the family's seafaring history. The stunning mural depicts an idyllic scene in Brewster, the town where the family has deep roots.
Photograph by Patrick Wiseman

BOTTOM LEFT
A complete redesign turned this kitchen from small and dark to a sophisticated, aesthetically pleasing space. Touches of red peek through the cabinetry's distressed black finish.
Photograph by Patrick Wiseman

FACING PAGE LEFT
Pastiche Botanica rosemary topiaries frame the serenely symmetrical composition. The kitchen of this remodeled 200-year-old home adjoins the cozy fireside seating area.
Photograph by Patrick Wiseman

FACING PAGE RIGHT
A delightful white orchid Pastiche Botanica creation is situated atop the carrera marble vanity, which was designed by Irina.
Photograph by Patrick Wiseman

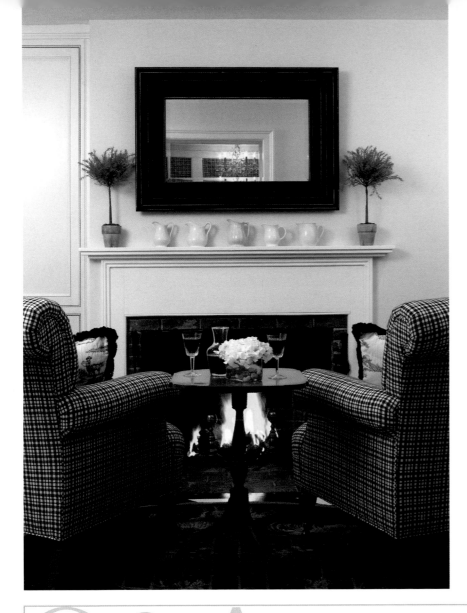

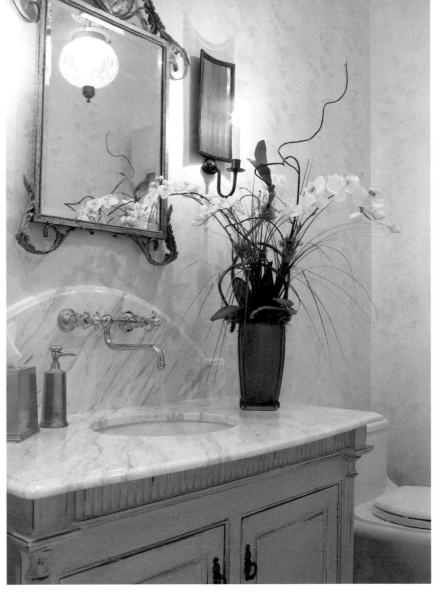

MORE ABOUT IRINA ...

WHAT IS YOUR MAIN DESIGN PHILOSOPHY?

Celebrate! I celebrate each day as a gift and help my clients adopt the same philosophy by designing spaces that crave to be experienced. Whether people use the spaces for working, everyday living, dining, entertaining or sleeping, my designs reflect an energy, style and mood that rejuvenates the soul.

HOW DID YOU BECOME INTERESTED IN INTERIOR DESIGN?

My father was a textile merchant, my mother was an avid antique collector and most of my family came from some sort of artistic background. I learned from an early age to appreciate art, beauty, color, form and function. I have always studied art on some level, and interior design was a natural fit.

WHY DO YOU OFFER WORKSHOPS IN HOME DECORATING?

Pastiche is a lifestyle, and my team and I are thrilled to let others experience the joy of our profession; topics range from making shell wreaths and Cape Cod-style Christmas trees to faux painting, window treatment and interior design. Whether clients want to "create it themselves" or carry home a pre-made, handcrafted botanical creation or other home accent, everyone enjoys perusing our shops.

WHAT COLORS BEST DESCRIBE YOU?

All of the colors of the ocean, from sea foam green to turquoise, to the deepest blue, because I can be as light as the seafoam floating atop the water but have been known to travel in deep waters as well.

PASTICHE OF CAPE COD, INC.
Irina Weatherley-MacPhee, IDS
1595 Main Street, Route 6A
West Barnstable, MA 02668
800.888.9348
Fax 508.362.8088
www.pasticheofcapecod.com

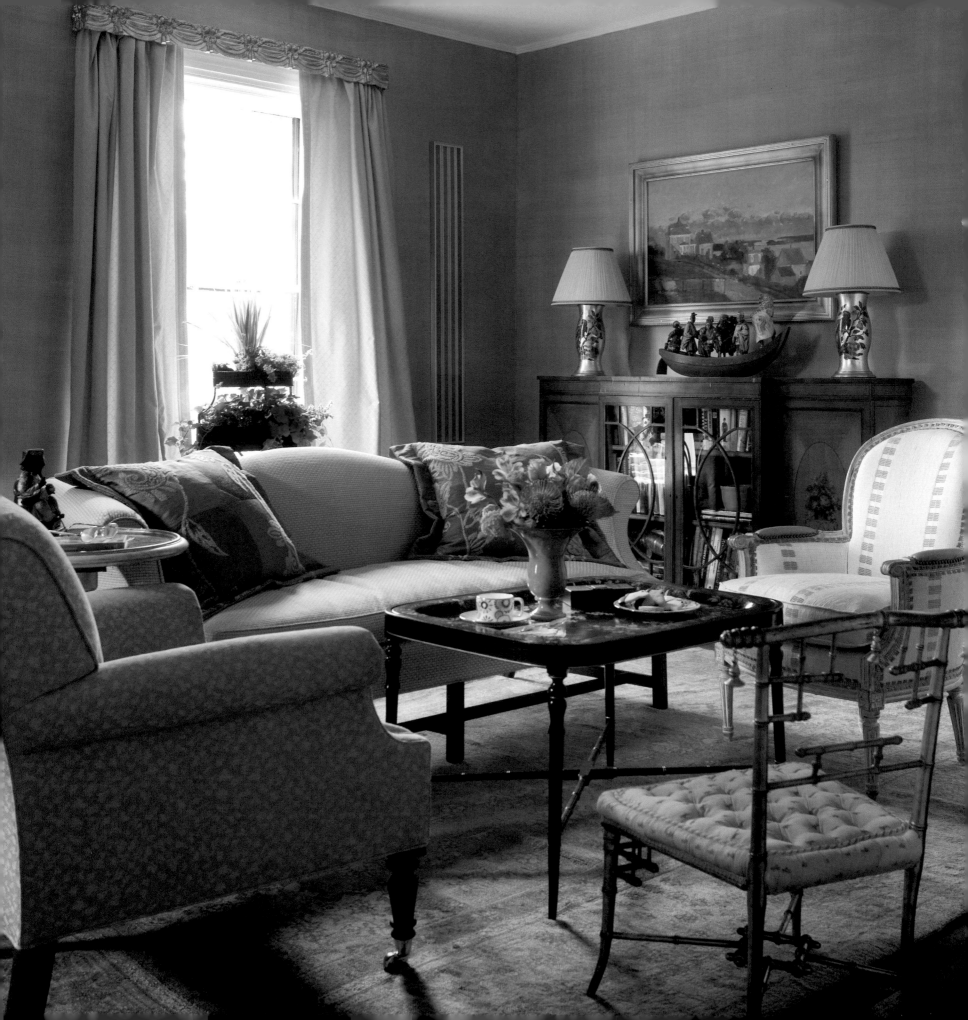

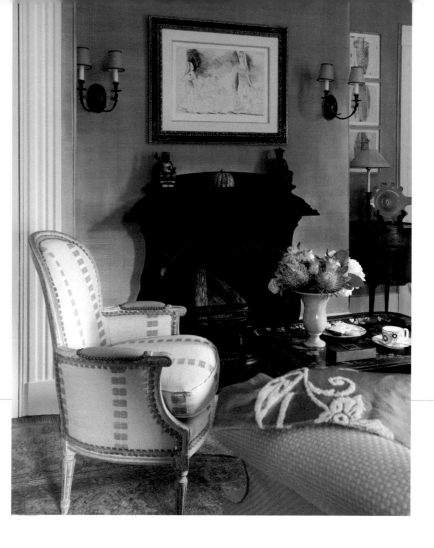

Karin Weller

KARIN C. WELLER INTERIOR DESIGN, INC.

K arin Weller fondly recalls creating doll clothes and miniature doll house curtains out of fabric swatches that her aunt, the owner of a fine linen store in Manhattan, would periodically share with the future designer. That early love of fabric continues today as Karin is celebrated for her delightful color and textile combinations as well as her refreshing and imaginative layouts.

Karin never limits herself to a specific vernacular, and her eclectic approach ensures that clients receive the best of all design worlds. She often thinks of the beloved decorator Sister Parish's maxim that charm is created by working with liability; Karin has embraced this philosophy and continues to push herself in all aspects of design.

One of her clients, writer/psychologist Dr. Shari Thurer, who lives on Boston's Beacon Hill, describes Karin: "She is the Jackie O of interior design with a soupçon more sauce. She is the decorator of choice for the intelligentsia of New England which is not only because of her exquisite taste and refinement but also because of her knowledge of history and art. She is able to articulate her aesthetic in a way that appeals to the left-brained as well as the right-brained. Her sophistication does not get in the way of warmth and sensitivity."

Breathtaking residential work has led to quite a spread of commissions for Harvard University and some of its finest educators. In addition to applying her touch to the former president's house and the entire Harvard Faculty Club, Karin redesigned a prominent Harvard Law School professor's office. Faced with the limitation of not being

ABOVE
A close-up view of a New England sitting room reveals a Picasso above an antique iron fireplace. Swedish sconces and a French chair complete the room's visual design.
Photograph by Eric Roth

FACING PAGE
The New England sitting room of two vibrant, young art collectors. Picasso and Dali live comfortably with prominent contemporary artists. Antique Oushak carpet.
Photograph by Eric Roth

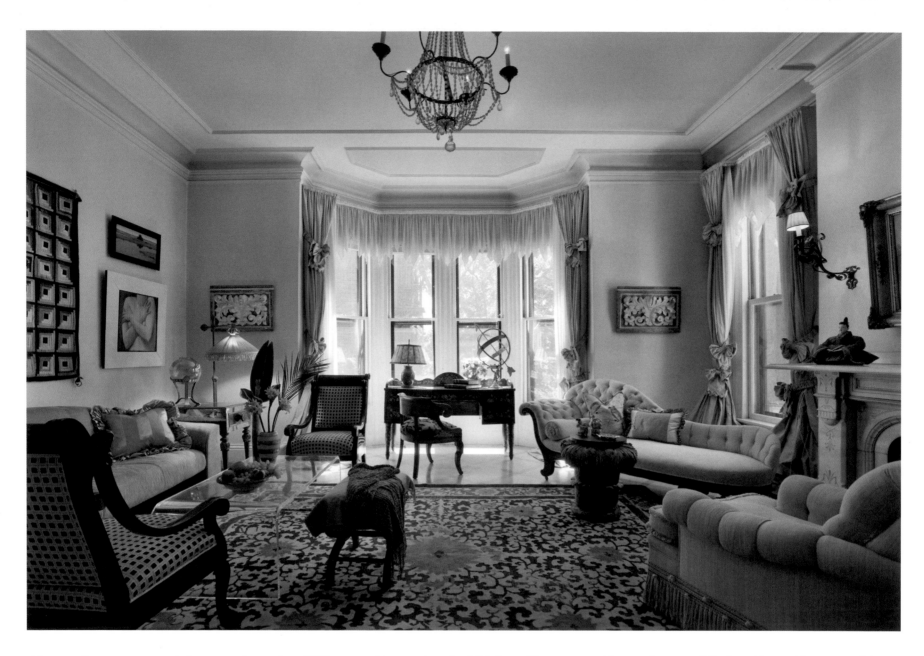

able to perform any structural changes to the modern 1970's space with an awkward wall of windows, she created an English study complete with appropriate windows, gold tea leaf ceilings, rich draperies and built-in bookcases. The man's colleagues were a bit concerned during the installation process, yet the result was unarguably exquisite.

When the talented designer does have the opportunity to edit architecture, redesign layouts and direct renovations, she is very careful to leave certain elements in situ, so as to preserve the architectural integrity.

Safeguarding the soul and charm of a building, while incorporating antiques in a fresh way, Karin strives to cater to her clients' modern-day needs and wishes. Design does not stop in the entryway, however, because the well-rounded professional also provides landscape solutions for her clients, including custom water features and lush combinations of greenery.

With her willingness to tackle even the most difficult projects and her wonderful team of craftsmen that has been assembled over the last 30 years, it is no wonder that Karin has done many Junior League Showhouses, been featured in multiple publications and has deeply-rooted relationships with her refined clientele.

ABOVE
Architectural ornaments from old Boston buildings combine with modern and antique furniture for a comfortable retreat as beautifully displayed in the living room of this 19th-century Beacon Hill, Boston townhouse.
Photograph by Eric Roth

FACING PAGE LEFT
A chinoiserie mural and gold tea leaf ceiling with hand-painted birds make this Boston, Massachusetts dining room resplendent. (Mural executed by Lord & Crown.) Antique lace panels add softness to the windows.
Photograph by Eric Roth

FACING PAGE RIGHT
A mural design, based on an illustration in a book of Swedish fairy tales, graces this little girl's bedroom in Newton, Massachusetts. (Mural executed by Pia Flander-Streeter.)
Photograph by Steve Rosenthal

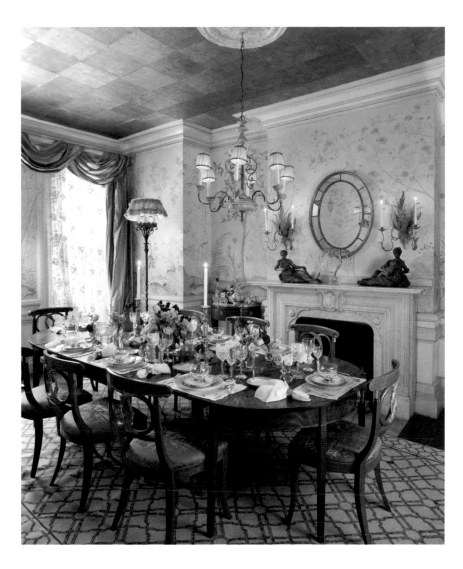

Q&A

MORE ABOUT KARIN ...

HOW DO FRIENDS DESCRIBE YOUR PERSONALITY?

My friends tease that I have several personalities, and I do. Because my clients come from all walks of life, I feel that in order to best serve them, it's invaluable for me to view the world from their perspective.

WHAT DOES YOUR OWN GARDEN LOOK LIKE?

It was featured in the 2006 Cambridge Garden Tour, and I designed the whole area around a huge elm tree. I selected shade-tolerant plants such as dogwoods, ferns, Mountain Laurel and Andromeda situated along a winding path that feels wild yet maintains order. Like my interiors, I introduced a variety of textures to add depth and interest.

WHY DO YOU OCCASIONALLY ACCEPT NON-RESIDENTIAL PROJECTS?

I treat all of my projects like they are residential, because the goal of making people feel comfortable in their space is applicable regardless of genre. Clubs are like large-scale residential designs, and I enjoy the challenge.

WHAT ARCHITECTURAL ELEMENTS WOULD YOU LOVE TO ELIMINATE?

Low ceilings and short windows.

WHERE DO YOU FIND DESIGN INSPIRATION?

I love visiting historical houses, museums and taking nature walks.

KARIN C. WELLER INTERIOR DESIGN, INC.
Karin Weller
12 Humbold Street
Cambridge, MA 02140
617.491.8067
Fax 617.864.0145

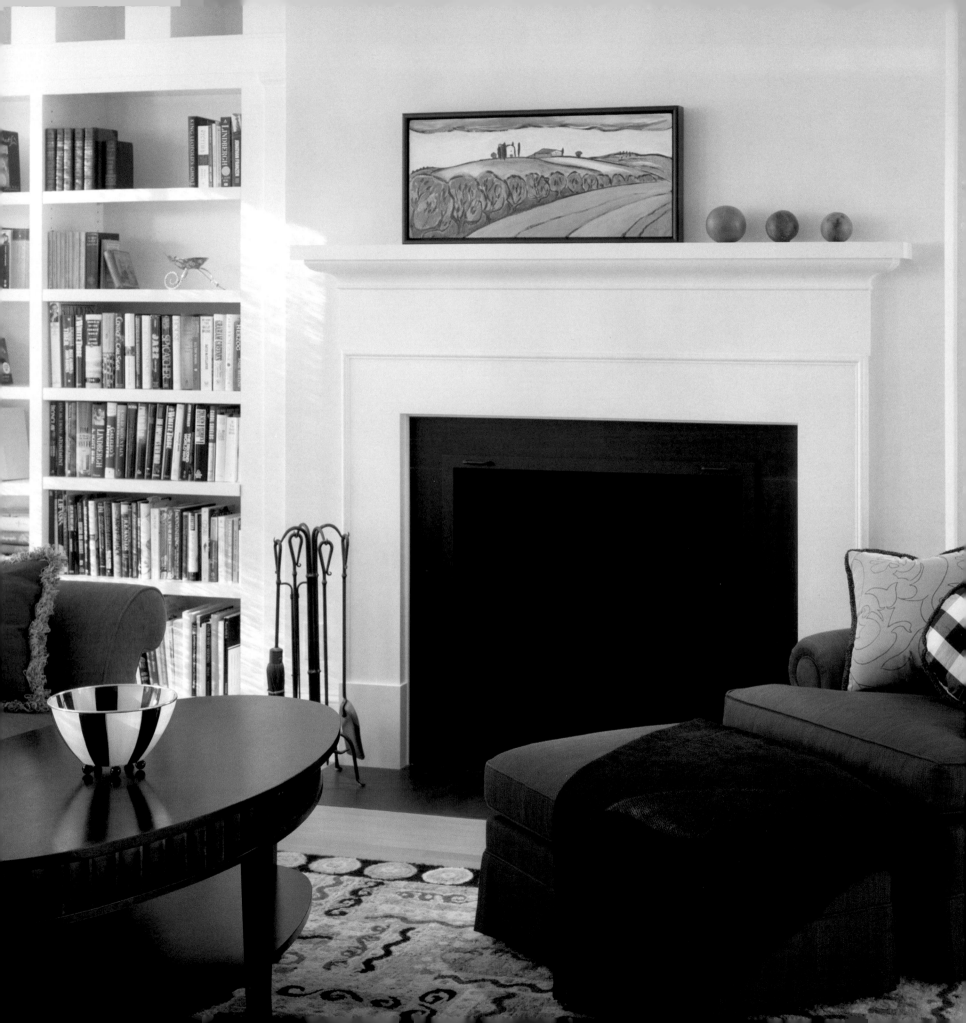

MARY WELLMAN

MARY WELLMAN ASSOCIATES

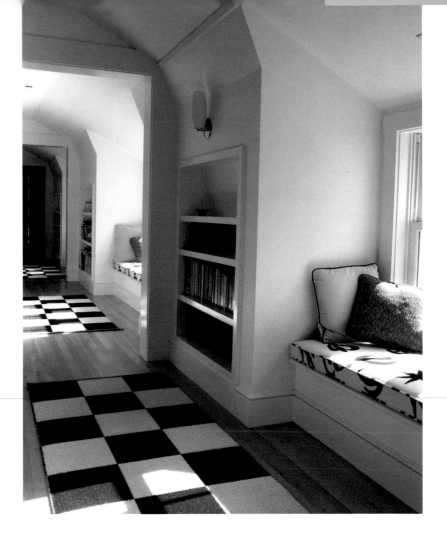

A successful space has a certain harmony with those who dwell within, becoming an extension of and reflecting its inhabitants. However, creating a successful space is no easy feat. It requires the expertise of such a trained eye as Mary Wellman's. With 25 years of experience to back her, Mary is adept at creating interiors that embody and portray the residents therein.

Mary's ability is largely due to her deep appreciation of the fine arts. Earning a B.A. in art history, Mary has since fed her love of art and architecture by traveling extensively. Her education, both formal and informal, imbued her with a great respect for history and a keen eye for form. She enjoys close involvement with the planning stage of design, respecting architectural detail and striving to complement and expand it with her work.

Her varied interests have informed the way she sees and envisions a space. Her firsthand knowledge of different parts of the world along with her continued research helps generate new and variegated design ideas. She often surprises clients by putting

seemingly disparate elements together to achieve remarkable results. She credits her intimate understanding of line, color and texture, among other artistic qualities, for this facility.

Mary Wellman's personal design taste is as varied as the places to which she has traveled. Her own home is filled with artwork and artifacts from the world over, and it is nearly impossible to pin her down to a particular style preference. But she is quick to note that her preferences are not the focus of her work. Certainly she brings to a project her expertise, but her job is to recreate the clients' vision and help them create their own worlds, whether Traditional or Contemporary.

ABOVE
The upstairs hall, including 12 rooms of exuberant color anchored with a black and white theme throughout.
Photograph by John Kreis

FACING PAGE
Lots of color, whimsy and "nothing too grown up" was the client's directive in this large and magnificent new construction for a couple with three young children.
Photograph by John Kreis

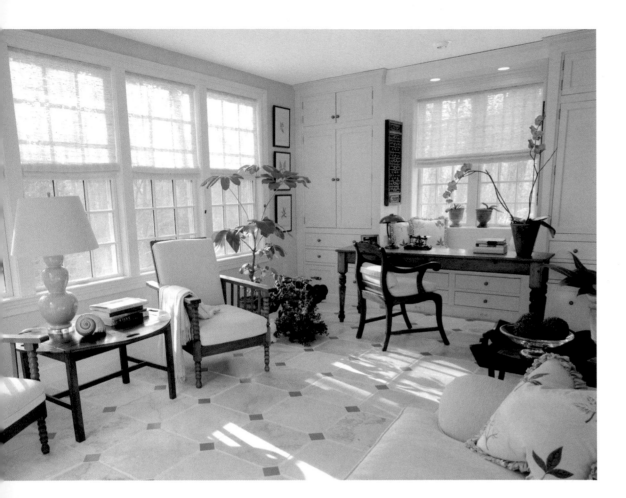

The one philosophy Mary brings with her to every project she does is that every room and every installation needs some wit and humor to it, something that causes her clients to re-envision something they have had for a long time or to see things in a new way. She loves to integrate into her designs items that people think they need to let go of in a way that transforms them and gives them new life.

Mary is thus a translator—of personalities into designs, of history into modern times, of worldly knowledge into domestic settings. She interprets and communicates intelligent design.

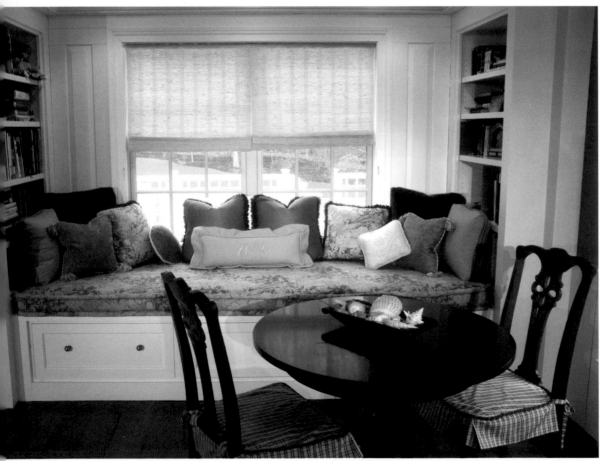

TOP LEFT
The sunroom of a meticulous renovation and addition to an 1830's farmhouse. Room colors and details were inspired by a treasured Indian Pichwai painting on linen.
Photograph by John Kreis

BOTTOM LEFT
A window seat was designed to provide another serene and cozy spot from which to view the woodlands.
Photograph by John Kreis

FACING PAGE
To create the design, the placement of each stone and shell in the Caribbean's West Indian tradition became the focal point of this great room on the ocean in Florida.
Photograph by John Kreis

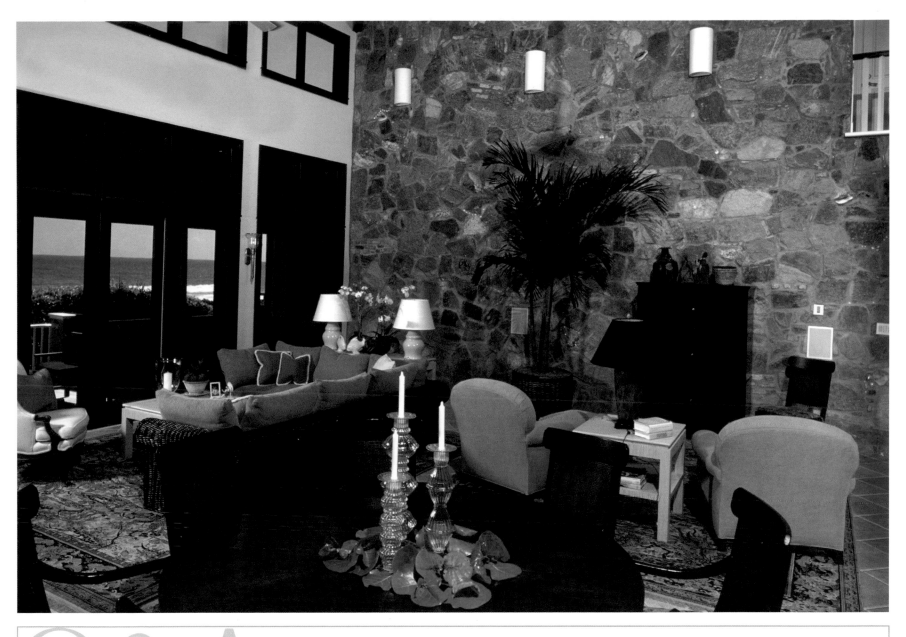

Q & A

MORE ABOUT MARY ...

WHO HAS HAD THE BIGGEST INFLUENCE ON YOUR CAREER?

One particular art history professor I had, Dr. Rodman Henry. A Renaissance scholar, his ability to communicate his vast knowledge and get his students to look at things in new ways influenced the way I perceive.

IF YOU COULD ELIMINATE ONE DESIGN OR ARCHITECTURAL STYLE FROM THE WORLD, WHAT WOULD IT BE?

Interiors that do not respect the buildings' integrity or surroundings, and interiors that take themselves too seriously!

WHAT ONE PIECE OF ADVICE WOULD YOU OFFER A PROSPECTIVE DESIGNER?

I mentor young designers, and I tell them all the same thing: travel as much as possible. Traveling awakens one's eye to what's out there, which is vital in this profession.

WHAT IS THE BEST PART OF BEING AN INTERIOR DESIGNER?

The excitement of partnering with clients to help them manifest their vision.

MARY WELLMAN ASSOCIATES
Mary Kaneb Wellman, Allied Member ASID
770 Boylston Street
Boston, MA 02199
617.375.9030
Fax 617.267.8153
www.marywellmanassociates.com

DESIGNER SUSAN SYMONDS INTERIOR DESIGN, page 249

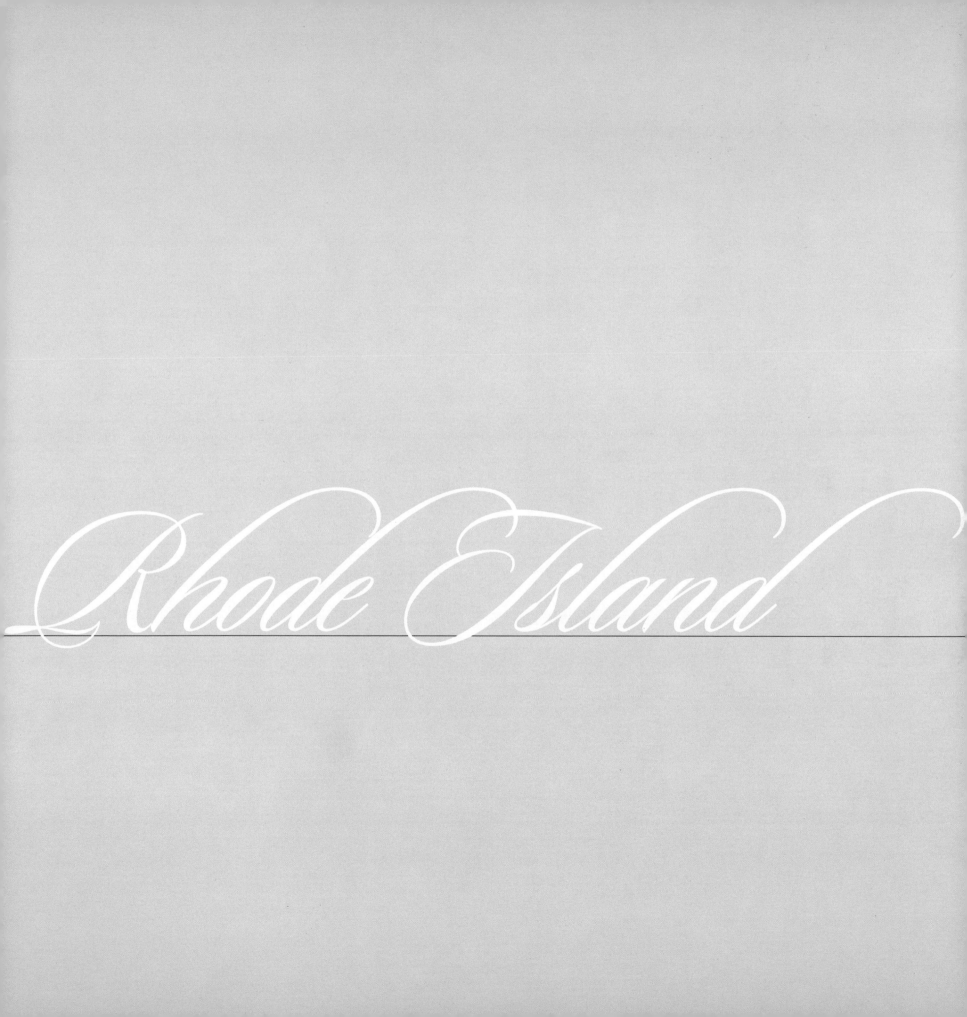

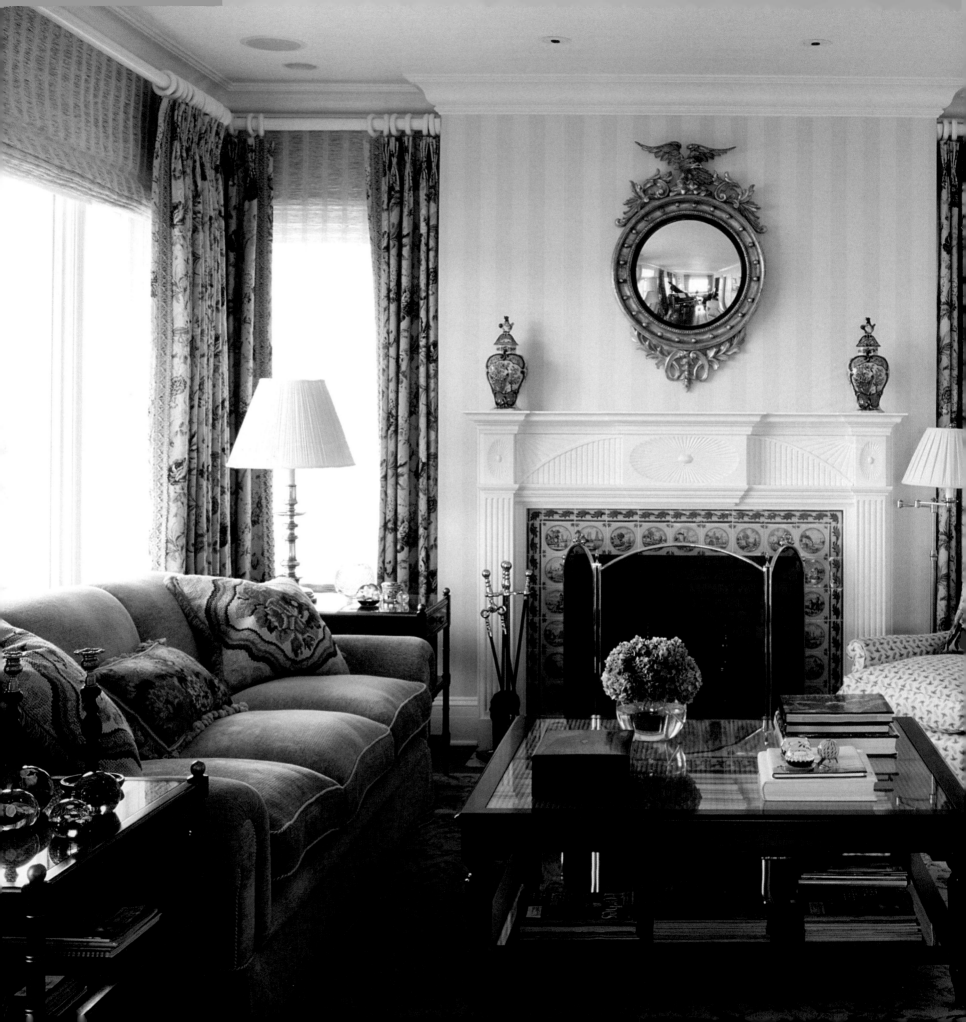

KEVEN HAWKINS

KEVEN HAWKINS, INC.

Architect turned decorator Keven Hawkins offers clients a uniquely comprehensive perspective. Although his true passion lies in the fine details of interior design, Keven spent many years practicing architecture and utilizes his expertise to craft renovation and new construction plans and skillfully direct every step of the process. He believes that in order to create a successful interior, the bones of a house must first be perfected; therefore, he stops at nothing to create spaces of enduring quality.

Residential design is Keven's primary area of interest, yet he has a healthy variety of projects to his name—including yachts, restaurants, spas and private jets—and he approaches each as if it were a home's interior. To ensure that each client and their design have his full attention, Keven limits project acceptance to just a handful per year.

Having earned degrees in both architecture and art history, he also earned a master's degree in historic preservation from the University of Pennsylvania. Keven is intimately familiar with the elements appropriate for a wide range of styles; whether designing a Manhattan apartment or a country estate, the esteemed decorator's creativity is rooted in American tradition, so he always incorporates antiques and

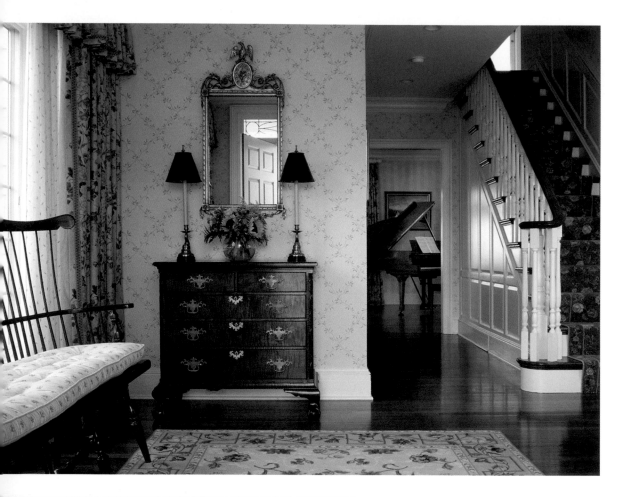

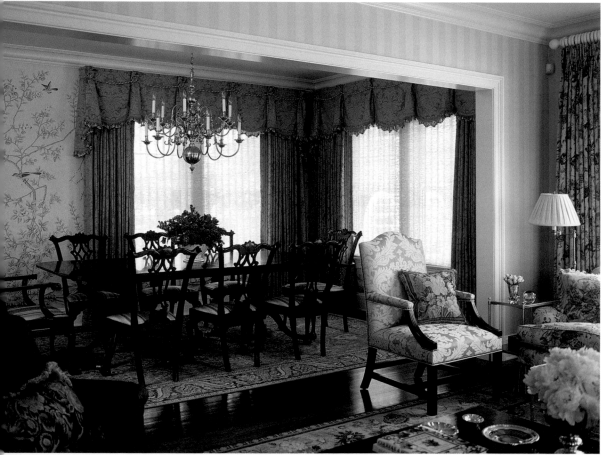

comfortable furnishings along with the state-of-the-art technologies conducive to his clients' modern lifestyles.

He enjoys the opportunity to surround his clients with beautifully crafted, timeless, versatile pieces, and to that end, he guides them through the selection process to make certain that they love each and every aspect. Over the course of his career, he has assembled amazing sources for custom furniture fabrication, millwork, specially printed fabric and hand-sewn window treatments. When projects warrant, Keven does not hesitate to commission hand-woven rugs—historical replicas, complete with period-consistent wear—and even custom-printed fabrics and handmade trimmings.

Keven goes to such great lengths because at the heart of his design philosophy is the importance of properly scaled pieces, followed by a good number of carefully selected antiques and objects, from tables and chairs to bookcases, ottomans and smaller accent pieces likes obelisks, which in his words, "complete the interior."

His wealth of knowledge about architecture and design aesthetics, dedication to providing luxurious havens, and innate ability to assist clients in unearthing their stylistic preferences make him a truly unique decorator.

TOP LEFT
A walnut-stained, wide-board oak floor, needlepoint rug, tiger walnut chest and 18th-century settee welcome guests to this New Jersey coast home. Keven based his design of the hand-tufted stair runner on the curtains' floral print.
Photograph by Carlos Domenech Photography

BOTTOM LEFT
Dining room walls are papered with hand-painted silk Chinese panels depicting cherry trees, bees and songbirds. An out-of-production Georgian damask comprises the silk-trimmed curtains and valances and covers the living room's Gainsborough chair.
Photograph by Carlos Domenech Photography

FACING PAGE LEFT
Warm persimmon grass-cloth walls and a 16th-century Chinese ancestral portrait grace the living room walls in this Asian-inspired Jupiter Island, Florida guesthouse. Gold-encrusted Sumatran batik panels flank the painting, and a lacquer-topped Chinese bamboo daybed serves as the coffee table.
Photograph by Carlos Domenech Photography

FACING PAGE RIGHT
The living room's seven-foot by nine-foot, hand-carved wood and hand-lacquered polychrome chandelier—custom designed by Keven—is one of a pair. The gracefully arced bar and velvet-covered custom-designed bar chairs sit atop travertine floors.
Photograph by Carlos Domenech Photography

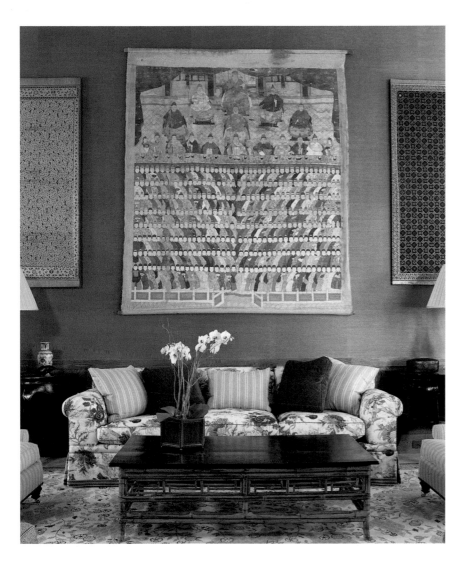

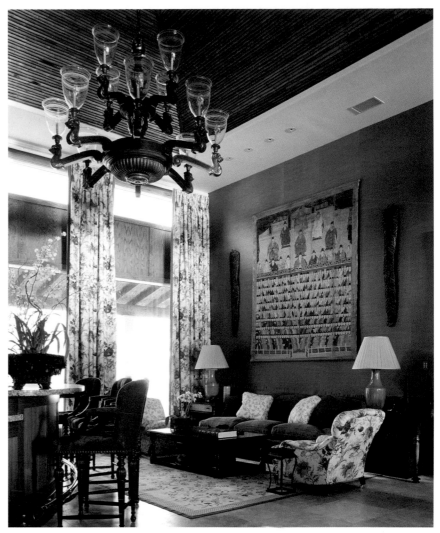

Q&A

MORE ABOUT KEVEN ...

WHAT IS YOUR GREATEST PERSONAL INDULGENCE?

I'm a great lover of horses and ride almost every day.

WHO HAS GREATLY INFLUENCED YOUR CAREER?

I had the privilege to work with the late, legendary decorator Mark Hampton. Additionally, I admire the interiors of Frances Elkins, the sister of renowned Chicago architect David Adler, and of course, Bill Blass.

WHAT ARE SOME MEANINGFUL FORMS OF RECOGNITION?

Foremost, I am mindful to satisfy my clients, but being named by *House Beautiful* as one of America's Top Young Designers was quite an honor.

HOW DO YOU LOOK OUT FOR YOUR CLIENTS' BEST INTERESTS?

I encourage them to purchase furnishings for the long term, mindful of quality design and appropriateness. About five years ago, I designed a couple's first apartment; they have since moved four times and because we selected good pieces, they translated nicely between the settings of New York, Palm Beach and San Francisco.

TELL US A LITTLE BIT ABOUT YOUR ENTHUSIASM FOR ANTIQUES.

I am always on the lookout for fine antiques and decorative objects and travel extensively to acquire pieces for current and future clients. A sampling of my inventory of hand-chosen furniture is listed on my Web site.

KEVEN HAWKINS, INC.
Keven Hawkins, AIA
123 Benefit Street
Providence, RI 02903
401.270.4835
Fax 401.270.3524
www.kevenhawkins.com

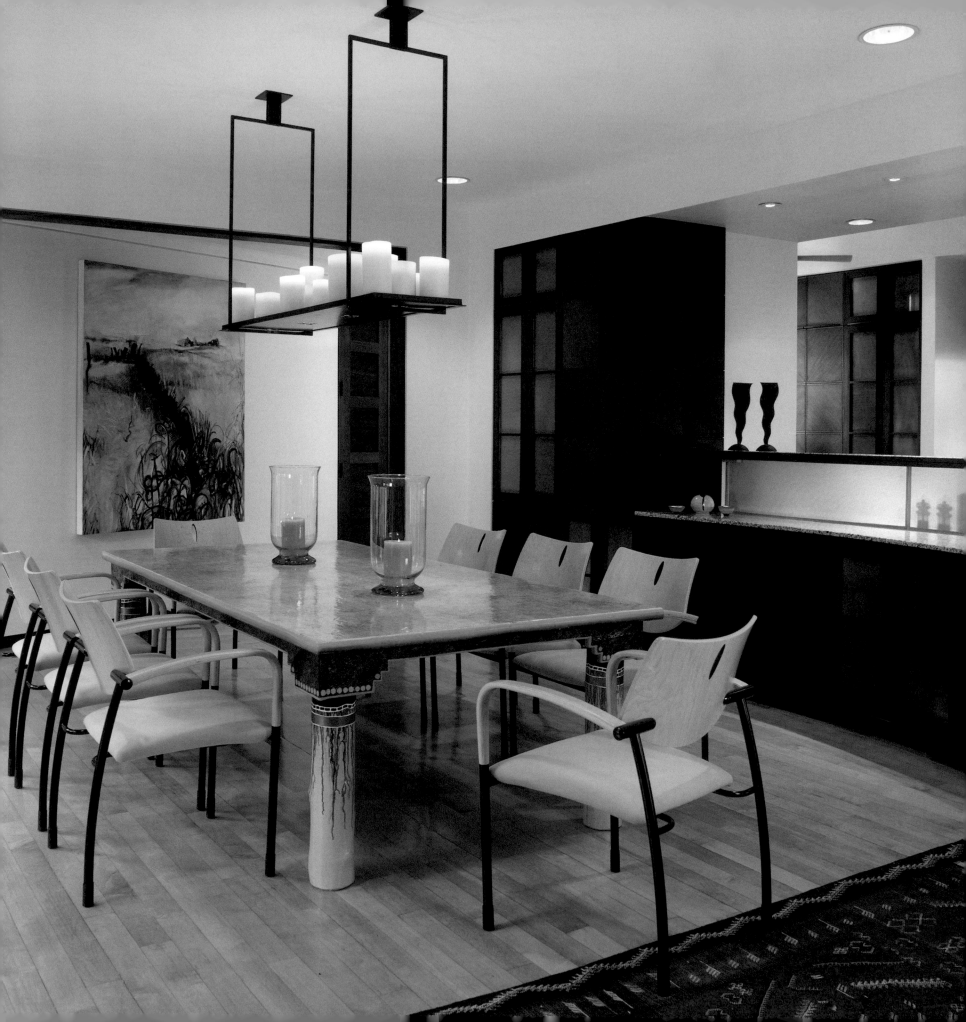

TRICIA HOGUE
JESSIE DELL

SCARBOROUGH-PHILLIPS DESIGN, INC.

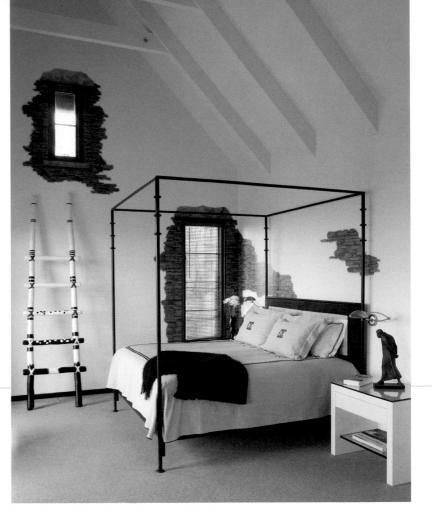

Tricia Hogue and Jessie Dell will tell you that serendipity plays a strong hand in design as well as in life. The designers, who started their firm Scarborough-Phillips in 1988, start with a plan, but always leave room for the unexpected.

New to Rhode Island, only serendipity can explain their meeting in Providence after each was referred to the same real estate agent. Once the agent learned that Tricia and Jessie were both designers, that Jessie had grown up in Philadelphia and Tricia had spent 14 years there, she introduced them. It seemed fated that they should work together.

Within two months of that introduction, the design firm Scarborough-Phillips—a combination of their maiden names—was born. The easy-going duo's approachable style focuses on listening to client needs and establishing an on-going dialogue that helps them understand how their clients live and work. Almost exclusively involved in large residential projects, the pair pride themselves on their ability to collaborate with clients, architects, contractors, and tradespeople.

They work in a wide range of architectural styles, with current projects in Rhode Island, Cape Cod, Nantucket, and Connecticut, as well as New Jersey and Florida. From 18th-century homes to Shingle Style and Craftsman, their work includes both contemporary and traditional styles, some of which have been published in national and regional magazines. They often play a significant role in developing the interior architectural details and have frequently designed custom furniture when the perfect piece cannot be found.

ABOVE
Whimsical faux stonework makes a tongue-in-cheek reference to the exterior masonry and initiates a dialogue between inside and out. The bedframe creates a "room within a room" while maintaining clean lines sympathetic to the architecture.
Photograph by Nat Rea

FACING PAGE
The light fixture, chairs, and custom table from a Santa Fe craftsman are all strong sculptural elements within this informal dining area. Colors take their cue from the large painting, part of the owners' extensive collection of 20th-century art.
Photograph by Nat Rea

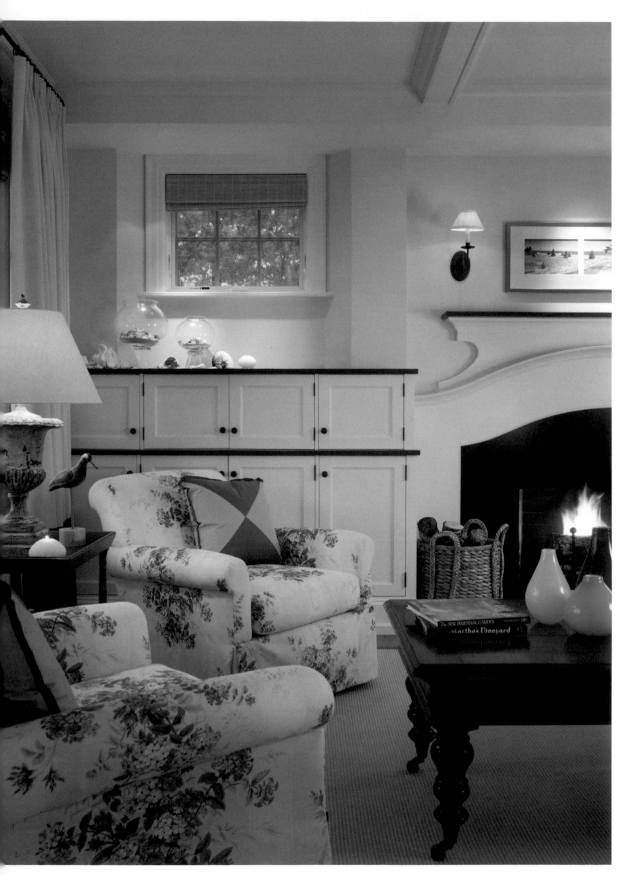

The collaborative process combines Jessie's ability to edit and organize with Tricia's spatial ability and talents for detailed drawings and furniture layouts. Together, they create designs uniquely suited to each client's individual needs and tastes. They concentrate just as much on what is not in a room as what is. By avoiding the tendency to fill every space, they use negative space to positive effect. Their goal is to meet their client's needs both functionally and aesthetically.

Because every project brings Tricia and Jessie new challenges, the team's knowledge constantly evolves. "If you think you know it all, then your design becomes stale and formulaic," says Tricia. Leaving room for serendipity—and realizing inspiration can come from anywhere—keeps their work exciting.

LEFT
Reflecting ocean views and the owner's love of blue, this Cape Cod living room manages to be both elegant and inviting. Tricia and Jessie designed the cabinetry to house a wet bar for casual entertaining.
Photograph by Nat Rea

FACING PAGE LEFT
A guest bedroom's serene alcove is an invitation to curl up with a cup of tea and a good book.
Photograph by Warren Jagger

FACING PAGE RIGHT
Stones and shells in resin, used as the vanity countertop, harmonize with the crisp nautical theme in this beach house powder room.
Photograph by Nat Rea

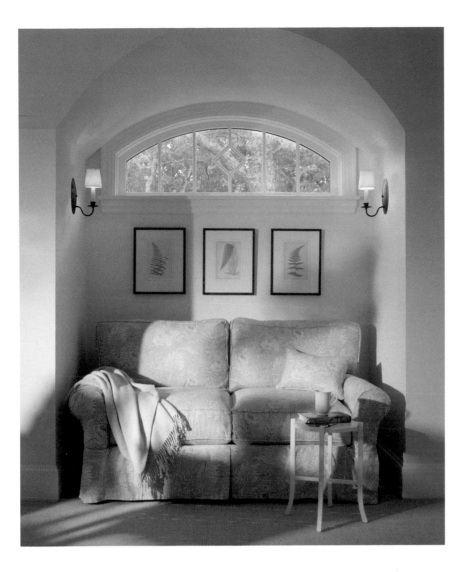

MORE ABOUT TRICIA & JESSIE ...

HOW LONG HAVE YOU BEEN AN INTERIOR DESIGNER/DECORATOR? HOW LONG WITH THIS COMPANY OR IN BUSINESS?

We have each been practicing interior design for 22 and 23 years, and in 1988 together we formed Scarborough-Phillips Design, Inc. in Providence. Jessie moved away in 1990, but we had so much fun designing together that we decided to keep working as a team, despite the distance—hence the split office in both Providence and Sarasota, Florida. It must be working well, since all our business is generated by word of mouth—whether from repeat clients or referrals from other professionals.

DESCRIBE YOUR STYLE OR DESIGN PREFERENCES.

We believe there is no such thing as a "bad" style—only bad design. We welcome the opportunity to expand our horizons.

WHAT ONE ELEMENT OF STYLE OR PHILOSOPHY HAVE YOU STUCK WITH FOR YEARS THAT STILL WORKS FOR YOU TODAY?

Don't overdo: editing is a critical part of every design project. Just because you can doesn't mean you should.

WHAT IS A SINGLE THING YOU WOULD DO TO BRING A DULL HOUSE TO LIFE?

Include books or personal collections—both personalize a house and give a glimpse into the interests of the people who live there.

SCARBOROUGH-PHILLIPS DESIGN, INC.

Tricia Hogue	Jessie Dell
116 Chestnut Street	127 Turquoise Lane
Providence, RI 02903	Osprey, FL 34229
401.521.9784	941.918.8170
www.scarboroughphillips.com	

235

ALAN RENIERE

ALAN RENIERE INTERIOR DESIGN

A long-time interest in architecture and design coupled with years of experience working with purveyors of fine antiques fueled Alan Reniere's decision to assume a career in the field of interior design. With his formal education in art history to guide him, Alan founded the Providence-based Alan Reniere Interior Design in 1980 and has since honed his craft in homes throughout New England and along the East coast.

At the heart of each of Alan's projects is a strict focus on the needs and desires of his clients. With the help of associate designers Catherine Branch—who has been with him since the firm's inception—and Kathleen Manchester, Alan tailors his designs to reflect the practical and stylistic preferences of the homes' residents. His residential interiors range in style from the requisite New England Traditional to the more relaxed Florida Contemporary and derivatives thereof, and he is always excited by clients' unique requests. Characterized by bold colors and patterns, one-of-

a-kind antiques and abundant artwork, Alan's designs consistently impress and delight viewers and residents alike.

Alan credits an acute sensitivity to architecture as well as a natural aesthetic sensibility for his ability to freely move through and work in a wide array of styles and structures. Blessed to live in a region that offers a wealth of historic houses, Alan often takes on home renovation projects, commissions to update and enliven homes while preserving their architectural integrity. His extensive travels—he visits Europe and the United Kingdom several times a year—have garnered him much exposure to a multitude of

ABOVE
Gracie wallpaper panels and an antique chandelier give sparkle to this intimate dining room.
Photograph by Nat Rea

FACING PAGE
The classic Lee Jofa hollyhock print was the inspiration for the living room of this charming seaside home.
Photograph by Nat Rea

design methods and materials and provided him a solid framework for cultural and historical trends, broadening his already far-reaching knowledge and abilities.

While remodeling is one of his specialties, Alan frequently embarks on new construction projects as well and does a great deal of work in loft and apartment homes in New York City. His work ranges from 1,500-square-foot lofts to 15,000-square-foot residences, proof of his spatial flexibility. Indeed, his design acumen helps him maximize space in even the smallest homes.

Alan's remarkable work graces the pages of *New England Home* and earned him local recognition when he won an award in *Rhode Island Monthly*'s annual architecture issue. However, the true rewards belong to those privileged to dwell in spaces they love—homes designed by Alan Reniere.

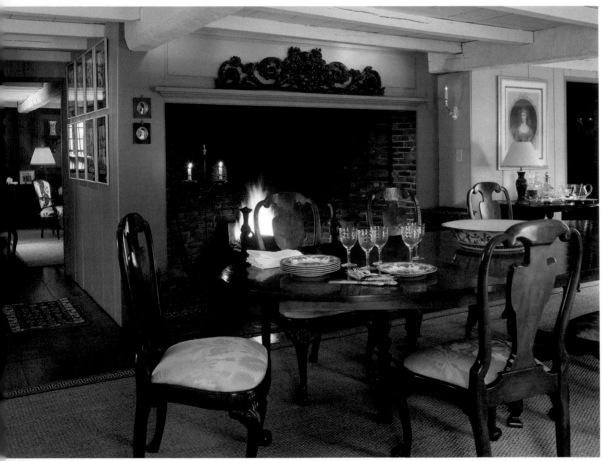

TOP LEFT
A mixture of antiques and warm pine paneling exude Old World ambience in the designer's living room.
Photograph by Nat Rea

BOTTOM LEFT
The massive fireplace provides a dramatic backdrop for the rich wood tones of the dining table and chairs.
Photograph by Nat Rea

FACING PAGE LEFT
This cozy corner of the kitchen is a natural place for guests.
Photograph by Nat Rea

FACING PAGE RIGHT
Exported Chinese porcelain adds crispness against the 1720's English dresser.
Photograph by Nat Rea

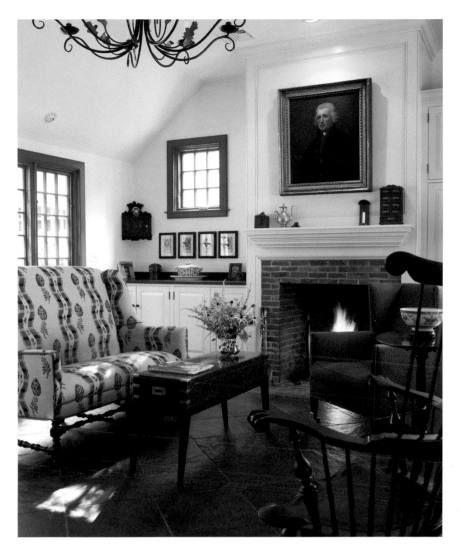

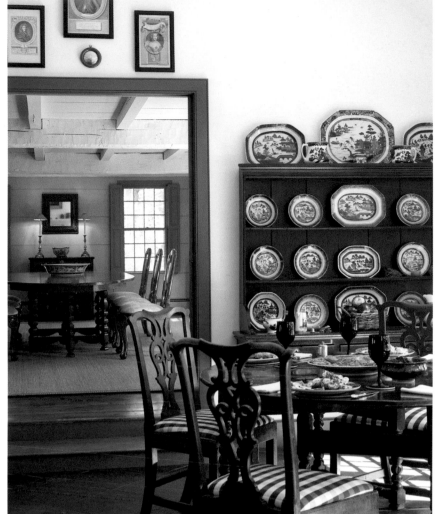

Q&A

MORE ABOUT ALAN ...

IF YOU COULD ELIMINATE ONE DESIGN STYLE FROM THE WORLD, WHAT WOULD IT BE?

I would eliminate "The International Style." It forces on the world the notion that Singapore and Manhattan, for instance, look the same. The specific, exotic histories unique to different countries are eradicated by repeated imitation. This sameness, this homogenization of the globe, is ruining the world.

WHAT COLOR MOST RESONATES WITH YOU?

Red is a color that conveys warmth and strength. I use it in my work, when I can, as an accent or for an entire room. It's a life force color—the Chinese love it for that reason.

WHAT DO YOU LIKE MOST ABOUT DOING BUSINESS IN NEW ENGLAND?

It's exciting to work in the many historic homes present in New England. Providence is a city with lots of 18th- and 19th-century architecture, and these homes offer variety and a constant source of challenge and excitement.

ALAN RENIERE INTERIOR DESIGN
Alan Reniere
200 Hope Street
Providence, RI 02906
401.274.7371
Fax 401.273.5321

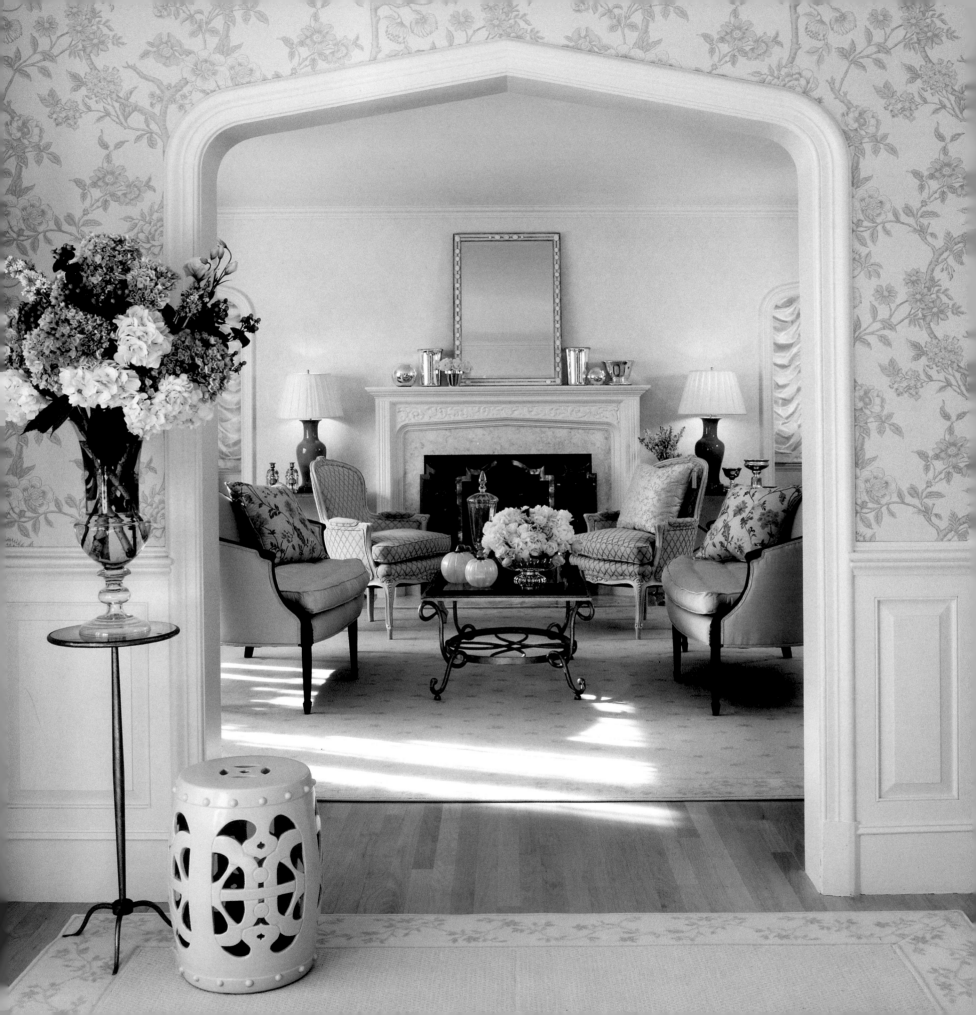

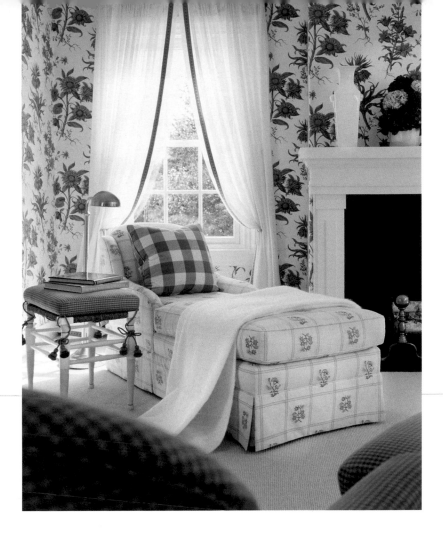

MERYL SANTOPIETRO

MERYL SANTOPIETRO INTERIORS

Meryl Santopietro has been actively engaged in her profession for nearly two decades. Her reputation as an incredibly qualified designer, who truly cares about each client, has taken her throughout New England, down to Naples and South Beach, Florida and even abroad to design a flat in London.

The graphic quality of Meryl's work is evident in the thoughtful compositions that she infuses with color and luxurious textures. Although Meryl is personally fond of bold splashes of color, she has the ability and vision to create an equally breathtaking interior with a pastel or even monochromatic palette. This is achieved by integrating multiple layers of tone and texture—chenille, smooth linen and crosshatch woven fabrics—throughout the space. Together, the design elements that Meryl employs produce an interesting, beautiful and comfortable environment.

Meryl feels that her role as a designer embodies more than creating beautiful designs. It encompasses listening intently to identify the needs and tastes of each client, exposing patrons to a new world of design possibilities, and ensuring that their experience is smooth, enjoyable and results in more than they could have ever imagined. Meryl

finds inspiration everywhere she goes, but the first place she always looks is within the clients themselves. She embraces the diversity of her clientele, and while she subsumes the general wisdom gained with each project, no two projects ever bear even a close resemblance.

The majority of Meryl's time is dedicated to the interior design of homes, but she also enjoys commercial projects and approaches such undertakings as large-scale residential designs because the goal is the same, to create comfortable environments that enrich people's lives. She was the interior designer who transformed the University Club

ABOVE
Lovely English country styling, in bold blue and cream tones, creates a cheerful ladies' retreat at Agawam Hunt.
Photograph by Nat Rea

FACING PAGE
English Tudor, with original architectural details intact, has been furnished to reflect the glamour of the 1930s.
Photograph by Nat Rea

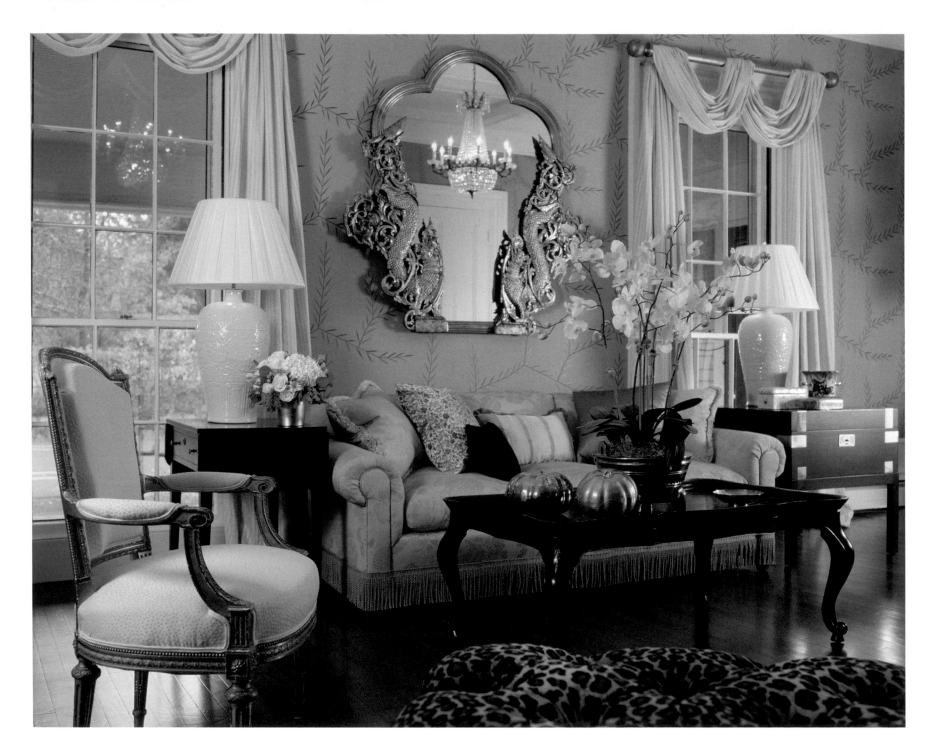

in Providence and recently completed the renovation of Agawam Hunt, the second oldest country club in the United States. Meryl performed a great deal of research for each project to obtain a comprehensive understanding of furnishings and colors for the time period and then determined a design direction that was appropriate for contemporary enjoyment. Although the magnitude of designing every space from dressing/locker rooms to dining areas and living spaces was challenging, she achieved her goal of satisfying a membership of hundreds. In view of her experience, dedication to her clients, artistic creativity and passion for design, she can certainly surpass the expectations of even the most discerning family.

ABOVE
Elegant and richly layered with textures, this living room is all about beauty and style.
Photograph by Nat Rea

FACING PAGE TOP
This traditional paneled living room at Agawam Hunt captures the refined and stately manners of a country estate.
Photograph by Nat Rea

FACING PAGE BOTTOM
This rustic dining room provides breathtaking views of the countryside from its spectacular Palladian windows.
Photograph by Nat Rea

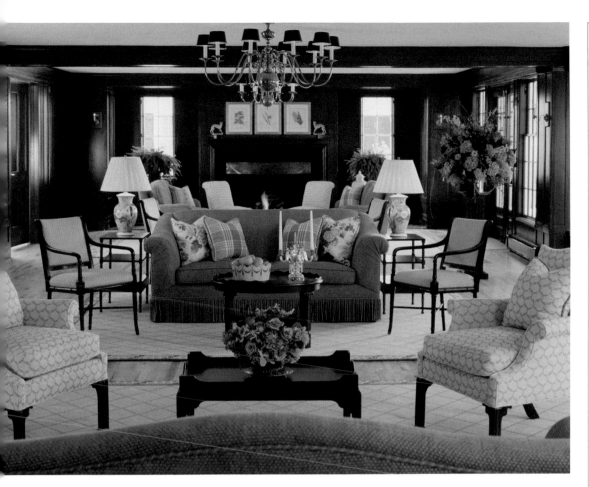

MORE ABOUT MERYL ...

WHAT IS THE HIGHEST COMPLIMENT YOU'VE RECEIVED?

A prominent custom furniture manufacturer felt that my designs represented his company so well that they asked to use images of my work in their worldwide marketing campaign.

DO YOU FIND INSPIRATION IN YOUR TRAVELS?

Definitely! On one occasion, upon returning from Paris, I was inspired by the color scheme that I observed and incorporated some variations into a showhouse that I had been creating.

WHAT INSPIRED YOU TO BECOME AN INTERIOR DESIGNER?

My vision of creating beautiful and elegant interiors that enrich and enhance our lives.

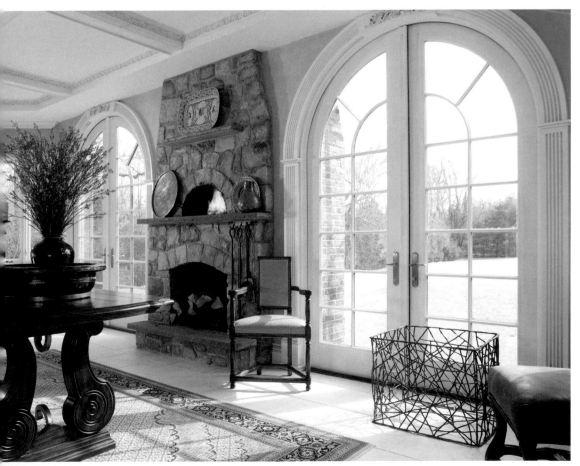

MERYL SANTOPIETRO INTERIORS
Meryl Santopietro
200 Hope Street
Providence, RI 02906
401.245.5375
Fax 401.245.3734

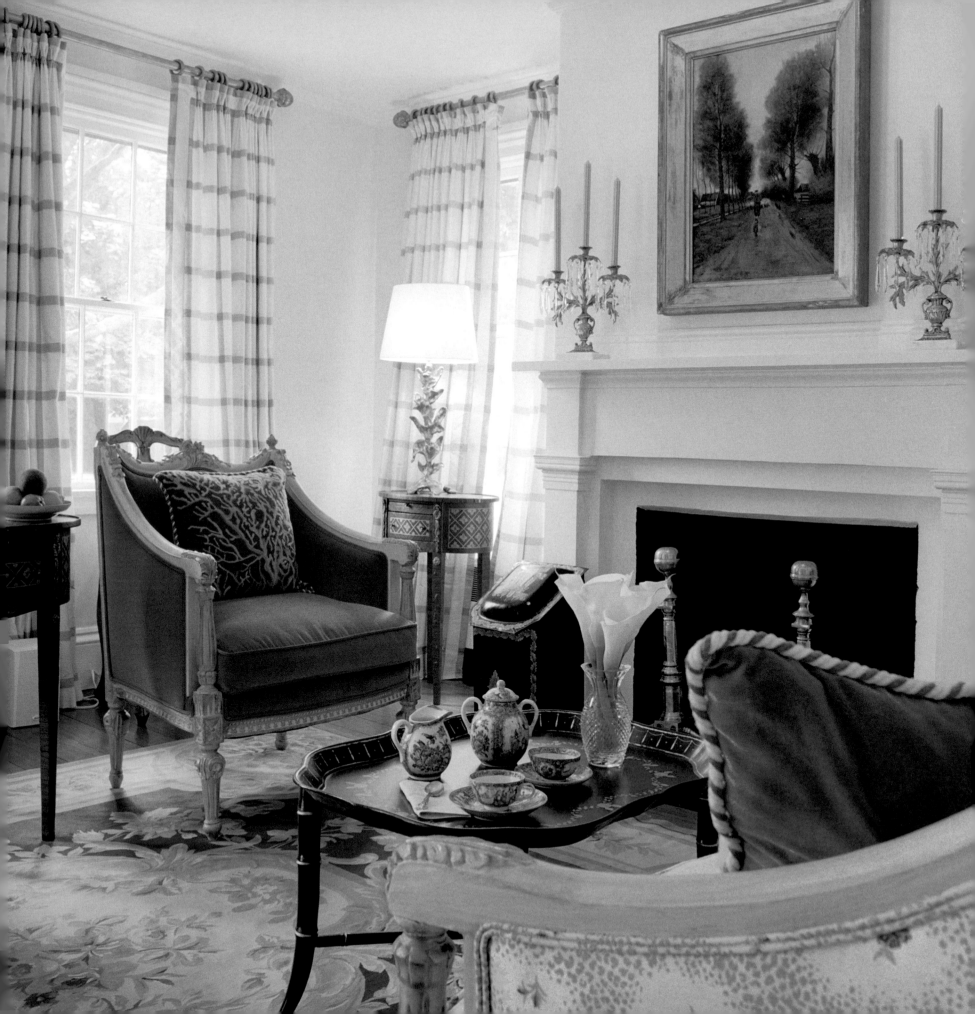

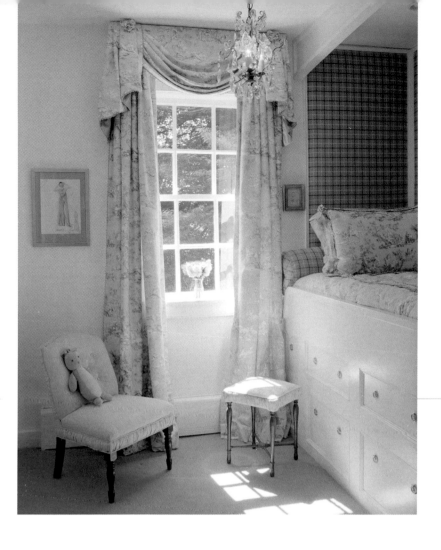

CYNDIE SEELY

CJ DESIGNS

When interior designer Cyndie Seely is on the scene, even the smallest details receive thoughtful consideration. Her signature layering technique—blending old with new and incorporating interesting textures, colors and scales—ensures that clients receive timeless designs infused with fresh ideas.

Because of the personal nature of residential interior design, Cyndie begins each project by unearthing her clients' interests, noting their likes as well as their dislikes. She cares deeply about creating spaces that exude beauty, originality and most importantly, the residents' personalities. Cyndie has become so proficient at identifying her clients' desires early on in the process that they are oftentimes completely taken aback when she presents them with the perfect inspiration pieces or accessories. A seasoned professional, Cyndie is mindful to accept only projects in which she sees the potential

for a great working relationship, and from this discerning plan, many close friendships and long-term partnerships have developed.

On the foundation of strong relationships, Cyndie is able to comfortably introduce clients to new ideas and push the envelope of design possibilities. Clients respect her work ethic and know that every creation is invented especially for them. She draws inspiration from her practical knowledge as the mother of four, interior architecture

ABOVE
An upstairs utility room was transformed into a restful, reflective, unfussy feminine bedroom. Walls upholstered in Lee Jofa's "Jac Sconey" check, window treatment and bedspread in Manuel Canovas "La Musardiere."
Photograph by Lisa Limer

FACING PAGE
A stately Bristol, Rhode Island living room with varied refined and rich fabrics.
Photograph by Lisa Limer

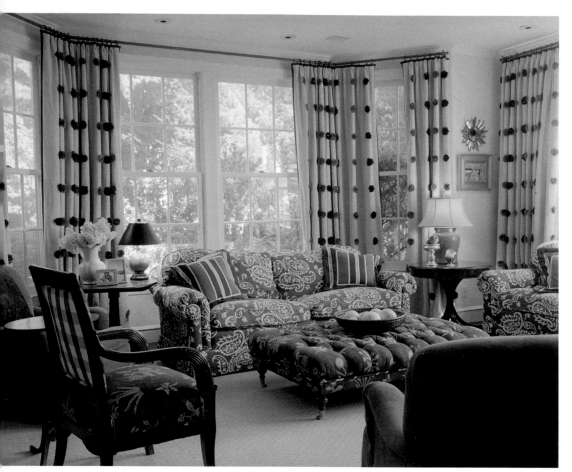

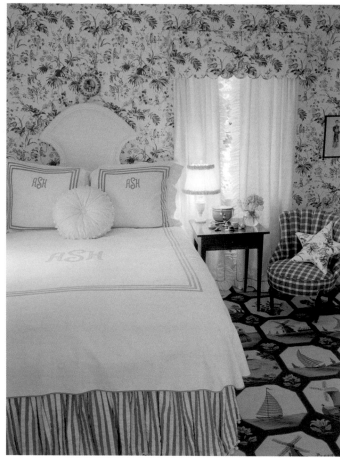

skills that were honed many years back at the Rhode Island School of Design and lifetime of keenly observing her surroundings. Complementarily, Cyndie's husband is an architect, and even though their firms operate separately, all patrons benefit from their combined design and technical wisdom.

Cyndie is the first to admit that in addition to working with great people, she loves the career perk of indulging, on a daily basis, in one of her favorite pastimes: shopping. Whether in Paris or Los Angeles, Cyndie never passes up the opportunity to explore the local offerings, on her clients' behalf, of course. She always seems to know where to find the right elements and has an unmatched mental catalog of the latest trends, clever techniques, styles and applications. Especially fond of giving a modern twist to traditional French and English vernaculars, she frequently incorporates custom built-ins and furniture, which add immeasurably to an interior's uniqueness.

Although Cyndie takes full advantage of the many elements on her palette of creativity, color has become somewhat of a specialty. She never shies away from color, but rather uses brilliant hues to evoke emotional responses and provide smooth transitions between living spaces. Whether splashing the walls of a dining room with hot pink or introducing more subtle colors through accent pieces, Cyndie makes the creative process look easy.

Regardless of how imaginative her designs may be, they all resonate with warmth and timelessness and express people's deeper essence.

ABOVE LEFT
A playful placement of pompoms on linen enriches a Barrington, Rhode Island living room pulsating with life.
Photograph by Lisa Limer

ABOVE RIGHT
A blue and white bedroom evokes dreams of sailing ships and blue horizons, anchored by a Portuguese needlepoint rug.
Photograph by Lisa Limer

FACING PAGE TOP
An elegant formal dining room is made even more expansive with the addition of a large antique mirror, which doubles the size of the room as well as reflects its bounty.
Photograph by Lisa Limer

FACING PAGE BOTTOM
A twin bedroom for close-knit sisters in Connecticut. Hot pink dominates this little girls' room and is accented with chenille bedspreads and pillows.
Photograph by James Grout

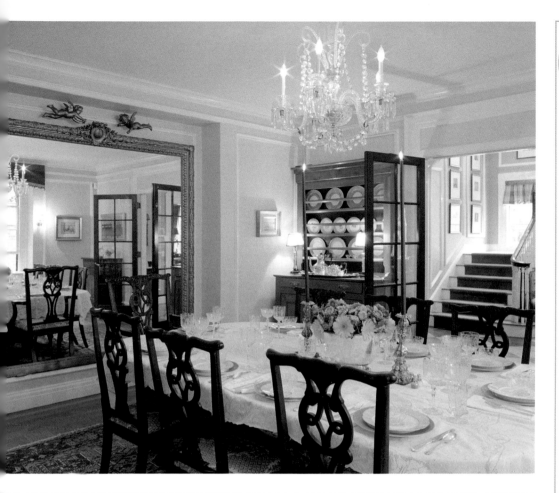

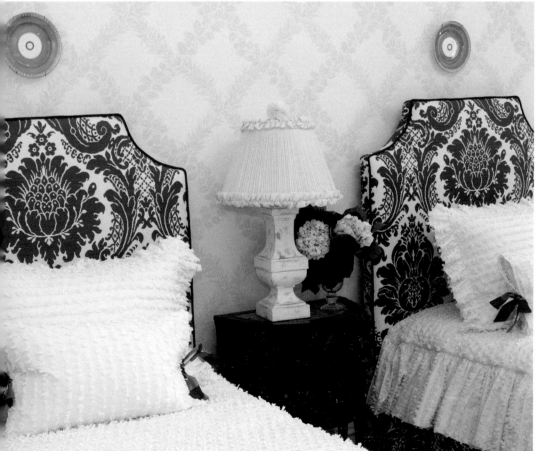

MORE ABOUT CYNDIE ...

HAVE YOU ALWAYS BEEN INTERESTED IN DESIGN?

Yes! I've been curious about design since I was a child, and in some form or another I've always loved expressing my creativity. Before I ventured full time into interior design nearly two decades ago, my sister and I actually had a business making children's clothes out of upholstery fabric.

WHEN YOU'RE NOT DESIGNING, HOW DO YOU SPEND YOUR TIME?

I love to entertain, so if I ever take a day off, it's probably because I'm throwing a dinner party that evening.

WHAT COLOR BEST DESCRIBES YOU?

Chocolate brown—it is deep, rich and goes well with many other colors.

DO YOU HAVE ANY PERSONAL INDULGENCES?

Shoes and handbags.

WHAT IS THE BEST PART ABOUT BEING AN INTERIOR DESIGNER?

The opportunity to be creative on a daily basis and make people happy in their environment.

CJ DESIGNS
Cyndie Seely
84B Harris Street
Pawtucket, RI 02861
401.722.8500
Fax 401.722.8501

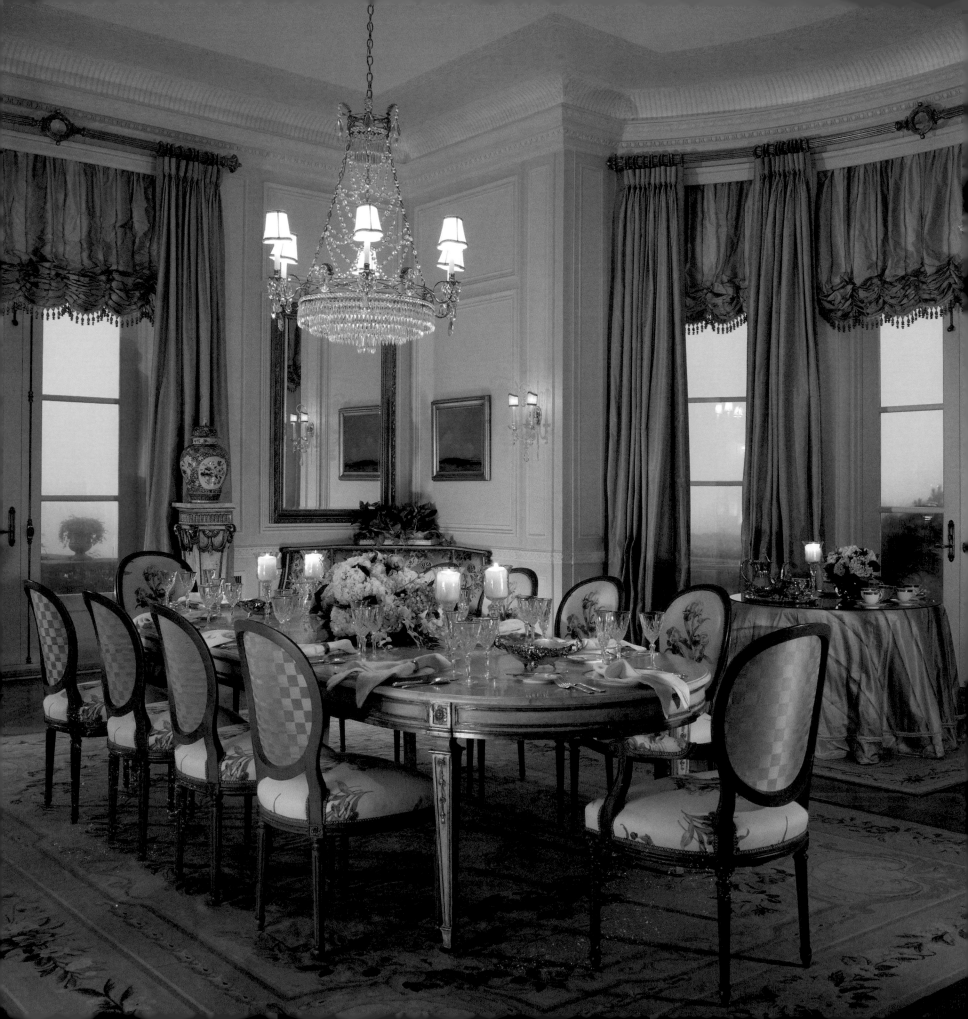

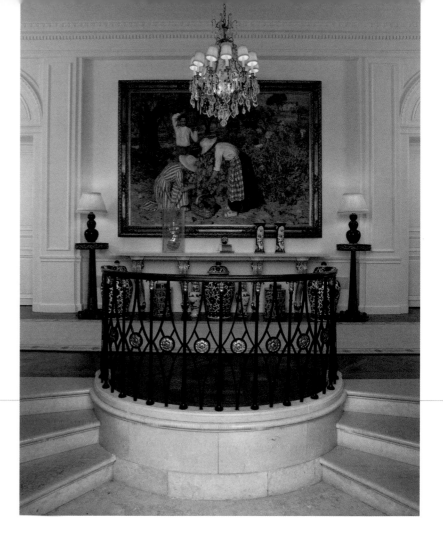

SUSAN SYMONDS

SUSAN SYMONDS INTERIOR DESIGN

One of the most highly respected designers in her field, Susan Symonds has been commissioned across the country and is renowned for the superior quality of her work. Sought after for her expertise in every aspect of project management, Susan guides each proposal to fruition including development of the overall concept and implementation, coordination and management of the entire plan. Though each of her projects vary greatly in size and scope, Susan brings diversity, talent and her broad knowledge of history, art and archaeology to each design whether it be residential, corporate, private institutions or private jets.

The remarkable locale of Providence, Rhode Island where Susan makes her home serves as a point of inspiration for her designs. The rich architecture, the city's long history dating back to the 17th century, and the talent and knowledge that pour from the Rhode Island School of Design and Brown University have helped to give Providence an artistic, cultural heritage and earn its shining reputation as a cultural gem. There is much to glean from the city, and Susan feels that one should never stop learning.

Continually investigating and evolving concepts along with her elemental ability to connect lifestyle with versatility allows Susan to develop an intimate rapport with clients, providing them with an unparalleled experience and personalized service. Susan's clients seek her intrinsic creativity to offer options that they might never have imagined, and her skill at truly listening to her clients as they express their own interests, goals, lifestyle and passions has been absolutely vital to her success.

ABOVE
The grand hall is most welcoming: Marble stairs and bronze railings draw one in, while the Blanche Camus painting sets the tone as the blue and white porcelains dazzle on a gilt wood and marble sideboard. Ormolu gilded bronze sconces from M.E. Dupont mix with a contemporary glass sculpture by Steven Weinberg.
Photograph by Nat Rea

FACING PAGE
This dining room features dramatic views of the Atlantic Ocean and the gardens and terraces of this extraordinary Newport estate. The room is treated with soft tones of stried walls and a hand-painted ceiling in an Adamesque manner. Rose Cummings silk curtains elegantly hang from custom-designed gilt rods.
Photograph by Nat Rea

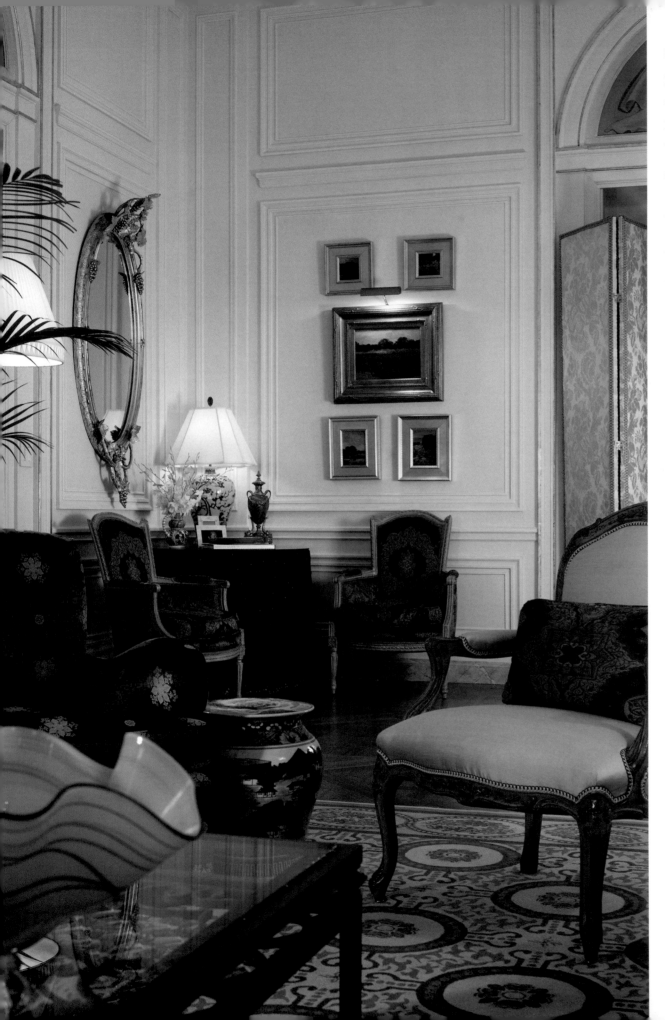

Susan also enjoys involving her patrons in the process of her designs, whether consulting on a color, fabrics or art, and her passion serves as their lead. She has found that the close collaboration between designer and client results in exquisite, individual environments that are aesthetically and functionally pleasing as well as more richly valued by those who live and work in them.

With her style philosophies firmly anchored in classic proportion, Susan's master plan ensures appropriate scale, balance and rhythm. Inspiration then serves as the method to her countless, successful projects. Moving with equal dexterity between many different styles, whether Classic, Contemporary or Traditional, her interiors are marked by an extraordinary use of color. Susan asserts, "Well-chosen color enhances the way that people live through intimate and energized spaces."

LEFT
In the corner of the ballroom/living room, a contemporary piece of David van Noppen glass fits comfortably with the blend of French and English antiques, deep-cushioned club chairs and French armchairs covered in Bergamo fabrics. Each design element is ever so nicely anchored by a Susan Symonds-designed rug.
Photograph by Nat Rea

FACING PAGE TOP
The ocean-facing loggia was enclosed with bronze doors, custom designed to meet velocity wind loads so that the clients and their guests may enjoy continual access no matter the weather. The room is a delightful confection of textures from Clarence House and Bergamo. An antique Korean royal robe enclosed in a Lucite box hangs behind the sofa, setting the palette for the room. The Steven Weinberg glass-a-round table with bold striped chairs for casual dining all rest on French limestone floors and a Susan Symonds-designed rug.
Photograph by Nat Rea

FACING PAGE BOTTOM
This rich mahogany library combines Old World grace and style, outfitted with the latest in audio/visual systems and conveniences. It is a cozy retreat that is in touch with the modern world. Fabrics from Travers and Hinson. Oil painting by Ken Auster.
Photograph by Nat Rea

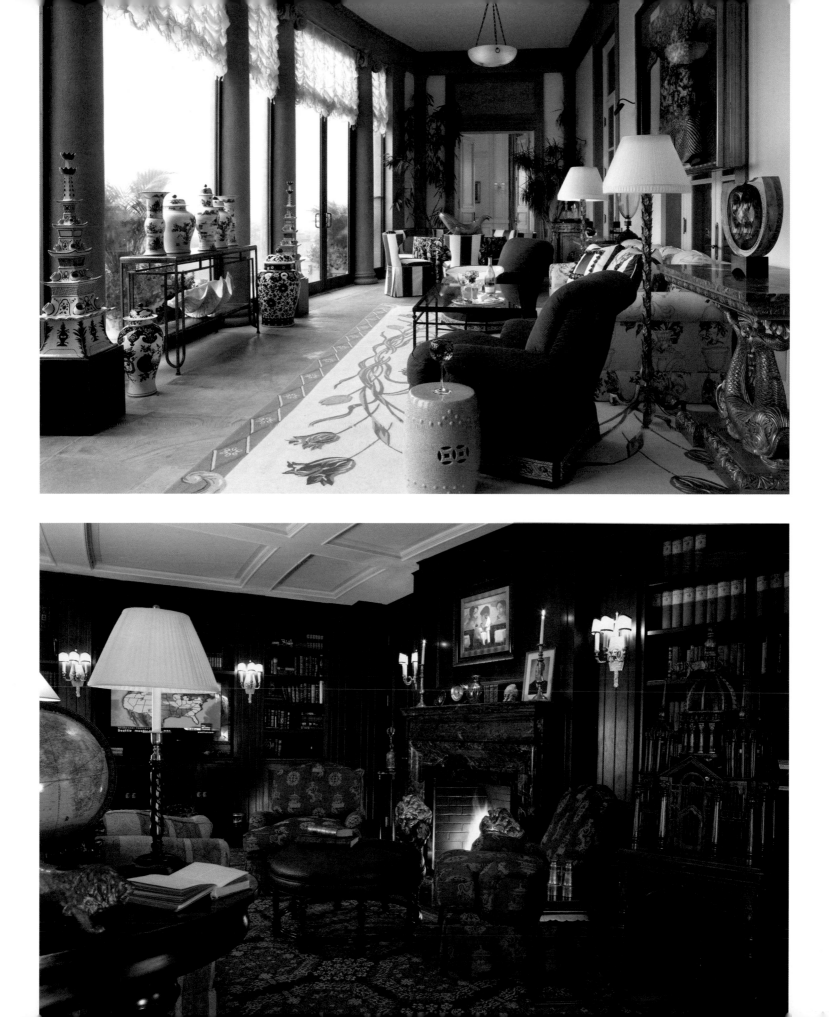

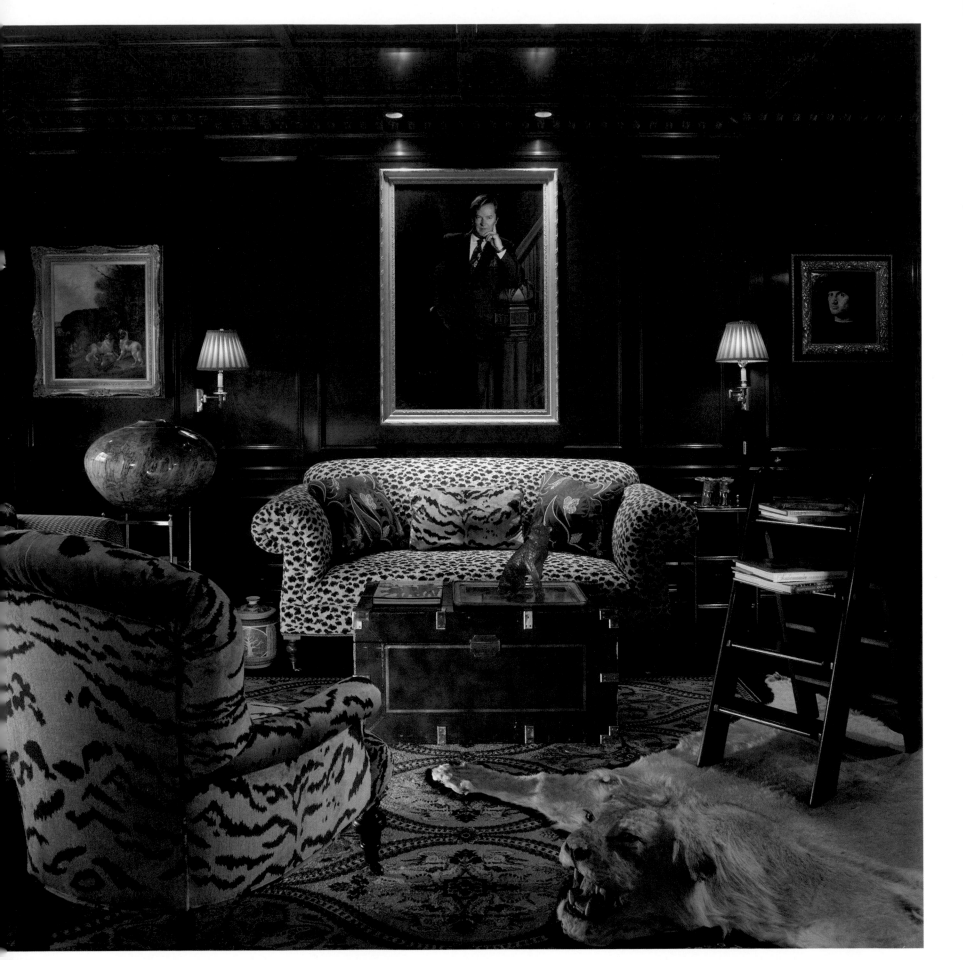

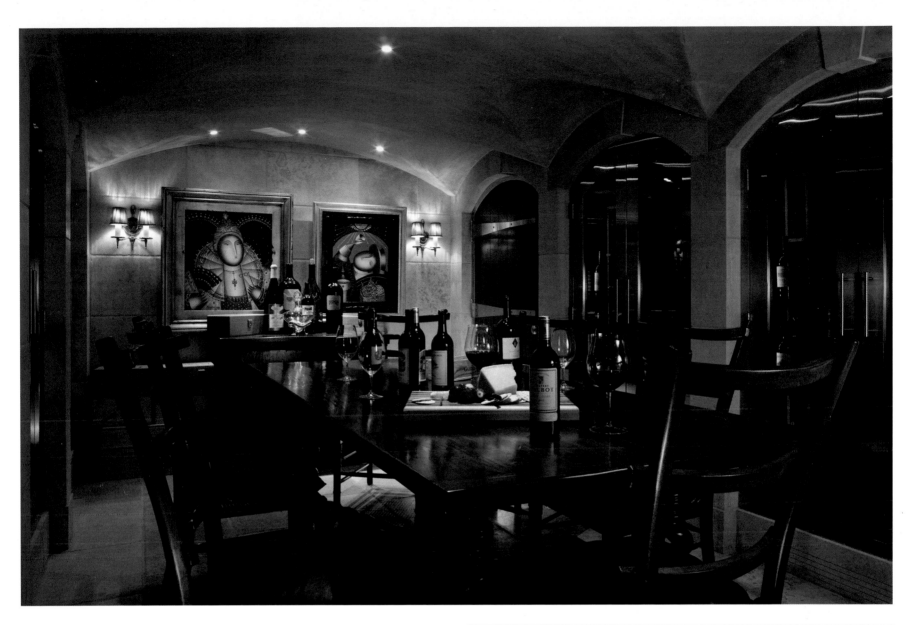

ABOVE
The wine cellar combines high-tech amenities with Old World craftsmanship. The Spanish limestone and Portugese tasting table are a perfect backdrop for the two portraits by Russian artist Arkipov. Even the merlots are happy in this oenophile's delight.
Photograph by Nat Rea

RIGHT
In a bright, airy living room, a glass-topped cocktail table with a trumpet-shaped brass base by sculptor Armond sits on an antique Aubusson rug. The owner's collection of glass includes work by Dale Chihuly, Steven Weinberg and Dante Marioni. Susan designed the room with furnishings and fabrics from Bergamo to Zimmer + Rohde, celebrating her clients and their collections.
Photograph by Nat Rea

FACING PAGE
The owner's portrait by artist Sharon Knettal, flanked by old master paintings, is the focal point of this library. Custom millwork of hand-rubbed, book-matched "crotch" mahogany, rich textures from Lee Jofa, Scalamandré, Bruschwig & Fils, Zimmer + Rohde, and a vintage lion rug as well as rug by the designer anchor this masculine retreat.
Photograph by Nat Rea

One of the highest compliments she received was a client's sincere thanks as they told her their new décor was more than they ever expected. Susan loves making her clients feel comfortable and proud of their homes. If they experience that instant tingle when they enter their completed space, she knows she has hit a home run! And, it is wonderful when other designers acknowledge and compliment her work and she receives coveted applause from her peers.

TOP LEFT
A contemporary house rebuilt into a French Country bastide sits on the ocean's edge. The dining chairs are truly special, designed by Susan to incorporate the clients' initials. The bright color palette holds its own with the shimmering hues of the Atlantic Ocean. Two paintings by Tom Sqouras flank the doors entering the living room.
Photograph by Nat Rea

BOTTOM LEFT
The living room is awash in light. A convex sunburst mirror and Country French tile fireplace surround pulls the eye into the room. Crisp color textures on the furniture sit on a softly hued Persian rug. This is a family house that takes a lot of wear and tear and always, because of the selection of fabrics and patterns from Clarence House, Brunschwig & Fils, Bailey and Griffin and Lee Jofa, is kept fresh.
Photograph by Nat Rea

FACING PAGE LEFT
The entrance way to the designer's own 1815 home defines the term eclecticism. Susan mixes objects that she has collected over a lifetime. Cobalt and sterling hurricanes sit next to 18th-century French chairs upholstered in playful tiger-patterned Scalamandré silk velvet.
Photograph by Nat Rea

FACING PAGE RIGHT
Painted Swedish dining chairs' seats in Dedar fabric, surrounding an ebony contemporary round table, dominate this space. The room has a fireplace and an entrance to the garden. A French rock crystal chandelier and Scalamandré silk curtains add considerable flash to an all-purpose room.
Photograph by Nat Rea

FACING PAGE BOTTOM
The designer, at ease in her library, with cockapoo, Tassels, on the custom-designed banquette covered in Cowan Tout fabric. Clarence House-cut velvet Roman shades add a simple and soft touch to the beautifully crafted and original windows. Susan's home is a comfortable retreat for her friends, her family and, of course, their dogs.
Photograph by Nat Rea

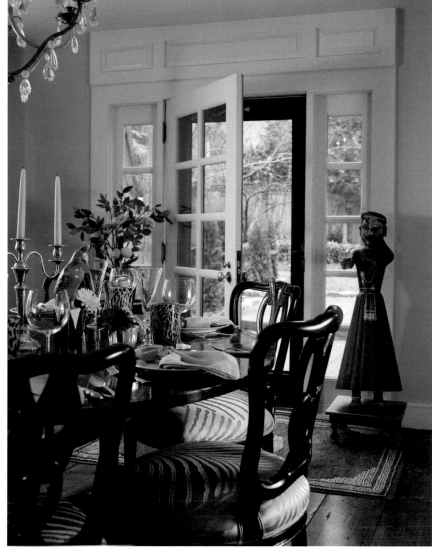

Q&A

MORE ABOUT SUSAN ...

IS THERE ONE THING IN YOUR LIFE IN WHICH YOU INDULGE?

My friends and family!

TELL US SOMETHING THAT PEOPLE MIGHT NOT KNOW ABOUT YOU.

I have an extensive background in the classics and archaeology.

HOW LONG HAVE YOU BEEN A DESIGNER?

For 33 years and I still love every minute!

WHAT COLOR BEST DESCRIBES YOU AND WHY?

Red, because it has energy, passion and strength.

WHO HAD THE BIGGEST INFLUENCE ON YOUR CAREER?

My father was the biggest influence on my design career. He was an avid collector who exposed me to all the beautiful things in life like art, music and history.

SUSAN SYMONDS INTERIOR DESIGN
Susan Symonds
68 Transit Street
Providence, RI 02906
401.273.9296
Fax 401.331.1809

255

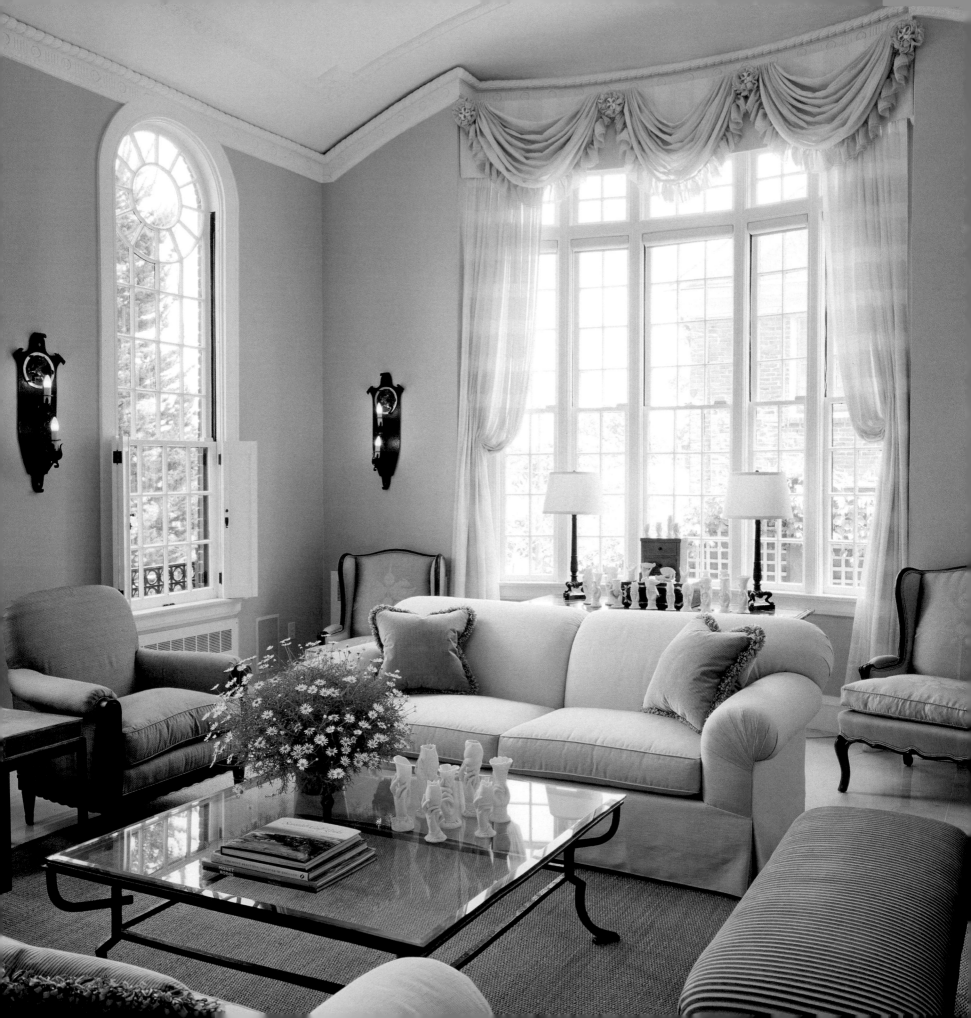

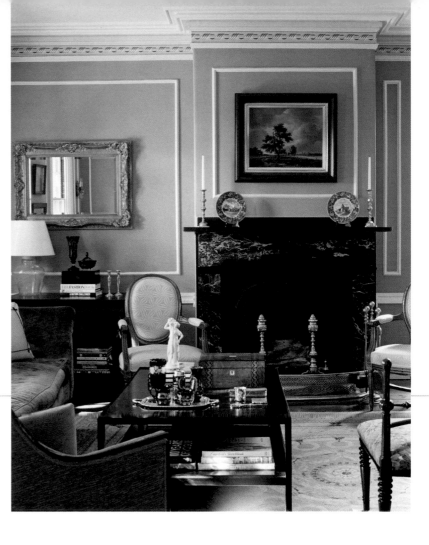

COURTNEY TAYLOR

TAYLOR INTERIOR DESIGN, INC.

Fine living, every day of the year. Courtney Taylor enjoys helping clients achieve this goal by surrounding them with only the highest-quality furnishings and accents. With comprehensive services that start with thoughtful interior architectural design and lead to brilliant color palettes, furniture plans, custom window treatments and luxurious linens, Taylor Interior Designs, Inc. is truly a turnkey firm.

Nancy Taylor established Taylor Interior Design the year her daughter, Courtney, was born. The younger Taylor's first professional creative outlet was through her Manhattan-based apparel design company, through which she honed her skills in form, color and fabric. Having been raised amid the excitement of a burgeoning interior design business, it was only a matter of time before Courtney joined the family tradition; and for nearly a decade, the mother-daughter duo has swept the East Coast with their striking designs. Many people may not be able to conceive of working so closely with their mother, but Courtney cannot imagine designing any other way and describes her mentor as "professional, patient and incredibly creative."

What began as a home-based business quickly grew into a diverse team of designers, who specialize in interior architecture, CAD, furniture design and lighting. Together, they have the expertise to accomplish everything from a small kitchen or bath remodel to a 10,000-square-foot, whole house design and enjoy the diversity of all projects in between.

Firmly grounded in their dedication to establishing a wonderful quality of life for each client, the Taylor designers have a philosophy with broad-reaching applicability. Whether designing within the walls of a stately Georgian home in New England or an

ABOVE
A meticulously preserved Greek Revival creates a wonderful design opportunity to show off original details of the house. The clients' antiques appropriately balance the straight-edged black lacquered coffee table and more contemporary fabrics that adorn the furniture.
Photograph by Sam Gray

FACING PAGE
Beautifully restored Tudor in Providence, Rhode Island. In this formal living room, vibrant wall color creates a stirring backdrop for a more quiet and neutral assemblage of furniture. Tailored sofas covered in a soft, pale, creamy silk anchor seating area. Original iron sconces circa 1920.
Photograph by Sam Gray

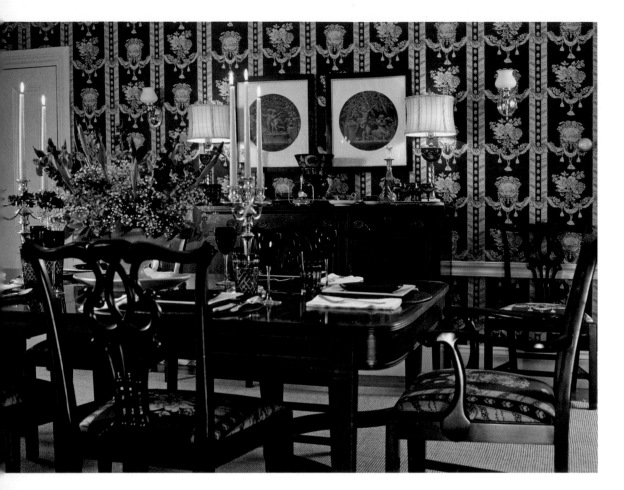

ultra-modern Florida residence, Courtney and the entire Taylor team excel at working with clients to define goals and guide the project to a successful completion. Clients' investments are respected so sincerely that the firm has a 20-year style pledge: Two decades down the road, interiors to their credit will still glow with elegance and sophistication. To this end, creativity often begins with residents' cherished belongings, after which delicate layers of design are woven into a thoughtful composition.

The design studio's atmosphere is wonderfully collaborative, and each designer feeds off the creativity of her counterparts. Courtney delights in the common instance when a designer has a beautiful presentation nearly complete and a peer moves a few colors around to make the palette pop even more. Each project has a different set of parameters, yet all are graced with the Taylor signature: Multiple layers of fabrics, colors and textures that solicit a response—excitement or relaxation—in harmony with the residents' lifestyle and preferences.

TOP LEFT
Large-scaled decorative wallpaper and coordinating fabric create a stately environment for this formal dining room. The ruby Bohemian glass collection, the original inspiration for the room, mimics the intricate designs of the wallpaper and fabric.
Photograph by Sam Gray

BOTTOM LEFT
More of the extensive collection of ruby Bohemian glass collected and purchased mostly in England. The lamps are converted oak altar candlesticks that sit atop a rare Portuguese marble-top writing table.
Photograph by Sam Gray

FACING PAGE LEFT
Pink velvet chairs complement the antique turquoise glass chandelier that hangs amid the quiet creamy neutrals in this formal dining room.
Photograph by Sam Gray

FACING PAGE RIGHT
In this library, soft textural solids were combined with stripes and prints to create a warm, comfortable setting to read and relax in. A custom-made bobbin-legged ottoman serves as coffee table and focal point for many of the clients' own collected appointments.
Photograph by Sam Gray

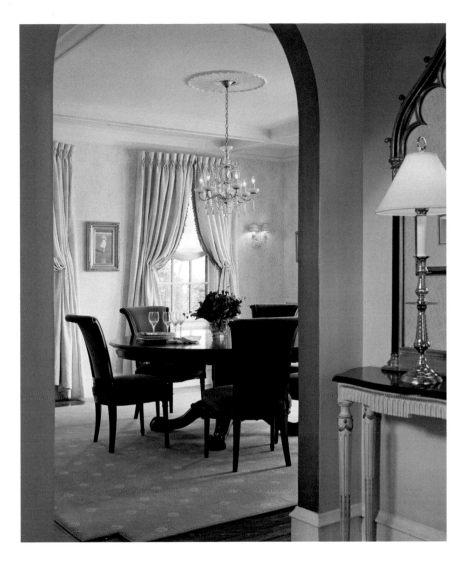

Q & A

MORE ABOUT COURTNEY ...

DO YOU EVER STEP INTO A PROJECT HALFWAY THROUGH?

Yes, sometimes clients begin designing on their own and become frustrated when their vision doesn't come through as they had intended. We are happy to help them make the most of the choices they've already made and redirect the design to better suit their needs and wishes.

HOW WELL DO YOU LIKE TO GET TO KNOW EACH CLIENT?

Very well! In order to create a thoughtful interior, we enjoy learning every detail of their routine, from what side of the bed they sleep on to whether they prefer a faucet with one handle or two. It's the little stuff that can make the biggest impact in people's lives.

HOW DO YOU ENSURE THAT INTERIORS WILL BE STYLISH FOR AT LEAST TWO DECADES?

We help our clients weigh the benefits when selecting colors and materials. For example, usually we stay away from painted tile as it tends to date an interior quickly.

WHAT IS THE MOST REWARDING ASPECT OF YOUR PROFESSION?

The goal is for clients to love living in their home, so when people comment that my team and I have made a difference in their lives, we couldn't ask for a greater compliment.

TAYLOR INTERIOR DESIGN, INC.
Courtney Taylor
125 Benefit Street
Providence, RI 02903
401.274.1232
Fax 401.454.4651

PROJECT PLACE

stablished in 1967 by a group of seminarians as a safe haven for teen runaways, Boston-based Project Place now serves over 700 clients every year. Providing a day of refuge for those experiencing homelessness is just the beginning of Project Place's services. Programs such as education, job training, work experience and housing help individuals dignifiedly reestablish themselves in society and yield a striking success rate.

2007 marked a significant milestone for the non-profit organization with the opening of Gatehouse. The six-story, mixed-use building boasts a commercial kitchen, dining area, conference room, classrooms, computer training center, restaurant, storage space, loading dock to support the businesses operated by Project Place clients and 14 units of affordable housing. Each unit was adopted by an interior designer, many of whom are featured in *Spectacular Homes of New England*, to ensure that the otherwise austere spaces are warm, inviting and foster feelings of security and encouragement. Gatehouse truly is a beacon for a better future for some of Boston's most vulnerable citizens.

One of the organization's initiatives, Clean Corners…Bright Hopes, affords displaced individuals the opportunity to make a difference in the community and earn a living by removing graffiti, sweeping streets, planting shrubbery and working on other special projects throughout the year. Neighborhood groups and business districts interested in this service can inquire with the enterprise office at Project Place. Local businesses can also lend their support by requesting a complimentary vending machine through the Project Pepsi program, which provides regular replenishing, maintenance and even empty can pickup services. The latest social venture, HomePlate, which is headquartered in Gatehouse, employs homeless individuals to market a line of wholesome homemade foods through a number of local venues, including pushcarts and local restaurants, as well as offer catering.

Project Place is a resource, a destination, an opportunity, a home and an organization that is unreservedly devoted to extending second chances to displaced individuals in New England.

ABOVE
Project Place's oldest business venture, Project Pepsi has employed over 100 individuals who are making strides to get their lives back on track.
Photograph courtesy of Project Place

FACING PAGE TOP
Project Place breaks ground on new home, GateHouse, on October 22, 2005. Members of the development team, community supporters and Mayor Thomas Menino (fourth from left) dig in to start efforts.
Photograph courtesy of Project Place

FACING PAGE BOTTOM LEFT
Award-winning chili served by one of Project Place's participants of HomePlate, a social enterprise employing women who have experienced homelessness.
Photograph courtesy of Project Place

FACING PAGE BOTTOM RIGHT
Project Place's Clean Corners…Bright Hopes crew partners with the Boston Red Sox to maintain the cleanliness around Fenway Park, creating job opportunities for homeless.
Photograph courtesy of Project Place

PROJECT PLACE
1145 Washington Street
Boston, MA 02118
617.262.3740
Fax 617.262.3282
www.projectplace.org

PUBLISHING TEAM

Brian G. Carabet, Publisher

John A. Shand, Publisher

Phil Reavis, Executive Publisher

Mary M. Whelan, Associate Publisher

Beth Benton, Director of Design & Development

Julia Hoover, Director of Book Marketing & Distribution

Michele Cunningham-Scott, Art Director

Mary Elizabeth Acree, Graphic Designer

Emily Kattan, Graphic Designer

Ben Quintanilla, Graphic Designer

Elizabeth Gionta, Managing Editor

Rosalie Wilson, Editor

Lauren Castelli, Editor

Anita Kasmar, Editor

Sam Gray, Contributing Photographer

Kristy Randall, Senior Production Coordinator

Laura Greenwood, Production Coordinator

Jennifer Lenhart, Production Coordinator

Jessica Garrison, Traffic Coordinator

Carol Kendall, Project Manager

Beverly Smith, Project Manager

PANACHE PARTNERS, LLC

CORPORATE OFFICE

13747 Montfort Drive

Suite 100

Dallas, TX 75240

972.661.9884

www.panache.com

NEW ENGLAND OFFICE

617.571.2099

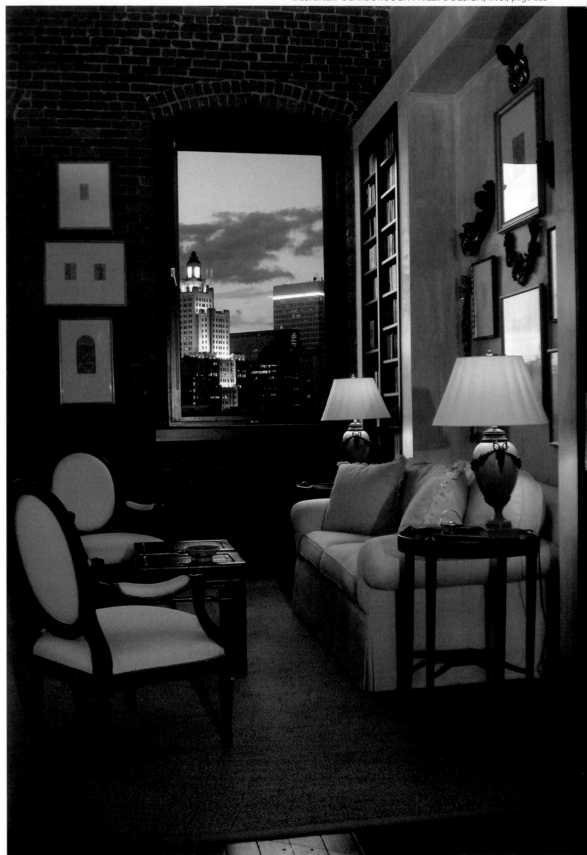

DESIGNER SCARBOROUGH-PHILLIPS DESIGN, INC., page 233

THE PANACHE COLLECTION

Dream Homes Series

Dream Homes of Texas
Dream Homes South Florida
Dream Homes Colorado
Dream Homes Metro New York
Dream Homes Greater Philadelphia
Dream Homes New Jersey
Dream Homes Florida
Dream Homes Southwest
Dream Homes Northern California
Dream Homes the Carolinas
Dream Homes Georgia
Dream Homes Chicago
Dream Homes San Diego & Orange County
Dream Homes Washington, D.C.
Dream Homes the Western Deserts
Dream Homes Pacific Northwest
Dream Homes Minnesota
Dream Homes Ohio & Pennsylvania
Dream Homes California Central Coast
Dream Homes Connecticut
Dream Homes Los Angeles
Dream Homes Michigan
Dream Homes Tennessee
Dream Homes Greater Boston

Additional Titles

Spectacular Hotels
Spectacular Golf of Texas
Spectacular Golf of Colorado
Spectacular Restaurants of Texas
Elite Portfolios
Spectacular Wineries of Napa Valley

City by Design Series

City by Design Dallas
City by Design Atlanta
City by Design San Francisco Bay Area
City by Design Pittsburgh
City by Design Chicago
City by Design Charlotte
City by Design Phoenix, Tucson & Albuquerque
City by Design Denver

Perspectives on Design Series

Perspectives on Design Florida

Spectacular Homes Series

Spectacular Homes of Texas
Spectacular Homes of Georgia
Spectacular Homes of South Florida
Spectacular Homes of Tennessee
Spectacular Homes of the Pacific Northwest
Spectacular Homes of Greater Philadelphia
Spectacular Homes of the Southwest
Spectacular Homes of Colorado
Spectacular Homes of the Carolinas
Spectacular Homes of Florida
Spectacular Homes of California
Spectacular Homes of Michigan
Spectacular Homes of the Heartland
Spectacular Homes of Chicago
Spectacular Homes of Washington, D.C.
Spectacular Homes of Ohio & Pennsylvania
Spectacular Homes of Minnesota
Spectacular Homes of New England
Spectacular Homes of New York

**Visit www.panache.com or call
972.661.9884**

Creators of Spectacular Publications for
Discerning Readers

INDEX

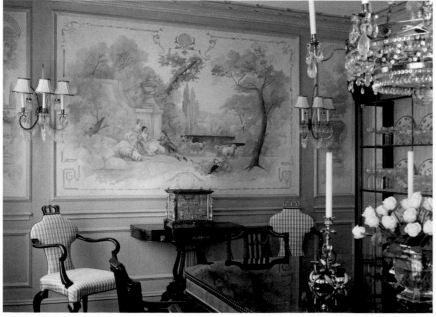

DESIGNER R. FITZ GERALD & CO., page 121

DESIGNER CEBULA DESIGN, INC., page 91